WITHDRAWN

The
Cinematic
Imagination

WRITERS AND THE MOTION PICTURES

The Cinematic Imagination

WRITERS AND THE
MOTION PICTURES

Edward Murray

Frederick Ungar Publishing Co.
New York

ONCE AGAIN TO PEG
AND
TO MY FIVE CHILDREN

You will see that this little clicking contraption with the revolving handle will make a revolution in our life—in the life of writers. It is a direct attack on the old methods of literary art. We shall have to adapt ourselves to the shadowy screen and to the cold machine. A new form of writing will be necessary. I have thought of that and I can feel what is coming. But I rather like it. The swift change of scene, this blending of emotion and experience—it is much better than the heavy, long-drawn-out kind of writing to which we are accustomed. It is closer to life. In life, too, changes and transitions flash by before our eyes, and emotions of the soul are like a hurricane. The cinema has divined the mystery of motion. And that is greatness.

—LEO TOLSTOY

Contents

ix

Dramatists, Novelists, and the Motion Picture

I

On an April evening in 1896, Charles Frohman—one of the most important producers at that time for the American stage—witnessed a presentation of Edison's Vitascope for a Broadway theater audience. Afterward Frohman remarked: "That settles scenery. Painted trees that don't move, waves that get up a few feet and stay there, everything in scenery that we simulate on our stages will have to go. Now that art can make us believe that we see actual, living nature, the dead things of the stage must go."[1] For many people in the theater the newly invented motion picture, which seemed to present a world more "real" than the stage, had to be competed with on its own terms. Only by offering audiences the same visual satisfactions as the cinema, they argued, could the drama hope to remain relevant to a machine age.

Now, it is interesting to note that during the nineteenth century pictorial stage realism had advanced enormously in a way that clearly prepared audiences for the motion picture. As A. Nicholas Vardac has shown, the fade, the dissolve, the chase sequence, parallel editing, music to heighten emotional scenes, and other techniques associated with films were first seen in a crude form on the stage. The motion picture was developed, Vardac believes, in response to an overwhelming need in modern man for greater visual realism.[2] Whatever the explanation for the tendencies described by Vardac in much nineteenth-century theater, one thing

1

remains certain about the present period: the motion picture has worked a revolution not only in the drama but throughout the whole of our technological society. It is not surprising that Arnold Hauser, in *The Social History of Art*, refers to the years following the First World War as "The Film Age." Indeed, films are now so popular that they have taken possession of prime time on television, a medium which at one point seemed to threaten the very existence of the motion picture.

Is it cause for wonder, then, that playwrights have been influenced by the screen?

Nevertheless, drama critics have generally deplored the influence of film on theater—the reason being that they have viewed this influence as an entirely negative one. Similarly, film critics have argued that the motion picture falsifies its unique nature by imitating and adapting stage plays. But who listens to critics? The average play today looks as though it was written and staged for the cameras. In films such as *Cinderella* (1900), *Red Riding Hood* (1901) and *A Trip to the Moon* (1902), Georges Méliès began a theatrical tradition that has lasted down to the present. When the sound film appeared at the end of the twenties, playwrights descended in force on Hollywood, thus forging still stronger ties between stage and screen. Throughout the thirties, forties, fifties, and even sixties—in spite of all the ready clichés about the "new theater" and the "new cinema"—stage and screen continued to maintain their close artistic and financial alliance.

Can anything *good* be said about the influence of film on drama? No less a personage than Tolstoy apparently saw great possibilities not only in the film itself but also in its influence on playwriting. On one occasion the Russian master confessed:

> When I was writing *The Living Corpse* I tore my hair and chewed my fingers because I could not give enough scenes, enough pictures, because I could not pass rapidly enough from one event to another. The accursed stage was like a halter choking the throat of the dramatist; and I had to cut the life and the swing of the work according to the dimen-

sions and requirements of the stage. I remember when I was told that some clever person had devised a scheme for a re- volving stage, on which a number of scenes could be prepared in advance, I rejoiced like a child, and allowed myself to write ten scenes into my play. Even then I was afraid the play would be killed. . . But the films! They are wonderful! Drr! and a scene is ready! Drr! and we have another![3]

Since it is my belief that the influence of film on the stage is a more complex problem than is ordinarily allowed, I wish to devote the first part of this book to an examination of cinematic borrow- ings by representative playwrights. For the most part, I shall be concerned with four major questions: Under what conditions does the cinematic imagination function legitimately and fruitfully in the drama? Under what circumstances does the influence of the film impair what purports to be a *dramatic* presentation of experi- ence? What normally happens to the film adaptation of a play that reveals filmic techniques? And, finally, is such a work generally more or less successful aesthetically than a noncinematic play that is translated into film?

II

Similar questions will be raised throughout the second part of the book. Historically, the cinematic imagination that Vardac has observed in nineteenth-century theater can also be seen in the development of the novel. D. W. Griffith claimed to have learned the technique of crosscutting from Dickens; Sergei Eisenstein, in "Dickens, Griffith and the Film Today," also argued that the Vic- torian novelist's work reveals equivalents of the close-up, montage and shot composition.[4] The novels of Flaubert, Hardy and Con- rad can also be said to have anticipated in part the "grammar of the film." Naturally, as the motion picture became the most popu- lar art of the twentieth century, the visual bias apparent in so much nineteenth-century fiction was enormously increased in con-

temporary fiction. Montage, parallel editing, fast cutting, quick scene changes, sound transitions, the close-up, the dissolve, the superimposition—all began to be imitated on the novelist's page. And over the years literary critics, like their colleagues in the theater, generally bemoaned this influence of the movies on the novel.

As early as 1915, educators had already begun to regard the film as a serious threat to literature. They were starting to use an argument, based on the relative strength and weakness of each medium, that would be rehearsed again and again in the years ahead. In "The Relation of the Picture Play to Literature," for instance, Alfred M. Hitchcock (not to be confused with the famous film director) gloomily informed his fellow English teachers that the motion picture was here to stay. But in spite of its vast appeal, Hitchcock argued, the cinema cannot really compete with the novel. Whereas a writer like Hawthorne is able to analyze characters and ideas in depth, the film-maker is restricted to a picture in two dimensions. Nevertheless, Hitchcock added, the fact remains that students—from among whom are supposed to come the future Hawthornes of our literature—go to the movies about three times a week, and that each new class reads more poorly than the last. The distressed educator concluded:

> There are better ways of stocking the mind than by flashing before the eye a kaleidoscopic jumble of unrelated information. There is danger in any form of amusement or instruction which merely gluts the mind. The picture play—who is she, this doubly pied piper of the new century, this siren with a sore throat, this—this—ah, that Charles Lamb were present to tell you! Even now methinks I hear him shrieking from his grave, "D-d-damn her at a venture!"[5]

However, not all literary men—certainly not the younger ones who in 1915 were among those students witnessing three or more "picture plays" a week—were prepared to "damn" the movies. With James Joyce as a guide, a new breed of fiction writer would soon attempt to find out the extent to which Hawthorne's art

could accommodate the technique of the film without sacrificing its own unique powers. The history of the novel after 1922—the year *Ulysses* appeared—is to a large extent that of the development of a cinematic imagination in novelists and their frequently ambivalent attempt to come to grips with the "liveliest art" of the twentieth century.

Part
One

DRAMATISTS
AND THE
MOTION
PICTURE

SHORT SUBJECT

The motion picture is filmed theater; it is an extension of the literary art of the stage, with some limitations removed.
—George Bernard Shaw

The film is the language of images, and images do not speak.
—Luigi Pirandello

Stage and Screen—Some Basic Distinctions

Film and drama have a number of features in common: both are able to tell a story; both use actors and speech; both deal with the emotional and ethical problems that beset human beings; and both require form or structure. Once such generalizations are made, though, obvious differences between the two mediums—for example, in the *way* that the stage enacts a story, and in the *way* that action is projected on a screen—are also readily discernible. Not to recognize the differences as well as the similarities between stage and screen is to court theoretical and creative confusion.

On the stage a "scene" can be defined in two ways: 1) as an act division with no alteration of place or time; 2) as a still smaller segment of an act in which the stage is occupied by an unchanging number of performers, so that when the stage composition changes—in other words, when there is an entrance or exit—a new scene commences. It is in the latter sense that the scene remains the basic unit in the structure of a play.

Ordinarily drama depends on a slow but steadily ascending line of tension; restriction in the number of sets and compression in time tend to augment the concentration of interest. In its most extreme form this type of structure is called focused or closed drama, and it remains the furthest removed from the film story at its most cinematic. Specific examples of the type are Sophocles's *Oedipus Rex*, Racine's *Phedre* and Ibsen's *Ghosts*. Even in panoramic or open drama—such as in Shakespeare's *Antony and Cleopatra*, where the form is loose and where there are many scenes

(in both senses)—the total structure of the play, though it bears a closer resemblance to film than the focused or closed form, is markedly different from a movie. Whether the playwright works in the tradition of focused drama or panoramic drama, almost invariably progression results from a series of dramatic confrontations building towards a crisis, climax, and conclusion.

It is otherwise with the film, where the basic unit is not the scene but the shot. Tempo in films varies greatly—from the fast cutting of Sergei Eisenstein and Alain Resnais, on the one hand, to the longer takes of Carl Dreyer, Jean Renoir and Michelangelo Antonioni, on the other; however, today the average shot probably stays on the screen about ten or twelve seconds. Since the filmmaker is able to show his subject from a number of different camera angles, and since he can easily shift his focus from one line of action to another, it would be foolish of him not to avail himself of such resources. A good screenplay, unlike a stage play, tends to find its unity, as John Howard Lawson has indicated, "less on the direct drive toward a goal and more on the theme."[1] Consequently, the structure of the film *seems* closer to life as it is ordinarily experienced than is the more stylized and conventionalized form of the average play. Except in rare instances (generally adaptations of epic novels like *Dr. Zhivago* and *War and Peace*) films—like life—do not stop the action for the sake of an intermission.

Unlike the dramatist, the film artist has complete control over space and time; that is, whereas the stage play unfolds in real space and time, the finished film projects a new space and time—one in which two places separated by three thousand miles and shot six months apart can be so edited that they appear on the screen as a single unbroken reality in the present. Continuity of space and time characterizes the stage play; discontinuity of space and time characterizes the motion picture. Because there is this radical difference between the two forms, stemming from physical properties of each, and because a play leaves less room for drastic alteration in structure than a novel, the difficulty of adapting plays into films remains very great.

The question of point of view is also relevant here. In Greek and Elizabethan drama, though events were mostly enacted in an objective fashion, the playwright was able to open up a subjective approach to character and idea through the use of a chorus or a soliloquy. The realistic theater of our own day is restricted to an objective viewpoint. Only by recourse to nonrepresentational techniques—such as the use of a narrator (*The Glass Menagerie, A View From the Bridge*) or expressionism (*The Emperor Jones, Death of a Salesman*)—can the playwright escape from the limitations of an unvarying point of view. It seems worth noting that at least three of the four plays just mentioned have been very much influenced by the movies. Even where the stage projects both objective and subjective viewpoints, however, the effect is different from that achieved on the screen. Jerzy Grotowski's work in the Polish Laboratory Theater has persuaded him that the theater can dispense with lighting, sound effects, make-up—it can even do without the stage itself—but that the one thing absolutely vital to it is the actor-spectator relationship. But note that this relationship differs radically from the experience one has in watching a motion picture. The fact that the theater involves live performances and that film involves performances projected from strips of celluloid constitutes a crucial distinction between the two forms of expression. In the theater the audience is generally riveted to a single angle of observation.* The movie director, though, can rapidly shift from objective to subjective—and to any number of subjective points of view—and in so doing seem to pull the audience directly inside the frame of his picture, giving the spectator the sense of experiencing an action from the viewpoint of a par-

* I say "generally" because at certain times in history theater has called for a change of playing space and a mobile audience. Recall in this connection the panoramic theater of the medieval period and some contemporary Happenings. Eisenstein had *Gas Masks* (1923) performed at the gasworks, the action moving from one floor to the next, and the audience trooping after it. This was Eisenstein's last play—for he rightly realized that the film could be much more flexible in regard to point of view and change of setting. After all, there are limits to how much even an audience composed of athletes can jump around!

ticipant. Identification of the viewer with the film character, then, can be much more intimate than the analogous situation in the theater.

Take, for example, the 1964 film version of Enid Bagnold's play *The Chalk Garden*. A child has been living with her grandmother, Mrs. St. Maugham, and the relationship between the two has become very close. One day the mother returns to claim her child again. When the bell rings, and as someone goes to open the door, the camera stays focused on the grandmother's worried face. Cut then to the empty hall before her, as she continues to wait and listen. Cut back again to Mrs. St. Maugham's troubled gaze. On the stage an approximation of this simple camera play could of course be achieved. For instance, the director might station the actress downstage in such a manner that the audience could watch her reaction to the events offstage. But the play director could not present a close-up of the grandmother's face, nor could he give the audience a glimpse of the empty hall—and the sense of the emotional barrenness which that shot symbolizes on the screen—from the perspective of the old woman.

Although the basic requirement in both drama and film is movement, they each move differently. On the stage—because of the limits imposed by point of view, time, place, and action—language is foremost in importance; on the screen—thanks to the camera's mobility—the image remains paramount. In a play there is verbal movement or fluidity; in a film there is visual movement or fluidity. This is not to say that there is no visual appeal in the theater, or that language has no place in a scenario; it is merely to affirm an order of priority. Long speeches in the theater can hold an audience spellbound; but long speeches on the screen nearly always bore the viewer, who "knows" (consciously or unconsciously) that words are being used where pictures would be much more appropriate. And if the words cannot be translated into pictures then it seems evident that the subject matter is essentially unsuitable for filming. No doubt, artists in both forms will attempt to refute these generalizations; and sometimes the results of their

experiments will prove interesting, perhaps even successful. In the main, however, the safest guide to success in the drama lies in the playwright's manipulation of language (no play of any depth can be written for the stage without language, for no amount of pantomime or ritual can take the place of Hamlet's soliloquy, or even a furious outburst by Big Daddy), while the key to high achievement in the cinema depends on an approach which forces the audience to look first and listen second.

Language that is thrilling in the theater generally strikes the movie viewer as artificial and hollow. The most impressive feature of *Othello*, which Orson Welles adapted in 1955, is the action that precedes the titles and the play proper. Welles shows the audience Desdemona's torchlight funeral procession, with alternating shots of the corpse, the evil Iago glaring inside his cage, and the marching soldiers chanting a dirge. The appeal here lies chiefly in the visual power of the scene, and to a lesser extent in the sound of the voices chanting. However, once the play itself begins on the screen, the clash between word and picture (or the conflict between Shakespeare and Welles) becomes painfully manifest. In order to maintain some semblance of visual dominance and fluidity, the director keeps his camera moving constantly—and most often pointlessly—in every conceivable direction. When Othello delivers his famous speech to the Senate, the audience strains to hear the magnificent language—not to stare at the back of the actor's head! In general, the more words are vital to the thrust and significance of a play, the less likely it is that the work will prove successful as a movie. "Even the so-called 'natural' stage dialogue is too inflated to appear natural on the screen," says Alexander Bakshy. "To be used at all it has to be stripped to the bone, reduced to the normal function of speech, which in nine cases out of ten is only a concomitant of action and not its source or substitute."[2]

If great language suffers when transferred to celluloid, bad dialogue fares even worse. This fact can be explained in part by the technique of the close-up: shoddy language sounds shoddier still

issuing from a mouth that stretches across a wide screen. Now it may be that if a director is skillful, and if the dialogue is generally kept subordinate to the picture, the close-up can occasionally "color the lines more subtly and richly than on the stage";[3] furthermore, the close-up can catch a significant grimace that might have been missed in the theater. Nevertheless, in most cases plays that are adapted into films—whether they are "opened up" or not—miss becoming screen classics because they remain too talky.

On the stage characters incline to be types and even symbols; on the screen characters tend to be more individualized and "realistic." One would think that a live performance would be more "real" than a performance projected mechanically on a screen, but generally just the reverse is true. While the playwright can present a "slice of life," such exercises in banality soon become boring; in order to compensate for the restrictions of his form, the dramatist must press language to the limits—an endeavor which results in various degrees of stylization. On the screen the "slice of life" is another thing. Because the film-maker can view his material from various angles, and because he can overcome the confinement of time and place which hobbles the playwright, "realism" seems more congenial to the screen than to the stage, where it takes an Ibsen to lift the mode to greatness. (And even in Ibsen there is more conventionalization of life than is at first apparent.) This is not to say that stylization is never successful in the movies. All art, to some extent, involves stylization. But when a film, such as *Citizen Kane*, makes use of stylization, it does so cinematically, or in conformity to the intrinsic nature of the medium. In short, filmic stylization is much different from theatrical stylization—as we shall see in the analysis of *Death of a Salesman* as a play and as a film. In a film adaptation, the intimacy the screen is capable of seems at odds with the more abstract and rigorous aesthetic distancing generally required by the stage.

Although the screen is more "realistic" than the theater, it does not follow that characters are more complex in a film than in a

play. Once again, just the opposite is the case. "One picture is worth a thousand words"—yes, provided that what the film-maker wants to "say" can be expressed in a picture. Actors are very important in the theater (which is one reason why most of them prefer the stage), but this is not the case in the movies—where the spectator sees not the performer in the flesh but a performance fragmented on film. "When Griffith began to take close-ups not only of his actor's faces but also of objects and other details of the scene," Richard Griffith and Arthur Mayer point out, "he demonstrated that it was the 'shot' and not the actor which was the basic unit of expression of the motion picture."[4] The *scene*, not the actor, is the basic unit in a play; but Griffith and Mayer are correct in calling attention to a fundamental difference between film and drama. Because stage characterization tends toward the abstract, and because language is the playwright's chief way of "getting at" character, it follows that dramatic personages can be more intellectually and psychologically complex than film characters. Discussing the film version of *Who's Afraid of Virginia Woolf?*, Edward Albee says: "Whenever something occurs in the play on both an emotional and intellectual level, I find in the film that only the emotional aspect shows through. The intellectual underpinning isn't as clear. . . Quite often, and I suppose in most of my plays, people are doing things on two or three levels at the same time. From time to time in the movie of *Who's Afraid of Virginia Woolf?* I found that a level or two had vanished."[5]

What Albee says of his own work is applicable to other plays transferred to the screen. Not even the most sensitive and talented film maker can hope to equal the depth of character revelation possible in the work of a major dramatist—at least not without making a movie that does *not* move, one that seems wordy and static. "Film art can evoke profound emotion," Lawson observes, "but . . . less on psychological penetration than on the juxtaposition and flow of images."[6] And there are distinct limits to how much can be revealed about character through filmic images alone.

Eugene O'Neill, Expressionism, and Film

*I saw how film technique could set me free in so
many ways I still feel bound down—free to realize a
real Elizabethan treatment and get the whole meat
out of a theme . . . As for the objection to the
"talkies" that they do away with the charm of the
living, breathing actor, that leaves me completely
cold. "The play's the thing," and I think in time
plays will get across for what their authors intended
much better in this medium than in the old.*

—Eugene O'Neill

I

Eugene O'Neill, born in 1888, was a boy when the motion
picture first appeared. He was twenty-four when his father, the
popular stage actor James O'Neill, made a silent film version of
The Count of Monte Cristo for the Famous Players Film Com-
pany. It was the same year—1912—that O'Neill began to write
plays. Since beginning playwrights rarely make money, O'Neill
decided to write film scripts in his spare time as a means of
realizing an income. Most of these scripts were comedies and
adventure stories. At one time O'Neill even planned to act in a
movie version of *The Last of the Mohicans*, which was to be shot
in New London, Connecticut, by an old friend, Guy Hedlund.
None of O'Neill's scripts were sold to the movies, however, and
the treatment of James Fenimore Cooper's novel failed to mate-

rialize. O'Neill's play, *The Movie Man: A Comedy in One Act* (1914), tells us something about his view at that time of films and film-makers. In the play Henry Rogers, a representative of Earth Motion Picture Company, and Al Devlin, his cameraman, seek to persuade a Mexican general that he must stage his next battle solely at the convenience of the moviemakers. "It seems significant that [O'Neill] always wrote for the screen on a typewriter but for the theater by hand," observes the playwright's biographer, Louis Sheaffer. "Behind the dual practice were most likely his different attitudes toward the two mediums: for the movies he was writing off the top of his head, concocting stories simply for money, whereas he was trying to get something of himself into his plays" (*Variety*, January 8, 1969).

Although O'Neill denied that he knew much about expressionism when he wrote *The Emperor Jones* (1920), he had read Strindberg, whose subjective *A Dream Play* (1902) represents an early example of the mode. Besides, expressionism and the movies were in the very air that O'Neill breathed: he could scarcely avoid being influenced to some extent by either one of them. Both Ibsen and Strindberg had led the way towards a shorter form of play construction. When the movies became popular, and when writers began to see possibilities in the screen, the newest of the arts accelerated the trend in the direction of shorter stage pieces. The expressionists agreed with F. T. Marinetti, the Italian Futurist, who advised dramatists to keep in step with the times by structuring their plays in the form of film scenarios. Not infrequently the results of this aesthetic were disastrous; but O'Neill was a finer writer than any of the expressionists (his only peer among them being the young Brecht), and consequently *The Emperor Jones* remains one of the most successful examples of the cinematic imagination on the stage.

The Emperor Jones is structured into eight scenes. The first scene is very long, for a good deal of exposition is required in order to prepare the audience for Brutus Jones's visions in the jungle. This scene is entirely dramatic in form. Scenes Two

through Seven, however, are a different matter. In Scene One the point of view is objective; in Scene Two through Scene Seven the perspective is objective-subjective; and in Scene Eight, O'Neill returns to an objective point of view. It is during the objective-subjective portions of the play that the dramatist exercises his filmic imagination.

Scene Two, for example, begins with action that could be translated into precise camera shots. O'Neill opens with an establishing long shot: "The end of the plain where the Great Forest begins." Then he dissolves to a medium shot: "The foreground is sandy, level ground dotted by a few stones and clumps of stunted bushes . . ." Next O'Neill calls for a panning shot: "Only when the eye becomes accustomed to the gloom can the outlines of separate trunks of the nearest trees be made out, enormous pillars of deeper blackness." He then cuts to a medium shot of Jones, who "enters from the Left, walking rapidly." Abruptly the camera moves in close to Jones: "He stops as he nears the edge of the forest, looks around him quickly, peering into the dark as if searching for some familiar landmark. Then, apparently satisfied that he is where he ought to be [cut to a medium shot], he throws himself on the ground, dog-tired."[1]

As Scene Two progresses, it becomes apparent that much of the dialogue could be omitted without real loss for the silent film cameras. In most cases even title cards would prove unnecessary. We do not need Jones to tell us that he is weary ("I's tuckered out sho' 'nuff" [p. 187])—we *see* him collapse, mop his brow and rub his aching feet. We do not need to hear Jones say that he cannot find the food he buried ("Is I lost de place? Must have! But how dat happen when I was followin' de trail across de plain in broad daylight?" [p. 189]—we *see* him consult his map, search the ground in vain and grow increasingly panic-stricken. We do not need to be informed that the woods are frightening to Jones ("Git in, nigger! What you skeered at? Ain't nothin' dere but de trees! Git in!" [p. 190])—we *see* that they are frightening to him.

On the stage, to be sure, some of O'Neill's language is indispensable. Whereas the camera can show us Jones's map with his markings scrawled childishly on it in a close-up, the actor playing Jones must tell the audience this information in the theater. More important, the drama is primarily a verbal art, as opposed to a visual one like the screen, and a serious play entirely in pantomime would come to seem strained and artificial. (Just as artificial as Russell Rouse's *The Thief* [1952], a movie made without dialogue—though not without sound—in the age of the talking film.) Yet even in the theater much of O'Neill's language could be eliminated from the jungle scenes in *The Emperor Jones* and the essential action—*thanks to the expository first act*—would remain clear to the audience. This statement could obviously not be made about any of the scenes in *Oedipus Rex* say or *Ghosts*—or, for that matter, about O'Neill's own later *Long Day's Journey Into Night*. For these great plays, unlike *The Emperor Jones*, are not cinematic.

The body of *The Emperor Jones* is built around a series of scenes that are highly visual. Consider the Little Formless Fears that Jones "sees" in Scene Two (pp. 189-190); or the protagonist's vision of the mute Jeff, whom Jones murdered in the past, in Scene Three (pp. 191-192). In Scene Four a gang of silent convicts appear accompanied by a guard who also silently cracks a whip over them (pp. 194-195); in Scene Five Jones "sees" some Southern planters at an auction block "exchange courtly greetings in dumb show and chat silently together" (p. 196). Scene Six contains exactly ninety-five words. The final scene in the objective-subjective mode—the one in which Jones encounters the Congo witch doctor and the crocodile—is also largely in pantomime; indeed, the whole scene contains fewer than seventy-five words of dialogue.

As the action of the play develops, and as Jones proceeds to regress further into the past, more and more of O'Neill's effects are projected in nonverbal terms. Some of Jones's visions, for instance, appear and disappear accompanied by lighting devices

which are clearly cinematic. In Scene Six, Jones's primitive ances-
tors materialize as follows: "Gradually it seems to grow lighter in
the enclosed space and two rows of seated figures can be seen
behind Jones;" when the vision ends, the "light fades out . . . and
only darkness is left" (pp. 198-199). In some respects the motion
picture would be more congenial than the theater to O'Neill's
material in *The Emperor Jones*. The camera, with its ability to
focus on small details, to enlarge the significance of objects that
can only be seen dimly—or sometimes not at all—on the stage,
might very well heighten the tension of some portions of the play.
On the screen the audience would not only see Jones firing his
gun—knowing full well that with each discharge of the weapon
the ex-convict is moving closer to his ultimate fate—but it would
also be privileged to see a close-up of the weapon and of Jones's
face working anxiously, thus emphasizing more forcefully the sig-
nificance of the action. At times, O'Neill's stage directions would
seem to defy satisfactory realization in the theater. How could a
patron in the second balcony discern that Jones, in Scene Seven, is
a man whose "eyes have an obsessed glare" (p. 200)? Certainly
the stage director could not rival the film-maker, whose technical
resources are so much more sophisticated, at the conclusion of
Scene Four: "[Jones] frees the revolver and fires point blank at
the guard's back. Instantly the walls of the forest close in from
both sides, the road and the figures of the convict gang are blotted
out in an enshrouding darkness" (p. 195). It seems quite likely
that O'Neill borrowed this last technique from the movies. Grif-
fith's *The Birth of a Nation* (1915), which the playwright probably
saw, displayed a fascinating range of expressive filmic devices; but
even some routine "photoplays" of the time occasionally altered
the shape of the screen (a process called "framing") for one
reason or another.

It seems worth mentioning here that one still sees films which
have sequences in them that are remarkably similar to the scenes
in O'Neill's play. In *The Flight of the Phoenix* (1965), directed
by Robert Aldrich, for instance, a passenger plane makes a forced

landing in a desert. As the weeks go by the survivors deteriorate
under the alternating relentless heat of the sun and the cold light
of the moon. Midway in the action an English soldier tells his
companions about a native girl he once saw perform an exotic
dance in Benghazi. Near the end of the film—as the soldier, like
Jones, is on the point of complete mental and physical collapse—
he suddenly "hears" the sound of music. Staring mutely at the
sand dunes, which are bathed in eerie moonlight, the soldier
"sees" the shadow of the native girl sensuously undulating on the
ground. By the time the scene ends the girl is entirely present to
the deranged soldier, the dance concluding abruptly with a close
shot of the crouching dancer smiling suggestively at the man. The
whole scene is rendered without a word of dialogue, and it is
probably the most effective bit of action in an otherwise mediocre
film.

Now it is important to observe that *The Flight of the Phoenix*
remains, in the words of Roger Manvell, "an uncompromisingly
realistic" film.[2] If *The Emperor Jones* were similarly realistic, the
stage would be unable to compete with the picture medium in
establishing its setting. For then only the screen could really cap-
ture the torrefying brightness of the late afternoon sun in Scene
One; only the screen could fully evoke the terrors of the Great
Forest at night, with its darkly swaying trees, menacing river, and
ghastly moonlight. But *The Emperor Jones* is obviously *not* a
realistic play. At this point in his life, O'Neill was in revolt against
what he conceived to be the limitations of realism. In the Prov-
incetown Playbill for the 1923-1924 season, the dramatist wrote:

> . . . it is only by means of some form of "supernaturalism"
> that we may express in the theater what we comprehend in-
> tuitively of that self-defeating self-obsession which is the dis-
> count we moderns have to pay for the loan of life. The old
> "naturalism"—or "realism" if you prefer . . . no longer ap-
> plies. It represents our fathers' daring aspirations toward self-
> recognition by holding the family Kodak up to ill-nature. But
> to us their old audacity is *blague*; we have taken too many

snapshots of each other in every graceless position; we have endured too much from the banality of surfaces. We are ashamed of having peeked through so many keyholes, squinting always at heavy, uninspired bodies—the fat facts—with not a nude spirit among them; we have been sick with appearances and are convalescing; we "wipe out and pass on" to some as yet unrealized region where our souls, maddened by loneliness and the ignoble inarticulateness of flesh, are slowly evolving their new language of kinship.[3]

What O'Neill is preaching here is the expressionist gospel. *The Emperor Jones* is at once the story of an individual man, a history of the black man throughout time, and an allegory about the primitive or irrational being that still lives in all of us, black and white, red and yellow, behind our civilized exteriors. As Jones sheds his clothes in a kind of psychological striptease, O'Neill attempts ·to go beyond appearances—quite literally now—to the man's "nude spirit." Hence *The Emperor Jones* is an extremely theatrical work of art in both conception and execution, in both style and setting. While O'Neill has borrowed cinematic techniques in the presentation of his play, he has nevertheless managed to subordinate them to an essentially dramatic and histrionic imagination. The author of *The Emperor Jones* has retained the playwright's traditional concern with the exploration of character; and while some of O'Neill's scenes, like episodes in German expressionist plays, are very brief, they are unified in structure and build toward a conventional catastrophe.

Significantly, the first play that O'Neill attempted to adapt to the silent screen was *The Emperor Jones*; like the scripts he had written before 1920, however, nothing came of his efforts. Finally, in 1933, a sound version of the playwright's short masterpiece was brought to the screen, adapted by DuBose Heyward and directed by Dudley Murphy. The film, which featured Paul Robeson in the role of Jones, was shot at Paramount's former Astoria, Long Island, studio where painted sets and an artificial jungle were created. As the reviewer for *Time* pointed out: "In Eugene O'Neill's

play, the most effective scenes were the ones which showed Brutus Jones . . . scrambling through a forest made dreadful by darkness, ghosts and the drums of a pursuit. These sequences are the least convincing in the cinema."[4] In addition, Jones's visions became unbelievable on the screen. "Each of [the protagonist's] memories came to life in a small medallion, set in the middle of a bush or in an apse of the forest," observes Raymond Spottiswoode. "The emperor recoiled in terror, and dispelled them only by firing at them the bullets reserved for his pursuers. The effect of this device was ludicrous, the mind being suspended half-way between the actual forest and the imagined incidents; the former faded into unreality, but the latter failed to acquire the body which had struck fear into the emperor."[5] Whereas certain features of the play, as I argued earlier, could be made more effective on the screen through the use of close-ups and transitional devices (William Lewin and Max J. Herzberg have counted about twenty-five dissolves in the movie[6]), the play as a whole proved to be too theatrically stylized for successful picturization.

Heyward altered the structure of the original work in order to make it more various, or cinematic. Although the running time of both versions is approximately the same, the film enacts about twenty years of Jones's life whereas the play focuses on a single night, bringing in the hero's background through dialogue and the visions. The first half of the movie is entirely the adaptor's creation and presents the events leading up to Jones's flight into the Great Forest; the second half is almost straight O'Neill, and in spite of those portions of the film which represent a technical improvement—and in a very few instances an expressive improvement—over the original, it is mainly a photographed stage play. More than one reviewer complained that the jungle sequences, which are fluid and exciting in the theater, are static in the film. Although a more gifted script writer and a more knowledgeable director might have achieved a better screen adaptation of O'Neill's play, no team could have really made a film version that would have had a power equivalent to the original.

As we shall discover again and again in this study, a playwright's or novelist's use of cinematic techniques is no guarantee that the finished play or novel will prove any more viable for the screen than a noncinematic construction. Indeed, in some cases the cinematic play or novel actually may prove to be *less* adaptable than a work that has not been influenced by the movies. True enough, in *The Emperor Jones* O'Neill borrows motion picture techniques; essentially, however, *The Emperor Jones* is a *play*; it is too stylized in stage terms for a movie camera. Although O'Neill uses devices reminiscent of the screen, he has transformed those devices—"theatricalized" them—for purposes of the stage.

II

A year after the theater opening of *The Emperor Jones*, Thomas H. Ince bought the screen rights to O'Neill's *Anna Christie* (1921). Released by First National Film Company in 1923, *Anna Christie* was the first cinema adaptation of an O'Neill play. Although the silent movie version (written by Bradley King and directed by John Griffith Wray) was little more than a photographed stage production, O'Neill told a journalist that *Anna Christie* on film was a "delightful surprise."[7]

Shortly after this O'Neill again began to think seriously of writing for the movies. He had seen Fred W. Murnau's silent masterpiece *The Last Laugh* (1924) and had been especially entranced by Emil Jannings's performance as the aging hotel doorman who is reduced to being a washroom attendant. During 1927 O'Neill made three attempts to write for the screen: he worked on an original scenario called *Ollie Oleson's Saga*; he also tried adaptations of *Desire Under the Elms*—his 1924 play, and one of the finest he ever wrote—and *The Hairy Ape*. Again Hollywood proved to be uninterested in O'Neill as a scenarist. A year later the Russians translated *Desire Under the Elms* into *Woman at the Fair*, which few people appear to have seen. Yet O'Neill's attitude toward films—his various disappointments notwithstanding—now

seemed positive. When he saw his first talking picture, *The Broadway Melody*, in Paris in 1929 he told George Jean Nathan: "I was most enthusiastic! Not especially at the exhibit itself, naturally, but at a vision I had of what the 'talky' could be in time when it is perfected."[8] He was even considering mixed-media for a new production of *Lazarus Laughed* (1928) in which only Lazarus would appear on stage, while the remainder of the action would be projected on a screen.

In 1930 there were two sound versions of *Anna Christie*. One was made in Germany and directed by Jacques Feyder for MGM; it was not shown in the United States until 1968, at which time the Museum of Modern Art had to obtain a print from the Czechoslovak Film Institute. The other version, also produced by MGM, was made in this country; it was adapted by Francis Marion and directed by Clarence Brown. *Anna Christie* is not one of O'Neill's best plays, and Brown's version—in spite of some shots of New York harbor, a scene at an amusement park, and some stormy moments at sea—remains largely a literal translation.* Apparently, O'Neill never saw the movie. The dramatist had informed the journalist Richard Watts, Jr. "that he was anxious to see [*Anna Christie* on film] because he admired Garbo. But a year later he told Watts he had not seen it and was not going to, because friends had warned him it was bad."[9]

By 1930 O'Neill's reputation was firmly established and he was making more money than ever before. *Strange Interlude* (1928), which ran for a year and a half on Broadway, enjoyed the longest first run of any of O'Neill's plays, while *Mourning Becomes Electra* (1931), though it ran for only five months, was hailed at the time as the "greatest American tragedy" and was instrumental in gaining its author the Nobel Prize for Literature in 1936. Now

* "Every bone of the play's framework . . . is carefully stressed in the important scenes in which Anna and her father and her lover are before the camera at the same time; the two men face each other at a table and Anna sits or stands between them, stressing the triangle; when Old Man Christopherson vents his periodic curse on the Ole Davil Sea he usually goes and looks out at the sea, and shakes his fist at it" (Anon., *Time*, XV [March 3, 1930], 28, 30).

Hollywood *was* interested in O'Neill as a scenarist; but O'Neill seemed not to be concerned any longer with Hollywood. Samuel Goldwyn, according to Sheaffer in the *Variety* piece cited previously, offered to pay the dramatist "any amount" to write a movie script for the Russian actress Anna Sten. Howard Hughes offered O'Neill "the astronomical (in those days) sum of one hundred thousand dollars to do the dialogue for an aviation epic." (O'Neill, by the way, received only seven thousand dollars from Ince for *Anna Christie.*) The playwright refused Hughes's proposal with a telegram in which the single word "No" was repeated twenty times.

While O'Neill was no longer anxious to write movie scripts, he still wanted to see his plays shaped into films. During 1932 he made a strong effort to arouse Hollywood's interest in some of his past stage presentations.* The next O'Neill work to reach the screen was *Strange Interlude*, which was released in 1932 by MGM, whose production head, Irving Thalberg, cast his wife, Norma Shearer, as Nina Leeds and Clark Gable as Edmund Darrell. Three writers received the credit for bringing O'Neill's five-hour drama (now cut to about two hours) to movie audiences: Beth Meredyth, C. Gardiner Sullivan, and Robert Z. Leonard; the latter also directed the film.

In *Strange Interlude* O'Neill had experimented with techniques derived from the novel; hence, in addition to using traditional dramatic dialogue, the playwright also resorted to Joycean interior monologues. O'Neill was no Joyce with language, however, and even some of his best work is marred by redundancies. Yet as a theater piece and as a reading experience, *Strange Interlude* still has the power to rise above its defects (it was successfully revived in 1963); as a film, it proved to be both an artistic and a box-office failure. The nine-act play is too long and too theatrical for the screen. As Stark Young observed in his review, the original is

* In what follows I have restricted my discussion to a consideration of the film versions of O'Neill's more important plays. The same practice is followed elsewhere in this study.

also too long, but the film-makers were forced to excise essential material.[10] One need not labor the problem: there is simply too much talk and not enough "action" in *Strange Interlude* for it to make a good movie. Few would probably quarrel with Alexander Bakshy's judgment that the film "conforms faithfully to its Hollywood type of an uninspired crossbreed of the stage and the screen."[11]

The movie version of his work which O'Neill liked best was *The Long Voyage Home* (1940), adapted by Dudley Nichols from four early plays of the sea: *Bound East for Cardiff* (1916), *In the Zone* (1917), *The Long Voyage Home* (1917) and *The Moon of the Caribbees* (1918). A cast headed by Thomas Mitchell and John Wayne performed well under John Ford's careful direction; and Gregg Toland's photography received a good deal of praise. Nichols was not entirely successful in welding the four short plays into a satisfactory structural whole, but Ford did manage to offset this defect in large measure by establishing a pervasive mood or atmosphere. Although the film's critical reception was mixed, unlike earlier adaptations of O'Neill's plays, Ford's *The Long Voyage Home* was *cinema*. And nobody appreciated this fact better than the dramatist himself, who once told a friend: "It was the talkless part of *The Long Voyage Home*—the best picture ever made from my stuff—that impressed me the most. . . ."[12]

O'Neill was far from impressed with the shoddy picturization of *The Hairy Ape*; consequently, in 1944, though he was no longer as affluent as he had been in the early thirties, he resisted the idea of selling *Mourning Becomes Electra* to Hollywood. "I've never liked having distorted pictures made of my plays," he wrote. "The picture medium has never interested me. . . Talking pictures seem to me a bastard which has inherited the lowest traits of both parents." Manifestly, time and experience had prompted O'Neill to forget his former concern with, and hopes for, the cinema. In the same letter he went on to say:

> Let's consider *The Hairy Ape*. It remains one of my favor-
> ites . . . I didn't really want to sell because I knew no one in
> Hollywood had the guts to film *my play*, do it as symbolic
> expressionism as it should be done, and not censor it into
> imbecility, or make it a common realistic stoker story. . . . So
> when I tell you I am not going to see the film—nor read one
> word written about it—nor even admit that it exists, I sure
> mean it! But all the same I will always feel guilty. The mem-
> ory of what *The Hairy Ape* is, was and should be, will, in a
> sense, be spoiled for me.

It seems not to have occurred to O'Neill that perhaps "symbolic
expressionism"—at least in the theatrical terms in which he con-
ceived it—was not the ideal material for a motion picture. Be that
as it may, the playwright ended his letter by again stating his
unwillingness to sell *Mourning Becomes Electra* "at any price."[13]

Nevertheless, O'Neill did sell *Mourning Becomes Electra* to
RKO Radio Pictures in 1946. Earlier that year he had seen Rosa-
lind Russell in *Sister Kenny*—which he said he had "liked tre-
mendously"—and when he learned that Miss Russell was availa-
ble for the role of Lavinia, he decided to consider the matter.
Perhaps, as Arthur and Barbara Gelb suggest, "the most impor-
tant factor in his decision was that Dudley Nichols would write,
direct and produce the film." At this time O'Neill was also quoted
as saying that while he enjoyed many motion pictures, he was
alarmed by the influence of Hollywood on the Broadway stage.[14]
Mourning Becomes Electra was one play that was *not* written for
the cameras, though, and anyone with even the most rudimentary
knowledge of the difference between stage and screen could have
predicted that the movie version would be an embarrassing failure.

Nichols's handling of the adaptation is much too reverent, and
the result is still another photographed stage play. This is espe-
cially unfortunate because O'Neill's ambitious trilogy is, as I have
suggested, much more theatrical than the majority of plays that
move almost automatically from stage to screen in our age of
realism. In "Working Notes and Extracts from a Fragmentary

Work Diary," O'Neill makes it clear that his approach in *Mourning Becomes Electra* is carefully organized in dramatic and theatrical terms:

> Obtain more fixed formal structure for first play which succeeding plays will reiterate—pattern of exterior and interior scenes, beginning and ending with exterior in each play . . . [U]se townsfolk at the beginning of each play, outside house, as fixed chorus pattern. . . .
>
> [G]et more architectural fixed form into outer structure—and more composition (in musical sense) into inner structure. . . . Repetition of the same scene—in its essential spirit, sometimes even in its exact words, but between different characters. . . . [15]

In addition to the "architectural" and "musical" structural patterns referred to by O'Neill, each play in the trilogy is also logically developed with a point of attack, a turning point, a crisis, a climax, and a conclusion. "And technically . . . I flatter myself it is unique thing in dramaturgy," O'Neill observed, "—each play [a] complete episode completely realized but at same time . . . not complete in that its end begins following play and demands that play as an inevitable sequel . . ." (p. 14). Such extreme dramatic formalization of structure is bound to seem contrived and artificial on the screen.

Similarly unpromising in respect to the movie medium is O'Neill's method of characterization in *Mourning Becomes Electra*: "Exclude as far as possible and consistent with living people, the easy superficial characterization of individual mannerisms—unless these mannerisms are inevitable fingerprints of inner nature —essential revelations . . . Peter and Hazel should be almost characterless . . . they are the untroubled, contented 'good' . . ." (p. 8). Unhappily, in the film *all* of O'Neill's characters appear to be "characterless." But even as a work for the theater, *Mourning Becomes Electra* seems too artfully designed, too much of an illustration of a theory—namely, a Freudian updating of the

Oresteia—than a deeply felt personal revelation by the artist. O'Neill does not have his eye on character here, but "on a plane where outer reality is mask of true fated reality—unreal realism . . ." (p. 12). On the stage (thanks to O'Neill's enormous energy and will) the symbols work to some extent; on the screen (as Robert Hatch remarks) they seem "ludicrous at a distance of six inches from the eye of the audience. It's a kind of intimacy that the greatest acting could not tolerate."* Furthermore, by placing the lens so close to the actors, Nichols succeeds in exposing O'Neill's inability to write tragic poetry. "If anything," John Mason Brown remarks, "the words [the characters] spoke seemed to have grown smaller, coming as they did from such big mouths."

O'Neill died in 1953, and so he did not live to see the film treatments of *Desire Under the Elms* and *Long Day's Journey Into Night.* Back in 1928, O'Neill himself had prepared a scenario of *Desire Under the Elms,* in which he changed Abbie Putnam from a New England woman to Stephanie, a Hungarian immigrant girl. More important, he also transformed the heroine's status from that of Ephraim Cabot's young wife to that of a housekeeper. He further eliminated the seduction by the woman of son Eben, the birth of the baby which results from their union in the play, and the mother's murder of the infant. Not much was left of *Desire Under the Elms* after O'Neill finished writing a scenario which would conform to the moral standards of moviegoers in the Jazz Age. (The dramatist's scorn, in the forties, for "distorted pictures" made from his plays appears somewhat ironic in the light of his own bowdlerization.) By 1958 Hollywood was ready for O'Neill's play as originally written, though American Abbie was changed to Italian immigrant Anna so that Sophia Loren could play the part. With the exception of a prologue, the return of the two older brothers, Simeon and Peter, later in the action, and the elimination of O'Neill's now unfashionable use of dialect, Irwin Shaw's screenplay was completely faithful to the original.

* New Republic, CXVII (December 8, 1947).

And that, of course, is exactly what's wrong with the film. *Desire Under the Elms* is one of the best plays O'Neill ever wrote; however, with its tight logical structure, half-symbolical characters, language shot through with animal and Biblical imagery, and mode of representation which walks a tightrope between realism and expressionism, the piece remains unsuitable for filming. As directed by Delbert Mann, the movie version of O'Neill's play appears small, sluggish, and stagy. There is the usual restriction one feels in the presence of a play literally transferred to the screen.

III

Without doubt *Long Day's Journey Into Night* (written between 1939 and 1941 but not produced until 1956) is O'Neill's masterpiece; it is certainly the finest play ever written by an American, and it is one of the few indisputably great plays of the modern theater. Though in 1923, O'Neill felt that realism ("holding the family Kodak up to ill-nature") needed to be replaced by expressionism ("some form of 'supernaturalism'"), in writing *Long Day's Journey Into Night* he returned to the earlier mode and showed that in the hands of a great dramatist realism could reveal both "the fat facts" and the "nude spirit." A motion picture version of O'Neill's long autobiographical play was released in 1963, and it is probably the best film yet made—or ever likely to be made—from the playwright's work. There is a certain irony here. In the expressionist *The Emperor Jones* and *The Hairy Ape*, O'Neill displays a cinematic imagination, but because of the dramatic and theatrical context within which the cinematic imagination functions, neither of those plays proved suitable for the screen. There are no filmic elements in *Long Day's Journey Into Night*, yet it became the most praised film version of any O'Neill play.

There are a number of reasons why *Long Day's Journey Into*

Night is a more successful motion picture than previous adaptations of O'Neill's work. For one thing, the director—Sidney Lumet—while neither a Fellini nor a Bergman, is certainly more accomplished than Clarence Brown or Alfred Santell; with the exception of Ford, Lumet is the best director to have adapted an O'Neill play for the screen. For another thing, the acting in the movie version of *Long Day's Journey Into Night* is excellent. Katharine Hepburn as Mary Tyrone, Ralph Richardson as James Tyrone, Jason Robards, Jr., as Jamie, and Dean Stockwell as Edmund are outstanding. But—and this is the crucial point—the original work itself remains the chief reason for whatever success the film achieves.

Long Day's Journey Into Night is not only more realistic than the best previously filmed O'Neill plays, it is also less "dramatic" in the conventional sense. O'Neill's play is structured into four acts, with Act Two divided into two scenes. However, if the individual scene units (each time there is a regrouping of characters on stage) are counted, we find there are six scenes in Act One, seventeen scenes in Act Two, eight scenes in Act Three, and four scenes in Act Four. Evidently the formal design of *Long Day's Journey Into Night* does not lie in any neat schematic balancing of act and scene sequences such as one finds in, for example, Sean O'Casey's *The Shadow of a Gunman*, where there are thirteen scene units in each act. Generally, the first act of a play is the longest, the last act the shortest; but the situation is just the opposite in O'Neill's masterpiece. Furthermore, examination of the work reveals that it possesses no dazzling Ibsen-like plot construction; it shows no sustained use of Chekhovian counterpoint and no semblance of Chekhov's other involved structural techniques; there are no signs in it of the "well-made play" (in either the historical or pejorative sense of that description); it employs none of Brecht's "epic realism"; and, finally it has none of the "anti-play" characteristics of the Theater of the Absurd. Since each of the main characters in O'Neill's play "proves the theme"—as Mary puts it, "None of us can help the things life has done to us.

They're done before you realize it, and once they're done they make you do other things until at last everything comes between you and what you'd like to be, and you've lost your true self forever"[16]—*Long Day's Journey Into Night* has nothing in common with Shakespeare's use of analogical structure, though in its length and especially in its richness of characterization the play suggests that "real Elizabethan treatment" which O'Neill once saw as a possibility for the "talkies." To sum up: *Long Day's Journey Into Night*—while it is a solidly constructed play—is unique in form; theme determines structure, and each scene unit is a revelation of the theme. Action in the play can be viewed only in terms of an increment of tension. Such a realistic, or seemingly unedited, picture of life is bound to transfer to film more easily than plays like *The Emperor Jones, Desire Under the Elms* and *Mourning Becomes Electra*, which are highly symbolistic and even allegorical.

Another reason why *Long Day's Journey Into Night* succeeds on film better than previously adapted O'Neill plays is that it is quite simply a better play than the others. Adapt any great play— or novel—to the screen, and *some* of the greatness is sure to come through any reasonably sensitive and intelligent treatment.

All the same, Lumet's *Long Day's Journey Into Night* is not a great film but still another photographed stage play. There is an opening scene in the front yard and another in the garage; after that the camera moves into the house permanently, or in other words for over two and a half hours. True, for the most part it is a far better photographed play than has heretofore been the case with O'Neill screen adaptations; however, that does not make Lumet's version a genuine motion picture. In "The Films of Sidney Lumet: Adaptation as Art," Graham Petrie argues that "even without dialogue, one could follow the emotional progression of the film, and catch the emotional tone, simply from the way in which [Lumet's] camera moves among the characters, creating a relationship based on tension, fear, suspicion, jealousy and a bewildering groping towards love and understanding."[17] I have my

doubts about that. It is difficult to separate ideas from emotions as the action of the play develops; and in *Long Day's Journey Into Night*, O'Neill probes ideas that cannot be photographed by Lumet or by any other director. "On the stage, O'Neill's great bundles of dialogue built the whole world of the play," Robert Hatch correctly observed in *The Nation* (October 13, 1962); "on the screen, they seem a perverse thwarting of dramatic movement." *Long Day's Journey Into Night* is filled with talk. It is great talk; but it is talk for the stage, not for the screen. As a result, Lumet is obliged to move his camera meaninglessly around the performers as they discourse within the confinement of the original stage setting. When occasionally the director seems to strike at least a balance between word and picture—most notably at the end when, as Mary delivers the play's concluding lines, the camera slowly recedes, then bolts forward for tight close-ups of each of "the four haunted Tyrones," and pulls back again for a final long shot—the visual approach (in John Simon's words) "merely draws attention to unresolved incompatibilities between two art forms."* In an interview, Lumet was quoted as saying: "For the benefit of those idiots who called *Long Day's Journey Into Night* a photographed stage play, every character had his own lens development. No two acts were shot alike" (*New York Times*, June 8, 1969). If the life of a play resides in its language, one will not make that play cinematic simply by finding "interesting ways to photograph actors while they incessantly *talk*. There is a basic problem here, but Lumet remains oblivious of it.

IV

According to Robert C. Roman in "O'Neill on the Screen," Paramount originally contemplated filming *The Iceman Cometh* (1946) in 1958. However, nothing seems to have come of the

* See *Private Screenings* (New York, 1967), pp. 41–42.

idea. Perhaps Paramount realized that O'Neill's play is only apparently realistic; that it is an allegorical exercise for the theater; that its large number of characters are merely philosophical abstractions; and that there is even more talk in it than in *Long Day's Journey Into Night*. While most of us would probably prefer to see Hollywood's experiments (if that is really the proper word) with O'Neill end forever with the respectable Lumet treatment of the masterpiece, Roman feels that *Beyond the Horizon* (1920), *The Straw* (1921) and *A Moon for the Misbegotten* (1957) "are ready-made for the screen." As if that were not enough to disturb our peace of mind, Roman adds: "And think of what an imaginative director and cameraman could do with *The Great God Brown* (1926)."[18]

Yes—only think of it!

Mixed-Media—from Bertolt Brecht to Happenings

Literature needs the film not only indirectly but also directly.

—Bertolt Brecht

I

It is not certain who first used motion pictures in a stage production, but Vsevolod Meyerhold would certainly have to be listed among the pioneers of mixed-media. By 1920, the famous Russian director was employing film sequences in stage plays and splitting the whole into thirty-five or forty scenes which flashed before the audience with cinematic rapidity. Meyerhold, who directed a movie version of Oscar Wilde's *The Picture of Dorian Gray* in 1915, insisted that the theater had to undergo "cinematification." In 1930, for instance, he wrote:

> . . . the play's division into acts, the inflexibility of conventional dramatic structure, must be superseded by episodes after the model of Shakespeare and the dramatists of the old Spanish theater, making it possible to abandon the antiquated pseudo-classical unities of time and action. We are entering upon a new phase of playwriting. We are creating a new kind of play.[1]

As Arthur Miller has suggested, however, "certain techniques, such as the jumping from place to place, although it's as old as Shakespeare, came to us not through Shakespeare, but through the movies. . . ."[2]

Other voices than Meyerhold's were raised for "a new kind of play." In 1924, Erwin Piscator took over the German Volksbühne and began to exercise a cinematic imagination upon the documentary material that fascinated him. For Ernst Toller's *Hurrah We Live*, Piscator had over ten thousand feet of film shot; in an effort to achieve simultaneous action, four motion picture projectors were employed during the performance. To show the march of world events and to telescope time while the protagonist was in prison, Piscator projected on a screen "newsreels" covering 1920-1927. Walter Ruttmann, the talented German film director, aided Piscator with the movie sequences.

Rasputin, which Piscator mounted in 1927, has been described by Mordecai Gorelik:

> The stage setting was shaped like a segment of a globe which opened in sections and turned on a revolving platform. The globe itself formed one projection screen; another screen hung above it, while at one side of the stage a narrow filmic "calendar" kept marginal notes on the multitude of events, giving dates and footnotes . . . The central screen permitted of a vast expansion of the action, as when the scope of military and naval operations was shown by means of three simultaneous battles.[3]

Crosscutting was used when, near the conclusion, the Czarina prayed to the ghost of Rasputin while on a screen shots of revolutionary soldiers appeared, symbolizing the collapse of the Romanov dynasty.

The most important playwright thus far to engage in mixed-media is Bertolt Brecht. The Epic Theater of Piscator and Brecht, of which so much has been written, represents a combination of nineteenth-century naturalism and twentieth-century expressionism. Both movements were reactions against the tight, logical causality of Ibsenian drama, and the slick, hollow structure of suspense in the "well made play." Brecht's Epic Theater is a revival, with some important modifications to be sure, of medieval and Elizabethan panoramic structure. Into his loose form, which at times resembles a lecture-demonstration, Brecht inserts songs,

mime, dance, signs, slides and motion picture sequences. The German playwright's much-discussed "alienation effect" was strongly influenced by Piscator. Both men (like Meyerhold in Russia) were at opposite poles from Constantin Stanislavsky in that they wanted not introspective psychology but feeling and emotion externalized on the stage. It can easily be seen then how well the camera adapted itself to Brecht's purposes, and why it has frequently been observed that when staged his plays sometimes seem like silent movies.

Brecht's concern with film derived from a number of sources. In "A Short Organum for the Theater" (1948), the playwright speaks of "an aesthetics of the exact sciences." He was very much open to the technological spirit of his age; indeed, at times the "Organum" reads like Zola's *The Experimental Novel*. For example, Brecht argues that "science and art meet on this ground, that both are there to make men's life easier, the one setting out to maintain, the other to entertain us. In the age to come art will create entertainment from that new productivity which can so greatly improve our maintenance and in itself . . . may prove to be the greatest pleasure of them all." In short, the theater must mirror the times; and since the motion picture is the most representative art of our scientific times, why not use its way of imitating life—even the mechanical process itself—on the stage?[4]

Over the years Brecht wrote several essays in which he outlined his views on stage and screen. In "The German Drama: pre-Hitler" (1936), the playwright suggests that the chief defect of his country's post-World War I theater was its inability to present on stage in a compelling manner the most vital themes of the day— the causes of the war, the class struggle, and the spreading industrialism. According to Brecht, Piscator's experiments with film enabled the theater to encompass the urgent issues of the time. Speaking of his associate's work, Brecht explains:

> The setting was thus awakened to life and began to play on its own, so to speak; the film was a new, gigantic actor that

helped to narrate events. By means of it documents could be shown as part of the scenic background, figures and statistics. Simultaneous events in different places could be seen together. For example, while a fight was going on between two characters for the possession of an Albanian oilfield, one could see on the screen in the background warships being launched in preparation for putting that oilfield out of commission entirely.[5]

Brecht reiterated these ideas in "Theater for Pleasure or Theater for Instruction" (also written sometime during the thirties), adding that "technical advances" now permitted "the stage to incorporate an element of narrative in its dramatic productions. The possibility of projections, the greater adaptability of the stage due to mechanization, the film, all completed the theater's equipment. . . ."

Throughout the twentieth century playwrights and novelists, great and small, have echoed Brecht's sentiments as expressed in "The Film, the Novel and Epic Theater" (1931):

> . . . the old forms of communication are not unaffected by the development of new ones, nor do they survive alongside them. The filmgoer develops a different way of reading stories [and viewing plays]. But the man who writes the stories [and the plays] is a filmgoer too. The mechanization of literary production cannot be thrown into reverse. Once instruments are used even the novelist [and playwright] who makes no use of them is led to wish that he could do what the instruments can: to include what they show (or could show) as part of that reality which constitutes his subject-matter; and above all, when he writes, to assume the attitude of somebody using an instrument.

It would be strange if Brecht's theories bore no relationship to his practice in the theater.

Brecht's play *The Mother* (based on Gorky's novel, *Mother*, which was also made into a film by Pudovkin in 1926) was completed the same year in which "The Film, the Novel and Epic Theater" was written. Brecht thought highly of this play—he him-

self selected it as the third of his works to be produced by the Berlin Ensemble; later a film was made of the production. In his notes to *The Mother*, Brecht points out that the play is "written in the style of a *Lehrstuck* ('play for learning')," and that "its concern is to teach the spectator a most definitely practical conduct that is intended to change the world. . . ." The writer then goes on to describe the first production of *The Mother*, dwelling on the scenic devices used to forward the play's activist mission:

> Quick scene changes were made possible by a system of solid iron pipes a little taller than a man, which were mounted vertically at varying distances about the stage, and to which could be hooked other horizontal, removable pipes of adjustable length, covered with canvas . . . Texts and photo documents were projected onto a large canvas in the background, and these could be left on during the course of a scene so the projection linen became a backdrop as well. In this manner, through the use of texts and photo documents as well as by the indication of actual rooms, the stage showed the great intellectual movement wherein the events transpired. The projections are by no means a mere mechanical auxiliary in the sense of a "visual aid," and offer no cribsheet for the lazy. They have no intention of assisting the spectator but aim rather to oppose him; they frustrate his total empathy and interrupt his mechanical assent. They render the EFFECT INDIRECT. In this fashion they are an organic part of the work of art.[6]

In Brecht's emphasis on "quick scene changes"—there are fifteen scenes in the play—one can discern at work what Meyerhold called the "cinematification of the theater." In his use of the projector, Brecht seems never to have gone beyond the relatively crude juxtapositions of the early Piscator. Thus, when the Mother, Vlassovna, bewails her fate in Scene One, "THE VLASSOVNAS OF ALL NATIONS" is projected on the screen; in this way, the playwright endeavors to shift the thematic focus from the particular to the general. Similarly, in Scene Four, as a counterpoint to the action, Marx's words, "THEORY TURNS INTO A MATE-

RIAL FORCE ONCE THE MASSES HAVE UNDERSTOOD IT!" direct the viewer's attention to the awakening process incumbent upon the proletariat. Pictures of the triumphant hammer-and-sickle, and photographs of such deep-dyed villains as the Czar, the Kaiser, Raymond Poincaré, Edward Grey, and Woodrow Wilson are also intended to function in terms of the Brechtian A-Effect.

It is certainly arguable whether the projections used in *The Mother* can support the large claims Brecht makes for them, whether they *are* anything more than "a mere mechanical auxiliary in the sense of a 'visual aid'. . . ." Devices such as those I have described smack too much of the agit-prop plays which were not the least of the forces operating on Brecht's dramatic imagination. In his introduction to Brecht's play, Lee Baxandall ranks it with such "classics" as Clifford Odets's *Waiting for Lefty*, Marc Blitzstein's *The Cradle Will Rock* and Vladimir Mayokovsky's *Bedbug* —which is not saying so much for *The Mother*! John Howard Lawson, who can generally be counted on for indulgence toward Marxist authors, says that Brecht's use of filmic technique suggests that the drama and the cinema may one day develop interlocking forms that will transcend what we now assume to be their essential differences.[7] Experiments in mixed-media—both Brechtian and non-Brechtian—do not, however, justify an overly sanguine outlook on such possibilities. Susan Sontag argues that the unreeling of film on stage enlarges the theater, but "in terms of what film is capable of, it seems a reductive, monotonous use of film."[8] One could go further than Miss Sontag and question whether the unreeling of film on stage really does expand the dimensions of the theater—except in sheer physical terms—and whether the manipulation of one or even a hundred movie projectors is precisely the way for the stage to justify its existence in an age of science and technology.

II

A few words are in order here on Brecht's screenwriting experience. The popularity of the *Three Penny Opera* (1928) prompted the Nero Film Company to make a movie version of the play in 1929. Brecht himself was engaged to do the adaptation, but apparently he failed to take the assignment with sufficient seriousness—though he did not neglect to alter the original so that it conformed to his developing Marxist views. When his scenario was rejected, the dramatist took his complaints to court. Although Brecht lost his case, he later accepted a settlement, having decided against an appeal. Eventually the film was written by the Hungarian critic Béla Balázs and directed by G. W. Pabst, one of the finest talents in Germany's "Golden Age of Cinema." The *Three Penny Opera* as a movie proved to be a box-office success. According to Frederic Ewen, Brecht "profited from the experience, for aside from the financial balm, it also led him to think more seriously about the writer's relation to industry in general and the film industry in particular."[9]

In 1932, the year after the *Three Penny Opera* was released, Brecht and Ernst Ottwalt teamed with director Slatan Dudow on a semidocumentary film about Berlin workers entitled *Kuhle Wampe* (called *Whither Germany?* in America), with music supplied by Hanns Eisler. *Kuhle Wampe*, as Siegfried Kracauer points out in *From Caligari to Hitler: A Psychological History of the German Film*, "was the first, and last, German film which overtly expressed a Communist viewpoint."[10] When Hitler became chancellor in 1933, Brecht went into exile in Denmark and Finland. In 1941, Brecht finally arrived at that place which has attracted so many writers in our time: Hollywood.

One is not surprised to learn that the "fraudulent glitter of Hollywood repelled" Brecht.[11] However, even a Communist has to eat; consequently, Brecht reconciled himself to the task of writing scenarios, remaining in California for almost seven years. He collaborated with director Fritz Lang on the story for *Hangmen*

Also Die, a fictional treatment of the assassination of the Nazi Heydrich; but believing that his work had been perverted, he insisted that final credit for the script be given to John Wexley (another revolutionary dramatist turned screenwriter). Brecht also worked on *Pagliacci* (for the Austrian tenor Richard Tauber), *Lady Macbeth of the Yards, Caesar's Last Days,* the songs for *Song of the Rivers,* and he helped to polish *Arch of Triumph.* His stay in Hollywood was made complete when the House Un-American Activities Committee called him to appear before it in 1947 to explain certain "suspicious" features of his work. Brecht told the Committee that he was not a Communist; he even managed to have some sly fun at the expense of the congressmen. Finally, the dramatist was excused—and he left the country. Like most writers who have worked in Hollywood, Brecht's experience in the film capital was far from being a happy one.

III

Of late there has been a marked increase in mixed-media. Some observers call it New Theater[12]; others dub it Expanded Cinema,[13] or the New American Cinema.[14] Many mixed-media artists are painters, sculptors, dancers, and musicians. Whereas Brecht's use of the technique was intended to teach audiences a lesson which would enable them to change the world along rational lines, the current devotees of multimedia insist upon the irrational basis of their art. Works of the New Theater and the New American Cinema tend to lack what Michael Kirby calls an "information structure"; such works possess—or so it is claimed —"significance" instead of "meaning."[15] A play by Brecht and a New Theater Happening both stand opposed to what the German playwright called "Aristotelian" drama; unlike Brecht, though, the artists of the New Theater have no story to tell. Henry Geldzahler says: "The strength and interest of a Happening when it is successful is in the force of its imagery, the carrying power of its

props, situations, costumes and sequences. In this they relate, per-
haps nostalgically, rather more to silent movies with their forceful
visual nonsense, than to anything in the highly verbal Theater of
the Absurd."[16] Geldzahler's comparison is a misleading one.
Even the zany comedies of Mack Sennett—though they make
their appeal on the visual level—possess character and plot.

But current partisans of mixed-media are hostile or indifferent
to drama and narrative. This becomes clear from their attitude
toward *time*, which is so important in the structure of a play.
Happenings do not depend on logic or even on the free association
of ideas for their form; instead of a predetermined end (accord-
ing to what passes as theory among mixed-media "thinkers")
onlookers are permitted any number of options, as much is left
to mere chance and improvisation. For the New Theater artist,
time is "material" or "spatial." Robert Whitman, who of all the
artists in this mode is probably most attracted to film, says: "Time
for me is something material. . . [I]t can be used in the same way
as paint, or plaster, or any other material. . . If I am making an
object, and I want to find the story of that object, one way to do it
is to see what people do when they are involved with it. . . The
images make real the experiences of the time."[17]

Roberts Blossom, who calls his work "filmstage," has a some-
what more involved concern with time:

> In movies what you see *has* presented itself potentially to
> touch, but has been abstracted forever from touch by the
> camera. But sound, which has never been touchable, remains
> reliably the same. Both sight and sound, however, have this in
> common in film: they are both past experiences presented as
> present . . . To combine a present experience (stage), which,
> though rehearsed, nevertheless has the touch element, with a
> past experience (film), presented as present, is thus to com-
> bine the unconscious (recorded) with the conscious (pres-
> ent). Sounds heard from the stage area can only come from
> visible or hidden (that is, potentially tangible) sources. Even
> from off-stage this is true. But a sound heard from a movie
> track or a tape-recorder has a visible-tangible source only in

the projector or tape-recorder. Its "real" source is removed in time. Thus the stage sounds heard during filmstage, even from off-stage, become localized as present. Time thus, perhaps for the first time in theater, becomes present as a spatial element.[18]

Filmstage and the like remain very much removed from the humanistic theater of Sophocles, Shakespeare, Ibsen, Chekhov, and Shaw. Whitman and Blossom speak not of character, or language, or good and evil, but of "objects" and "spatial elements." Happenings (as well as the vocabulary in which they are described) tend to be impersonal, mechanical, and often pretentious. Although partisans of the mode give lip service to the "life-enhancing values" of Happenings, the majority of such works are uncomfortably faithful reflections of that gray, computerized world against which so many young people today are rebelling. People who favor Happenings talk about "processing," "programming," and "feedback"—which sounds more like a description of an eight-hour day at the office or plant than an exciting aesthetic experience. But then multimedia experimentalists have no real aesthetic; they much prefer an "anything goes" attitude. Indeed, most of these "artists" apparently view their creations as "disposable"—like other consumer products in our society—rather than made for the ages. That such works will consequently go the way of drinking cups and paper towels goes without saying.

Mixed-media has "progressed" from Meyerhold, through Piscator and Brecht, to "filmstage." Yet to most critics none of the experiments in this bastard mode over the past fifty years have seemed especially valuable. Brecht, for example, appears at his best when he is not tinkering around with movie projectors. Whether any work in mixed-media will eventually be judged a classic, or whether the future will see the production of a masterpiece in the genre, remains to be seen. At present, however, the status of the form seems dubious to say the least.

Tennessee Williams—after
The Celluloid Brassiere

> When I was little, I used to want to climb into the
> [movie] screen and join the action. My mother had
> to hold me down.
>
> —Tennessee Williams

I

In *Tennessee Williams and Friends* Gilbert Maxwell says that
the famous playwright was "too weak, timid, and introspective to
join in healthy games [as a boy] . . . [and] retired into a make-
believe world of motion pictures. . . [A]ll through childhood and
adolescence [he] sought escape in movie houses from a world of
poverty and misunderstanding that seemed often too harsh to have
the reality of that fanciful world dancing before [his] eyes on a
silver screen."[1] When Williams came to write his most obviously
autobiographical play, *The Glass Menagerie* (1945), he had his
narrator, Tom Wingfield, announce: "I go to the movies because
—I like adventure. Adventure is something I don't have much of
at work, so I go to the movies." Later in the play, however, Tom
rebels against the escapism offered by films: "People go to the
movies instead of *moving*! Hollywood characters are supposed to
have all the adventures for everybody in America, while every-
body in America sits in a dark room and watches them have them!
I'm tired of the *movies* and I am *about* to move!"[2] According to
Maxwell, Williams himself has never abandoned his moviegoing

habit: "To this day," he remarks, "Tenn and I are childishly ardent movie fans. We go to pictures together and always sit in the loge where we can whisper and laugh without disturbing too many people, or being summarily ejected for becoming helpless with glee when a film turns out to be unintentionally funny." Finally, Maxwell reports that Williams is fond of searching for old movie magazines, which he saves for their pictures of the silent film stars that charmed him as a child.[3]

II

Williams has written that in the summer of 1939 he was employed "at Clark's Bootery in Culver City, within sight of the MGM studio. . . ."[4] He was still unknown then, and he had gone out to California with the intention of working as a scenarist.[5] While he was selling shoes, Williams won a prize of one hundred dollars for a group of one-act plays called *American Blues*; this prompted him to abandon his screenwriting ambitions—at least for a time. When *Battle of Angels* (1940) failed in Boston, the young playwright's return to the "movies" took the form of a job as an usher in Manhattan's Strand Theater. At last, in 1942, Williams's agent secured him a six-month contract with MGM at two hundred and fifty dollars a week. Elated, and filled with ambition, the would-be scriptwriter departed for the screen colony.

But Williams—like so many writers before and after him—was soon to be disillusioned about the ways of Hollywood. When he arrived at MGM, the dramatist was under the impression that he was going to work on an adaptation of Margerite Steen's best seller, *The Sun Is My Undoing*. Instead he was ordered to write a script for a Lana Turner movie entitled *Marriage Is a Private Affair*. Williams dutifully labored on his assignment for several weeks; when the scenario was finished, he submitted it to his superiors, confident that he had done a good job on his first assignment. However, the script was rejected—possibly because the

material was too intellectually and emotionally demanding for Miss Turner's talents. Today Williams refers to *Marriage Is a Private Affair* contemptuously as *The Celluloid Brassiere*.

The aspiring—but now slightly disenchanted—screenwriter's next chore was supposed to be a script for the child star Margaret O'Brien. In view of the fact that Williams was less than enthusiastic about a vehicle for Miss O'Brien ("Child stars make me sick," he told the MGM moguls) his second assignment also proved unsuccessful. Determined to make good in Hollywood, Williams then set to work on an original scenario, *The Gentleman Caller*. When it was completed, the young writer presented it to the reigning powers, modestly predicting that *The Gentleman Caller* would run twice as long as *Gone With the Wind*. Misunderstanding, the production heads at MGM returned *The Gentleman Caller* with the comment that they were not interested in filming a second Southern epic. Not surprisingly, Williams's contract was not renewed at the end of six months.

Two years later, Williams's abortive scenario was transformed into the play that made its creator famous: *The Glass Menagerie*. Ironically, MGM was among the studios bidding frantically for the box-office hit; the work that was originally conceived while Williams was on the MGM payroll, however, went to Warner Brothers for half a million dollars. Since then Williams's work has proved to be extremely attractive to motion picture producers—so much so that Hollis Alpert, in a review of *This Property Is Condemned* (based on a short play by Williams), has been moved to remark "that Hollywood is now able to whip up the familiar Southern mixture with very little help from the master himself. . . Now the next step is for Hollywood to invent Tennessee Williams movies on its own—that is, if it can think of the titles."[6] (Incidentally, it is said that no less than sixteen writers worked on *This Property Is Condemned!*)

Nevertheless, Williams claims that he has not really enjoyed working in Hollywood. Even when a playwright adapts his own work for the screen, Williams argues, he has far too little control

over the final product. (That Williams felt obliged to rewrite the last act of *Cat on a Hot Tin Roof* in order to please his director, Elia Kazan, seems to have escaped his mind.) "Unfortunately, once a movie gets rolling," says Williams, "there's not much the author can do. Too many people are involved. And it's too difficult to keep checking up on it."[7]

Williams's attitude towards the movies, it would seem, represents a mixture of childish fascination, smug condescension, and financial dependence. Since such strong emotions are involved here, it would be strange if the playwright's interest in films had no influence on his dramaturgy.

III

As *The Glass Menagerie* shows, that influence was actually present at the start of Williams's career. I am not now merely referring to the autobiographical dimension present in Tom Wingfield's compulsive escape into movie adventures. Before *The Gentleman Caller* became *The Glass Menagerie,* Williams had studied at the New School for Social Research in New York under Erwin Piscator. It is no accident that the expressionistic devices called for in the published version of *The Glass Menagerie* (and omitted in the Broadway production) are reminiscent of the mixed-media techniques employed by Piscator and Brecht. Although in his "Production Notes" to *The Glass Menagerie* Williams disparages "the photographic in art," he nevertheless attempts to justify his use of the screen for projecting pictures and titles in the play:

> Each scene contains a particular point (or several) which is structurally the most important. In an episodic play, such as this, the basic structure or narrative line may be obscured from the audience . . . The legend or image upon the screen will strengthen the effect of what is merely allusion in the writing and allow the primary point to be made more simply and lightly than if the entire responsibility were on the spoken

lines. Aside from this structural value, I think the screen will
have a definite emotional appeal, less definable but just as
important . . . A free, imaginative use of light can be of
enormous value in giving a mobile, plastic quality to plays of
a more or less static nature.[8]

Thus, when Amanda speaks of her girlhood an image of the
mother in her youth suddenly flashes on the screen (p. 9); when
Laura confesses to having deceived Amanda, the words: "THE
CRUST OF HUMILITY" illuminate the screen (p. 18). One is
reminded here of Piscator's filmic "calendar" in *Rasputin* and of
Brecht's use of Marxist slogans in *The Mother*. Critics seem in
unanimous agreement that in staging the play Eddie Dowling was
wise to eliminate the screen device. The projection of images and
titles throughout the action seems not merely redundant but some-
times even unintentionally farcical. As Gerald Weales points out:
"in the dinner scene, when Laura, panic-stricken at the idea of
sitting down with the gentleman caller, drags herself unwillingly
toward the table, Williams calls for the legend: 'TERROR!' As
she stumbles and Amanda and Tom cry out, the screen says,
'AH!' This would put us back with the Gish sisters in the silent
movies and not, as the device suggests, with Piscator and Brecht
on the edge of the Epic Theater."[9]

In 1950, *The Glass Menagerie* was made into a film. Williams
and Peter Berneis worked on the script; Irving Rapper directed.
The finished product demonstrates one of the paradoxes of mod-
ern writing: works written with an obvious debt to the cinema
almost never translate well into motion pictures. Here is a play
that uses a movie screen, fluid lighting devices, silent action, and a
final dissolve—yet *The Glass Menagerie* fails to live on celluloid.
In order to escape the confinement of the original single setting,
the adaptors created scenes in a business school, a shoe factory, a
dance hall, a zoo, and a ship at sea. This was a legitimate use of
the motion picture medium, but it failed to save the adaptation.
Hugh MacMullan, who was dialogue director for the film, argues
that *The Glass Menagerie* "is essentially descriptive and without

motion," that it is not suitable for film. Some of the difficulty, according to MacMullan, stems from Williams's use of a narrator. Film is too realistic, he suggests, to permit a narrator who looks directly into the camera; in addition, the use of a narrator's voice has been overdone and tends to be trite; and, finally, the language of Tom's narration is too "literary" for the screen.[10]

MacMullan is largely correct about a narrator being generally ineffective on the screen, though occasionally the technique does work (recall, for example, *Alfie* [1966], in which the title character addresses the audience in both off-screen and on-screen narration). That Tom's narration is too "literary" for the screen is probably more to the point, though here too it should be added that some drama critics also feel that even in the play Tom's comments to the audience have the negative effect of lowering tension. However that may be, it seems that very little hard thinking was brought to bear on the problem of adapting a play such as *The Glass Menagerie* into a motion picture. Although some theorists have compared the unreeling of film to the world of dreams —seeing the screen as a "subjective" medium opposed to the more "objective" stage—"dream plays" are invariably mangled when transferred to pictures. *The Glass Menagerie* is a "memory play," and as such it remains unadaptable into another medium: photographing the characters and events of the play all but completely destroys the "delicate or tenuous material" of the original (p. ix).

MacMullan seems to be confused about the structure of the play. According to him, *The Glass Menagerie* "does not have any clear (in the classic sense) plot line; the entire action hinges on the incident and incidence of the Gentleman Caller." True, Williams's play tends towards the episodic; but a close analysis of the action reveals the presence of a traditional form. The pivotal points in the structure could be isolated as follows: Dramatic Question: Will Laura be an old maid? Turning Point: Tom agrees to bring home a gentleman caller for Laura. Crisis: Will the caller, who kisses Laura, marry her? Climax: No, the caller cannot

marry Laura because he has a fianceé. Conclusion: Laura is going to be an old maid. Suppose *The Glass Menagerie* had an even tighter plot ("in the classic sense")—would *that* have made it more promising material for the screen? The countless dismal screen versions of such plays make this seem unlikely.

Finally, it should be noted that Williams—according to his mother—objected to the flashback in the movie which showed Amanda "dancing at a ball as a young girl when, as he put it, 'they tried to get a *Gone With the Wind* effect'."[11] As MacMullan himself acknowledges, this flashback is open to criticism in respect to the logic of point of view inasmuch as it is Tom's "memory play," not Amanda's. Such muddled use of flashback sequences is, however, far from uncommon in movies.

A survey of Williams's plays after *The Glass Menagerie* reveals the cinematic imagination at work in a significant number of them. In his introduction to *Summer and Smoke* (1948), the playwright says: "Everything possible should be done to give an unbroken fluid quality to the sequence of scenes."[12] Williams has frequently insisted on this "fluid" movement for his stage images. Speaking of *Camino Real* (1953), he points out that Elia Kazan "was attracted to this work mainly . . . for its freedom and mobility of form . . . its continual flow."[13] With his experience of directing in Hollywood, Kazan has helped to accentuate the filmic qualities of Williams's plays. In his treatment of *Cat on a Hot Tin Roof*, for example, in one scene Kazan employed a hollow spotlight to follow the action and focus on the key character in a way that resembled a screen close-up.

Williams has also been inclined to use what might be called filmic metaphors in his plays. Consider Scene One in *Summer and Smoke*, where the holiday rockets explode at intervals while Alma Winemiller and John Buchanan talk below in the park: There is a "burst of Golden light over their heads. Both look up. There is a long-drawn 'Ahhh . . .' from the invisible crowd." At one point, John counts the puffs of light, while Alma watches anxiously.[14] The sexual significance of the rockets seems evident. However,

there is a certain awkwardness about the scene (the too obvious orgasmic symbolism is not at issue here), and one feels that the device properly belongs to a visual medium, that the bursting rockets ought to be *seen*. For in how many movies have we not been exposed to like filmic equivalents for physical and emotional states? Without belaboring the point, it should also be noted how Williams uses music in plays like *The Glass Menagerie* or *A Streetcar Named Desire*, where specific themes or motifs are faded in and out with movie-like precision.

Many of the scenes in Williams's plays resemble sequences from the silent film days of the dramatist's boyhood. Perhaps the most apparent instance in this connection occurs in the following scene from *Camino Real*:

> A *white radiance is appearing over the ancient wall of the town. The mountains become luminous. There is music. Everyone, with breathless attention, faces the light.* Kilroy *crosses to* Jacques *and beckons him out behind the crowd. There he snatches off the antlers and returns him his fedora.* Jacques *reciprocates by removing* Kilroy's *fright wig and electric nose. They embrace as brothers. In a Chaplinesque dumb-play,* Kilroy *points to the wildly flickering three brass balls of the Loan Shark and to his golden gloves: then with a terrible grimace he removes the gloves from about his neck, smiles at* Jacques *and indicates that the two of them together will take flight over the wall.* Jacques *shakes his head sadly, pointing to his heart and then to the Siete Mares.* Kilroy *nods with regretful understanding of a human and manly folly. A Guard has been silently approaching them in a soft shoe dance. . . .* Kilroy *assumes a very nonchalant pose. The* Guard *picks up curiously the discarded fright wig and electric nose. Then glancing suspiciously at the pair, he advances.* Kilroy *makes a run for it. He does a baseball slide into the Loan Shark's welcoming doorway. The door slams.*[15]

In *Sweet Bird of Youth* (1959), which has as one of its chief characters an aging movie queen, Williams introduces a device that would have pleased his former teacher, Piscator. While the

hero, Chance Wayne, remains trapped inside a hotel, the villain, Boss Finley, is outside haranguing a crowd.

> Chance *walks slowly downstage, his head . . . in the narrow flickering beam of light. As he walks downstage, there suddenly appears on the big TV screen, which is the whole back of the stage, the image of* Boss Finley.[16]

Williams then proceeds to play off the live action against the screen action, seeking that simultaneity of effect that the creators of Epic Theater and not a few others in the theater have tried so hard to achieve in our time. The technique used in this scene, by the way, was replaced by simple cutting in the movie version of *Sweet Bird of Youth.* It is also interesting to note that four years before the Williams play appeared George Cukor directed the film *A Star Is Born,* in one scene of which Judy Garland is shown receiving an Oscar in a long shot at the left of the screen, while at the right side a tremendous close-up of the star appears on a TV screen.

The reference to light in the previously quoted stage directions from *Sweet Bird of Youth* prompts discussion of another important continuing element in Williams's plays. The use of electric light on the stage dates back to the middle of the last century. Adolphe Appia was one of the most gifted pioneers in the imaginative employment of light, but much of his thinking was influenced by Symbolist aesthetics, which called for a poetry and a drama resembling music. As M. H. Abrams has been able to show, the roots of Symbolism in this respect can be discovered in German criticism of the late eighteenth century.[17] Stage technology in the nineteenth century made possible many original and sophisticated uses of light. When movies arrived, however, stage lighting was no longer influenced by music alone, for light is one of the basic properties of film. Gerald Weales has observed that Williams manages light in order to enhance the non-realistic quality of his plays. In *Suddenly Last Summer* (1958), for instance, when Catherine Holly describes her seduction "the lights have

changed, the surrounding area has dimmed out and a hot white spot is focused on" the girl.[18] The same technique is repeated in other plays. "Light can be used as a dramatic metaphor, as in *The Eccentricities of a Nightingale*, when the dead fireplace flames again, indicating that Alma and John can make love," argues Weales, "and as a visual parallel, as in *Camino Real*, where the blue flame in the chafing dish on the Mulligans's table flares up and dies down while Marguerite and Jacques discuss dying in a sanitarium."[19]

It does not seem to have occurred to Weales *how* "visual" these devices are, or how much they owe to Williams's interest in the cinema. By blacking out all but the most vital action, the dramatist aims for a stage version of a movie close-up. In other words, Williams attempts to escape from a narrow stage realism through a theatrical technique inspired by the movies! It is worth noting that Sidney Lumet spoiled the film version of *The Fugitive Kind* by frequent lapses into theatrical lighting. In one key scene, as Val Xavia (Marlon Brando) tells Lady Torrance (Anna Magnani) about some symbolic birds, the light in the store slowly fades until the speaker's eyes alone are illuminated. The device might have succeeded had Lumet provided a realistic basis for the change in lighting. As matters stand in the film, though, the lighting technique remains distracting and pretentious.

Patently, the "dramatic metaphors" and "visual parallels" noted by Weales as recurrent features of Williams's plays are also staple elements of film art. Take a single example: the famous juxtaposition of shots by Claude Autant–Lara in his adaptation of Raymond Radiquet's novel *Devil in the Flesh*. While the lovers embrace passionately on their bed, the camera discreetly moves off, travels slowly around the bed and ends on a close shot of flames leaping in the fireplace. Later in the film—after the death of the woman—the man revisits the room; once again the camera traverses the bed, closing in on the fireplace, where now only ashes remain. The symbolism here is essentially the same as that cited by Weales in Williams's plays.

IV

Tennessee Williams has probably sold more plays to the movies than any other dramatist of the twentieth century. In "Cinematic Structure in the Work of Tennessee Williams," George Brandt argues that *A Streetcar Named Desire*—because it is organized into scenes instead of act divisions—is close to the structure of film and that is why it "translated exceptionally well to the screen"; he further maintains that *The Glass Menagerie* is Williams's most cinematic play.[20] But Brandt forgets to mention that *The Glass Menagerie* did not translate well to the screen. Actually *A Streetcar Named Desire* is not very cinematic at all. Most critics probably would agree that the two plays mentioned above, together with *Cat on a Hot Tin Roof*, represent Williams's finest work for the stage (with *Suddenly Last Summer* and *The Night of the Iguana* not far behind Williams's most notable achievements). Plays such as *The Glass Menagerie*, in which Williams employs cinematic devices rather extensively, do not film successfully because at the same time they are extremely *theatrical* (which is why *Suddenly Last Summer* fails as a movie). The more "realistic" plays, such as *A Streetcar Named Desire* and *Cat on a Hot Tin Roof*—wherein the cinematic imagination is much less in evidence —are actually better on the screen (which is why *The Night of the Iguana* pleases where *Suddenly Last Summer* disappoints). Generally speaking, plays—especially distinguished plays—do not provide satisfactory motion picture material. In rare cases, however, some of the greatness of the original work survives the transition from stage to celluloid. Such works may not represent the best use of the film medium, they may not possess their most authentic existence on the screen, but nevertheless—due to outstanding character portrayal—they manage to hold a motion picture audience. Of course, it also helps if a gifted screenwriter and a brilliant director are given charge of the adaptation.

A *Streetcar Named Desire*—which opened on Broadway in December 1947 and was a tremendous hit—represents a major turn-

ing point in motion picture history. Many people in Hollywood
were afraid to handle the play due to its themes involving insanity,
compulsive promiscuity, homosexuality, and rape. However,
Charles K. Feldman was willing to take a chance on Williams's
play, and paid the dramatist three hundred and fifty thousand
dollars for the right to make the movie version. Williams and
Kazan (who also directed the play) had to wage an uphill battle
to preserve the play's integrity. The censors wanted to eliminate
the rape scene; but since, as Williams rightly pointed out, Stanley
Kowalski's violation of Blanche DuBois represents the structural
and thematic climax of the piece it could not very well be omitted.
As a sop to the censors, though, Williams suggested that Stanley
be punished for raping Blanche by having his wife, Stella, threaten
to leave him at the end. "Thus the twelve-year-old could believe
Stella was leaving her husband. But the rest of the audience would
realize it was just an emotional outburst of the moment."[21]
Kazan frequently waxed impatient with the attitudes of Warner
Brothers. After the picture was completed, he remarked hotly:
"They didn't want anything in the picture that might keep *anyone*
away. At the same time they wanted it to be dirty enough to pull
people in. The whole business was rather an outrage."[22] Accord-
ing to the playwright's mother, Williams liked the movie version
of his masterpiece. "They filmed it as I had written it except for
one change because of censorship," he said. "We couldn't mention
the homosexuality as a human problem."[23] However, as Hollis
Alpert points out in his review of the film, "it would take a singu-
lar obtuseness not to know just what Blanche is referring to when
she speaks of the unmanliness of her husband. The taboo has been
compromised with rather than obeyed" (*Saturday Review*, Sep-
tember 4, 1951).

 The film version of A *Streetcar Named Desire*, which was re-
leased in 1951, boasted an outstanding cast (some of whom had
appeared in the play); Vivien Leigh as Blanche, Marlon Brando
as Stanley, Kim Hunter as Stella and Karl Malden as Mitch played
the most important roles. "Before the shooting began, Kazan sug-

gested to Williams that he make the script more suitable to movie technique," Murray Schumach reports. "The director's idea was to open the film in Blanche's home town. But he soon realized that in his desire to make the play more cinematic he would weaken the drama."[24] Nevertheless, Kazan and Williams *did* "open up" the play somewhat for the film version. For example, after Blanche is introduced at the beginning of the movie, Kazan swings the action to a bowling alley which is merely mentioned briefly in the play. In order to compensate for the inherent dramatic (as opposed to cinematic) structure of the piece, Kazan keeps his camera in constant motion.

At its best, this technique faithfully captures the psychotic hysteria of the central character—most noticeably during the rape scene in which Kazan uses a subjective point of view as the camera eye darts insanely back and forth across the room—projecting itself upon the harsh, violent, "normal" world surrounding Blanche. At its worst, the galloping lens becomes obtrusive—a doomed attempt to infuse filmic life into the corpse of a play. Although the acting is superb, the director relies much too heavily on close-ups to point up every dramatic moment in the plot.

There is more involved here than merely the over-employment of a specific technical device. Alpert applauds the movie for throwing off "some of the more artificial aspects that the stage presentation required," adding that Kazan's "camera and . . . sound-track are far better equipped . . . to show the travail of Blanche DuBois." Alpert, who thinks that movies are a superior kind of theater because they are more natural, fails evidently to understand what constitutes the life of the drama. To some extent the movie treatment of A *Streetcar Named Desire* is *too* natural, *too* "realistic"; it takes us too close to the actors and the action; it lacks the aesthetic ("artificial"?) distancing achieved in the theater. Perhaps this is why Philip Hartung, while praising the movie, nonetheless finds Stanley on celluloid infinitely more horrible ("almost unbearable") than Stanley on the boards, with the result that Stella's "love" for this character becomes harder to credit than in the play (*Commonweal*, September 28, 1951).

In some ways *Cat on a Hot Tin Roof*—which ran on Broadway in 1955 and was released by MGM in 1958—is the most interesting example of a Williams play adapted to the screen. It is no secret that *Cat on a Hot Tin Roof* succeeds as a play in spite of its structural defects. There are actually two published versions of the last act, neither of which is wholly satisfactory. Analysis reveals that both versions have an Ibsenian structure. In the original form the point of attack occurs in Act One when Maggie the Cat, addressing her husband Brick, says:

> . . . if I thought you would never, never, *never* make love to me again—I would go downstairs to the kitchen and pick out the longest and sharpest knife I could find and stick it straight into my heart . . . But one thing I don't have is the charm of the defeated, my hat is still in the ring, and I am determined to win![25]

The dramatic question, then, is: Will Maggie "win" Brick's love and succeed in gaining Big Daddy's inheritance? Near the end of Act Two, the turning point occurs when Big Daddy accuses his son Brick of refusing to face the real nature of his love for the late Skipper. Will Brick face his truth now, and enable Maggie to "win"? The crisis arrives in Act Three when Maggie announces that she is pregnant. What will Brick's reaction be? At the climax, Maggie vows to make her husband really impregnate her, thus assuring her victory; however, she apparently fails to elicit Brick's love, for he refuses to face his truth. Kazan, whom Williams wanted to direct his play, did not like the last act. Consequently, the dramatist produced a second resolution, in which he suggests that Brick may be changing in his attitude toward Maggie. Once again, though, Brick avoids squarely facing the question of his latent homosexuality. Most critics speak of "evasion" here on the part of Williams. However that may be, *Cat on a Hot Tin Roof* remains one of the most powerful—though flawed—plays in the modern theater.

Homosexuality was a strong theme for the American screen in the fifties. It is not surprising then that when Richard Brooks

came to adapt the play for Hollywood he played down the devia-
tion motif, preferring to view Brick's sexual difficulties within the
larger context of the man's general arrested emotional develop-
ment. Brooks also chose to adhere to the more optimistic Broad-
way version of the structure. The real problem facing the film-
maker, however, was the technical one. Because the film medium
is capable of greater intimacy than the stage,* Brooks evidently
felt obliged to soften some of the more dramatic moments in the
play. For example, the point of attack in the film is de-empha-
sized; Maggie's line—"My hat is in the ring, and I am determined
to win!"—is actually omitted. Since a movie audience can, thanks
to the close scrutiny of the camera, see from the expression on
Maggie's face that she is "determined to win," language becomes
redundant here. Similarly, the motion picture is a more fluid
medium than the stage, and the adaptor must eschew whatever
suggests a theatrical rhythm; in other words, the pivotal points in
the logical structure of a play are generally too obvious for the
screen. Except in rare instances there are no curtains in a motion
picture. Even Brooks's handling of the resolution is not filmic
enough—which is to say that it seems too "neat" or overly remi-
niscent of the play.

All the action of the original takes place within a single setting:
the bed-sitting-room of the Pollitt mansion in Mississippi. Natu-
rally, Brooks found this adherence to unity of place, which gen-
erally works to a play's advantage on the stage, much too restric-
tive for his own medium. As a rule, "opening up" a drama for its
film version does not save the result from being still another more
or less thinly disguised photographed stage play. Nonetheless,
some attempts by film-makers to escape the "unities" are more
inspired and successful than others. Not all of Brooks's inventions

* Today in many theatrical presentations the actors mingle with the
audience, sitting in their laps and staring closely into their faces. No doubt,
soon there will be sexual intercourse between actors and audience in the service
of greater "intimacy" or "involvement." Of course, even the movie close-up
provides a frame for the sake of distancing, or aesthetic detachment; there is
simply more of such distancing, however, in the traditional theater.

in this connection are equally brilliant. It does little for expressive purposes, for example, to show the audience Big Daddy (played by Burl Ives) arriving at the local airport after a visit to the Mayo Clinic, or to include a party scene on the Pollitt veranda. Such moments are mere "window dressing"; they are not effectively cinematic.

However, the opening scene added for the film *is* effective. We see the drunken Brick (Paul Newman) attempting to jump hurdles on the athletic field at three o'clock in the morning. Although the stadium is empty, Brick hears (through a subjective use of sound) the cheers that, in the sober light of day, he will never hear again. This scene invented by Brooks does more than merely *show* us how Brick broke his ankle, for if that was all it accomplished it would scarcely justify the time and trouble to shoot it. Even less does it prove how the movies are "superior" to the stage because the camera can take the audience outdoors. The filmic virtue of the scene, in terms of structure, character and theme, is that it transports us directly and immediately into Brick's inner world of crippling neuroticism. There is a great amount of dialogue in *Cat on a Hot Tin Roof*—even in the film version—but Brick says little; Big Daddy and Maggie (Elizabeth Taylor) do most of the talking. Perhaps the film succeeds somewhat better than the play in that it enables the audience to apprehend more readily some of the reasons behind Brick's long painful silences. Of course, it must be owned that Brooks accomplishes this feat at the expense of minimizing the homosexual theme, which is much more important in the stage version.

It is to Brooks's credit that he does not resort to jumpy camera work in order to lend an appearance of cinematic action to what is in reality verbal action—though it is also true that about halfway through the film one begins to experience a cramped sensation, an impatience with the adaptor's fidelity to the play's focused structure and time-sequence. Since *Cat on a Hot Tin Roof* is even more talky than *A Streetcar Named Desire*, Brooks slashes long speeches and in some cases shifts key lines backward and forward

in the action. While Maggie's monologues in Act One can hold a theater audience enthralled, the same talk transferred in its totality to the screen would only produce intolerable boredom in a movie audience. Hence, in the film Maggie's exposition about Skipper is moved from the beginning of the action to the big confrontation scene (the turning point) between Brick and Big Daddy. This alteration in the structure provides further visual relief by inserting Maggie into an exceedingly protracted scene (for a movie) involving only two actors. Furthermore, as Maggie delivers her delayed exposition here, Brooks keeps his camera close to her; and as she moves, the camera (not *too* obtrusively) moves with her.

This technique might not force us "to look first and listen second," but it at least obliges us to look *while* we listen (which seems the best that a film-maker can get with even abbreviated Williams dialogue). When the turning point reaches its apogee, Brooks leads Brick and Big Daddy away from the bed-sitting-room to the landing outside; then he takes them down the stairs—both men screaming wildly at each other—to the parking space where Brick unsuccessfully tries to escape in his automobile. A close-up of the car's rear wheel spinning ineffectually in a mud puddle is an apt visual metaphor of Brick's emotional condition—a metaphor which Williams himself no doubt appreciated.

Brooks also makes use of crosscutting and a subjective point of view (though not of a subjective camera). In Act Two of the play, Big Daddy refers to some items he purchased on a vacation in Europe which are presently collecting dust in the basement. Following this lead, Brooks creates a scene in the basement between Big Daddy and Brick (it comes after the turning point) in which father and son achieve a degree of communication denied them even in the more cheerful second version of the drama. While this breakthrough in understanding is developing below, the director intercuts a scene—which does appear in the play—being enacted upstairs as Brick's older brother Gooper and his wife Mae wrangle with Big Mama over the forthcoming inheritance. This juxtaposition of the two lines of action is filmically arresting.

When Brick and Big Daddy return from the cellar, the latter

knocks Gooper's legal papers to the floor, watching contemptu-
ously as his scheming son grovels at his feet in an effort to retrieve
them. Brooks then alternates high angle shots from Big Daddy's
point of view, in which Gooper seems pitifully small on the floor,
with low angle shots from the son's viewpoint, in which the father
is the picture of overwhelming authority. (In neither subjective
shot, however, does the camera actually replace the viewpoint of
the character himself.) Like the cutaway discussed above, this
employment of a subjective point of view is a welcome addition to
the adaptation.

One use of camera placement and editing in *Cat on a Hot Tin
Roof* deserves special mention because it underlines a crucial
difference between stage and screen. In the original version of the
play, Maggie tells Brick: "I *do* love you, Brick, I *do!*"; to which
her husband—as the third act curtain slowly descends—replies:
"Wouldn't it be funny if that was true?" Brick's response echoes a
reply his father made to a confession of love by Big Mama earlier
in the play.[26] Thus, through verbal repetition, Williams is able to
suggest a thematic relationship between Brick and Big Daddy. The
motion picture is uniquely equipped to establish such relation-
ships, however, through creative editing. In the film the scene
between Big Daddy and Big Mama is shot in the bed-sitting-room;
visible on the balcony are two other unhappily married people:
Brick and Maggie. Brooks then proceeds to alternate shots of
father and mother in the foreground, son and daughter-in-law in
the background, with shots of Brick and Maggie in the fore-
ground, father and mother in the background. In short, the movie
makes its point visually. Because Big Daddy's face can be seen
more vividly on the screen than on the stage, his line—"Wouldn't
it be funny if that was true?"—is unnecessary, and therefore
omitted from the film. After all, the movie audience can *see* the
unspoken words in Big Daddy's expression as he looks after his
departing wife. (Needless to say, Brick's original parting line, or
echo, is eliminated from the movie, which follows the "happy
ending" suggestion of the Broadway version.)

One of the two best later Williams efforts for the stage is *Sud-*

denly Last Summer (1958). In spite of some cinematic touches in this short play—such as the hot spot of light on Catherine which resembles a close-up, the bird cries behind Mrs. Venable's description of the beach of the Encantadas which function like background film music, and the "dissolve" within Scene Four[27]—it basically remains one of the playwright's most theatrical (in the good sense of course) presentations. *Suddenly Last Summer* is a morality play; the names of the characters alone suggest the symbolical nature of the piece: Mrs. Venable, Dr. Cukrowicz (Dr. Sugar), Mrs. Foxhill, Sister Felicity, and the like. Scene One is very largely a monologue by Mrs. Venable, and throughout the play the language used is rich in poetic imagery. At the beginning of Scene Two, the author says: "The following quick, cadenced lines are accompanied by quick, dancelike movement, almost formal. . . ."[28] The plot involves a homosexual poet, who is never seen but is recreated for the audience through dialogue, and who offers himself as a sacrifice to "God" by allowing a horde of avenging boys to devour him. Technically and thematically, *Suddenly Last Summer* would not seem to be very promising screen fare.

Nevertheless, in 1959 Williams and Gore Vidal undertook an adaptation of the play for Columbia Pictures. (When critics registered doubts about the suitability of the subject matter for movie audiences of that "innocent" decade, producer Sam Spiegel announced: "Why, it's a theme the masses can identify themselves with"!)[29] The play, which runs on the boards for about seventy minutes, is stretched out to a hundred and fourteen minutes on the screen, but with no gain in character development or thematic complexity. Not surprisingly, the script is talky, the movement sluggish, the whole business arty and self-consciously portentous.

Joseph L. Mankiewicz's direction is very much wanting in imaginative use of the camera. When Mrs. Venable takes Dr. Cukrowicz into her late son's garden, the director fails to exploit the visual symbolism in the scene—a symbolism which remains vitally necessary to the development of the play's meaning. Mankiewicz's

camera passes over the garden "jungle" in a cursory way without stopping to focus upon the significance of the all-important Venus flytrap. Instead, Mankiewicz relies on words, words, words. On the stage, Mrs. Venable's monologue is enough to set the audience's imagination going and sufficient for thematic purposes; on the screen, however, the monologue becomes annoying, for the viewer longs to rummage about in the vegetation and the director's refusal to allow him this privilege thwarts an understanding of the play. Too much of the original piece is involved in talk about the past; and while this is all right for the stage, which is most often constrained to create word-pictures, it is considerably less than ideal for the screen. To Mankiewicz's credit there is only one flashback in the movie; but that one, which comes near the end when Catherine describes the death of the homosexual poet, is not handled well. A good cast, starring Katharine Hepburn as Mrs. Venable, Montgomery Clift as the doctor, and Elizabeth Taylor as Catherine, was wasted in a movie that—because of the inherent nature of the original—should never have been made. Williams, who was once again dissatisfied with the adaptation, seemed not to grasp the essential quality of his one-act play. He called the film an "unfortunate concession to the realism that Hollywood is too often afraid to discard. And so short a morality play, in a lyrical style, was turned into a sensationally successful film that the public thinks was a literal study of such things as cannibalism, madness and sexual deviation."[30] Actually the movie is less than candid on the score of "sexual deviation," with the result that the theme is left hazy for those unfamiliar with the play.

The Night of the Iguana, which opened on Broadway in 1961, is Williams's most impressive drama since *Cat on a Hot Tin Roof*. Like most of the author's plays, *The Night of the Iguana* depends heavily on characterization through protracted confrontations involving two actors—much of the time through recourse to lengthy monologues—in which theme is developed by analogy, image, and symbol. There is the use of another "hot light" in this play, similar to the cinematic effect achieved in *Suddenly Last Summer*, and

still another filmic transition between scenes within Act Two;[31] but the soul of the work is verbal and theatrical.

Offhand, *The Night of the Iguana* does not seem promising material for a good film. As adapted by Anthony Veiller and directed by John Huston, however, the 1964 movie version of Williams's play is nearly as good a movie as *A Streetcar Named Desire* and *Cat on a Hot Tin Roof*. Richard Burton is excellent as a defrocked clergyman slowly destroying himself; Deborah Kerr as a spinster and Ava Gardner as the owner of a Mexican hotel also turn in good performances. By starting the action in the hometown of the minister, the adaptors not only escape the limitations of a single set (all the action of the play takes place at the hotel), they also help the audience to understand the clergyman's tortured character better perhaps than in the play. Other sequences are also invented for the film. Unlike most movie attempts to "open up" action, the additions here blend smoothly into the original without jarring either the structure or texture of the work. (One exception, a fight between a bus driver and some local citizens, is obvious, pointless, and boring.)

Yet certain inevitable difficulties make themselves felt in Huston's treatment of the film. Although I do not agree with Stephen Taylor's negative evaluation of the movie, I do concur with his judgment that it contains a conflict between dialogue and picture. "It is like watching one ballgame on television and listening to another on radio," argues Taylor. "You need two minds to follow the action. [Huston] has simply failed to find the images necessary to maintain coherence. The talk and cinematography move at different speeds, and the effect can be dizzying."* The case is overstated, but since *The Night of the Iguana* was originally conceived as a play, it would be strange if there were no tension between word and image in the film. The marvel is that Huston was able to keep that tension to a minimum, and in so doing construct a remarkable motion picture.

* See *Film Quarterly* (Winter 1964), 50–52.

Thematically, *The Night of the Iguana* is almost completely faithful to the play. Of course, the conclusion becomes a "happier" one than in the original (Burton ends up with Miss Gardner); an anecdote about excrement is eliminated (with no great loss except perhaps among coprophiliacs); and when Miss Kerr relates her encounter with a pitiable clothes fetishist, she is not permitted to say: "I looked the other way while his satisfaction took place"[32] (she still averts her gaze, but the word "satisfaction" is primly omitted). All in all, though, Williams is well served by Veiller and Huston.

Since writing *The Night of the Iguana*, Williams's output has markedly deteriorated. So much so, that some critics believe that the dramatist has exhausted his talent. Be that as it may, Williams is the creator of at least three outstanding plays in the modern drama. More relevant to this study, the Williams canon reveals considerable evidence of a cinematic imagination, and the many film versions of his plays offer instructive lessons for a future "poetics of adaptation."

SHORT SUBJECT

Does the thing heard replace the thing seen does it help it or does it interfere with it. Does the thing seen replace the thing heard or does it help or does it interfere with it.

I suppose one might have gotten to know a good deal about these things from the cinema and how it changed from sight to sound, and how much before there was real sound how much of the sight was sound or how much it was not. In other words the cinema undoubtedly had a new way of understanding sight and sound in relation to emotion and time.

I may say that as a matter of fact the thing which has induced a person like myself to constantly think about the theater from the standpoint of sight and sound and its relation to emotion and time, rather than in relation to story and action is the same as you may say general form of conception as the inevitable experiments made by the cinema although the method of doing so has naturally nothing to do with the other. I myself never go to the cinema or hardly ever practically never and the cinema has never read my work or hardly ever. The fact remains that there is the same impulse to solve the problem of time in relation to emotion and the relation of the scene to the emotion of the audience in the one case as in the other.

—Gertrude Stein

Arthur Miller—*Death of a Salesman,* *The Misfits,* and *After the Fall*

Movies . . . have . . . created a particular way of seeing life, and their swift transitions, their sudden bringing together of disparate images, their effect of documentation inevitable in photography, their economy of storytelling and their concentration on mute action have infiltrated the novel and playwriting—especially the latter—without being confessed to or, at times, being consciously realized at all.

—Arthur Miller

I

Arthur Miller's *Death of a Salesman* (1949) relies heavily on expressionistic devices; and it is the expressionistic side of the work which makes it the most successful example thus far of a cinematic play.

The "swift transitions" in viewpoint and the "sudden bringing together of disparate images" present a formidable staging problem in *Death of a Salesman,* which is in large measure a stream-of-consciousness play. As I have tried to show elsewhere,[1] three time-sequences may be distinguished in Miller's play: first, there is "present" time, that is, action moves forward in the present without reference to the subjective—the point of view is wholly objective; secondly, there is "past" time, that is, although the action

remains in the present ("There are no flashbacks in the play," the dramatist says, "but only a mobile concurrency of past and present . . .")[2], we are locked inside Willy's mind, viewing *his* imaginative reconstruction of the past—the point of view is wholly subjective; thirdly, there is "simultaneity," that is, the action remains in the present but we are not wholly inside Willy's head, for there is both objective reference to other characters and subjective projection by Willy—the point of view is objective-subjective.

There are twenty-four time-sequences in the play. Movement results from progressive causal logic in the present interwoven with the mental re-creation by Willy of his past. It is the juxtaposing, and in some instances fusing, of these two patterns that constitutes the structure of Miller's play. With its tight, logical, Ibsenian arrangement of the action in present time, which covers about twenty-four hours, *Death of a Salesman* is focused in structure; but this structure is also panoramic, thanks to the play's one hundred and twelve scenes and twenty-four time-sequences. This remains no small accomplishment. Although *Death of a Salesman* is as episodic as a typical expressionist play, Miller achieves depth of characterization and complexity of theme through his refusal to abandon his earlier devotion to the Ibsenian form.[3]

Anyone who saw the original production will testify that Jo Mielziner, who designed the sets and lighting, succeeded admirably in finding stage equivalents for filmic dissolves and fades. Mielziner points out that he had the buildings surrounding the Loman house painted in bright colors on unbleached muslin. When the action moved into the "past," he faded the lights behind the painted buildings, causing them to vanish; projection units from the auditorium then cast leaf patterns on the muslin and parts of the house to symbolize the shift in point of view.[4] It was all managed very smoothly. Elia Kazan's experience directing movies also served the production well.

Although *Death of a Salesman* is an outstanding example of cinematic drama, Miller's play is not the stuff of which great films

are made. The movie version of the play, which was written by Stanley Roberts and directed by Laslo Benedek, appeared in 1951. In his "Introduction" to the *Collected Plays*, Miller argues that "aside from the gross insensitivity permeating its film production," the movie erred by projecting the various time-sequences on the same plane of realism: "The basic failure of the picture was a formal one. It did not solve, nor really attempt to find, a resolution for the problem of keeping the past constantly alive, and that friction, collision and tension between past and present was the heart of the play's particular construction."[5]

It is impossible to concur fully with Miller's analysis of the film. Thematically, the Stanley Kramer production of *Death of a Salesman* is almost completely faithful to the original. For some reason, Robert omits mention of Willy's father. Hence, the sound of the flute—which is so important in the play—remains unrelated to the elder Loman who played the instrument, with the result that a rich psychological dimension present in the original is absent from the adaptation. Also puzzling is the more sympathetic handling of Happy in the film. For example, the stage Happy's cruel denial of his father in the cafe scene is not shown in the film. In addition, most of the sex talk between the brothers (which is certainly not present in the play for its own sake) is eliminated from the movie version. On the whole, however, Columbia Pictures made a sincere endeavor to be honest with Miller's subject matter.

Nor would it seem to be a fault of film's greater vividness that both the objective and subjective portions of the adaptation possess the same degree of realism. After all, both levels of action seem equally real to Willy; therefore, there is no reason why the movie should not render both with the same order of concreteness. And the film *does*, I believe, manage to keep "the past constantly alive"—thereby keeping faith with "the heart of the play's particular construction."

The cinematic features of the original (some critical opinion to the contrary notwithstanding) translate successfully to the screen. In the play Willy goes to the refrigerator, talking to himself in the

dimly lighted kitchen; gradually, the surrounding apartment houses fade out, while the brightness of the "past" fades in. In the film the camera remains close to Willy's face as he stands beside the refrigerator—then all at once it pulls back to reveal the "past" shining brightly in the backyard. On the stage, it should be noted, Young Biff and Young Happy carry real rags and a real pail of water; on the screen there is in addition a real automobile. However, it is only a practical as opposed to a theoretical consideration that prevents the automobile from also appearing on stage. In other words, the film does not violate the logic of the play here at all.

In the card-playing episode Willy and Charley talk in the present while at the same time the dead Ben converses with Willy. In the theater, Ben, announced by appropriate theme music, simply appears on the forestage and enters the scene; in the film, Ben is visible in the distance beyond the table and gradually grows larger until he becomes part of the scene. As the past merges into the present, the wall-line of the house seems to dissolve into the darkness in both versions. Another scene achieves the same simultaneity. As Willy moves from Linda to The Woman of his guilty past, all three characters in the film are held for a moment in a single shot. Here the filmic fluidity of the original is easily conveyed on the screen, for the scene in the play and the scene in the movie are almost identical. (True, The Woman in the play primps at a "mirror," while the mirror in the movie is real; but since the rags and the pail in the play are real—why not the mirror?)

During the cafe scene in the play the present and the past are projected simultaneously because the audience is constantly aware of the presence of the Loman house. Apparently the film-makers believed that such an effect might prove confusing on the screen. Consequently, instead of juxtaposing past and present within the same frame, the camera moves in close to Willy as he sits at the cafe table, pans suddenly to one side to reveal his "thoughts" about Young Bernard in front of the house many years ago, and then just as suddenly moves back to Willy in the cafe. Although it

would have been possible for Benedek to achieve single-frame simultaneity here, as he did in the card-playing scene, there is no doubt that the illusion of two causally related events is forcefully communicated by a camera which seeks to reflect Willy's "way of thinking at this moment of his life."[6]

This is not to say that the movie always manages the effect of simultaneity as well as the play does. On the stage at the end of Act One Willy is upstairs in bed with Linda, remembering Biff's days of glory as a football star; downstairs (thanks to the skeleton set) Biff steps into the darkened kitchen and lights a cigarette. The tiny cigarette glow is replaced by "a golden pool of light," which suggests both the moonlight of the present and the sunlight of Ebbets Field in the past. Upstairs, Willy recalls Biff as hero; downstairs, Biff reveals the nonhero. As Willy declares that such "greatness" as Biff once knew "can never really fade away," the light on Willy fades, and in effect, fades on Willy's dream. Downstairs, a new light begins to glow: the flame of the gas heater with which Willy had earlier tried to kill himself.[7]

The film fails to match the brilliance of the play in this scene. Benedek is content to shoot the action between Willy and Linda intact—then to show Biff downstairs studying the tubing. Thus the ironic juxtaposition of images is largely lost, and the paralleling of dialogue, symbol, and light is relinquished. It would not have been necessary to erect a skeleton set or to utilize a split screen in order to approximate the effect of the play in this scene. Some inspired and sensitively paced crosscutting by Benedek might very well have served the playwright's intention.

In some ways, however, the film is an improvement over the original. On the stage, for example, after the scene just discussed the first act curtain comes down on Biff holding the rubber tubing with which Willy has attempted suicide. The second act curtain rises on Willy eating breakfast in his kitchen. On the screen the image of the tubing in Biff's hands is replaced by the image of a flower in Willy's hands as he tends his garden before breakfast. This is a skillful juxtaposition of Miller's own symbols of life and

death in the play, but Benedek also employs them for effective cinematic continuity. The effect might have been suggested on the stage; however, it would not have had the immediacy (in the movie there is no intermission between the two shots) and visual enlargement possible on the screen. Furthermore, the film image seems to underline more strikingly than the play the symbolic significance of the tubing which Biff examines: shortly prior to the ending of Act One, Linda warns her son that Willy's "life is in your hands!"[8]

At certain times, point of view is also rendered more successfully in the movie. For example, the picture opens with the camera inside Willy's car, shooting over his shoulder through the windshield—a strategy that immediately prepares the audience to see the world from the salesman's perspective. During a scene between Willy and The Woman the floor momentarily slants off at a crazy angle to suggest the protagonist's state of mind. Finally, at the climax of the action when Willy takes his last drive, the neon lights of the city seem to become brilliant diamonds luring the salesman to his death. On the stage such effects are largely unobtainable.

Since the film version of *Death of a Salesman* is generally faithful to the original in terms of content, and since the cinematic techniques used by Miller transfer well enough to the screen—wherein does the film fail to equal the power and beauty of the play? *Death of a Salesman*, though filmic as a play, is also highly *theatrical*—and it is its theatricalism that vitiates the adaptation. As noted, dialogue that sounds "natural" on the stage too often rings wooden and artificial from the screen. And the more theatrical the original scene (such as the Requiem in Miller's play—from which Roberts cuts more than half the dialogue in a vain effort to make the scene move cinematically), the more unsatisfactory the translation. Benedek admits that in some scenes he "depended primarily on the dialogue and the power of the performances."[9] This plan of action may sometimes prove defensible in a movie; under Benedek's direction, however, too many of the scenes in his

film seem stagy, or talky. The director should have placed less stress on language, and more emphasis on facial expression, movement, gesture and surroundings.

Benedek argues that "In the Brooklyn apartment building, pressing down on Willy's small house, I used only the set, as tall and close as possible, but no extras in the windows or passing by, for Willy wasn't concerned with people but with the stifling closeness of that huge wall."[10] But this defense is acceptable only in part. Occasionally, the audience should be made to see, as at times Willy himself would, the people who exist around him. And why not? The logic of the film elsewhere would appear to demand it. As Benedek himself points out: "In the subway tunnel there were extras walking along with him as long as Willy would be aware of them—when he became submerged in the fantasy about his dead brother, he was alone with him in the endless tunnel."[11]

The director's reference to the subway episode raises still another problem. To see an actor talking to himself within the highly conventional setting of a play is one thing; to see that same actor's face enlarged on the screen, revealed against a background of other faces—and still talking to himself—is vastly different. The movie Willy seems much more psychotic than the stage Willy, with the result that credibility is damaged by asking an audience to believe that such a man has not yet been confined to a mental institution. But there is more involved here than a question of plausibility. While it is true that men can now and then be seen talking to themselves in public, it is simply too painful to watch such behavior on the part of a character with whom we are asked to identify. There is a problem here in decorum.

Benedek claims that the film version of *Death of a Salesman* should not be approached realistically because the project was conceived by him as being theatrical. Need it be said that the director appears confused about the nature of his medium? "While there are films that draw their strength from other sources," Benedek remarks, "a theatrical picture like *Death of a Salesman* fails or succeeds with the performance of its cast."[12] Miller's charac-

ters, who are at once real and symbolic on the stage, often seem merely grotesque and bombastic in the movie. Although Frederic March is probably miscast as Willy,* the chief blame for the acting approach in the picture resides with Benedek, who has not often enough replaced Miller's theatrical stylization with cinematic stylization.

Performing in front of a camera is vastly different from acting on the stage. When Willy is fired from his job, Benedek shoots the crushed and silent March from behind in a medium long shot which is cinematically effective. But when, in the hotel scene, Willy is seen on his knees pounding the floor histrionically, Benedek is in the theatrical mode. While the broad gesture is necessary for the playgoer in the last balcony, it is both redundant and ludicrous on the screen. Throughout Benedek's *Death of a Salesman*, then, a theatrical approach clashes with a realistic and cinematic one—thus insuring the failure of the film. Ironically, Miller's great play—which remains a prime example of the screen's influence on playwriting—suffers a mediocre existence as a motion picture.

II

The Misfits—the screenplay for which was written by Miller— was released in 1961. Directed by John Huston, the movie starred Clark Gable, Marilyn Monroe and Montgomery Clift. The material for the film began as a short story; it then became a "cinema-novel"; and finally it took shape as the completed film.

According to W. J. Weatherby, scenarist Miller was "on location all day and every day, and then he would rewrite during part of the night, sometimes at Huston's prompting, generally at his own. Then he would read his new lines to Huston and they would argue over them until they reached agreement."[13] Miller's own

* Mildred Dunnock, Kevin McCarthy and Cameron Mitchell play Linda, Biff and Happy, respectively.

comments on the making of *The Misfits* seem worth quoting at length:

> What I wanted was a vision that a director would see in such a way that he would know what the finished film was to look like. The writing would provide this vision. It would also tell the actors what the effect was intended to be. It contained hard information of the sort one finds in the novel. The prose was meant to be exact and purposeful. I never for a moment thought of writing the story in the usual screen manner. For the writer, the term "medium shot" means nothing, and when he uses such a term he is hardly conveying his vision. I've always suspected that most screenwriters, the journeymen of the craft, can't write English. They vacate their responsibility as writers, and hope that the camera will bail them out, that it will see things they were either too incapable, or too lazy, to put in. What you read in the book, is what Huston worked from.[14]

In the published version of *The Misfits*, Miller remarks in an "Author's Note":

> [*The Misfits*] is the kind of tale which the telegraphic, diagrammatic manner of screenplay writing cannot convey because its sense depends as much on the nuances of character and place as on the plot. It therefore became necessary to do more than merely indicate what happens and to create through words the emotions which the finished film should possess. It was as though a picture were already in being, and the writer were recreating its full effects through language, so that as a result of a purely functional attempt to make a vision of a film clear to others, a film which existed as yet only in the writer's mind, there was gradually suggested a form of fiction itself, a mixed form if you will, but one which it seems to me has vigorous possibilities for reflecting contemporary existence.[15]

There are no camera directions in Miller's cinema-novel; instead, the setting is presented with a full description of sights and sounds, which the director must translate into filmic action. The

reader of *The Misfits* is made to *feel* the place described, and each of the major characters is introduced with a lengthy analysis of physical appearance and psychological motivation. In some ways, *The Misfits* is not very different from the text of *The Crucible*, where the dramatist also indulges in long discussions of scene and character.

What distinguishes *The Misfits* from a play like *The Crucible*, however, is the technical problem involving point of view. Miller and Huston are said to have frequently argued about whether a key scene should be seen from a main character perspective or in a neutral omniscient manner. By using the present tense—"There is . . . We can see . . ."—Miller hopes to capture an "immediacy of image."[16] The author's descriptions suggest a variety of viewpoints on the action: main character angle, objective or dramatic, and subjective camera. The cinema-novel opens with an attempt to draw the reader-audience completely into the action: "We can see through our windshield almost to the end of Main Street [in Reno, Nevada], a dozen blocks away. Everything is sharp to the eye at this altitude. . . [A] loud buzzing draws our attention. A gambling emporium on the left . . . is broadcasting the buzzing noise into the street . . ." (p. 1). The windshield is part of "our vehicle," and it is not until several pages later that Miller says: "Guido hops out of what we now see is a tow truck and comes around and lifts a battery out of the back" (p. 4). Afterward, when Roslyn watches Perce riding the bull at the rodeo, the author forces us into an identification with the girl: "Roslyn can feel the earth shake as the bull pounds out across the arena, and once having felt the thunder of its weight she nearly goes blind, seeing only tattered impressions that filter through her fear. . . The crowd is roaring but she does not hear it" (pp. 71-72). Any reader with a normal amount of cinematic literacy could easily imagine visual and auditory means for conveying Roslyn's viewpoint on the screen. Although Miller does not employ technical terms, the camera angles appropriate to the following scene are nevertheless readily apparent:

[Gay] turns and climbs up onto the hood of the car; he is very drunk, and shaken. He looks over the crowded street from this new elevation. Just below him Roslyn and Guido are looking up into his face, and he seems twice his normal size. Drunks mill around below, the bar lights blink crazily behind him . . . the jazz cacophony is flying around his ears like lightning. (p. 80)

Such shifts in perspective obviously contribute to the rhythm and complexity of *The Misfits*.

Unfortunately, though, the suggestions of alternating point of view in the published version of *The Misfits* are not carried out in the film itself. Miller's directions for the opening seem to call for a subjective camera, whereas Huston actually shoots the scene slightly behind the cab with the back of Guido's head visible. The movie audience is never made to "feel the earth shake" with Roslyn. Nor is a high angle shot from Gay's point of view employed when he stands on the hood of the car and looks over the crowded street. Similarly, Huston ignores Miller's call, in the same scene, for a shot up at Gay from the point of view of Roslyn and Guido which would make Gay seem "twice his normal size."

Miller has always been very much concerned with the structure of his plays. He told Alpert that in writing *The Misfits* he tried to strike a "balance between the progression of the story and the nature of the life there, which was plotless. . . ."[17] James Goode quotes Miller as saying, however, that *The Misfits* "couldn't be a play . . . because one of the elements is a sense of wandering without any elaborate preparation or reason, a sense of wayward motion which is manifestly a movie technique."[18] Miller's comments to Goode are far from being unassailable. Many contemporary plays—not a few of them influenced by "movie technique"—manifest "wayward motion." Furthermore, *The Misfits* is not so very different in its basic dramatic structure from the Ibsenian plays Miller writes for the theater; that is, a close reading of the screenplay, or cinema-novel, would reveal the equivalent of a play's point of attack, turning point and resolution. Miller is no Chekhov; he needs a plot.

The action of *The Misfits* is structured into twelve numbered sections of varying length. Breaks between the "chapters" represent major time jumps. At certain places within six of the major segments of the narrative action, Miller has triple-spaced in order to indicate minor time lapses or important shifts in viewpoint, the latter category constituting an example of crosscutting to simultaneous events. To bind the action, Miller adopts a familiar motion picture strategy: circular continuity. *The Misfits* opens, as noted, with a view of Reno through the windshield of Guido's truck; the story ends with Roslyn raising "her eyes to the star through the streaks and dust of the [truck's] windshield" (p. 132). Similarly, the author employs the truck, or sometimes a car, to hook together the twelve major sequences of action. Thus, sections two, three, six, seven, nine and ten begin with a motor vehicle racing to some new location (a device which, on the thematic level, also suggests the desperation of the characters and their frantic search for meaning); sections eight, eleven and twelve begin with the image of a parked vehicle. Inasmuch as Miller omits camera directions, Huston was free to use his own imagination in the transitions from section to section. Should the director match-dissolve from section one to section two, or should he merely fade in and out? Would a fast cut from the excited reaction of Gay and Guido to Roslyn's decision to join them at the end of section two, to the shot of the two vehicles speeding down the highway at the start of section three capture Miller's intention better than an optical effect? Such problems should make the relationship between scenarist and director a properly collaborative one.

Although there are some good things in *The Misfits*, it cannot be said that it succeeds either as a movie or as a cinema-novel. Sentimentality tends to mar both versions. More pertinent to present concerns, however, is the fact that as a reading experience *The Misfits* seems too bare to compete on equal terms with a major novel—even a short novel like *The Great Gatsby*, where the imagery is dense and the patterning is intricate. "There is no essential difference between the events as we read about them and as we see them on the screen," says Alpert. "There *is* a difference

in impact. The spare, clear prose is no match for the vividness achieved by the camera."[19] True enough, perhaps. Held to the highest standards, though, it must be admitted that *The Misfits* is far from being a memorable filmic experience. It is not difficult to detect in Miller's various pronouncements on *The Misfits* the basic cause of failure: the author has too much respect for the word and too little regard for the "merely" visual. "The movie springs from the way we dream," Goode quotes Miller as saying. "The art of cutting follows the physiology of a dream. In the dream we accept because we see it. . . The play . . . is built on words." And Miller suggests that because it takes more intelligence and imagination to follow words than to watch pictures the stage is superior to the cinema.[20] At times, the author of *The Misfits* sounds as though he considers screenwriting a form of slumming for the dramatist.

Actually, the most impressive feature of *The Misfits* is its occasional appeal to the eye: the busy scenes on the streets of Reno and the rodeo town; the struggle between Perce and the bull; the near fistfight between Gay and a stranger; and, most of all, the roundup. "Nothing else in the film is so effective, dramatically and pictorially, as the trapping of the horses," Henry Popkin rightly notes. "Without the embarrassment of speech, the camera best displays the art of the director . . ." (*Commentary*, May 1961).

The last point needs underlining. Not only is there too much dialogue in *The Misfits*, there is also too little compensation for the reader or viewer in the form of thrilling speech. Although Miller places an enormous importance on words, and although he is ordinarily capable of writing realistic and functional dialogue (the language in *The Misfits* is definitely below par), he has none of Williams's poetic ability. Miller's strong point as a dramatist (aside from his moral sense) has always been a gift for forging a complex structure of meaning and for projecting characters locked in a struggle of conflicting wills. The filmic techniques apparent in *Death of a Salesman* would seem to suggest that Miller might make an accomplished scenarist. Paradoxically, though, the evidence of *The Misfits* prompts one to conclude that Miller's cinematic imagination can be seen at its best in some of his plays.

III

After *Death of a Salesman, After the Fall* (1964) is Miller's most filmic play. Like the earlier piece, *After the Fall* is in the tradition of expressionist stream-of-consciousness drama: "The action," says Miller, "takes place in the mind, thought, and memory of Quentin."[21] Thus, characters "appear and disappear instantaneously, as in the mind" (p. 1). For example, in one scene the protagonist recalls how his best friend's wife, Elsie, once tempted him—and suddenly the woman "appears"; then, as Quentin seeks to relate this personal sexual guilt to a wider frame of causation, the tower of a Nazi concentration camp "appears"— followed by Quentin's mother; progression continues by the "logic" of free association (pp. 33-34). The technique here is similar to the rapid replacement and juxtaposition of images on the screen where analogies and contrasts are underscored; in short, Miller is using montage.

Cinematic technique wedded to a basic Ibsenian structure resulted in economy of means and a powerful theme in *Death of a Salesman*; *After the Fall* is a bloated, redundant thesis play without achieved form or persuasive substance. The dramatist's montage method of construction is one reason for the failure of *After The Fall*. By indulging in a loose and open manner of presentation, Miller—in his haste to articulate an intellectual formulation that will tidily sum up our present plight—is tempted to circumvent, or to leapfrog over, that need for close inspection of matter, that necessity to definitely particularize time and place and gradually accumulate significant details, which results in a tight mesh of probability. At one point, Quentin says: "some unseen web of connection between people is simply not there" (p. 44); and near the end, he remarks: "We are all separate people" (p. 119). If you accept these lines at face value, you might argue that the form is appropriate to the theme. But it would not be wise to place too much stress on these lines because they are expressions of a passing mood and remain, moreover, clearly at odds with the main thrust of the play's theme.

It can be more cogently argued that the form is inappropriate to the theme because what else does *After the Fall* assert if not that all men are *one*—one in hatred, one in evil, one in guilt, but also one in their need for love, hope, courage, and understanding? The montage form generously allows for rapid focusing on moments scattered in time and place; it does not accommodate, it is not hospitable to, that sense of relatedness that it is the burden of Quentin to propound for three hours in the theater. Instead of looking toward the films of Griffith and especially Eisenstein—in which cutting back and forth between one character and another, between one event and another, disrupts psychological and spatial relationships—Miller perhaps should have paid more attention to *mise en scène* as defined by André Bazin. Although the term is originally derived from the theater, Bazin uses it to stress the content of a film shot as opposed to the juxtaposition of shots. Whereas montage suggests a fragmented world, *mise en scène*— because it emphasizes relationships within a single in-depth frame —suggests a unified world.[22]

Nevertheless, there are some noteworthy moments in *After the Fall*. At the play's climax, for instance, Quentin seizes his movie actress wife, Maggie (reminiscent of Miller's ex-wife, the late Marilyn Monroe) by the throat and begins to choke her. Suddenly, in order to link the present moment to psychological motivation originating in the past, Quentin's mother "appears." Miller's protagonist "stands transfixed as Mother backs into his hand, and he begins to squeeze her throat. . . ." When it occurs to Quentin that he is in the act of committing a murder, he releases his mother, who then "stumbles into darkness"—and he becomes conscious of Maggie again, "who is now getting to her hands and knees, gasping" (p. 125). Clearly, Miller has tried to capture here—and, in spite of my reservations about *After the Fall* in general, I think brilliantly—a stage equivalent for a motion picture dissolve.

Film-makers, no less than dramatists, have experimented with ways of projecting what comes easily to the novelist, namely, the revelation of a character's thoughts. In Ford's *The Informer*

(1935), Gypo's stream of consciousness is projected at crucial moments in the film; once, for example, the drunken protagonist encounters a strange girl whose form—through a superimposition —changes into Kate, of whom Gypo is thinking. Naturally, it is much easier for a movie director to dissolve from a shot of a man choking his wife to a shot of the same man choking his mother, and then switch back to the original shot, than it is for the dramatist to suggest the same psychological motivation. Miller, however, shows that the filmic effect can be approximated on the stage, and with no little degree of artistic success.

After the Fall also makes use of what Miller calls "condensed dialogue," a technique designed to create the impression of "time swiftly passing in the mind." Hence, Quentin and Maggie are listening to a recording she has made and the latter is unhappy with her pianist. Immediately Quentin steps out of the scene and shouts:

> Weinstein, get her Johnny Black! *The music turns over into another number and her voice, swift, sure.* There now! Listen now! (p. 101)

Note that the dialogue is not "condensed" in the sense that the language itself is truncated or mutilated; it is *time* that is condensed, or telescoped, and this results in a condensation of speech.

It could be argued that Orson Welles prepared the way for modern dramatists in the depiction of "time swiftly passing in the mind." In *Citizen Kane* (1941), in order to show the deterioration of the central character's marriage, Welles conceived the idea of shooting the action of the man and wife at their breakfast table over a long period of time. Without interrupting the continuity of the dialogue, Welles moves the breakfast talk from loving endearments, through increasing disaffection, to final alienation. It was a brilliant technical stroke by Welles, and one that Miller showed could be more or less duplicated in the theater.

It could also be maintained that *After the Fall* was influenced by Alain Resnais's film *Hiroshima, Mon Amour* (1959). Like

After the Fall, the French movie endeavors to dovetail private guilt and public guilt. Whereas Miller attempts to coordinate Quentin's complicity with his mother's betrayal of his father and the complicity of all men in the Nazi atrocities against the Jews, Resnais shows a love affair between a French woman and a Japanese man against the background of an atrocity caused by hate: the atomic blast at Hiroshima. Whereas Miller cuts back and forth between Quentin's discourse to the Listener in the present scenes and fragments of scenes in the past, Resnais (who has more in common with the montage construction of Eisenstein than with the deep-focus, or in-depth, shooting of Welles) intercuts shots and sequences from the French woman's love affair with a German soldier during the war with the present romance enacted in Japan. It is not surprising that Resnais says: "I asked Marguerite Duras [the scenarist] for a love story set in Hiroshima which would not look too absurdly trivial in the context of the atomic bomb"[23]; or that Miller, attempting to explain why he wrote *After the Fall*, views the play "in the context of the atomic bomb" (*Los Angeles Times*, April 4, 1965). In sum, Resnais's film and Miller's play are very similar in theme and technique.

The Theater of the Absurd
and Film—Eugene Ionesco
and Samuel Beckett

RICHARD SCHECHNER: *What influence has the cinema had on you?*
EUGENE IONESCO: *I think it must have had one, since I've been going to the movies for years and years. You figure it out. That's your work.*

I

Perhaps Martin Esslin, in *The Theater of the Absurd*, was the first commentator to call attention to the relationship between cinema and the dramaturgy of the Absurd. Esslin argues that silent film comedy, like the Theater of the Absurd, has a dreamlike unreality; that it depicts a world in perpetual but meaningless motion; and that it shows how profound "poetry" can be expressed without words. Even the comic vaudevillean figures of the sound film—W. C. Fields, the Marx Brothers, Laurel and Hardy —helped to shape the Absurd imagination. Esslin quotes Ionesco himself as saying that the Marx Brothers were the biggest influence on his playwriting.[1]

In *Notes and Counternotes*, Ionesco offers a collection of polemical pieces written over the years in defense of his creative work. These essays help to explain the form of the writer's plays and to underline the rationale behind them; they also contain

some pointed remarks by an important dramatist on pivotal differences between stage and screen. Looking back over his career, Ionesco reflects:

> Sometimes it seems to me that I started writing for the theater because I hated it. I used to enjoy reading literature and essays and I used to go to the movies. Occasionally I would listen to music and visit the art galleries; but I almost never went to the theater . . . The fictional element in the novel did not worry me at all and I accepted it in the cinema . . . Film acting did not fill me with the same indefinable malaise, the same embarrassment as acting in the theater . . . I think . . . what worried me in the theater was the presence of characters in flesh and blood on the stage. Their physical presence destroyed the imaginative illusion . . . In a novel you are *told* a story; it does not matter whether it is invented or not, nothing stops you believing it. In a film you are *shown* a fictional story; it is a novel in pictures, an illustrated novel. So a film too tells a story; of course, the fact that it is visual in no way changes this and you can still believe it.[2]

The novel and the film, the playwright contends, are "pure" forms, but the theater is "impure." It was, and remains, Ionesco's task to create a theater in which the fictional element would not be compromised by anything "foreign" to it.

Like Antonin Artaud, Ionesco believes that contemporary speech has become mechanical and meaningless. One does not go to Ionesco's Theater of the Absurd in order to hear great language; for, according to the playwright, "the theater is more than words. . . The theater appeals as much to the eye as to the ear." Lest the reader grasp at a too easy identification of theater and film, Ionesco argues that the drama "is not a series of pictures, like the cinema, but architecture, a moving structure of scenic images. . . Just as the words are complemented by gesture, acting and pantomime, which can take their place when words are no longer adequate, so they can be amplified by the scenic elements of the stage as well."[3] Later in his book, Ionesco asserts that his aesthetic desire is to project an "inner drama" onto the stage; and

he adds: "So there is no plot, no architectural construction [I think the playwright contradicts himself at times], no puzzles to be solved, only the inscrutable enigma of the unknown . . . simply a sequence of events without sequence. . . ."[4]

Perhaps an examination of Ionesco's *The Chairs* (1952) will clarify the extent to which this Absurdist play is cinematic, and—equally important—the extent to which it is not at all cinematic. The first thing to observe about *The Chairs* (this should come as no surprise to anyone who has read Ionesco's essays) is that there are many protracted moments of silent action in the piece. The dramatist informed the first director of the play: "What is needed is plenty of gesture, almost pantomime, light, sound, moving objects, doors that open and close and open again, in order to create [a sense of] emptiness. . . [A]ll these dynamic objects *are* the very movement of the play, though this may not as yet be movement as you see it."[5] Here is an example of what Ionesco intends by "movement" in *The Chairs*:

> *The doorbell rings again, then several more times, and more times again; the* Old Man *is beside himself; the chairs, turned towards the dais, with their backs to the audience, form regular rows, each one longer as in a theater; the* Old Man *is winded, he mops his brow, goes from one door to another, seats invisible people, while the* Old Woman, *hobbling along, unable to move any faster, goes as rapidly as she can, from one door to another, hunting for chairs and carrying them in. There are now many invisible people on stage; both the* Old Man *and* Old Woman *take care not to bump into people and to thread their way between the rows of chairs. The movement could go like this: the* Old Man *goes to door No. 4, the* Old Woman *exits by door No. 3, returns by door No. 2; the* Old Man *goes to open door No. 7, the* Old Woman *exits by door No. 8, re-enters by door No. 6 with chairs, etc., in this manner making their way around the stage, using all the doors.*[6]

A little later in the play, Ionesco inserts an even longer sequence of silent action;[7] while the ending, in which the Orator vainly

attempts to communicate with the crowd, is largely nonverbal. Similar examples from *The Chairs* and other Ionesco plays might also be cited.

There would seem to be little reason then to doubt Ionesco's assertion that he was strongly influenced by the great comedians of the cinema. When the playwright describes the structure of an Absurd play as a "sequence of events without sequence," he recalls to mind the world of so many film comics who invariably reduce human existence to the level of a madhouse. In his essay, "Comedy's Greatest Era," James Agee speaks of the "nightmare effect" produced by a sequence in a Laurel and Hardy movie, in which the two comics "are trying to move a piano across a narrow suspension bridge. The bridge is slung over a sickening chasm, between a couple of Alps. Midway they meet a gorilla."[8] This weird "nightmare effect" is everywhere discernible in Ionesco's work. *The Chairs* is shot through with a ballet-like silent movement which Theodore Huff finds one of the hallmarks of Charlie Chaplin's art.[9] Nor is one surprised when the dramatist has the Old Man in his play imitate the month of February by "scratch [ing] his head like Stan Laurel."[10]

However, like so many writers who have been influenced by the movies, Ionesco betrays ambivalence toward the cinema. For example, one of the invisible guests in *The Chairs* carries an equally invisible motion picture camera in order to record the absurd proceedings for posterity. According to the Old Man, there is even a movie theater on the premises. This would make the home of the Old Man and Old Woman a perfect symbol of a mechanical—or madhouse—world.[11]

In important ways, however, *The Chairs* is—and properly so—uncinematic. As Ionesco expresses it, a film is "a series of pictures," whereas a play is "a moving structure of scenic images." The distinction is crucial. Being mobile, the film-maker's camera tends to demand subjects which will challenge its capacity to follow physical "action." True, attempts have been made to film immobility: one thinks of Josef von Sternberg's *The Salvation*

Hunters (1925), which has been called "the dreariest picture on record,"[12] and of the more recent *Empire* (1964) by Andy Warhol, whom John Simon charitably refers to as "an aesthetic, moral and intellectual bankrupt,"[13] in which the camera stays focused on the Empire State Building for eight hours in order to "prove" that movement is not a necessary element in film art. But most film lovers would probably agree that a movie refusing to picture movement is a bad movie, or a contradiction in terms. Although *The Chairs* contains much physical activity, Ionesco's play remains—in spite of its cinematic influences—basically histrionic.

Physical movement on stage and physical movement on film are by no means the same thing. In discussing Yeats's dramaturgy, Eric Bentley points out that an authentic playwright "learns not to write for the stage without knowing what he wants in visual terms. The 'literary dramatist' sees the characters in his mind's eye moving about in their natural setting. The genuine playwright sees them in the highly unnatural setting of the stage . . . as pure color, line, and three-dimensional form, all dominated by . . . electric light."[14] *The Chairs* was conceived by a gifted dramatist who knew very well what he wanted in "visual terms"—but within the "highly unnatural setting of the stage." Even in the theater, it must be owned, some people find Ionesco's work static and boring. On the screen *The Chairs* would prove unendurable.

One reason for this is that Ionesco's Old Man and Old Woman are symbols or abstractions—they are not really human beings. In the concrete medium of the movies such stage figures representing Everyman and Everywoman disappear, their metaphysical dimension replaced by an aura of the psychotic. Although there is much nonverbal action in *The Chairs*, there is more dialogue—and of a very "stagy" sort—than an accomplished screenwriter would dare offer to a film director. No doubt Siegfried Kracauer rides his thesis too hard when he insists that cinema is best in depicting street scenes and mob scenes;[15] but it is safe to say that a camera fixed on a single set and restricted to two or three actors—the rest

of the "cast" remaining invisible—will not ordinarily result in a very satisfactory motion picture.

Let us hope then that some bright producer does not decide to film Ionesco's "cinematic" play *The Chairs*. Entranced by the silent comedy elements in the piece, the would-be adaptor might be seduced into ignoring what is even more obvious—namely, that Ionesco's masterpiece is also a very *theatrical play*.

I I

> *You know, Sam's incredible. He grasps his own work visually. He can think cinematically.*
>
> —Joseph Coffey, a cameraman, on Samuel Beckett

Samuel Beckett's *Waiting for Godot* (1952), like Ionesco's *The Chairs* and other Absurd plays, has, as noted, often been linked to the tradition of film comedy. Writing in *The New York Times* (September 24, 1967), Esslin once again compares Beckett's characters to such famous comedians as Charlie Chaplin, Buster Keaton, and Laurel and Hardy. Estragon and Vladimir in *Waiting for Godot* resemble Chaplin's tramp, says Esslin, because all three characters are outcasts of a highly mechanized society. Furthermore, like Chaplin's little man, Beckett's two bums embody indestructible courage in the face of a hostile environment. Esslin, as I shall attempt to explain later, makes a too easy philosophical identification of Beckett's characters with the comics of the screen; all the same, there is much evidence in *Waiting for Godot* in support of the argument that the play has been influenced by the silent film.

Waiting for Godot begins with some stage business that is repeated, with slight variations, throughout the play: "Estragon, *sitting on a low mound, is trying to take off his boot. He pulls at it with both hands, panting. He gives up, exhausted, rests, tries again. As before.*"[16] Shortly afterward Estragon returns to his

silent struggle with the boot: "*Estragon with a supreme effort succeeds in pulling off his boot. He peers inside it, turns it upside down, shakes it, looks on the ground to see if anything has fallen out, finds nothing, feels inside it again, staring sightlessly before him*" (p. 8). At times, this nonverbal business involves a search for a carrot, or the inspection of the inside of a hat. When Pozzo and Lucky first appear on the scene their entrance is largely silent (p. 15). Act Two similarly begins with mute action (p. 37). Each of the four men in the play, it should be noted, wears a Chaplin-like derby; and at one point the hats become the subject of a low comedy routine, silent film style:

> Estragon *takes* Vladimir's *hat*. Vladimir *adjusts* Lucky's *hat on his head*. Estragon *puts on* Vladimir's *hat in place of his own which he hands to* Vladimir. Vladimir *takes* Estragon's *hat*. Estragon *adjusts* Vladimir's *hat on his head*. Vladimir *puts on* Estragon's *hat in place of* Lucky's *which he hands to* Estragon. Estragon *takes* Lucky's *hat*. Vladimir *adjusts* Estragon's *hat on his head*. Estragon *puts on* Lucky's *hat in place of* Vladimir's *which he hands to* Vladimir. Vladimir *takes his hat*. Estragon *adjusts* Lucky's *hat on his head*. Vladimir *puts on his hat in place of* Estragon's *which he hands to* Estragon. Estragon *takes his hat*. Vladimir *adjusts his hat on his head*. Estragon *puts on his hat in place of* Lucky's *which he hands to* Vladimir. Vladimir *takes* Lucky's *hat*. Estragon *adjusts his hat on his head*. Vladimir *puts on* Lucky's *hat in place of his own which he hands to* Estragon. Estragon *takes* Vladimir's *hat*. Vladimir *adjusts* Lucky's *hat on his head*. Estragon *hands* Vladimir's *hat back to* Vladimir *who takes it and hands it back to* Estragon *who takes it and hands it back to* Vladimir *who takes it and throws it down*. (p. 46)

But why go on? It would be pointless to cite the many similar sequences in *Waiting for Godot*.

Obviously, the pantomime in *Waiting for Godot* is not there for its own sake. It is not there to display Beckett's ability to imitate silent film action on the stage. Like the other elements in the play, the mute action underlines the playwright's vision of an absurd

universe. As Esslin, in the *Times* piece earlier referred to, points out: "the great archetypes of the silent film were naive creations; Beckett is a highly sophisticated, deeply learned, philosophically erudite artist."

Consequently, it would be imprudent to push the analogy between Beckett's work and the art of the film comedians too far. The reasons for this are both technical and thematic. The structure of *Waiting for Godot*, like the form of *The Chairs*, is very theatrical; if possible, though, there is even less plot in Beckett's play than in Ionesco's. Although there are numerous moments in *Waiting for Godot* which depend for their effect on visual action alone, the piece as a whole could not be said to offer very promising motion picture material. The argument advanced in the last section in regard to *The Chairs* applies as well to Beckett's masterpiece. As Alain Robbe-Grillet, who has himself been strongly influenced by the movies, says: "Attempts doubtless already existed, for some time, which rejected the stage movement of the bourgeois theater. *Waiting for Godot*, however, marks in this realm a kind of finality." By "stage movement," Robbe-Grillet does not intend physical movement. "What does *Waiting for Godot* offer us?" he asks. "It is hardly enough to say that nothing happens in it. That there should be neither complications nor plot of any kind has already been the case on other stages. Here, it is *less than nothing* . . . a kind of regression *beyond* nothing."[17] Great movies have been made, of course, which lack plot progression; all the same, one would be hard pressed, I think, to name a major work of cinematic art in which absolutely "nothing happens in it."

And it is here that comparisons between Chaplin and Beckett become strained; for whereas *Waiting for Godot* is almost wholly static, Chaplin's movies always contain a plot and sometimes even a subplot. The differences between the two artists, for all of Beckett's borrowings from the great movie comedian, are philosophically based. As Günther Anders observes, a metaphysic separates Chaplin's tramp and Beckett's characters. In order to create

laughter, Chaplin's little man must be in constant motion; he must engage in conflict with the world without pause. But Estragon and Vladimir are "paralyzed clowns"; for them, the world does not even exist—"hence they renounce altogether any attempt to concern themselves with it."[18]

When characters refuse "altogether" to struggle against their fate, the result is stasis. Thanks to Beckett's ontology his characters, or "paralyzed clowns," are abstract and two-dimensional. Through aesthetic distancing and theatrical stylization, it is true, such figures can be made to live on the stage; transported to the screen, however, they almost always lose their peculiar histrionic "reality." Furthermore, there remains a question of dialogue. In spite of his fondness for pantomime, Beckett depends on language to a much greater extent than does Ionesco. Indeed, the characters in *Waiting for Godot* seem to talk constantly. At first glance, Beckett's language (and, like his friend Joyce, he is a master of language) looks filmic; diction and syntactic structure, for example, are both equally simple. However, two things should be observed about this language: one, it has more of a musical quality than a conventional dramatic thrust (since "nothing happens" the usual employment of stage dialogue is unnecessary); and two, without speech the playwright could not make clear the absence of a functional relationship between language and movement. On the screen, the duets of Vladimir and Estragon would not only seem wordy, they would also lose whatever poetic beauty, or "magic," they possess on the stage. The screen medium (and one cannot repeat this truism too often) does not take kindly to such theatrical posturing and extreme formalization of speech. In a good motion picture the verbal is kept subordinate to the visual; silent action should, to a large extent, carry the essential action. In *Waiting for Godot*, Beckett's pantomime takes second place—as it should—to the language.

III

Yet, because Beckett's plays *do* possess a great amount of visual action, and because critics have emphasized the Chaplin-like and Keaton-like quality of his characters, it is not surprising that the dramatist has been encouraged to transfer his talents to the screen. Beckett's first scenario, entitled *Film*, was written in 1964. The work runs for only twenty-two minutes, and unlike *Waiting for Godot*, it has no dialogue. Buster Keaton performed under Alan Schneider's direction in this largely one-character piece, which was shot on Pearl Street in New York City, under the Manhattan end of the Brooklyn Bridge. The cameraman, whom I quoted earlier, describes the neighborhood as "semi-demolished and desolate. It looked as though the street was all that existed, all there was—a world blocked off."[19] Of course, this exactly suited Beckett's purposes. Schneider told Richard Schechner that Beckett "wrote it, and I then composed a shooting script, which I showed to him. Based on his comments and a weekend discussion, Beckett, the camera director, and I made up another shooting script, because a lot of things were not clear to me, and he kept changing the script."[20] The director got Beckett to look at the various shots through the camera before shooting, and afterward the writer participated in the editing, too. Both Schneider and the technical crew found Beckett an accommodating screenwriter.

In *The New Yorker*, Schneider calls *Film* "quite a simple thing. It's a movie about the perceiving eye, about the perceived and the perceiver—two aspects of the same man. The perceiver desires like mad to perceive and the perceived tries desperately to hide. Then, in the end, one wins." The director adds that, in his opinion, the perceiver wins.[21] A year later Schneider was more articulate about *Film* in the interview with Schechner:

> There's a man pursued by someone else, and that someone else is the person represented by the subjective camera. Whenever the camera exceeds a certain angle in relation to this man, the man becomes aware of it; when the camera

withdraws, the man ceases to be aware of it. I would ask a question like, "What does he think happened to the other guy?" He doesn't exist; he exists only when he exceeds the angle, and when he withdraws from the angle, as far as this guy's concerned, the other fellow doesn't exist. That's the premise . . . Then [Beckett] wanted photographs of Buster at different ages which he very specifically spelled out, and we couldn't get real pictures just like that and had to fake other ones . . . There was a constant attempt on the part of the professional movie people involved to "free" the script. But in this film every shot had to be from the point of view of the guy observed or the camera observing, which meant all shots in the film were subjective shots. Everybody balked at that, because it confined us tremendously, but it also made the style of the picture.[22]

Schneider, it should be said, makes Beckett's movie sound much more technically involved and thematically significant than it really is.

When *Film* was shown at the Venice Film Festival in October 1965, according to Rudi Blesh in *Keaton*, both the movie and the actor received a five-minute standing ovation.[23] However, audiences at the Third New York Film Festival that same year were not overly impressed by *Film*. Stanley Kauffmann, who covered the festival for the *New Republic*, says: "The Beckett film was one of the weaker of his many restatements of his sole theme";[24] John Simon, in *Private Screenings*, remarks that *Film* "might with equal right have been called *Upanishad*, *Lobotomy*, or *Ginger Snaps* . . . [It has] a rickety but ultra-pretentious super-structure erected over a gaping hole. Beckett really should refrain from supplying his middlebrow detractors with so perfect a weapon against himself, and one that is so irresistibly tempting even to his defenders."[25] Can anything by Beckett be all bad?

Film, which is in black-and-white, opens with a close-up of a monstrous eye staring into the camera. Just as Arthur Miller's first image of what was to become *Death of a Salesman* was a picture of an enormous head that would fill the stage and underline the

theme, Beckett's initial image of a huge eye establishes the subject matter of *Film*—namely, "the ambiguity of perception." From the eye Schneider cuts to a long shot of Keaton hurrying along a city street. Throughout the film, the actor keeps his back to the camera; he wears a hat and, for much of the time, a scarf over half his face. On the street, Keaton keeps close to the sides of buildings, shrinking from the gaze of both the camera and other people. Once he encounters a prim minister and his equally prim wife, both of whom stare into his face with horror. The single sound in the entire picture is something like "Shuss!" from the wife to her husband, as they gape after the figure of the fleeing recluse. Entering his shabby building, Keaton runs into an old lady on the stairs. She too stares into his face—and then promptly faints.

Upstairs in his room, the man with the hidden countenance bolts the door, slides furtively across the wall, and carefully pulls down his shade. He then tries to relax. But, alas, there is no peace. Eyes seem to glare at his face from every corner of the room. Keaton deliberately proceeds to eliminate every perceiving eye one-by-one: the cat and the dog are sent out into the hall; the parrot cage and the goldfish bowl are covered with a coat; and the mirror on the wall is similarly concealed. Wearily, Keaton sinks into a rocker and opens a large Manila envelope. (Even the envelope, however, seems to have "eyes.") In Keaton's hands now are snapshots of himself at various stages of his life. The last snapshot shown is of the actor with a patch over his eye, staring directly into the camera. Desperately, Keaton tears up all the pictures; then, momentarily relieved, he slumps back in his chair. Escape from self, though, is impossible. There is a slow traveling shot which traverses the entire room, finally coming to rest on the face of Keaton as he sits in his chair. Across the room a mirror image of himself with a patch over his eye stares back at him. Keaton, suddenly horrified, buries his face in his hands. *Film* ends with the same close-up of the eye which opened the "action."

By eliminating dialogue and sound, and by concentrating solely on physical movement, camera movement and editing, Beckett

seeks to achieve "pure cinema." Thus, gesture is made to carry heavy symbolic meanings. Repeated close shots of Keaton feeling his pulse are apparently intended to suggest the existential question: "Am I really alive—am I really living an authentic existence?" Point of view is very much restricted; that is, the camera never exceeds a forty-five-degree angle of vision. Shots from the camera-eye perspective are in clear focus; whereas the occasional shots from the protagonist's viewpoint are slightly fuzzy, out of focus. At the end, the two viewpoints come together in an attempt to show how the outer eye and the inner eye are both aspects of one entity. *Film*, explains Beckett, "is a search of non-being in flight from extraneous perception breaking down in inescapability of self-perception. . . [It] will not be clear until the end of the film that the pursuing perceiver is not extraneous but the self."[26]

While *Film* cannot be said to be all bad, it cannot be said to be very good either. There is something a little too precious about the approach: a suggestion that deep things are being attempted, and that any member of the audience who admits to being bored is simply resisting "serious art." Like Beckett on the boards and Beckett on the page, Beckett on the screen tends toward redundancy. Although *Film* is very short, the limitation of the camera-eye to Keaton's back and the absence of sound finally becomes oppressive. The theory advanced in favor of this austere approach sounds good—but the theory translated into practice is another matter. To have relied solely on visual "action" in the sixties seems perversely archaic—much like a modern dramatist who would express the "essence of theater" by a return to Greek hexameters (or like Artaud and his followers who would have playwrights regress even further and ditch language altogether). Why should a film-maker refuse to use what he has every right to use? There are enough handicaps to the successful exercise of any art without manufacturing more of them. Are silent pictures the only alternative to excessively talky ones? Besides, "pure cinema" is a myth; sound and speech were inherent in the silent film from

the start, as the use of the piano and dialogue cards alone suggest.

Dramatists who belong to the Theater of the Absurd have made a significant contribution to world theater. So far Ionesco, Beckett, and Pinter have each turned their talents to the screen. As yet, though, the Cinema of the Absurd remains an undistinguished genre. Cinematic techniques in the theater are one thing; cinematic techniques on the screen—we are learning more and more—are something else.

Critique of the Cinematic
Drama and Present Trends

I

Modern theater shows that writers have been strongly influenced by the motion picture in the construction of their plays. However, whether the cinematic imagination on stage is good or bad depends on how it is used and on the quality of the play *qua* play. Naturally, the material of a poor play will not be enhanced by "cinematifying" it. The crucial question remains: Is the filmic method assimilated to the essentially dramatic and/or theatrical nature of the play as a whole—or is the nature of the play as a whole swallowed up by the filmic method?

A playwright may borrow cinematic techniques to make his action move faster, more smoothly, and more extensively; but he must realize that in the final analysis the stage cannot really match the screen's narrative range, pictorial powers, or ability to tell a story swiftly, and that if subtle characterization or richness of theme is sacrificed to speed, the loss outweighs the gain. This would appear to have been one of the errors of the German expressionists—none of whose plays have endured—who were also among the pioneers of mixed-media; even at its best—as in Brecht —mixed-media seems crude and obvious, the cinematic imagination here being too direct for most dramatic or even theatrical purposes.

The sane approach for playwrights in the Film Age would seem to be the avoidance of two extremes: the aping of cinematic techniques to the detriment of their own art; and the futile effort to

purge from their work every trace of a cinematic imagination. *The Emperor Jones, Death of a Salesman, The Chairs* and *Waiting for Godot* remain examples of outstanding plays which are, in spite of their filmic borrowings, inherently dramatic or histrionic. In each case the playwright has subordinated to the demands of his own unique art a specific technique derived from the movies. That *The Emperor Jones* and *Death of a Salesman* both failed on the screen only serves to underline the point.

When a play is brought to the screen the audience has a right to expect a degree of cinematic technical complexity and a level of thematic depth at least comparable to the original. There is no question here of literal fidelity to the source. Though occasionally some of the power in the original comes through even in an unimaginative adaptation, no one who is sensitive to film or drama wants a photographed stage play. The more a play depends on language and on its untranslatable appeal to what Francis Fergusson calls the "histrionic sensibility,"[1] the less likely it is that the work will prove viable on the screen. This is why Lillian Hellman argues that poor plays "that are written with technical skill often can be turned into the best screenplays because the writer can do more with them, can exercise his imagination better" (*The New York Times*, May 10, 1968). Form and content are so joined in a good play, however, that any technical alteration is bound to change its meaning.

Generally speaking, then, the finer the play, the harder it will be to make a good movie out of it; the more theatrical the original, the worse the film version of it. Nor should cinematic influences on plays mislead us. *Long Day's Journey Into Night, A Streetcar Named Desire* and *Cat on a Hot Tin Roof* made better films than *The Glass Menagerie* and *Death of a Salesman*—both of which are "cinematic" plays—because they were more realistic, or less theatrical, than most great stage pieces. Even relatively successful adaptations, such as the three I have cited, however, are extremely rare. The immense majority of superior plays fail to survive the transfer from stage to screen; while inferior plays—though they

ordinarily adapt better than major works—hardly ever achieve the
level of the most distinguished original screenplays.

II

Yet there is every indication that today the cinema exerts far
more pressure on the stage than ever before. No one produces a
play without first giving thought to residual and subsidiary income
from a film sale. Many plays—a good number of them "flops"—
are pre-sold to Hollywood with even the starring roles cast in
advance.

That most film versions of plays suffer from a bad case of
staginess has not deterred the movie moguls from buying nearly
every play—good, bad, and indifferent—in sight. A play, some
producers feel, offers a "visual concept" of its potential for the
screen. The reasoning here is difficult to understand. If a play is
good, the "visual concept" it presents as a potential motion pic-
ture should ordinarily remain unfavorable. What is actually hap-
pening more and more frequently today, though, is that dramatists
are presenting film scenarios in the guise of plays.

With monotonous regularity, Clive Barnes's drama reviews in
The New York Times point up the influence of film on the drama-
turgy of new writers. Barnes—correctly, I believe—identifies the
structure of Howard Sackler's *The Great White Hope* as cinematic
in its fluid movement and quick transitions (December 14, 1967).
The dialogue of *Joe Egg* has the unheightened, undramatic quality
of film speech; in addition, the form of the play is cinematically
episodic (February 2, 1968). Ed Bullins's *A Son, Come Home* is
filmic in its use of flashbacks (March 9, 1968). Rosalyn Drexler's
The Line of Least Existence is likened to a film comedy (March
25, 1968). *In the Matter of J. Robert Oppenheimer* by Heinar
Kipphardt contains slide projections and spotlight close-ups; fur-
thermore, the structure of the piece is "edited" like a film (June 7,
1968). And so on and so on.

If the technique of the latest plays reveals the influence of the

motion picture, their subject matter also owes much to Hollywood. Woody Allen's *Play It Again, Sam* features a protagonist who identifies himself with Humphrey Bogart. *But Seriously . . . ,* by Julius J. Epstein, is about a day in the life of a Hollywood screenwriter. James Leo Herlihy's *Bad Bad Jo-Jo* also has a scenarist for a hero (and also uses photo-visuals). In Robert Somerfeld's *The Projection Room* a Hollywood director is in hell, doomed to watch bad films throughout all eternity. The central character in Donald Ross's *Shoot Anything With Hair That Moves* is a film publicist whose greatest joy in life is to watch bad old movies on television. And this list could go on and on.

Most Broadway dramatists clearly write with one eye focused on the movie studios. The situation, however, is the same elsewhere; for now the film companies are buying off-Broadway plays, and paying handsome prices for them, too. *Futz*—Rochelle Owens's masterpiece—was actually pre-sold to the films. When Rex Reed interviewed Mart Crowley, author of *The Boys in the Band,* he remarked: "*The Boys in the Band* looks like a movie, reads like a movie and plays like a movie" (*The New York Times,* May 12, 1968). Was anyone really surprised when Crowley sold his "play" to the movies for a quarter of a million dollars? Wasn't Hollywood the true destination of *The Boys in the Band* from the start? But is the art of either playwriting or film-making advanced by this kind of creative schizophrenia?

Those who look to the off-off-Broadway theater as a way out of the increasingly unhealthy alliance of stage and screen are in for a disappointment. Many of these young authors have already written scenarios and adaptations; more important, they are writing their "plays" with the screen in mind. For example, the eight works in Robert J. Schroeder's "anti-tradition" and "anti-Establishment" anthology, *The New Underground Theater* (New York, 1968), reveal evidence of having in one way or another been influenced by the movies. The plays either present their action in the form of a film, or else they weakly satirize the Hollywood Dream Factory. Jean-Claude van Itallie's *I'm Really Here* attempts to do both, and only succeeds in exposing the emotional

barrenness and intellectual nullity of its creator (who has also lent his meager talents to a movie entitled **Virtues**).

Grant Duay's *Fruit Salad* (still another stale serving of mixed-media) clearly shows the direction of much contemporary drama, both underground and otherwise. An autobiographical headnote to the piece in the Schroeder volume is of more interest than the play itself; says Duay: "I began writing screenplays three years ago during which time I received invaluable experience in different phases of film-making, working on underground short films and pilot television commercials. *Fruit Salad* is my first play. At present, I'm reworking my previously written screenplays, transferring them to other mediums." It takes no great psychological perception to see where Duay's real interests are. Playwrights used to fail at playwriting and then turn to the screen; today they fail at screenwriting and turn to the theater—always with the hope, though, that by writing cinematic plays they will make it back to the Hollywood they both love and hate.*

Are matters any better on campus? Robert Brustein, Dean of the Yale School of Drama, declares: "At present, students are abdicating their place in the theater to the middle-aged, and going to the movies instead. Hopefully, they will soon discover the more electrifying satisfactions of the stage" (*The New York Times*, August 13, 1967). What "electrifying satisfactions" does Dean Brustein have in mind? Ironically, a large number of plays presented at Yale have clearly been influenced by the motion picture. In Jules Feiffer's *God Bless*, for instance, a flashback technique (is it surprising, in view of the writer's preference for film over drama?) is "achieved through the screening of photos of a succession of Presidents" (*Variety*, October 16, 1968). In *Mysteries and Smaller Pieces*, as performed at Yale by the Living Theater Company, the dialogue "becomes somewhat secondary, with more emphasis on the art of picturing than saying. At times, this be-

* Jules Feiffer, author of *Little Murders*, admits he likes films better than plays: "I consider an evening in the theater a triumph if, at the end of it, I don't feel like I should have gone to a movie instead" (*The New York Times*, January 26, 1969). Don't many other dramatists feel the same way?

comes a fault, as in a downstage word-and-action scene competing for attention with an upstage background of silent orgy rhythm" (*Variety*, September 25, 1968). *Frankenstein,* another production of the Living Theater, owes more to the horror films of the thirties and after than to the original novel by Mary Shelley. Certainly Rochelle Owens knows the direction the wind is blowing in. After selling *Futz* (which to be sure begins with a film sequence) to Hollywood, the playwright enrolled in the screenwriting course at Dean Brustein's School of Drama in order to adapt the piece to celluloid herself. Isn't the path of Miss Owens's future artistic development clear as clear?

But how many of our playwrights are in a position to cast the first stone? Wherever one looks today—Broadway, off-Broadway, off-off-Broadway, the campus—the influence of the cinema is omnipresent. Playwrights borrow film techniques, use Hollywood characters and characters influenced by Hollywood as subject matter, and depend on film sales for their very existence. In addition, playwrights want the thrill of being associated with an art form that is more popular than any other among young people today. As I have tried to suggest, many dramatists themselves seem to prefer film to the stage and would like to abandon the theater entirely in favor of scenario writing.

Movie actor Kirk Douglas has remarked: "I think if Shakespeare were alive today, he'd be writing screenplays" (*Variety,* November 13, 1968). Perhaps. But there is a difference between writing screenplays—and writing plays that aspire to be screenplays. On this subject, O'Neill had something to say which playwrights today would do well to ponder. "Plays should never be written with . . . Hollywood in mind. This is a terrific handicap to an author, although few of them seem to realize it," he declared. "The theater should be their sole thought. If this were only true, you would find sound development underneath the plays of today. Unfortunately, just the opposite is occurring."[2] O'Neill's words are even more relevant now—when the cinematic imagination in the theater threatens to replace the dramatic imagination entirely —than they were twenty-five years ago.

Part
Two

NOVELISTS

AND THE

MOTION PICTURE

SHORT SUBJECT

For me, I despise [the film] myself—but I love it too. It is not art, it is life, it is actuality. . . . For it is all raw material, it has not been transmuted, it is life at first hand. . . . It is much too genuine to be theater. . . . The film possesses a technique of recollection, of psychological suggestion, a mastery of detail in men and in things, from which the novelist, though scarcely the dramatist, might learn much.

—Thomas Mann

Of course [the cinema is] a marvelous toy. But I cannot bear it, because perhaps I am too "optical" by nature. I am an Eye-man. But the cinema disturbs one's vision. The speed of the movements and the rapid change of images force men to look continually from one to another. Sight does not flood one's consciousness. The cinema involves putting the eye into uniform, where before it was naked. . . . Films are iron shutters. . . . Real life is only a reflection of the dreams of poets. The strings of the lyre of modern poets are endless strips of celluloid.

—Franz Kafka

Page and Screen—Some
Basic Distinctions

The novelist uses words, the film-maker uses pictures; therein lies the simple but major difference between the two art forms. Although it is both possible and desirable for the novelist and film-maker each to suggest the objective and subjective realms as co-existing—as indeed they do in the empirical world—it is also true that the basic difference between page and screen imposes strict limits on the power of each to convey certain kinds of material. Because he employs a linguistic medium, the novelist is uniquely privileged to explore thoughts and feelings, to discriminate among various sensations, to show the complex interpenetration of past and present, and to handle large abstractions. While some recent film-makers have sought to compete with literature by projecting involved subjective relationships, the cinema possesses a relative weakness in this area and vies with the novel at its peril. Too many film-makers who concern themselves *exclusively* with the inner world of man—or in other words with a subject matter that more appropriately belongs to the literary artist—end up producing static, confusing and boring exercises in noncinema.

Again, there is no question here of one medium being "superior" to another. "What is it that the cinema lacks?" Raymond Durgnat asks. "That greasy dull brown patina of cultural 'prestige' that has made so many works of art all but invisible? Perhaps it lacks, above all, that thick screen of 'busy,' intricate, but often tautologous, intellectual detail which, in currently fashionable literary formula ('complexity,' 'density,' 'texture'), serve to protect

the moral-emotional hypochondriac from the impact of straight-forward emotion."¹ But is Durgnat's defensive sarcasm really necessary? Why should one at this late date need to disparage the virtues of the novel in order to justify the claims of the cinema? For both fiction and film—*though each in its own way*—are capable of attaining the level of great art.

"In the cinema, one extracts the thought from the image," André Levinson observed over forty years ago, "in literature, the image from the thought."² Inasmuch as the image comes first on the screen, the film is a more economical medium than the page. Whereas a film-maker can encompass an entire business office in a single frame, a novelist is limited to the piecemeal notation of each person and object in that office. "On paper all you can do is say something happened, and if you say it well enough the reader believes you," John Huston remarked once. "In pictures, if you do it right, *the thing happens, right there on the screen.*"³ Thanks to its dramatic impact, its powerful immediacy, a film is capable of arousing in an audience that "straightforward emotion" which Durgnat rightly esteems. To repeat: "One picture is worth a thousand words"—*provided it is a picture of external reality.* The motion picture medium's advantage over the verbal medium is offset then by a clear disadvantage. As Pudovkin declared in his classic treatise on the movie: "Most good films are characterized by very simple themes and relatively uncomplicated action."⁴

True, the sound film has made possible a more complex approach to life than Pudovkin's statement seems to allow; it is also true that films such as *Hiroshima, Mon Amour* make enormous demands on a viewer. Nevertheless, when one considers the average quality picture, and when one compares the film with the resources which modern novelists possess, the Russian director's observation appears to be still generally valid.

Some theorists are fond of drawing parallels between language and pictures; thus, the word is equated with the shot, the phrase or sentence with the scene or sequence, grammar and syntax with editing, and so forth. Though there is a degree of correspondence

between fiction and film—and hence some validity to the fore-going analogy—the differences between them are even greater. While, as Huston puts it, "the thing happens, right there on the screen"—it always happens in the present tense. Even when the past is projected in a flashback, it is unreeled in the here and now with the same immediacy as scenes set in the present. Memory of past events can be treated with much more ease and in much more depth by the novelist than by the film-maker. The use of the conditional tense, though possible in film, also can be done much more economically on the page. For the true "language" of the film resides in the alternation of shots on the screen, in expressive camera angles, and in movement and lighting. I shall return to this matter shortly when I discuss style in fiction and film.

The pictorial, as opposed to the linguistic, nature of film ac-counts for the fact that point of view can be manipulated in a more complex fashion in the novel than in the motion picture. Granted, the film can present subjective views of people and hap-penings; it can in addition project more than one perspective on a single action. Yet there are limitations here. It is certainly foolish to expect that even the most sophisticated camera can duplicate the intricate subjective probing found in *The Sound and the Fury*, say, or *Finnegan's Wake*, wherein even the linguistic resources of Faulkner and Joyce occasionally falter before the extreme density of the psychological-philosophical subject matter. Largely because of the impact of the movies, however, novelists have tended in-creasingly to objectify their stories. André Malraux more or less defends this practice:

> . . . the novel seems to retain one advantage over the film: the possibility of moving to the *inside* of its characters. But on the one hand, the modern novel seems less and less to analyze its characters in their moments of crisis; and on the other hand, a dramatic psychology—that of Shakespeare and, in large measure, of Dostoevsky—in which secrets are suggested either by acts or by half confessions (Smerdyakov, Stavrogin), is perhaps no less artistically powerful nor less revealing than analysis.[5]

Apparently Malraux forgets that Shakespeare, who wrote for the stage, was *forced* to objectify his material and that Dostoevsky, who was perhaps the most dramatic of nineteenth-century novelists, might succeed with a method which in the hands of a lesser artist could only result in self-defeating externality. Whenever a novelist goes too far in imitation of either plays or films he forfeits his unparalleled power to dissect character and thought in depth. This problem is too broad and too complicated to pursue further in the present context. Suffice it to note that, as Phyllis Bentley maintains, summary is a strong weapon in the hands of a fiction writer and for him to surrender it "at the very moment when other arts—the film and the broadcast—are just beginning to employ it to intersperse their scenes, seems strange."[6]

If the film cannot truly contend with the novel on the score of depth analysis and subjective viewpoint, how can it have such strength in character portrayal? "We have come a long way from the 'literary' conception of a film as 'explaining' or 'analyzing' people's psychology," Durgnat says. "The film's job is not so much to provide 'information' about the characters' minds as to communicate their 'experience,' whether intellectual, emotional, physical, or a blend of all three."[7] If an order of priority were given to Durgnat's three forms of "experience," however, the physical would come first, to be followed by the emotional and then by the intellectual. Not even Balzac or Tolstoy can make us "see" a face or a body—or anything physical—as vividly as a movie camera can. And because this is true—because the screen is able to magnify a facial expression to an extraordinary degree—the film-maker can communicate ecstasy or sorrow with a palpability that is almost unbearable. Though the novelist can also reveal strong feelings and emotions, and though it is also true that feelings and emotions can be rendered in more involved ways on the page than on the screen, it must be owned that emotions and feelings are expressed with more directness in the film than in the novel. This suggests that watching a film story is ordinarily a less reflective but a more moving experience than reading a novel.

Intellectually, though, the film is no match for the novel. As Pauline Kael observes in reviewing the film version of *Ulysses* (*New Republic*, May 6, 1967):

> . . . how does one photograph intellectual pride? Pride can be photographed (Autant-Lara did it in the Michèle Morgan-Françoise Rosay section of *The Seven Deadly Sins*), but *intellectual* pride? Zinnemann did it in the sequence of *The Nun's Story* when the nun was told to fail her examinations, but that was a simpler kind and there were actions planned to dramatize it. Joyce gives us the drama within Stephen's consciousness. The movie *Ulysses* can provide the meeting between Stephen and his sister when she is buying the penny French primer, but what made us *care* about that scene in the novel —the agenbite of inwit—is missing.

And the "agenbite of inwit" must forever escape the camera because—as noted at the outset of this chapter—the novelist uses words, the film-maker uses pictures.

Which raises the question of style. Be he novelist or film-maker —"style is the man." The literary artist can express himself in short declarative sentences, like Hemingway, or in long involved constructions, like Faulkner; he can employ understatement—"At the start of the winter came the permanent rain and with the rain came the cholera," says Frederick Henry in *A Farewell to Arms*. "But it was checked and in the end only seven thousand died of it in the army"[8]—or he may prefer to rely on the oxymoron—all those "furious immobilities" one finds in Faulkner's *Light in August* or in *Absalom, Absalom!*. "By a man's metaphors you shall know him."[9] But how can a *literary style* be communicated on the screen? Take away Henry James's seemingly endless fussy qualifications, or Conrad's almost too perfect English diction— and what's left? An answer is suggested, at least insofar as Conrad is concerned, by the insubstantial caricature of *Lord Jim* which appeared on the screen, and which does not even merit discussion.

A rough correspondence exists between the structure of a novel and the structure of a film; for example, crosscutting can be used

in both narrative forms. But style, as I have suggested, is another matter. In a novel style means the arrangement of words; in a movie "style" is almost ("almost" because dialogue in a film is part of its style) wholly nonverbal. In his famous preface to *The Nigger of the "Narcissus,"* Conrad said: "My task which I am trying to achieve is, by the power of the written word to make you hear, to make you feel—it is, before all, to make you *see*. That— and no more, and it is everything."[10] He therefore put the primary emphasis on "seeing," but it was on "seeing" entirely through the agency of "the written word." Years later, D. W. Griffith echoed the great novelist by declaring: "The task I'm trying to achieve is above all to make you see."[11] The early film master meant to make his audience "see" in terms of pictures. A film director's style appears in his idiosyncratic use of all the techniques of his medium; for (as partisans of the *auteur* theory never tire of reminding us) the great film master selects his camera angles, his shot sequences, his locales, images and symbols, with the same almost obsessive-compulsive concern as a literary artist like Hemingway or Faulkner selects his words, his sentences and paragraphs, his similes, metaphors, and image clusters. However, it is important to add that not only are the ways of "seeing" different in film and fiction, but *what* is seen is also different.

Although Conrad apparently anticipated cinematic technique, he was primarily interested in psychological exploration; his method might be compared to that of Griffith, but his goal was different.

A number of Conrad's stories have been made into films; however, none of them—including the occasionally praised *An Outcast of the Islands* (1952)—are of much significance. Surely there is a lesson here, since Griffith could take a mediocre novel like Thomas Dixon's *The Clansman* and develop it pictorially into a motion picture classic. What Griffith makes the audience "see" in *The Birth of a Nation* is not the inner landscape (or "soulscape") of one or more characters—not the "agenbite of inwit" stemming from a sense of lost honor, which is the concern of Conrad in

Lord Jim—but mainly physical action: the movement of armies, the devastation of the South, and the rise of the Klan.

The point made here about the different ways in which life is "seen" in a Conrad novel and in a Griffith film is basic to an understanding of the two art forms. As I have previously pointed out, despite such differences the movies have had an enormous influence on the modern novel. In the pages that follow I shall try to show what happens to a filmic technique when it is borrowed by a fiction writer like Joyce or Hemingway, for example, as opposed to one like Dos Passos or Steinbeck; and what takes place when a novel—cinematic or otherwise—is adapted to the screen. Such an investigation should prove conclusively that, in spite of their similarities, the novel and the film remain fundamentally different ways (in Kenneth Burke's fine phrase) of "encompassing life."

CHAPTER NINE

Theodore Dreiser in "Hooeyland"

Ever since the inception of the moving picture technique, I have looked on it as an artistic medium far surpassing for most expressive purposes, writing, painting, and the other arts, and I have hoped that my own work could be satisfactorily translated into it.

—Theodore Dreiser

Although Theodore Dreiser had always been interested in the movies (as the above quote from his letter to Sergei Eisenstein makes clear[1]), the art of the film seems never to have influenced the great American naturalist's technique.* Nevertheless, the novelist's relationship with Eisenstein, in respect to the latter's abortive attempt at a film treatment of *An American Tragedy* (1925), and his legal struggle with Paramount Pictures over that studio's adaptation of the same novel in 1931, remain important milestones in the history of writers and the motion picture.

In "Myself and the Movies," written two years before his death, Dreiser says:

> My first personal contact with Hollywood and the Movies was in September, 1919. It was an extremely pleasing place and I liked it enormously, so much so that once I was permitted to come to look over the Paramount lot and, possibly,

* Dreiser was thirty-two years old when Edwin S. Porter's *The Great Train Robbery* (1903) appeared.

116

make some realistic suggestions in connection with pictures, I stayed three years.[2]

It was not until 1926, when he sold the silent film rights of *An American Tragedy* to Famous Players (later Paramount) for ninety thousand dollars, that Dreiser's troubles with Hollywood started. By 1930, the screen version of the novel was still unproduced. Pressure from moralists and super-patriots, Dreiser believed, was preventing the moviemakers from acting on their investment. Finally, the author began to exert some pressure of his own; he threatened to sue the studio for failing to produce the silent film treatment of *An American Tragedy*. Paramount assured Dreiser that the movie would shortly be produced and that in order to show their good will they would pay him fifty-five thousand dollars for the sound rights. Then, to further indicate that they meant business, the Paramount bosses, Jesse Lasky and B. P. Schulberg, arranged for Eisenstein and Ivor Montagu to adapt the novel.

Dreiser had first met Eisenstein in 1927 on a visit to the Soviet Union. In *Dreiser Looks at Russia*, published the following year, the novelist devotes five pages to a discussion of the Soviet film industry. With *Potemkin* (1925) and *The End of St. Petersburg* (1927) in mind, Dreiser asserts that Russian movies are "far superior to our American or Hollywood product." He remembers Eisenstein as "a most communicative and more communistically convinced person than any among such directors as I had met." Although he admired Eisenstein, Dreiser found the Russian's approach to art overly moralistic.[3] In *Sergei M. Eisenstein*, Marie Seton says that the director and the novelist "did not immediately understand each other. Dreiser was not the dynamic man [Eisenstein] had expected; his ponderous manner of speaking appeared slow and provincial for so great a literary figure. Patiently Dreiser tried to comprehend Eisenstein's new work; its imagery moved him to wonder, but it seemed most strange."[4]

When Dreiser learned that Paramount had engaged Eisenstein

to bring *An American Tragedy* to the screen, he was elated. The Russian later remarked of the novel: "Even though not beyond ideological defects, *An American Tragedy* . . . has every chance of being numbered among the classics of its period and place."[5] Paramount assured Eisenstein that he would have a free hand and that there would be no trouble from the censors.

The scenario completed, Eisenstein submitted it to the studio, confident that he had worked a "miracle."[6] Lasky and Schulberg, however, were disappointed. They would have preferred a "simple, tight whodunit about a murder . . . and about the love of a boy and a girl."[7] The production heads at Paramount had probably never seen Eisenstein's brand of "Soviet realism," or even so much as read Dreiser's novel. At any rate, the Hollywood businessmen rejected Eisenstein's treatment and looked elsewhere for an adaptation of *An American Tragedy.*

Since, as noted, Dreiser was not influenced by the technique of the movies little need be said about the various film versions of his novels in relation to their sources. A few observations, though, would appear to be in order. Eisenstein believed that the sound film would come into its own with the recording of the interior monologue. The Russian referred to Dreiser's description of Clyde's thought processes as "primitive rhetoric," adding that James Joyce could capture the stream of consciousness only by breaking "through the limits of [literature's] orthodox enclosure." For Eisenstein the motion picture alone "commands a means for an adequate presentation of the whole course of thought through a disturbed mind."[8] It seems to me that Eisenstein overlooks the fact that—"orthodox" or not—Joyce was able to project a deep level of interior monologue within the form of the novel. The Russian rightly ridicules the rolling-eyeball school of silent film acting as being too crude and simple to do justice to the fullness of Clyde's inner conflicts; and he is further correct in maintaining that the sound film offers much greater opportunities for character and thematic revelation than did the silent film. But Eisenstein deceives himself, and attempts to deceive the reader, about the

respective merits of film and fiction in regard to the internal mono-
logue. Although it is doubtful that a single page of *An American
Tragedy* can be considered as in the stream-of-consciousness tra-
dition (for one thing, the emphasis on verbal and syntactic distor-
tion found in *Ulysses* and *The Sound and the Fury* is missing from
Dreiser's novel), Eisenstein's handling of the interior monologue
reveals the inability of the film to compete even with the nine-
teenth-century novel in terms of psychological penetration.

In his discussion of Dreiser's "primitive rhetoric," Eisenstein
cites a mere nine lines from the two bulky volumes which com-
prise *An American Tragedy*. True enough, compared with the
subtleties of a Joyce or a Faulkner, Dreiser's analysis of Clyde's
inner turmoil while Roberta Alden drowns is indeed "old-fash-
ioned." However, what Eisenstein ignores is the cumulative power
of the ten pages covering the scene on the lake; from them he
extracts less than ninety words. The analyses packed into those
ten pages cannot be separated from the massive documentation in
the more than eight hundred pages of the entire book, and they far
exceed in complexity anything within reach of the sound film.
Each art form has its strength and limitation. Whatever the cam-
era can show, it can show much more powerfully than words can
describe. But film does not have the power to show everything;
film does not possess any equivalent for the analytical, connota-
tive, and intellectual range of language on a page. Eisenstein's
proposed treatment of *An American Tragedy* is excellent; only
hubris, however, could have led him to the conviction that the
potential of sound film had made it possible for him to improve
upon Dreiser's description of Clyde's tortured feelings during the
drowning scene.

Indeed, I would argue that Eisenstein's use of the soundtrack
results in a rhetoric even more "primitive" than that allegedly
employed by Dreiser. Once Clyde and Roberta are out on the
water, Eisenstein's script calls for the following: "Two voices
struggle within [Clyde]—one: 'Kill—kill!' the echo of his dark
resolve, the frantic cry of all hopes of Sondra and society; the

other: 'Don't—don't kill!' the expression of his weakness and his fears, of his sadness for Roberta and his shame before her. In the scenes that follow, these voices ripple in the waves that lap from the oars against the boat; they whisper in the beating of his heart. . . ."[9] Aside from the repetition of "Kill—kill!" and "Don't—don't kill!" in the lake scene and immediately afterward Eisenstein uses a total of fifty-six words, twenty-five of which are in the interior monologue. The scene as written is simple but powerful; perhaps one might even go so far as to say that in terms of film it could not be improved upon. Nevertheless, it cannot be affirmed that Eisenstein's visual imagery or sound effects constitute an advance in psychological penetration over Dreiser's prose.

Here is the passage from *An American Tragedy* which Eisenstein extracted from the scene on the lake as an example of Dreiser's awkward treatment (Clyde and Roberta are both in the water):

> You might save her. But again you might not! For see how she strikes about. She is stunned. She herself is unable to save herself and by her erratic terror, if you draw near her now, may bring about your own death also. But you desire to live! And her living will make your life not worth while from now on. Rest but a moment—a fraction of a minute! Wait—wait —ignore the pity of that appeal. And then—then— But there! Behold. It is over. She is sinking now. You will never, never see her alive any more—ever.[10]

And here is the parallel section from the Eisenstein scenario:

> Once more rings out the long-drawn booming cry of the bird. The overset boat floats on the surface of the water.
>
> Roberta's head appears above the surface.
>
> Clyde comes up. His face showing terrible fright, he makes a movement to help Roberta.
>
> Roberta, terrified by his face, gives a piercing cry and, splashing frantically, disappears under the water. Clyde is about to dive down after her, but he stops, and hesitates.[11]

There is nothing in Clyde's behavior here, and very little in the entire scene unit, that could not be conveyed by the silent film. The reader can decide for himself then about the relative merits of Dreiser's "primitive rhetoric" and Eisenstein's "inner monologue."

In December of 1930, Paramount gave *An American Tragedy* to screenwriter Samuel Hoffenstein and director Josef von Sternberg with instructions to make a ten-reel sound adaptation. Hoffenstein was not known as a gifted screenwriter; von Sternberg —while a man of some talent—was certainly no Eisenstein. In his own medium the director was by no means the equal of Dreiser in the fiction form. To make matters worse, von Sternberg was unsympathetic toward the novelist.

When Dreiser read the scenario of *An American Tragedy* (which Hoffenstein dispatched in five weeks) he furiously rejected it. In a letter dated March 10, 1931, the novelist informed Lasky that Hoffenstein and von Sternberg had "botched" the assignment. The chief defect in the script, as Dreiser saw it, was in characterization. Clyde was now an "unsympathetic . . . sex-starved 'drugstore cowboy'" rather than a "creature of circumstances." The web of causation, progressive and relentless in the novel, was destroyed in the adaptation because the script concentrated on the trial scene. Both technically and thematically the movie version lacked "imagination, inventiveness, and ingenuity." Finally, the author suggested that he himself prepare a script, with the assistance of H. S. Kraft, and that Chester Erskin be invited to direct the film.[12]

The Paramount brass were sufficiently upset to meet Dreiser at the airport when he arrived in California. On April 11th, the novelist told a reporter that Hollywood should be called "Hooeyland," and that the Hoffenstein-von Sternberg scenario should be retitled *A Mexican Comedy*.[13] On more than one occasion, Dreiser threatened Paramount with legal action if they persisted in destroying the integrity of his novel. Writing to Harrison Smith on April 25th, the author argued that the movie people had no "right

to change the structure, or . . . ideographic plan of the book so that when shown it will convey to the public a characterization of the work which is not consistent with it nor with my own intellectual and artistic structure as therein manifested." No doubt Dreiser was well aware that a ten-reel film could not pretend to duplicate a novel the length of *An American Tragedy*; but he apparently believed that the film-makers, by telescoping the basic structure, could remain faithful to the theme of the original. The novelist asked Smith to join a group of responsible men who were to view and judge the merits of the Paramount release.[14]

On June 15, 1931, Paramount screened the von Sternberg version of *An American Tragedy* for the eighteen-man jury and twenty-man sub-jury selected by Dreiser. The majority of critics assembled rejected the adaptation, thus upholding the author's condemnation of the film. Dreiser then took Paramount to court on July 22nd; however, Justice Graham Witchief denied the writer's claim. On August 5th, Dreiser wrote to Louise Campbell: "I lost my suit—but not exactly. Actually I made them add seven scenes—fore and aft—seven hundred and fifty feet of screen. They came here and begged me to endorse it in its new form. I could have called off the suit and taken the credit but I chose not to do so. And I'm glad I didn't."[15] When the movie was finally released about a month later, the reviewer for *The Nation*, Alexander Bakshy, called it an "emasculated Dreiser," deploring its hollow characterization and lack of social significance.[16]

As W. A. Swanberg suggests in his biography of the writer, Dreiser was the first important literary figure to challenge the studios in respect to their grossly insensitive attitude towards adaptations.[17] One can only regret that since 1931 so few writers have showed the courage, integrity, and persistence displayed by Dreiser in his struggle with Hollywood over *An American Tragedy*.

Six years after the novelist's death, Paramount tried again with a screen version of the book. This time the movie was called *A Place in the Sun* (1951). Whatever its title, there seems little

doubt that Dreiser himself would have dismissed it as another *A Mexican Comedy.* In *Fun in a Chinese Laundry,* Josef von Sternberg defends his treatment of Dreiser's novel by saying: "I eliminated the sociological elements, which, in my opinion, were far from being responsible for the dramatic accident with which Dreiser concerned himself."[18] George Stevens, who directed *A Place in the Sun,* is not (so far as I know) on record as saying the same thing, but his film is similarly lacking in meaningful social criticism.

Neither picture shows a willingness to criticize American society as Dreiser does in the novel. In 1931, with a depression throughout the land, sympathy was for the underdog—even if society itself went uncriticized; in 1951, with affluence and McCarthyism everywhere, poor girls were unfashionable and the values of American society were even more sacrosanct. Andrew Sarris is probably right, though, when he says that von Sternberg's technique is closer to Dreiser's own objective method than Stevens's arty, romantic, and subjective pictures.[19] What would Dreiser have thought of Clyde, played by Montgomery Clift in *A Place in the Sun,* going to the electric chair to the accompaniment of romantic background music and with a superimposed shot of Elizabeth Taylor's face in soft-focus floating dreamily above his head? In Dreiser's uncompromisingly realistic novel, Clyde has other things on his mind: "There it was—at last—the chair he had so often seen in his dreams—that he so dreaded—to which he was now compelled to go. He was being pushed toward that—into that—on—on—through the door which was now open—to receive him—but which was as quickly closed again on all the earthly life he had ever known."[20]

The Stream-of-Consciousness Novel and Film, I—James Joyce

Almost all writers from Joyce on have been influenced by movies. . . .

—Pauline Kael

I

It is almost a critical commonplace to link Joyce's name with the movies, and more than one commentator has called attention to the cinematic elements in A *Portrait of the Artist as a Young Man* (1916), *Ulysses* (1922), and *Finnegans Wake* (1939). Joyce saw films occasionally in Paris and elsewhere on the Continent between 1902 and 1909, and he was fascinated by them. In fact, the author was so taken by the new invention in 1909 that he persuaded a Trieste movie syndicate to open theaters in Ireland, commencing with Dublin, and to hire him as their advance agent. Joyce was guaranteed ten per cent of the profits. As Herbert Gorman remarks: "For a brief period Joyce the businessman superseded Joyce the artist."[1] The Volta Theater, located at 45 Mary Street, opened on December 20, 1909 with a program of Italian films—*The First Paris Orphanage, The Tragic Story of Beatrice Cenci* and the like—which were well-received by the newspaper reviewers. But it is difficult to see how Joyce (the question of the medium's technical possibilities to one side here) could have been

greatly impressed by the fare; at any rate, after ten days of super-
vision he left the Volta in charge of an associate and returned to
Trieste. Eventually—thanks in large measure to the novelist's ne-
glect of the operation—the Dublin theater failed, and Joyce real-
ized little financial profit from his venture into cinema.

Nevertheless, the writer's exposure to movies excited him and
became not the least of the influences on his technique. By the
twenties Joyce was a regular patron of the film theaters, visiting
them in the late afternoon or early evening when his mind was
tired from working all day. Morley Callaghan recalls a visit with
Joyce in which the latter began discoursing enthusiastically about
films. "As he talked," notes Callaghan, "I seemed to see him in a
darkened theater, the great prose master absorbed in camera tech-
nique, so like the dream technique, one picture then another flash-
ing in the mind. Did it all add to his knowledge of the logic of the
dream world?"[2]

One man, Sergei Eisenstein, saw clearly the relationship be-
tween Joyce's technique in *Ulysses* and the montage experiments
of the various Russian film directors. Eisenstein met Joyce in
1930, the year after the encounter described by Callaghan, and
the two men discussed literature and the movies. "When Joyce
and I met in Paris, he was intensely interested in my plans for the
inner film-monologue, with a far broader scope than is afforded by
literature," says Eisenstein. "Despite his almost total blindness,
Joyce wished to see those parts of *Potemkin* and *October* that,
with the expressive means of film culture, move along kindred
lines."[3] For Eisenstein filmic techniques such as the flashback, the
fade-in, fade-out, and focusing were natural mind processes; hence
Joyce's interior monologue was bound to resemble the film direc-
tor's montage work. Even later in life Eisenstein informed a group
of film-makers: "We must study Joyce."[4] The Russian felt that
film-makers could capture the flow of man's inner world in a more
concrete and satisfactory form than could the novelist. "The sub-
ject must not be reproduction of man thinking as in *Ulysses*,"
Eisenstein explained to the drama critic Brooks Atkinson. "This is

where creation in film begins. It must not be representation. It is wrong to think of cinema as drama."⁵ But this was *after* Eisenstein had attempted to sway Joyce into permitting a Russian movie version of *Ulysses*. Although the novelist was intrigued by the prospect of seeing Leopold Bloom on the screen, he managed to resist the temptation. "Following these meetings," according to Eisenstein's biographer, "Joyce told his friend Jolas, the editor of *transition*, that if *Ulysses* were ever made into a film, he thought that the only men who could direct it would be either Walter Ruttman the German, or Sergei Eisenstein the Russian."⁶ Ruttman's *Berlin* (1927), like Joyce's *Ulysses*, is a succession of images of a large city between dawn and midnight. The German director's "Dream of the Hawks" sequence in *Siegfried* (1924) could not have failed to impress the writer who was already at work on *Finnegans Wake*.

Warner Brothers also asked Joyce to allow them to make a motion picture version of *Ulysses*. "Officially," says Richard Ellmann, Joyce "discountenanced the idea (though he had once endorsed it), on the ground that the book could not be made into a film with artistic propriety."⁷ Joyce's friend, Stuart Gilbert, attempted—without opposition from the novelist—scenarios for both *Ulysses* and the "Anna Livia Plurabelle" section of *Finnegans Wake*; the poet Louis Zukofsky also tried his hand at a scenario of *Ulysses*. But it was not until 1967 that Joyce's two masterpieces appeared for the first time on the screen.

II

Somewhere Joyce once referred to the corrected galleys of *Ulysses* as "mosaics." A. Walton Litz has made a systematic examination of Joyce's method of construction in *Ulysses* and *Finnegans Wake*, and he has been able to show that the writer's use of the word "mosaics" was indeed accurate.⁸ Joyce did not compose *Ulysses* in sequential order. After first designing the general

outline of his book, the novelist then proceeded to develop now this portion of the work, now that, until the plan was finally realized in the form of a rough first draft. This is, of course, precisely the method that a film director employs in making a picture. Scenes shot in a specific location will, in the completed film, be intercut with scenes shot in another time and place; in other words, after all the shooting is finished the director and/or film editor collects the "mosaics" and assembles them in the proper sequence. It seems fitting that in his most cinematic novel Joyce should have adopted a method of construction which has so much in common with the art of making films.

The structure of *Ulysses*, with its eighteen parts—each of which has its own style and characteristic rhythm—is "edited" like an Eisenstein film, in which various kinds of pictorial movement create an expressive variety of formal patterns. It is no accident that both Joyce and Eisenstein, as heirs to the nineteenth-century tradition of Symbolism, aimed for musical effects in their respective arts. *Ulysses* has frequently been discussed in terms appropriate to music. Critics, for example, have found in the book a theme, a counter-theme, a meeting, a development and a finale. Similarly, *Potemkin*—which, according to its creator, fascinated Joyce—has been compared in its three major movements to a symphony. Apparently musical forms seemed promising to Joyce and Eisenstein because (among other reasons) the stream of consciousness, like the motion picture, is a flow of images characterized by a variable pace or tempo.

And speaking of images, Joyce projects a far greater number of them in *Ulysses* than do most fiction writers. A good example is the last page of the novel in the Molly Bloom soliloquy: ". . . O and the sea the sea crimson sometimes like fire and the glorious sunsets and the figtrees in the Alameda gardens yes and all the queer little streets and pink and blue and yellow houses and the rosegardens and the jessamine and geraniums and cactuses. . . ."[9] Such imagery, however fluid, would not in itself have fascinated Eisenstein, who placed so much emphasis on the juxtaposition of

images. *Ulysses* is filled with the rapid, startling cutting that the Russian director made famous on the screen. In the "Lestrygonians" section of the novel, as Leopold Bloom recalls romantic moments from his past sexual life, Joyce twice ironically intercuts: "Stuck on the pane two flies buzzed, stuck" (p. 173) and "Stuck, the flies buzzed" (p. 174). The juxtaposition here of beauty and ugliness—or at any rate, of the human and the animal —resembles the sundry visual metaphors used by Eisenstein. In *Ten Days That Shook the World* (1928), as Alexander Kerensky ascends the magnificent staircase of the Czar's Winter Palace, Eisenstein intercuts shots of nearby statues which ironically expose the man's greed for power; afterward, inside the palace, shots of Napoleon alternate with pictures of Kerensky posturing fatuously. *Ulysses* and the films of Eisenstein reveal many other instances of what the latter called a "montage of attractions."

It is no exaggeration to say that *Ulysses* contains equivalents for almost every conceivable filmic technique. Consider the following interior monologue of Leopold Bloom:

> Walk on roseleaves. Imagine trying to eat tripe and cowheel. Where was the chap I saw in that picture somewhere? Ah, in the dead sea, floating on his back, reading a book with a parasol open. Couldn't sink if you tried: so thick with salt. Because the weight of the water, no, the weight of the body in the water is equal to the weight of the. Or is it the volume is equal of the weight? It's a law something like that. *Vance in high school cracking his fingerjoints, teaching. The college curriculum.* (p. 71)

The words that I have italicized represent the point at which— thanks to Bloom's association of ideas—Joyce cuts to the character's store of memories for an answer to his scientific problem. We might say that in such instances Joyce is crosscutting between memories. But there are other times when the author cuts back and forth between Bloom's interior monologue—in which he seems lost in the past—and present occurrences. At a funeral, for example, Bloom remembers his dead son, Rudy:

. . . My son inside her. I could have helped him on in life. I could. Make him independent. Learn German too.
—Are we late? Mr. Power asked.
—Ten minutes, Martin Cunningham said, looking at his watch.
Molly. Milly. Same thing watered down. Her tomboy oaths.
. . . (p. 88)

Observe that Joyce not only cuts from within to without, but that Bloom (as in the previous example cited) also cuts from Rudy to Molly to his daughter, Milly, in the course of his ruminations.

Frequently, in his attempt to do justice to the full range of mental activity, Joyce slows the tempo of Bloom's interior monologue, abandoning quick cuts for dissolves in which one image seems superimposed upon another:

> Cityful passing away, other cityful coming, passing away too: other coming on, passing on. Houses, lines of houses, streets, miles of pavements, piledup bricks, stones. Changing hands. This owner, that. Landlord never dies they say. Other steps into his shoes when he gets his notice to quit. They buy the place up with gold and still they have all the gold. Swindle in it somewhere. Piled up in cities, worn away age after age. Pyramids in sand. Built on bread and onions. Slaves Chinese wall. Babylon. Big stones left. Round towers. Rest rubble, sprawling suburbs, jerrybuilt, Kerwan's mushroom houses, built of breeze. Shelter for the night. (p. 162)

If space permitted one could easily show how Joyce also approximates slow-motion effects in *Ulysses* (perhaps the Molly Bloom soliloquy would be the best example here[10]), as well as fast-motion effects (as in the expressionistic Nighttown sequence). Almost every interior monologue in the book could qualify as a novelistic equivalent of a close-up, with flashbacks of varying length (some a mere sentence or two, others twenty pages) introduced, as already noted, by cuts, fades and dissolves.[11]

The "Aeolus" episode of *Ulysses*—which consists of sixty-three short sections, each headed by a newspaper caption—represents a

sustained use of crosscutting. But the section that has been cited more often than any other as an example of Joyce's cinematic imagination is "The Wandering Rocks" episode. Covering less than thirty-six pages, the structure of this part is split up into nineteen scenes. Robert Humphrey regards "The Wandering Rocks" as a "superb example of space-montage"; that is, a montage in which time remains fixed while the spatial element changes—or the exact opposite of a "time-montage," where space remains fixed and the interior monologue moves freely in time.[12] Though the overall structure of the episode can be described as an instance of space-montage, Joyce occasionally uses time-montage, too.

The novelist's chief problem in "The Wandering Rocks" was to find some way to impose unity on the episode and to make clear the simultaneous enactment of the diverse events depicted, all of which occur between three and four o'clock in the afternoon. In the first scene, which follows Father Conmee about the city, reference is briefly made to a crippled sailor; later, in the third section, the same one-legged man becomes the center of attention. The two scenes, though unified by the person of the sailor, do not clearly correspond in time. Simultaneity *is* achieved, however, when, in the first scene, Joyce reports: "At Newcomen bridge Father Conmee stepped into an outward bound tram for he disliked to traverse on foot the dingy way past Mud Island" (p. 219)—and then, in the section immediately following, which focuses on Corny Kelleher, the novelist notes: "Father John Conmee stepped into the Dolymount tram on Newcomen bridge" (p. 221). Also in this second section, Joyce observes: "Corny Kelleher sped a silent jet of hayjuice arching from his mouth while a generous white arm from a window in Eccles street flung forth a coin" (p. 222); while in the third section, on the same page, the novelist reports: "A plump bare generous arm shone, was seen, held forth from a white petticoat—bodice and taut shiftstraps. A woman's hand flung forth a coin over the area railings." Is there a better way to manage a cross-section view of a subject than through crosscut-

ting? Provided the writer has, like Joyce, found a way of making his material cohere, a cinematic technique would seem to be especially well-suited for projecting a panoramic view of a great city.

III

In 1961 the late Jerry Wald purchased the screen rights to *Ulysses* for seventy-five thousand dollars, with the intention of having Jack Cardiff direct the adaptation. When Joseph Strick, who had not been able to outbid Wald for Joyce's novel, asked the producer if he could direct the movie instead of Cardiff, Wald is said to have replied: "I haven't time to think about that—I'm too busy with *Peyton Place*"! After Wald's death, Darryl F. Zanuck considered filming the novel too; he finally decided, though, that it would not pass the censors. Strick later told a reporter: "I got my grubby little fists on the book at last." The year was 1964. Shooting on the film did not begin, however, until two years later. No serious concessions to the censors were ever even contemplated. Strick and Fred Haines did the scenario, but the dialogue (according to Strick's own estimate) is ninety-nine per cent Joyce. At one time the producer weighed the possibility of making a trilogy of the film version of Joyce's long book; however, the cost of such an undertaking, not surprisingly, was prohibitive. Although *Ulysses* was shot on location, the action was updated from 1904 to the present, since it would have cost too much to re-create the vanished Dublin of Joyce's young manhood. The completed film was produced for about a million dollars, a mere pittance by Hollywood standards.

From the beginning Strick was well aware of Joyce's cinematic technique. He points out that whereas the average movie requires about three hundred camera set-ups, *Ulysses* demands over two thousand. "The task is to construct a set of images worthy of being seen in the same room while those words are being heard,"

said Strick. "Our obligation is to make a film good enough for people who have read the book," he added. "Our opportunity is to create an entirely new experience for those who have not."*

How well did Strick succeed in realizing his twofold intention? According to the majority of critics—not very well. Ads for the movie proclaimed: "This film was made without compromise— exactly as Joyce wrote it." *Exactly?* Joyce's great book runs to seven hundred and sixty-four pages; Strick's film version is over in a hundred and forty minutes. By necessity the adaptors have focused on those scenes in the novel—such as Stephen's stroll on the beach, Bloom's attendance at Dignam's funeral, his visit to Kiernan's pub, his encounter with Stephen, the Nighttown sequence, and Molly's soliloquy—which can be dramatized for the camera-eye. But, alas, even such scenes are only pale reflections of the analogous sections in the novel. As Richard Ellmann, who is perhaps the foremost authority on Joyce, says:

> The film begins well, with a clever counterpoint between the first three chapters about Stephen and the next three about Bloom. But the rapidity of scene changes becomes troublesome, as if the audience were repeatedly being told, "Well, you get the idea," and were then bundled off to another part of Dublin. What in Joyce is deliberately strolling and pointillistic becomes breathless and kaleidoscopic. The sensation of being treated to excerpts is obtrusive. As for the analogy with the *Odyssey*, which might offer the principal avenue by which the film could do what Joyce could not do, this is dropped except for the black patch worn by the Cyclopian Citizen. The epic contracts into a domestic comedy.
>
> (*New York Review of Books*; June 15, 1967)

The viceregal procession, the scene in the library, the man garbed in the macintosh, the brother of Parnell, the singing barmaids—all had to go. Not only are whole blocks of structure and the mytho-

* Strick's comments on the making of *Ulysses* can be found in an interview he gave to Stephen Watts, which was published in *The New York Times* on October 2, 1966.

logical parallels eliminated by Strick, but also much of the complexity of character is stripped away from the leading actors in the piece.

Bloom (played by Milo O'Shea), for instance, is seen mostly from the outside. "To deprive us of Bloom's monologue, as the script almost totally does," Ellman observes, "is to leave out nine-tenths of Bloom, keeping only the inane residuum." The interest in popular science which Bloom manifests throughout the novel is almost nonexistent in the film; similarly, Bloom's obsession with his son Rudy's death is very much de-emphasized. Someone has counted forty references to Rudy in the book, while in the film there are about ten. The unfortunate result is that the man who won the Ascot race—twenty references in the book, and about the same number in the movie—looms larger than Rudy!

Stephen (played by Maurice Roeves) is also a simpler and less interesting character in the film than he is in the book. His views on aesthetics disappear, together with much of his snobbery, vainglory, and rebelliousness. On the other hand, Molly's soliloquy (as several critics have pointed out) seems disproportionately long in the total structure of Strick's *Ulysses.* Commenting on Barbara Jefford's handling of the soliloquy, Ellmann says:

> It is not her fault that the monologue is not really translated into film, or that the audience is taken by verbal rather than by visual surprise. The visual images, which include a few shots of Lt. Gardner, of Gibraltar, and, gratuitously, of Indian nature goddesses, catch little of the slide and drift of the words. Molly tends to blend all her gentleman friends, including her husband, into a single, rather unsatisfactory, composite male, and one would expect some radical montage . . . But little is offered, and, curiously, the film is linear whereas the words leap backwards and forwards and together.

The attempt to make a movie version of *Ulysses* was doomed to failure. Although Joyce's novel is full of techniques comparable to those employed on the screen, the techniques are *verbalized* in the book or exercised at a linguistic-intellectual level beyond the

capacity of a movie camera to record. Unless we get inside the mind—*deep* inside the mind—of Joyce's characters, we do not know them. Cinema is unsurpassed at rendering the surfaces of things; when required to penetrate the complex psyche of a character, however, it is sadly inferior to what can be done by the stream-of-consciousness novelist. The film treatment of *Ulysses* is not only unable to project satisfactorily the full range of interior life in Joyce's characters, it also fails to suggest the abstract dimensions of the book. Aside from the already-mentioned Homeric parallels, Strick's movie treatment also lacks the sense that there is an immense intellect "within or behind or beyond or above his handiwork, invisible, refined out of existence, indifferent, paring his fingernails" (as Stephen puts it in that famous discourse on aesthetics in *A Portrait*[13]). Perhaps a more gifted adaptor than Strick might have done a better job of finding images to compare with Joyce's words and of discovering ways to "get at" the intellectual meat of the book; but no adaptor—however talented— would have really "succeeded," given the inherent limitations of the medium, in making a movie that could stand comparison with the original.

Since Strick's adaptation has no real existence as a film, it fails, not only in its attempt to be "good enough for people who have read the book," but also in its endeavor "to create an entirely new experience for those who have not." Most critics were of the opinion that viewers unfamiliar with the novel would not understand the screen version and hence would be bored by the proceedings. Although Strick deserves an "A for effort," the fact is that *Ulysses* on film remains, at best, mediocre.

IV

In *Finnegans Wake*—contrary to the statements of some critics[14]—Joyce manifests very little cinematic imagination. Narrative structure in *Finnegans Wake*, unlike that in *Ulysses*, seems

to vanish entirely. True, Joyce fashions a cyclic form—the fragment of a sentence which ends the book completes the sentence which opens it—and circular forms have been much employed by film makers; however, Joyce's manipulation of the circular form is inseparably linked to his complex view of experience, a view which is highly abstract and uncinematic. The four sections of *Finnegans Wake*, which are in turn partitioned into a number of smaller sections, parallel Giambattista Vico's philosophy of history. Yet even this intellectually involved but finally tenuous scaffolding is effaced by the author's experiments with language.

The opening page of *Finnegans Wake* should plainly show that Joyce's last masterpiece is very much more difficult in style than the by no means simple *Ulysses*:

> riverrun, past Eve and Adam's, from swerve of shore to bend of bay, brings us by a commodius vicus of recirculation back to Howth Castle and Environs.
>
> Sir Tristram, violer d'amores, fr' over the short sea, had passencore rearrived from North Armorica on this side the scraggy isthmus of Europ Minor to wielderfight his penisolate war: nor had topsawyer's rocks by the stream Oconee exaggerated themselse to Laurens County's gorgios while they went doublin their mumper all the time: nor avoice from afire bellowsed mishe to tauftauf thuartpeatrick: not yet, though venissoon after, had a kidscad buttended a bland old isaac: not yet, though all's fair in vanessy, were sosie sesthers wroth with twone nathandjoe. Rot a peck of pa's malt had Jhem or Shen brewed by arclight and rory end to the regginbrow was to be seen ringsome on the aquaface.
>
> The fall (bababadalgharaghtakamminarronnkonnbronntonnerronntuonnthunntrovarrhounawnskawntoohoohoordenenthurnuk!) of a once wallstrait oldsparr is retaled early in bed and later on life down through all christian minstrelsy. The great fall of the offwall entailed at such short notice the pftjschute of Finnegan, erse solid man, that the humptyhillhead of himself.promptly sends an unquiring one well to the west in quest of his tumptytumtoes: and their upturnpikepointandplace is at the knock out in the park where oranges

have been laid to rest upon the green since devlinsfirst loved livvy.[15]

Most critics have pointed out that Joyce's writing here and elsewhere in *Finnegans Wake* makes its appeal—even more than it does in the writer's other work—not to the eye but to the ear. One explanation for Joyce's increasing stress on sound might be his growing blindness. A second explanation would involve discussion of point of view. Eisenstein believed, as noted previously, that the movement of the mind resembles the editing of film; and in my analysis of *Ulysses* I tried to show how skillfully Joyce uses cinematic devices such as the fade and the dissolve to project the stream of consciousness. In *Finnegans Wake,* which covers one night and a dawning, Joyce employs a single dreamer; but that dreamer, traveling unencumbered in time, takes on a number of identities as he descends into the area of Jung's "collective unconscious." Here symbols are overlaid by symbols, and every word seems to possess multiple meanings. According to Melvin Friedman, "the ambiguity attached even to the identity of the dreamer makes the task of treating it as a stream-of-consciousness novel almost impossible."[16]

In *Ulysses,* Joyce edits the action back and forth between the conscious and the unconscious mind; he also crosscuts between subjective and objective perspectives. In *Finnegans Wake,* however, only the dream world, or the domain of the unconscious, is on view; similarly, in the later book there is no objective reference or point of view—there is only the subjective. Hence Joyce might have felt that there was little need for him to use cinematic techniques in a work which, unlike *Ulysses,* did not really require them. Perhaps that is why Eisenstein, speaking at the Institute of Cinematography in 1934—and considering Joyce's work-in-progress on *Finnegans Wake* strictly in relation to the motion picture— dismissed it as being "retrogressive."[17]

The brave soul to assume the difficult task of bringing Joyce's most literary book to the screen was Mary Ellen Bute. In an

article which appeared in 1954, Miss Bute suggested why she had initially been attracted to the author of *Ulysses* and especially *Finnegans Wake*. At the time she had been experimenting with electronic films, or "abstronics" (a Joycean portmanteau word for abstractions and electronics), in the hope that eventually she could "manipulate light to produce visual compositions in time continuity much as a musician manipulates sound to produce music."[18] Like Joyce, Miss Bute was originally interested in the drama. When she witnessed a performance of Mary Manning's *Passages From Finnegans Wake*, the film-maker decided to create a movie version of the book and to get Miss Manning to do the scenario.

Obviously, the filming of *Finnegans Wake* presented enormous difficulties. "We cut down the long descriptive and expository passages to almost nothing," Miss Bute informed Gretchen Weinberg in an interview, "and imitated Joyce's method of collapsing time and space, where Moses and Napoleon can appear in the same sequence." As Miss Bute sees it, *Finnegans Wake* "is primarily a visual work"—though she quickly adds that the master's language, even where it is supposed to be "visual," poses special problems for a film adaptor. To circumvent such obstacles, Miss Bute decided to use subtitles and to "supply the audience with a libretto, including the dialogue and a synopsis of the story. We hope it will affect them as an opera would: after seeing it once and reading the libretto, you go back again to study it." Music plays a vital role in the film. As Miss Bute explains it:

> In a job like this, it's essential to get at the essence of the material you're working with. It's not a film where the presentation is solely a visual one. My abstract films were based on the relation of music, sound, color and movement but in *Finnegans Wake* it's the literary and intellectual idea that you try to combine with the visual and musical. The treatment is realistic because when you begin refracting images through a prism, for instance, as Joyce does with words, it becomes too elaborate and the basic idea is lost. It will do the book a better

service if the film's simple than something that's extremely far out or "experimental." *The film is not a translation of the book but a reaction to it.* It represents my point of view, naturally, but it's as much a James Joyce film, I hope, as a Mary Ellen Bute film.[19]

The film version of *Finnegans Wake* had its premiere at the University of Minnesota in 1965, on the eighty-third anniversary of Joyce's birth. Two years later it opened to the general public in New York City. Miss Bute's film begins with a quotation from Joyce himself on the artist's necessity to create a new language for a new subject matter. The quotation is in subtitles, as is a brief explanation by the adaptors of Joyce's aims in *Finnegans Wake*. As Miss Bute points out in the interview referred to above, the strategy here is to prepare the movie audience for the unusual subject matter of the film. The subtitles are replaced by a long shot of a Dublin river, and this is followed by a close shot of the water running rapidly. Dissolve then to the dreamer and his wife in bed. After a moment we hear the words which open Joyce's book, while on the screen we see the words reproduced as subtitles below a superimposition of the river and the dreamer. Slow motion is employed to capture the dreamer's "fall," as he tumbles out of bed. We watch Finn crashing noisily through cosmic space, his form splitting into three persons, while shots of a building collapsing are intercut with the fall. Finally, Finn is stretched out in his coffin, the film's credits appear, then disappear—and *Finnegans Wake* proceeds, commencing with a scene of the celebrants at the dreamer's wake.

The strength and weakness of Miss Bute's movie become apparent before much viewing time elapses. Without the subtitles, the audience, it is true, would miss much of the significance of Joyce's language; all the same, the duplication of speech and subtitles seems (even more than is usually the case) awkward and annoying. Like a foreign film that is shown with translation subtitles, *Finnegans Wake* on the screen compels the viewer to do three things: watch the physical action, listen to the soundtrack,

and read. The sight versus sound, or picture versus language, problem is much greater in *Finnegans Wake* than in *Ulysses* because of Joyce's extremely difficult style, which requires more than the usual amount of intellectual perception and concentration, and because the words are frequently so beautiful or so witty that the audience takes infinitely more delight in them than in the visual properties of the film. Only a purist would deny that *at times* it is perfectly proper for language to assume a commanding position in a film; but only a person thoroughly confused about the essential nature of the medium would fail to see that such a struggle between sight and sound—much less between sight and sound-reading—if carried on throughout the length of the action could result in nothing less than a filmic catastrophe. Occasionally, Miss Bute's *Finnegans Wake* strikes a happy balance between picture and language (the scenes at the shore involving the Wagnerian motif seem to me to be especially memorable), but on the whole the movie is an artistic enterprise divided against itself.

Finnegans Wake as a film is most impressive when it moves rapidly from image to image, when it plays with our customary notions of time and space, in an effort to approximate pictorially the flow and rhythm of the original. A quick cut from Isabel-Isolde in the countryside to Mrs. Earwicker (played by the same actress, Jane Reilly) outside the pub in her wedding dress is a filmic equivalent of the sleeping mind's ability to ignore "reality" factors. Miss Bute's decision not to experiment too much in her adaptation was probably a mistake. Her use of animation, slow motion, stills, rapid motion, stop-action, negative images, documentary footage juxtaposed to fictional action, and the like, are—on the whole—the most interesting portions of the film. It would have been far better for Miss Bute to have erred on the side of the cinematically experimental than to have committed the mistake of shooting a highly theatrical film version of a great novel.

This is exactly the impression given by most of the Bute-Manning version of *Finnegans Wake*. The credits tell us that the movie is based on Miss Manning's dramatization of Joyce's book, but the

structure of the film differs considerably from the form of the play. How then account for the fact that so much of *Finnegans Wake* on the screen seems stagy? The explanation probably lies in the fact that Joyce's book, like a play by Shakespeare, appeals more to the ear than to the eye. Some of the scenes in the film—such as the one in the pub and the one in the music hall—seem to go on and on; in short, they are far too static or theatrical for effective screen action. While Miss Manning's dramatic imagination is partly to blame for the film's failure, it is important to note that oddly enough the two scenes just referred to last much longer on the screen than the same passages in the play. Whatever the explanation for this unfortunate situation, the fact remains that in such scenes language establishes complete suzerainty over the pictorial. Miss Bute was obviously aware of the problem, for in such scenes she is driven to the all too familiar expedient of moving her camera about in an attempt to impose a spurious filmic dimension on material that remains essentially uncinematic. Meaningless high angle shots of the characters in the pub, or a shot of Earwicker and his sons seated on the floor and photographed through the legs of a table and chair, point up the problem, inasmuch as such shots contribute nothing to the expressive quality of the scene. The theatrical portions of the movie clash with the more filmic sequences, thus producing an undesirable incongruity in perspective.

Any adaptation must deal with the fact that the writer's "essential vision" is almost inextricably bound to the form and matter of the original. With *Finnegans Wake* the adaptor's problem is greater than usual. As Melvin Friedman has remarked: "One of the peculiarities of Joyce's writing evident after *Ulysses*, is that one can scarcely understand a single page without knowing the rest of the book."[20] How, then, could a film lasting no more than ninety-five minutes hope to convey the "essence" of *Finnegans Wake*, which extends over six hundred pages and is incredibly complex linguistically and intellectually? Although Miss Bute is probably a more knowledgeable film-maker than Joseph Strick,

her *Finnegans Wake* is less satisfactory than his *Ulysses*, simply because the later book is more difficult—or rather, more *impossible*—to film than the earlier, more "cinematic," novel. Whether one regards Miss Bute's *Finnegans Wake* as a "translation" or merely as a "reaction"—and the same is true of Strick's *Ulysses*—one's final judgment is much the same: Joyce's work is not for filming.

The Stream-of-Consciousness Novel and Film, II—Virginia Woolf

[T]*he film-maker has enormous riches at his command. The exactitude of reality and its surprising power of suggestion are to be had for the asking . . . If into this reality he could breathe emotion, could animate the perfect form with thought, then his booty could be hauled in hand over hand. The past could be unrolled, distances annihilated, and the gulfs which dislocate novels (when, for instance, Tolstoy has to pass from Levin to Anna, and in so doing jars his story and wrenches and arrests our sympathies) could, by the sameness of the background, by the repetition of some scene, be smoothed away.*

—Virginia Woolf

I

Unlike Joyce, Virginia Woolf seemed to have had very little genuine respect for the movies of her time. (Less than two months before her death in 1941, Mrs. Woolf wrote in her diary: "We have been to Charlie Chaplin. Like the milk girl we found it boring."[1]) This difference in the attitude of the two writers can be explained, at least in part, on the basis of their social backgrounds. Joyce came from a seedy middleclass environment and

from a family with no claim to literary sophistication; Mrs. Woolf was born into a well-to-do family, whose head was Leslie Stephen, editor of the *Dictionary of National Biography* and the *Cornhill Magazine*. It is well to recall that the movies began by appealing to uneducated working-class people. As Alfred Hitchcock, remarking on Mrs. Woolf's generation, points out: "No well-bred English person would be seen going into a cinema; it simply wasn't done. . . England is strongly class-conscious. . . . Prior to 1925, English films had been very mediocre; they were mostly for local consumption and were made by bourgeois." It was not until after 1925 that some young college students began to take a serious interest in the art of the film. "Out of this was born the London Film Society, which put on special shows on Sundays for a coterie of intellectuals."[2] Virginia Woolf's various observations on the movies over the years more or less reflect the changing attitudes of her class, though, as I have suggested, she never became a cineaste.

Perhaps Mrs. Woolf's first public reference to movies and literature appears in a review she wrote entitled "The 'Movie' Novel" for the *Times Literary Supplement* (August 29, 1918), in which she attacks Compton Mackenzie's *The Early Life and Adventures of Sylvia Scarlett*. Recalling to her readers' minds such classic characterizations of the past as Moll Flanders and Tom Jones, Virginia Woolf says:

> Compared with Mr. Mackenzie's characters they are a slow-moving race. . . . But consider how many things we know about them . . . without a word of description perhaps, but merely because they are themselves. We can think about them when we are no longer reading the book. But we cannot do this with Mr. Mackenzie's characters; and the reason is, we fancy, that though Mr. Mackenzie can see them once he can never see them twice, and, as in a cinema, one picture must follow another without stopping, for if it stopped and we had to look at it we should be bored. Now, it is a strange thing that no one has yet been seen to leave a cinema in tears. The cab horse bolts down Haverstock-hill and we think it a good

joke; the cyclist runs over a hen, knocks an old woman into the gutter, and has a hose turned upon him. But we never care whether he is wet or hurt or dead. So it is with Sylvia Scarlett and her troupe. Up they get and off they go, and as for minding what becomes of them, all we hope is that they will, if possible, do something funnier next time. No, it is not a book of adventures; it is a book of cinema.[3]

For Mrs. Woolf, who was intent as a novelist on exploring the inner world of man, the movies were ludicrously external and superficial, and hence a poor model for fiction writers. Like George Bernard Shaw, who believed that it was a waste of time for the cinema to show "gulls and cliffs and all that,"[4] Virginia Woolf was unable or unwilling in 1918 to grant the unique powers of the new medium. Her bias in favor of the subjective approach to experience is clearly brought out in her essay, "The Movies and Reality," which appeared in the *New Republic* on August 4, 1926, or one year after the publication of *Mrs. Dalloway.* Though her later article suggests a new respect for film, Mrs. Woolf's remarks leave little doubt that her hopes for the medium reside chiefly in what it might become and not to any great extent in what it has so far accomplished.

She begins her essay in an ambivalent fashion by saying that movies appeal to the savage in man—but then she adds that the same kind of savage once awaited the advent of Mozart. She concedes that film is an art because it permits the audience to view time past with detachment—but then adds that "the picture-makers seem dissatisfied with such obvious sources of interest as the passage of time and the suggestiveness of reality." What really disturbs Mrs. Woolf, one suspects, is the fact that the movies do not seem to be very much concerned with the kind of "reality" that interests *her.* Nevertheless, Virginia Woolf argues, the film-makers are right to forge their own form of art; and for that reason, all literary adaptations should be eschewed. This thought prompts her to ridicule the film treatment of *Anna Karenina*: "the brain knows Anna almost entirely by the inside of her mind—her

charm, her passion, her despair. All the emphasis is laid by the cinema upon her teeth, her pearls, and her velvet." Whereas Tolstoy is able to create character from the inside, the movies photograph character solely from the outside. Like Shakespeare, film artists must learn to transform thought into imagery; unlike Shakespeare, however, the film-maker must avoid *all* that "is accessible to words, and to words alone . . ." The motion picture must discover a means of penetrating the subjective world, but in a way that remains wholly its own. Perhaps, Mrs. Woolf suggests, *The Cabinet of Dr. Caligari* (1919) holds the answer for the future Shakespeares and Tolstoys of the cinema. In that German expressionist film, she recalls, "a shadow shaped like a tadpole suddenly appeared at one corner of the screen. . . . For a moment it seemed as if thought could be conveyed by shapes more effectively than words."

Mrs. Woolf then arrives at what seems to be the central point of her essay. "Is there," she asks, ". . . some secret language which we feel and see, but never speak, and, if so, could this be made visible to the eye? Is there any characteristic which thought possesses that can be rendered visible without the help of words?" Perhaps, the writer suggests, abstract art may yet prove to be the salvation of the film: "some residue of visual emotion which is of no use either to painter or to poet may still await the cinema." The expressionist approach might possibly open new doors to the film by allowing for the projection of fantasies in the unconscious. At this point in her thinking, Virginia Woolf was still unable to see that perhaps some alternation between the objective and subjective might be the most satisfying artistic solution to the problem of "reality."[5]

About a month after Mrs. Woolf's article was published, the *New Republic* printed a piece by Gilbert Seldes entitled, "The Abstract Movie." Using the English novelist's essay as a starting point for his own reflections on the cinema, Seldes notes that Mrs. Woolf's article was "apparently written without knowledge of the abstract films which have been made in Paris in the last two or

three years." According to Seldes the films were not "entirely successful," but they were "made for pure visual enjoyment"; instead of attempting to convey "a definite thought," these abstract films were content to be merely "evocative."[6]

No writer could have been more appreciative of the "evocative" than the anti-intellectual Mrs. Woolf. The words "life" and "reality" appear repeatedly in her reviews and essays, and in a way that is relevant to the present study. In *The Common Reader*, which came out the same year as *Mrs. Dalloway*, the writer says: "Life is not a series of gig lamps symmetrically arranged; but a luminous halo, a semi-transparent envelope surrounding us from the beginning of consciousness to the end." And in Mrs. Woolf's opinion, it is the job of the novelist to project his view from the "envelope," or inside, "with as little mixture of the alien and external as possible."[7] It is worth noting that Virginia Woolf's brand of either-or thinking ("life" cannot be reduced to "a series of gig lamps"—but does it follow that it can be reduced to "a semi-transparent envelope"?) dictates the form of both *Mrs. Dalloway* and *To the Lighthouse*. But on November 28, 1928—a year after the publication of the latter novel—Mrs. Woolf's diary reveals a shift in her thinking. "And what is my own position towards the inner and the outer?" she asks. "I think a kind of ease and dash are good;—yes: I think even externality is good; some combination of them ought to be possible." She decides, then, that the best method is "to give the moment whole; whatever it includes."[8]

"What is meant by 'reality'?" she asks the following year in *A Room of One's Own*—and she replies:

> It would seem to be something very erratic, very undependable—now to be found in a dusty road, now in a scrap of newspaper in the street, now a daffodil in the sun. It lights up a group in a room and stamps some casual saying. It overwhelms one walking home beneath the stars and *makes the silent world more real than the world of speech*—and then there it is again in an omnibus in the uproar of Piccadilly. Sometimes, too, it seems *to dwell in shapes too far away for*

us to discern what their nature is. But whatever it touches, it
fixes and makes permanent.[9]

The italics in the above quotation are mine. Is there anything in
Mrs. Woolf's remarks that would indicate an inability on the part
of the motion picture to reveal "reality"? And would this not seem
to refute her belief, suggested in "The 'Movie' Novel," that film is
necessarily or inherently superficial? Finally, in 1935, the novelist
says: ". . . I have now reached a further stage in my writer's
advance. I see that there are four? dimensions: all to be produced,
in human life: and that leads to a far richer grouping and propor-
tion. I mean: I; and the not I; and the outer and the inner—no
I'm too tired to say: but I see it. . . . New combination in psychol-
ogy and body—rather like painting."[10] It seems clear that as time
passed Virginia Woolf came to see the limitations in her early
aesthetic, in which she exaggerated the claims of the "spiritual"
and the "subjective" at the expense of the "material" and the
"objective."*

It is against such a general background of critical thinking that
one must view Mrs. Woolf's comments on the movies. "We can
say for certain that a writer whose writing appeals mainly to the
eye is a bad writer," the novelist declares in 1925, "that if in
describing, say, a meeting in a garden he describes roses, lilies,
carnations, and shadows in the grass, so that we can see them, but
allows to be inferred from them ideas, motives, impulses, and
emotions, it is that he is incapable of using his medium for the
purposes for which it was created."[11] Which may or may not be
true in the case of the novelist; and even if true, it does not follow
that the motion picture is inferior to prose simply because it ap-
peals to the eye. Mrs. Woolf speaks respectfully of the image in
"The Movies and Reality"; nonetheless, one feels that for the
writer the word, and not the picture, remains the *superior* way to

* Whether this intensely introspective novelist ever succeeded in giving
equal due to both the "inner" and the "outer" in a finished work of art after
To the Lighthouse is a question that lies outside the limits of the present
inquiry.

explore "life." Furthermore, the novel and the film have more in common than Virginia Woolf seems willing to admit. Although the novel is better able to reveal the stream of consciousness and the camera is better equipped to record the stream of physical events, both forms of art can deal with the "inner" and the "outer." Why should the novelist restrict himself *entirely* to the psychological level? Why should the film-maker limit himself *completely* to the abstract and nonverbal? Indeed, as Mrs. Woolf herself eventually recognized, the artist should strive for wholeness (without, to be sure, losing his sense of priorities within the limitations of his medium): "some combination" of the "inner and the outer" is probably the best way for the artist in either form to convey an experiential impression of "life" in all its fullness.

That the novel and the film have much in common is borne out by the enormous borrowing between the two mediums in the last sixty odd years. Virginia Woolf herself suggests one reason for this cross-fertilization of technique. In *Granite and Rainbow* she argues that "poetry" in fiction means not "poetry of language," but "poetry of situation." It is the latter form of "poetry" that is "natural" to the novel. As examples of "poetry of situation," Mrs. Woolf cites Natasha gazing at the stars in *War and Peace* and Catherine pulling feathers from a pillow in *Wuthering Heights*. "And it is significant," she adds, "that we recall this poetry, not as we recall it in verse, by the words, but by the scene."[12] This perspective on the difference between poetry and fiction would seem to place the novel and the film much closer together than Virginia Woolf's comments elsewhere would lead one to believe.

II

To pass from Virginia Woolf's theories about fiction, movies, and "reality" to a consideration of her novels is to perceive how very much her own work is cinematic in technique. Her first two

novels—*The Voyage Out* (1915) and *Night and Day* (1919)—are traditional in form. At this point in her development she has not yet discovered a fluid means for expressing her feeling about the nature of "life." But *Jacob's Room* (1922) represents a new departure, for in this novel Mrs. Woolf depends exclusively on the stream of consciousness as her subject matter. Speaking of the "cinematic technique" in *Jacob's Room*, Dorothy Brewster describes Mrs. Woolf's prose as a camera "sometimes sweeping over crowds, then focusing on an individual or a group, now giving a close-up of a little scene and again ranging the heavens...."[13]

Perhaps the best example of filmic method in *Jacob's Room* takes place in section thirteen, wherein Virginia Woolf, like Joyce in "The Wandering Rocks" episode in *Ulysses*, conveys a sense of simultaneity through rapid crosscutting. For example, while Clara Durrant and Mr. Bowley are walking through a park, a horse without a rider suddenly runs past, and the frightened woman begs her escort to stop the animal. Mrs. Woolf then flashes forward briefly—" 'Tut-tut!' said Mr. Bowley in his dressing-room an hour later. 'Tut-tut'—a comment that was profound enough, though inarticulately expressed, since his valet was handing his shirt studs"—and then flashes back to the park an hour before to observe from the viewpoint of Julia Eliot the runaway horse, and Mr. Bowley's attempts to halt it. As Julia moves out of the park, she glances at her watch, which "gave her twelve minutes and a half in which to reach Bruton Street. Lady Congreve expected her at five."[14] Mrs. Woolf then cuts to a clock at Verrey's striking five—followed by a second cut to Florinda looking at the clock. Someone appears who reminds Florinda of Jacob—and the novelist switches abruptly to Jacob, who is seated in Hyde Park. The latter reads a letter from Sandra . . . and almost imperceptibly Virginia Woolf dissolves back to the woman writing the letter . . . and then back to Jacob again, who is now talking to a ticket collector. Jacob's contemptuous treatment of the man permits the author to cut to Fanny Elmer as she reflects upon Jacob's behavior to such menials. As Fanny rides past Westminster, Big Ben

sounds five o'clock—which again suggests diverse actions occurring simultaneously.*

That the technique in *Jacob's Room* remains cinematic is supported by Mrs. Woolf's own observations in "The Movies and Reality," where the novelist argues that the film editor can destroy a sense of distance by playing scenes occurring separately against an unvarying background. The author's cinematic imagination is even more important, however, in *Mrs. Dalloway* than in *Jacob's Room*. In the later novel, as David Daiches points out, there is a constant alternation of two basic methods: "We are either moving freely in time within the consciousness of an individual, or moving from person to person at a single moment in time."[15] And in order to manage the transitions smoothly (a reader could easily become confused as the focus shifts from individual to individual, from group to group), Mrs. Woolf has recourse once again to the striking of a clock, a car which is seen by a number of characters, and a plane writing in the sky which also catches the attention of many people at the same moment throughout London.[16]

Virginia Woolf's transitions in *Mrs. Dalloway* follow the same basic pattern. In her use of the automobile as a linking device, for instance, the novelist cuts easily from Mrs. Dalloway jumping nervously at the sound of the car and Miss Pym's "Dear, those' motor cars," to the car itself being regarded from the pavement by various individuals.[17] Since the blinds in the automobile are drawn, the crowd is led to speculate about its passengers. The novelist's camera-eye pans smoothly from face to face, catching the puzzled expressions and recording the spoken comments or, more often, the unspoken inner monologues of the persons studied. Thus, Mrs. Woolf cuts from Edgar J. Watkiss to Septimus

* This technique is standard movie practice. In *The Stranger* (1946), directed by Orson Welles, the evil protagonist—also played by Welles—is identified with a clock which he has repaired in the village church. At a tense moment in the action we see Welles' wife (Loretta Young) greeting guests at home, while in the distance is heard the clock striking the hour. Cut then to a store downtown—with the sound of the clock carrying over—where we discover Welles engaged in his nefarious designs.

Warren Smith; from the latter's wife, Lucrezia, back to Mrs. Dalloway; now she cuts from one of these characters to focus on the crowd—then in for a close-up of Sarah Bletchley and her baby, or Emily Coates, or even the familiar Mr. Bowley; until, finally, the plane writing in the sky forces all eyes upward—and the basic technique is repeated with a fresh subject matter.

Continuity is all in *Mrs. Dalloway*. Whereas *Jacob's Room* is formally segmented into fourteen sections, the later work eschews any break in the narrative flow, except for some triple spacing occasionally to set off major sequences. Hence even on the mechanical level *Mrs. Dalloway* more nearly approximates the fluid movement of a motion picture than it resembles the more "old-fashioned" literary art of John Galsworthy, whose *The Forsyte Saga* (1906) is divided into books, parts and chapters, each containing a specific title. Of course, Mrs. Woolf returns to titles and partitions in *To the Lighthouse*, but the rest of her filmic technique remains the same. Indeed, in some respects it is made even more polished. As Melvin Friedman observes: "The continual movement in and out of the mind of the character to objective statement and back again gives a certain fluidity to *Mrs. Dalloway*. The same effect is achieved in *To the Lighthouse* but with a greater economy of means."[18] Is it an accident that during the period in which she took a critical interest in the movies (all her snobbery notwithstanding) Virginia Woolf's stream-of-consciousness fiction moved in the direction of a cinematic presentation?

This is not to say, though, that *Jacob's Room*, *Mrs. Dalloway*, and *To the Lighthouse* are essentially "movie novels" (to use Mrs. Woolf's own pejorative description). Speaking of Alain Resnais's film, *Muriel* (1963), Eric Rhode notes: "These shifts of consciousness remind us of the wide-ranging technique employed by Virginia Woolf in *Jacob's Room* and *Between the Acts*. But whereas Mrs. Woolf's transitions can be brooded over and do relate to some central theme, Resnais's transitions are violent and abrupt, and act as a denial of all centrality."[19] There is no time to "brood over" a transition in a motion picture. This is why Alistair

Cooke's observations on Virginia Woolf's technique in *The Years* (1937) are so misleading. After quoting two different pages from the novel, Cooke remarks that both could be "used without much change as the shooting script of a film."[20] *Ulysses* on film should indicate clearly the difference between cinematic technique in stream-of-consciousness fiction and cinematic technique on the screen. Although Gordon Taylor of New York Presentations is reportedly at work on a movie treatment of *Orlando* (1928), none of Mrs. Woolf's more complex novels have ever gone before the cameras. And, it should be said, with good reason!

If the work of Joyce and Mrs. Woolf appears to betray the influence of the motion picture of their time, the contemporary film (as my quotation from Eric Rhode on Alain Resnais suggests) owes a great deal to the stream-of-consciousness novelists of the twenties. While she was constructing *Mrs. Dalloway*, Virginia Woolf observed in her diary: "It took me a year's groping to discover what I call my tunnelling process, by which I tell the past by installments, as I have need of it. This is my prime discovery so far. . . ."[21] Flashbacks generally retard the tempo of a novel or movie because they interrupt the forward motion of the story in order to laboriously explain something. Due in large measure to the pioneering efforts of Mrs. Woolf, though, flashbacks in fiction and film have become less and less employed in solid blocks of exposition, but are now increasingly projected in fragments, in sudden bursts of recollection, smoothly woven into the fabric of the present moment. In some recent films the remembrance of things past lasts no longer than a split second on the screen, being cut in and out of the present with dazzling swiftness.*

The interaction between fiction and film, the mutual borrowing

* Naturally, a philosophical revolution, with its roots in our altered perception of time, is one of the factors operating on modern narrative development. The past used to be tidily packaged within a long coherent flashback. Once the thought of William James, Sigmund Freud, and Henri Bergson became known, however, writers like Mrs. Woolf responded by fusing past and present, by showing how memories exist dynamically and meaningfully in the mind of a fictional character here and now.

of techniques, can be fruitful—provided that the novelist exercises his cinematic technique on subject matter appropriate to his chosen medium, and that the film-maker remains aware that the screen is not a page that an audience can "brood over" at leisure in order to puzzle out its meaning. By such standards Virginia Woolf, in *Jacob's Room, Mrs. Dalloway,* and *To the Lighthouse,* was a novelist to her fingertips.

The Stream-of-Consciousness Novel and Film, III—William Faulkner

If I didn't take, or feel I was capable of taking, motion-picture work seriously, out of simple honesty to motion pictures and myself too, I would not have tried. But I know now that I will never be a good motion-picture writer; so that work will never have the urgency for me which my own medium has.

—William Faulkner

I

Of the many novelists who have worked in movie studios as screenwriters, none have enjoyed a higher literary reputation than William Faulkner. When the future Nobel Prize winner went to Hollywood for the first time in 1932, he had already written what are probably his two finest novels: *The Sound and the Fury* (1929) and *Light in August* (1932). Between 1932 and 1954, Faulkner spent a total of four years in California and worked on about forty-four films. There is no evidence that the period spent in the studios had much influence on the technique of the novelist's later fiction. As Joseph Blotner has suggested, Faulkner's experience is rather unusual in that some of his literary preoccupations occasionally slip into his movie work, and not, as is frequently the case, the other way around.[1] In fact, the pre-Holly-

wood *The Sound and the Fury* and *Light in August* are more cinematic than *A Fable* (1950), which was originally intended as a scenario.[2] I shall return to Faulkner's movie writing, but first I should like to discuss the author's fiction in terms of the cinematic imagination.

Much of what I have already said about the filmic qualities in the work of James Joyce and Virginia Woolf also applies to the greatest American novel in the stream-of-consciousness tradition, *The Sound and the Fury*. "You should approach Joyce's *Ulysses*," Faulkner told a *Paris Review* interviewer, "as the illiterate Baptist preacher approaches the Old Testament: with faith."[3] The following quotation from the interior monologue in the Quentin section of *The Sound and the Fury* reveals the extent of Faulkner's debt to Joyce's masterpiece:

> Because women so delicate so mysterious Father said. Delicate equilibrium of periodical filth between two moons balanced. Moons he said full and yellow as harvest moons her hips thighs. Outside outside of them always but. Yellow. Feetsoles with walking like. Then know that some man that all those mysterious and imperious concealed. With all that inside of them shapes an outward suavity waiting for a touch to. Liquid putrefaction like drowned things floating like pale rubber flabbily filled getting the odour of honeysuckle all mixed up.[4]

This passage projects the same filmic juxtaposition of sacred and profane images (or the same sexual ambivalence toward women) as does Leopold Bloom's stream of consciousness.

At times Faulkner's crosscutting within the stream of consciousness is even quicker and more dazzling than anything to be found in the fiction of his predecessors. Below is part of a page from the Benjy section. The scene alternates for the idiot Compson between events occurring at the family table in the present (April 7, 1928) and an event that occurred in the past (November 1900), when Benjy's name was changed. I have indicated the cuts, or time-shifts, within brackets:

Raskus said, "It going to rain all night." [Name change]
You've been running a long time, not to 've got any further
off than mealtime, Jason said.
See if I dont, Quentin said. [Present]
"Then I don't know what I going to do." Dilsey said. "It
caught me in the hip so bad now I cant scarcely move. Climb-
ing them stairs all evening." [Name change]
Oh, I wouldn't be surprised, Jason said. I wouldn't be sur-
prised at anything you'd do.
Quentin threw her napkin on the table.
Hush your mouth, Jason, Dilsey said. She went and put her
arm around Quentin. Sit down, honey, Dilsey said. He ought
to be shamed of hisself, throwing what ain't your fault up to
you. [Present]
"She sulling again, is she." Raskus said.
"Hush your mouth." Dilsey said. [Name change]
Quentin pushed Dilsey away. She looked at Jason. Her
mouth was red. She picked up her glass of water and swung
her arm back, looking at Jason. Dilsey caught her arm. They
fought. The glass broke on the table, and the water ran into
the table. Quentin was running. [Present]
"Mother's sick again." Caddy said.
"Sho she is." Dilsey said. "Weather like this make anybody
sick. When you going to get done eating, boy." [Name
change]
Goddamn you, Quentin said. Goddamn you. We could
hear her running on the stairs. We went to the library. [Pres-
ent]
Caddy gave me the cushion, and I could look at the cush-
ion and the mirror and the fire. [Name change][5]

The montage construction of the passage quoted from the
Quentin section, and the montage form of the scene above from
the Benjy section, represent but part of an overall montage struc-
ture in the novel; that is, each of Faulkner's four parts—the Benjy
section, the Quentin section, the Jason section, and the Dilsey
section—are meaningfully juxtaposed to one another.

Just as Joyce and Virginia Woolf rely on visual symbols as
unifying devices for their stream-of-consciousness narration, so
Faulkner uses fire, water, light, trees, flowers and clocks as recur-

rent images in an effort to impose order on his seemingly chaotic subject matter. All critics agree that time is central to the organization of Faulkner's novel, and perhaps the clock symbolism is the most important motif in *The Sound and the Fury*. "A fictional technique always relates back to the novelist's metaphysics," Jean-Paul Sartre reminds us. "The critic's task is to define the latter before evaluating the former. Now, it is immediately obvious that Faulkner's metaphysics is a metaphysics of time."[6] The past for Faulkner remains a living part of the present; indeed Quentin informs us that there is only "is": "was the saddest word of all there is nothing else in the world its not despair until time its not even time until it was."[7] Faulkner's time-sense, his concern with *simultaneity*, is very much filmic. Arnold Hauser sees "simultaneity" and the "spatialization of the temporal element" nowhere better expressed than in film—an art form which coincided with Bergson's theory of time; indeed Hauser suggests that the screen virtually created the "time categories" of all modern art.[8]

The Sound and the Fury is then, like *Ulysses*, a highly cinematic novel. But, again like Joyce's great work, Faulkner's novel is not really motion picture material. It seems doubtful whether even the most gifted director—be he a Bergman or a Fellini—could ever bring *The Sound and the Fury* to the screen with anything like the equivalent power of the original. Form cannot really be separated from content in a great work of art; yet no film director could crosscut with the speed Faulkner displays in the quoted scene from the Benjy section, for example, without confusing a movie audience. Certainly it is a critical commonplace that structure in a narrative or dramatic work is a major index to its meaning. And few novels are more complex in form than *The Sound and the Fury*. Nevertheless, the scrambled structure Faulkner projects is entirely justified. "Faulkner did not first conceive this orderly plot so as to shuffle it afterwards like a pack of cards," Sartre notes, "he could not tell it in any other way."[9] With such obvious points in mind, it might prove instructive to examine briefly the 1959 movie version of *The Sound and the Fury*.

The adaptation of Faulkner's novel was done by Irving Ravetch

and Harriet Frank, whose chief blunder was to unscramble the form of *The Sound and the Fury*. By telling the story in chronological order, by largely omitting even references to the past, and by eliminating Quentin entirely, the motion picture people finished with something that bears only the faintest resemblance to the original. Furthermore, Jason—whom Faulkner once called a "completely inhuman" man[10]—is transformed into the hero of the film! (Other ludicrous aspects of the movie—such as the conversion of Jason into a Cajun to accommodate Yul Brynner's accent, and Mrs. Compson not being a Bascomb any longer—scarcely deserve mention.) Whereas Caddy is the central referent in the novel, her daughter (played by Joanne Woodward) becomes the main character in the movie, even to narrating portions of it (quite meaninglessly it should be added). Instead of running off at the end of the film with a carnival pitchman, the girl returns to the old Compson homestead—and to Jason! Gone are the time motifs in the novel; gone are the various levels of symbolism—religious, social and philosophical—in the novel; gone are all attempts to probe character in depth; gone—well, just about everything has gone except Faulkner's title and the names of a few characters. Martin Ritt's direction is poor. Of course, it was impossible for the film-makers to find adequate technical means for duplicating or even approximating Faulkner's complex interior monologues. Why then—since the whole meaning of *The Sound and the Fury* resides in its technique—was the movie attempted in the first place? Why still another Hollywood production which fails to be either a reasonably faithful adaptation or a distinguished motion picture in its own right?

Although *Light in August* does not belong to the stream-of-consciousness genre, it remains a dense psychological novel constructed (like *The Sound and the Fury*) in a montage form—a form, by the way, which is basic to Faulkner's thinking. Walter J. Slatoff has been able to show that the writer's most characteristic figure of speech is the oxymoron.[11] Faulkner's fondness for a rhetorical antithesis which brings together two contradictory terms

—and which in turn determines the form of the work as a whole —recalls Eisenstein's definition of montage as "collision," as "the conflict of two pieces in opposition to each other."[12] In *Light in August* Faulkner juxtaposes the stories of Joe Christmas, Gail Hightower, Joanna Burden, and Lena Grove in another attempt to show how past events shape the present. Instead of using interior monologues to expose the simultaneous existence of past and present events, the novelist depends largely on flashbacks to underscore causality. As Irving Howe views it: "The numerous cinematic flashbacks come to appear too conspicuously 'functional,' several of them occurring whenever the source or meaning of a scene requires more material than Faulkner can provide within it."[13] Howe seems to misunderstand Faulkner's purposes. The flashbacks are not there merely to supply expository material for actions in the present that need further explanation. Since the past is Faulkner's subject—or a large part of it—the flashbacks are not simply "functional"; they are thematically necessary, and consequently they justify the montage structure of the work.

Some of the transitions in *Light in August*, which link the present with the past, resemble the fade-out, fade-in technique of the film. At the end of Chapter Five, for instance, Joe Christmas is on the verge of killing Joanna Burden:

> When he heard eleven strike tonight he was sitting with his back against a tree inside the broken gate, while behind him again the house was dark and hidden in its shaggy grove. He was not thinking *Maybe she is not asleep either* tonight. He was not thinking at all now; thinking had not begun now; the voices had not begun now either. He just sat there, not moving, until after a while he heard the clock two miles away strike twelve. Then he rose and moved toward the house. He didn't go fast. He didn't think even then *Something is going to happen. Something is going to happen to me.*

The sound of the clock striking signals the shift in time from present to past; the words in italics transport the reader directly inside the mind of Christmas, in preparation for the following

chapter in which Faulkner reveals the character's basic motivation. Note that the italicized words are fictional equivalents for a filmic slow dissolve—as the opening of Chapter Six, with its fluid succession of images, indicates:

> Memory believes before knowing remembers. Believes longer than recollects, longer than knowing even wonders. Knows remembers believes a corridor in a big long garbled cold echoing building of dark red brick soot-bleakened by more chimneys than its own, set in a grassless cinderstrewn-packed compound surrounded by smoking factory purlieus and enclosed by a ten foot steel-and-wire fence like a penitentiary or a zoo, where in random erratic surges, with sparrow-like, childtrebling orphans in identical and uniform blue denim in and out of remembering but in knowing constant as the bleak walls, the bleak windows where in rain soot from the yearly adjacenting chimneys streaked like black tears.[14]

Although the two passages just quoted resemble familiar motion picture techniques, and although the writing is filled with images and visual symbols, much of both paragraphs is also too psychologically complex for the screen. Other parts of the novel—such as Faulkner's analysis of Hightower's final retreat into his fantasy world—would similarly defy picturization. All the same, in some respects *Light in August* would seem to present an easier task for the film adaptor than *The Sound and the Fury*. The earlier stream-of-consciousness novel is almost entirely lacking in dramatic confrontations or action; furthermore, the intensely subjective approach to three of its major characters is not a method congenial to a movie camera. On the other hand, *Light in August* has a number of striking clashes between characters and a pictorial quality that has caught the eye of most critics. A flexible point of view in *Light in August* permits the reader to see Faulkner's people not only from the inside, but also from the outside. For example, the description of Christmas which follows could be interpreted by an actor and easily projected on film by a director:

He looked like a tramp, yet not like a tramp either. His shoes were dusty and his trousers were soiled too. But they were of decent serge, sharply creased, and his shirt was soiled but it was a white shirt, and he wore a tie and a stiffbrim straw hat that was quite new, cocked at an angle arrogant and baleful above his still face. He did not look like a professional hobo in his professional rags, but there was something definitely rootless about him, as though no town nor city was his, no street, no walls, no square of earth his home. And that he carried his knowledge with him always as though it were a banner, with a quality ruthless, lonely, and almost proud . . . He was young . . . with a cigarette in one side of his mouth and his face darkly and contemptuously still, drawn down a little on one side because of the smoke. After a while he spat the cigarette without touching his hand to it and turned and went on. . . . [15]

The reader is made to see Joe Christmas, as well as the other characters in *Light in August,* in a way that he never sees Quentin Compson, say, or perhaps even Dilsey in *The Sound and the Fury.*

As yet, though, *Light in August* has not been brought to the screen. The late Jerry Wald, who was responsible for the adaptation of *The Sound and the Fury,* once cited *Light in August* as being among the "difficult but stimulating challenges to screen adaptors."[16] If Faulkner's great novel *must* be brought to the screen, then one can only hope that a director like the late Carl Dreyer, who once expressed interest in *Light in August,* will draw the assignment. Considering the fate of Faulkner works already filmed by Hollywood, however, the prospects for someone like Dreyer taking charge (the Danish director's films were never popular and never made a lot of money) are not exactly rosy.

The first Faulkner novel to be made into a movie was his sensational potboiler, *Sanctuary* (1931), which Paramount released in 1933 under the title of *The Story of Temple Drake.* The most charitable thing that can be said about this film is that it deserves to be forgotten. In 1961 Hollywood tried again (this time retain-

ing the original title) and using Yves Montand and Lee Remick in the leading roles. The result was, if one can conceive of such a thing, even more deplorable than the 1933 version. James Poe's script eliminated at least six of the original characters—including the only memorable one in the wretched novel, Popeye (who was also omitted from *The Story of Temple Drake*)—and had Montand, following in the footsteps of Yul Brynner, playing a Cajun bootlegger named Candy! Not even Tony Richardson, who later directed *Tom Jones* (1963) with such skill, could bring life to *Sanctuary*.

Perhaps MGM's adaptation of *Intruder in the Dust*, which was published in 1948 and released as a film the following year, remains the best Hollywood treatment so far of a Faulkner property. The fact that *Intruder in the Dust* is far from being equal to the novels Faulkner wrote at the height of his powers—*The Sound and the Fury, Light in August* and *Absalom, Absalom!*—should not be forgotten. Great novels rarely translate well into another medium. The film version of *Intruder in the Dust* also profited from a good script by Ben Meadow, fine direction by veteran Clarence Brown, and outstanding performances by David Brian, Claude Jarman, Jr., and especially Juano Hernandez. Faulkner himself was quoted as saying at the première in his hometown of Oxford, Mississippi: "All in all I think it is a good movie."

Although *Intruder in the Dust* is not a stream-of-consciousness novel, and although it is not in the same class as *Light in August*, it is probably more of a psychological than a social study of racial types in the South. Dorothy B. Jones, in "William Faulkner: Novel Into Film," has written the most perceptive criticism of *Intruder in the Dust* on film with which I am familiar. While granting that the movie manages to make the main points of the book, Miss Jones argues that in some important respects the film is also different due to the essential limitations of the camera. The basic problem, as is so often the case when novels are adapted to the screen, involves the matter of point of view. Whereas Faulkner shows us the conflict in young Chick's mind from the inside, the

movie is chiefly restricted to projecting the boy before us from the outside. Only occasionally does Brown use subjective perspectives. As Miss Jones points out: "This objectification of the story has important results. Along with the basic differences in the natures of the two media, it accounts for the fact that the film fails to interpret what Faulkner had to say about Chick." The film tends to emphasize action; the novel inclines toward analysis of motives. Miss Jones is not the only critic to complain of fuzzy character motivation in the movie. "Consequently, at the end of the film," the critic concludes, "one does not sense, as one does at the close of the novel, that something important has happened to this boy, that he has achieved new dimension, and that he has grown immeasurably as a result of his working through of this experience."[17]

Eight years passed before another Faulkner novel appeared on the screen. *The Tarnished Angels* (1958) is very freely adapted from *Pylon* (1935); but with Rock Hudson in the starring role, the Douglas Sirk movie has too much going against it to be successful. *The Long Hot Summer* (1958), written by the team responsible for the mangling of *The Sound and the Fury* and also directed by Martin Ritt, is based largely on *The Hamlet* (1940). "We changed the name," Ritt is supposed to have said, "so people wouldn't confuse it with that other *Hamlet*. But the book too had to be considerably changed before we could even begin to make a film out of it." Spoken by anyone but a typical Hollywood director—by a Bergman, say, or a Kurosawa—such a statement would seem no more than the assertion of a self-evident truth. Coming from Ritt, though, it is clearly a rationalization for the emasculation of the original. Even the reviewers who found something to praise in the talky film version of *The Hamlet* objected to the non-Faulknerian happy ending.

Finally, in 1969, *The Reivers* (1962) appeared on the screen, again written by Ravetch and Frank, and directed by Mark Rydell. Edmond L. Volpe once observed: "*The Reivers* . . . is a natural for Hollywood. Faulkner probably never turned out so

tailor-made a script when he was actually writing for the movies
... [T]he novel could be transferred [easily] to the screen to pro-
vide popular sentimental comedy in the tradition of Clarence
Day's *Life With Father*."[18] That the subject matter of *The
Reivers* was made to order for Hollywood seems clear from the
enthusiastic review of the film by Kathleen Carroll in the New
York *Daily News* (December 26, 1969): "If all you wanted for
Christmas was a nice movie about nice people, then *The Reivers*
... is the perfect present. With its sugarspun characters and home-
spun charm, it is like watching the very best of Walt Disney. And
what could be nicer than that?"

II

It was the success of his novel *Sanctuary* that brought Faulkner
to Hollywood in 1932, where he started work at MGM for five
hundred dollars a week. The next year a film, adapted by the
novelist himself from his short story "Turnabout" (1932), was
released under the title of *Today We Live*. Unlike *The Sound and
the Fury*, "Turnabout" is simple in construction and chronologi-
cally arranged; about eighty-five per cent of the action is in dia-
logue form. Faulkner had little difficulty shaping the story for the
screen, and he produced the scenario in five days. The finished
movie, which stars Joan Crawford, Gary Cooper and Franchot
Tone, can still occasionally be seen on television. As one commen-
tator has remarked, though, *Today We Live* "is so loaded with
individual heroism and sacrifice that it will strike modern audi-
ences as stupid."[19]

Two years later Faulkner wrote his only story with a California
setting, "Golden Land" (1935), which pictures life for a real-
estate man in Los Angeles as spiritually empty and futile in com-
parison to a hardier, more primitive, existence in his native Ne-
braska. "Golden Land" reflects Faulkner's contempt for modern
technological society in general and his distaste for the tawdry

screen colony in particular. Although the writer made an honest effort to do respectable work for the studios,* he was never really happy away from his desk in Oxford; he could never forget that it was only the need for money that brought him periodically to the Pacific coast. At times, Faulkner earned as much as a thousand dollars per week in Hollywood. According to Joseph Blotner's estimate, Faulkner's total earnings at the studios (the writer drew most of his checks from MGM, Twentieth Century-Fox, and Warner Brothers) was about a hundred and fifty thousand dollars— not a very great sum for four years' work by one of the major novelists of the century.

But perhaps at bottom Faulkner never wanted to make too much money in, or from, Hollywood. (He once tried to sell *Absalom, Absalom!* [1936] to the movie moguls, and asked for only fifty thousand for that magnificent novel.) Shortly before his death in 1962, the writer told a group of students at the University of Virginia:

> There's some people who are writers who believed they had talent, they believed in the dream of perfection, they get offers to go to Hollywood where they can make a lot of money, they begin to acquire junk swimming pools and imported cars, and they can't quit their jobs because they have got to continue to own that swimming pool and the imported

* But how seriously could a writer of Faulkner's stature take assignments such as the following: *The Road to Glory, Banjo on My Knee, Gunga Din, The Last Slaver, Splinter Fleet* (later retitled—in case anyone cares— *Submarine Patrol*), *Dance Hall, Drums Along the Mohawk, The DeGaulle Story, Country Lawyer, Battle Cry, God Is My Co-Pilot, Air Force, Background to Danger, Life and Death of a Bomber, Northern Pursuit, Deep Valley, Strangers in Our Midst, Stallion Road, The Left Hand of God,* and *Land of the Pharaohs?* Fortunately, some of these titles never materialized into film. *The Southerner* (1945), *Mildred Pierce* (1945), and *The Big Sleep* (1946) are among the better movies in which Faulkner had a hand. Although *To Have and Have Not* (1944) is also one of the more agreeable Faulkner screenplays, and although the film bears little relation to its source, it must have irritated the writer to have had to adapt such a mediocre work from the hand of Hemingway, who was never forced to perform such chores at the studios.

cars. There are others with the same dream of perfection, the same belief that maybe they can match it, that go there and they resist the money. They don't own the swimming pools, the imported cars. They will do enough work to get what they need of the money without becoming a slave to it, and that, in that sense, it is as you say, it is going to be difficult to go completely against the grain or the current of a culture. But you can compromise without selling your individuality completely to it. You've got to compromise because it makes things easier.[20]

Faulkner never deceived himself about his screen-writing work. He said once: "I don't like scenario writing because I don't know enough about it."[21] At another time, referring to his fellow scenarist Harry Kurnitz, Faulkner explained: "He understands footages and that sort of thing. I just try to figure out what a character would be likely to do in a given situation." (On the same occasion, the novelist said of his moviegoing activities: "Movies and I don't agree chronologically. In Oxford there is one show at seven o'clock, and the town goes to bed at nine-thirty. It's not that I don't like the movies, but my life just isn't regulated that way.")[22]

Could it have been the necessity for team-writing and collaboration that really inhibited Faulkner as a script writer? He once informed an interviewer that "a moving picture is by its nature a collaboration, and any collaboration is compromise because that is what the word means—to give and to take."[23]

People in the film industry have offered conflicting evaluations of Faulkner's screenwriting abilities. In the article previously cited, Jerry Wald remarks: "[Faulkner] had a particularly excellent sense of story construction, but his actual writing was rather indifferent."[24] On the other hand, Howard Hawks once reflected: "[Faulkner] has inventiveness, taste, and great ability to characterize and the visual imagination to translate those qualities into the medium of the screen. He is intelligent and obliging—a master of his work who does it without fuss."[25] Malcolm Cowley has

argued that Faulkner's movie work merely called forth his "talent," or conscious craftsmanship, while his "genius," or unconscious inspiration, was involved in novel writing.[26] And so it goes.

One thing, however, remains certain: none of the films that Faulkner was associated with betray the slightest evidence of the artist who wrote *The Sound and the Fury* and *Light in August*. Had Faulkner been permitted to write and direct his own movies (the way Norman Mailer and Alain Robbe-Grillet are doing today) perhaps his "genius" would have manifested itself on the screen, too. As it is, one must go to Faulkner's early masterpieces to find his cinematic but—ironically—unfilmable prose qualities in operation.

John Dos Passos and the Camera-Eye—*Manhattan Transfer* and U. S. A.

In the motion pictures [of the twenties] we were enormously stimulated by Eisenstein's Potemkin. *One of the first fruits of Eisenstein's influence was that it led us to make a new appraisal of old Griffith's* The Birth of a Nation.

—John Dos Passos

I

In *The Best Times: An Informal Memoir,* John Dos Passos recalls the trip he made to Soviet Russia during the twenties: "Pudovkin was the sort of man you could talk about anything with and Eisenstein was boasting of how much he had learned from *The Birth of a Nation* and that old scoundrel of a capitalist D. W. Griffith. These men were so different from the few American movie people I'd run into, it was absolutely startling. They were men of broad reading, anxious to learn, to take on new impressions." The novelist adds that in his conversations with Eisenstein both men "agreed thoroughly about the importance of montage."[1]

The influences on Dos Passos's artistry were various. In a stimulating essay, "John Dos Passos: Technique vs. Sensibility," Marshall McLuhan traces the novelist's aesthetic roots to the eighteenth century:

As a boy in Chicago, Dos Passos was devoted to Gibbon's *Decline and Fall of the Roman Empire*. Artistically, Gibbon's late use of baroque perspectivism, the linear handling of history as a dwindling avenue, concurred with the eighteenth-century discovery of the picturesque, or the principle of discontinuity as a means of enriching artistic effect. So that the later discovery of contemporary imagism and impressionism by Dos Passos, and his enthusiasm for the cinematic velocity of images in the French poet Cendrars, corresponds pretty much with the original revolution in eighteenth-century taste and perception which carried letters from the style of Gibbon to Sterne.

Discontinuity, McLuhan argues, can be found in the novels of Walter Scott, in the poems of Lord Byron, and in the work of Walt Whitman, who "took pride that in his *Leaves of Grass* 'everything is literally photographed.' As for the larger lines of [Whitman's] work, it is plain that he uses everywhere a cinematic montage of 'still' shots." But it is in the work of Dickens and, especially, in Flaubert's *Sentimental Education* that "the acceptance of the city as the central myth or creation of man first leads to the mastery of that huge material by means of the technique of discontinuous landscape." That Joyce's great book about Dublin had an influence on the creator of *Manhattan Transfer* and *U. S. A.* goes without saying.[2]

Dos Passos may not have seen Karl Grune's *The Street* (1923), but it is certain that he was familiar with the theories and work of the Russian director Dziga Vertov. The latter formulated a theory of film which he dubbed "The Kino Eye." Vertov argued for a documentary form of cinema, one that would be equipped to convey a sense of actual urban existence in the twentieth century; moreover, he proceeded to make a movie, *Kino Eye* (1924), in order to show what he had in mind.

John H. Wrenn has insisted that Dos Passos's major novels represent a successful fusion of fiction and documentary;[3] however, it seems to have escaped Wrenn that Dos Passos calls one of his chief technical devices in *U. S. A.* "The Camera Eye" and

that, again like Vertov, he calls another formal method by the name of "Newsreel." When the Russian film *Men and Jobs* (1932), written and directed by Alexander Macheret, was released, its brutal documentary approach upset audiences. In his account of the Soviet film industry, Jay Leyda says that *Men and Jobs* "was accused of being too rude and crude . . . [some] criticized the first naturalistic sound film as over-naturalistic (one critic found the influence of John Dos Passos!). . . ."[4] Leyda's exclamation point may not be as necessary as he thinks. Since the twenties artists of the different media have been working on much the same material; and there has been a good deal of interaction between them and enough borrowing of forms to cause aesthetic alarm even among those who are not purists.

Discontinuity, imagism, impressionism, expressionism—these various ways of handling modern experience in art left Dos Passos very much open to the influence of montage and other motion picture techniques when he came to write the novels which in the twenties and thirties made him famous.

II

Manhattan Transfer is a "modern" novel in the sense that there is no plot; the focus of interest is the structure of the city itself and the effect it has on individuals. Instead of dwelling on the lives of several characters, as was typical in past fiction, Dos Passos introduces more than fifty people in order to reveal a broad social spectrum. The form of *Manhattan Transfer*, ostensibly chaotic, suggests the aimless and meaningless existence of the urban masses. Whereas William Dean Howells, in his study of a cross-section of people in New York, borrowed from the drama to make the scenes of *A Hazard of New Fortunes* (1889) move, Dos Passos relies on a filmic technique to cover a much more diverse range of activity than the older writer had attempted. In *Manhattan Transfer* one scene is rapidly displaced by another in what

Blanche Gelfant calls a "syncopated cinematic movement. As the smallest unit of structure, the fleeting aesthetic impression is ideally suited to the synoptic form, for while it allows for range and flexibility, the rapid transition from one impression to another accelerates the novel's pace to suggest the incessant restless movement within the city itself."[5]

As Robert Gessner has also noted,[6] on the first page of *Manhattan Transfer* the author uses three crosscuts. The novel opens as follows: "Three gulls wheel above the broken boxes, orangerinds, spoiled cabbage heads that heave between the splintered plank walls, the green waves spume under the round bow as the ferry, skidding on the tide, crashes, gulps the broken water, slides, settles slowly into the slip." After two more sentences devoted to a description of this scene, the writer cuts abruptly to another part of the city: "The nurse, holding the basket at arm's length as if it were a bedpan, opened the door to a big dry hot room with greenish distempered walls where in the air tinctured with smells of alcohol and iodoform hung writhing a faint sourish squalling from other baskets along the wall." Once again two more sentences follow—then Dos Passos quickly cuts for the third time: "On the ferry there was an old man playing the violin." And so forth.[7] Scenes whirl past, for the most part, observed from the outside, with emphasis placed on gesture, description, and movement. Although Dos Passos records sense impressions, he rarely moves inside his characters for psychological analysis. He makes little or no use of summary.

But if the structure of *Manhattan Transfer* is filmic, so is its style. My first quotation from the novel, in which the author describes the ferryslip, shows the imagistic pictorial side of Dos Passos's texture. The second quotation underlines how the writer's open punctuation gives an impression of hurried straightforward movement. The third reference, though necessarily brief, announces still another characteristic Dos Passos treatment of language: a short, clipped, hard-surfaced style—"a machine prose for a machine world."[8] Indeed, there are moments when Dos

Passos, obviously impatient with the ordinary novelistic past tense, abruptly switches to the present tense in an effort to gain a greater degree of immediacy. Thus, in one of his transitions the novelist cuts from Ellen Thatcher, who is described in her bed in "conventional" terms ("And the rain lashed through the window and the song grew louder until it was a brass band in her ears. . . ."), to the next apparently simultaneous scene elsewhere: "Jimmy Herf sits opposite Uncle Jeff. Each has before him on a blue plate a chop, a baked potato, a little mound of peas and a sprig of parsley. 'Well look about you Jimmy,' says Uncle Jeff."[9] Images, movement, machine-like objectivity—these are of course characteristic properties of film; but the occasional departures from the past tense to the present tense in *Manhattan Transfer* also suggest a prose affinity with the camera, for it is one of the peculiar qualities of the motion picture that—even when recording a flashback—it always appears in the "present tense." Dos Passos is not the only modern novelist who has attempted to vie with the screen on the score of immediacy.*

Dos Passos's major effort, however, remains his trilogy *U. S. A.*, which is composed of *The 42nd Parallel* (1930), *1919* (1932), and *The Big Money* (1936). Where *Manhattan Transfer* studies a single city, *U. S. A.* seeks to embrace the whole of America between the Spanish-American War and the execution of Sacco and Vanzetti in 1927. In order to impose some formal design and unity on his vast undertaking, the novelist alternates four distinct techniques: 1) fictional character depiction (there are twelve such main characters); 2) biographies of contemporary historical figures (twenty-six such personages are treated); 3) the "Newsreel"; and 4) "The Camera Eye." The last two techniques, which I shall discuss presently, are obvious movie borrowings. Like *Manhattan Transfer*, though, the whole of *U. S. A.* is also cinematic.

* One can find such departures from the customary past tense construction in F. Scott Fitzgerald's *The Great Gatsby*, William Faulkner's *Light in August*, and William Styron's *Lie Down in Darkness*.

Consider, for example, the complex structure of the trilogy it-self. More than one aspect of Dos Passos's *U. S. A.* is reminiscent of Griffith's 1916 film epic, *Intolerance*. In thirteen reels, Griffith ambitiously projects four key stories of intolerance in the history of mankind: 1) the fall of Babylon; 2) the story of Christ; 3) the St. Bartholomew massacre; and 4) the clash between capital and labor in the modern period. Whenever Griffith alternates his time-sequence, he employs a shot of Lillian Gish rocking a cradle (the director got the idea from Whitman's poem "Out of the Cradle Endlessly Rocking"), which device functions as both a unifying element and a thematic symbol. At the time of its release, *Intoler-ance* was not well-received by either audiences or critics. Today the film has acquired the status of a classic, and its influence on film-makers,* novelists, and dramatists is probably greater than is generally realized. Nevertheless, some film scholars still believe that *Intolerance* remains defective in both conception and execu-tion. Hence, Paul Rotha claims that the "theme carried no power because of its *general* treatment,"[10] while Ernest Lindgren ar-gues: "The real weakness of *Intolerance* does not lie in the exces-sive magnitude of its theme, but in the fact that Griffith did not embody that theme in a single clearly articulated course of ac-tion."[11] The four stories were told in such a bewildering discon-tinuous fashion, Richard Griffith and Arthur Mayer contend, that audience identification and emotional involvement with the char-acters was impossible.[12]

Although *U. S. A.* covers a much shorter time period than *Intolerance*, Dos Passos alternates many more stories than does Griffith. Nonetheless, the novelist's four basic technical strategies not only function, like Griffith's image of Lillian Gish, as formal controls over the grand scheme but, inasmuch as they represent "four levels of American experience,"[13] they also resemble the four time-levels of *Intolerance*. Griffith once said of his film: "The stories will begin like four currents looked at from a hilltop. At

* One of whom was Eisenstein—who was in turn very much admired by Dos Passos.

first the four currents will flow apart, slowly and quietly. But as they flow, they grow nearer and nearer together, and faster and faster, until in the end in the last act, they mingle in one mighty river of expressed emotion." This is also the movement of *U. S. A.*, for Dos Passos, like Griffith, fashions his narrative in such a way that the seemingly diverse paths of his fictional characters increasingly intersect in the hopeless muddle of life in twentieth-century America. It is even possible, as I shall later suggest, to make the same criticism of *U. S. A.* that film commentators have leveled at *Intolerance*.

Frequently, description in the Dos Passos trilogy is subjectively impressionistic in a cinematic way. In *The Big Money*, for example, a nightclub scene is rendered from the point of view of Charley Anderson. Whereas a novelist of the pre-film age would probably present the action in an objective, omniscient "long shot," Dos Passos—like a good movie director—carries the reader's eye through the nightclub with the character:

> Charley was following Doris's slender back, the hollow between the shoulderblades where his hand would like to be, across the red carpet, between the white tables, the men's starched shirts, the women's shoulders, through the sizzly smell of champagne and welshrabbit and hot chafingdishes, across a corner of the dancefloor among the swaying couples to the round white table where the rest of them were already settled.[14]

The effect here is very near to the subjective camera technique of F. W. Murnau in his classic *The Last Laugh*.

Dos Passos and Eisenstein, the reader will recall, both "agreed thoroughly about the importance of montage." For the Russian montage meant the arrangement of shots to suggest a concept other than the sum of the concepts suggested in those shots. Eisenstein, like Dos Passos, was not interested in narrative or conventional storytelling; logical sequence was of less concern to him than the development, through juxtaposition, of a thesis or argument. The term "shock cutting" is often used to describe Eisenstein's method. Such a technique obviously resembles Dos Pas-

sos's organization in *U. S. A.*, where the four controls over structure alternate ironically and meaningfully, where fiction is contrasted or counterpointed with fact, and where the didactic element is often very strong. Similarly, Eisenstein's quick cutting finds its stylistic parallel in the elliptical prose and discontinuous syntax of Dos Passos's novel.

Montage has a different meaning in America, however, than in Europe. For Hollywood technicians montage means an assembly of short shots designed to condense time or to contrast space. A stereotyped use of montage in this sense would be a series of rapid shots of newspaper headlines flashed on the screen for the purpose of telescoping time and moving the action from one crisis to the next. The "Newsreel" sections of *U. S. A.* largely fall within the Hollywood concept of montage, as Dos Passos repeatedly throws together newspaper headlines, advertisements, and lyrics from popular songs in a quick succession of fragments. I use the word "largely" above because the "Newsreel" often combines both the American and Russian definition of montage. In "Newsreel LI" of *The Big Money*, for instance, sentimentality is strikingly juxtaposed with the harsh economic facts of American life:

> *The sunshine drifted from our alley*
> HELP WANTED: ADVANCEMENT
> positions that offer quick, accurate, experienced, well-recommended young girls and young women . . . good chance for advancement
> *Ever since the day*
> *Sally went away*
> GIRLS GIRLS GIRLS[15]

Needless to say, the political sympathies of Dos Passos and Eisenstein often lead to slanting—a fact which has given offense to a later generation of readers and viewers.*

* Dos Passos uses the newsreel approach again in his later novel, *Mid-Century* (1961); but here his political bias is toward the right instead of the left.

In an unsympathetic discussion of *U. S. A.*, Eleanor Widmer argues that the characters created by Dos Passos are in reality mere Hollywood clichés: "The role of Eleanor Stoddard," Miss Widmer maintains, "has appeared in dozens of the thirties society movies, played by the cool Joan Fontaine or her earlier prototypes, the self-contained, highly motivated social climber. . . We know Eleanor Stoddard only from the outside, by a series of visual tableaux. . . ." Charley Anderson dies in the tradition of James Cagney, while the passing of Eveline Hutchins "smacks of the historic cinema, the camera pulling away from the prone body as the party conversation dissolves in the still air." Only Margo Anderson's characterization is entirely satisfactory, claims Miss Widmer, for here "conception and technique are united—the movie star plays herself, her screen image, and the personification of the American Dream simultaneously."[16]

Although Miss Widmer overstates her case against Dos Passos, and although she apparently overlooks the number of excellent films that came out of Hollywood in the thirties, there is much truth in her argument. Characterization is a weak point in both *Manhattan Transfer* and *U. S. A.* For in aping the methods of the cinema, Dos Passos neglects to exploit the unique advantages of fiction—chief of which perhaps is its ability to probe character from the inside and in depth. Dos Passos too often focuses his prose-camera on externals; his impressionistic descriptions, even when they become subjective, remain almost wholly on the sense level. "The Camera Eye" in *U. S. A.* is relevant here. Evidently Dos Passos intends this device to balance the "objective" approach of the "Newsreel"; some critics have viewed "The Camera Eye" as a personal, or autobiographical, element in the structure. But if one compares "The Camera Eye" to the internal monologues of *Ulysses* or *The Sound and the Fury*, one can readily see how superficial Dos Passos's approach remains. It is a serious defect of *U. S. A.* that what one chiefly recalls after reading it are its showy mechanical techniques, and not its characters.

And even the techniques, which seemed so dazzling and inno-

vative thirty years ago, now appear questionable. Inasmuch as *Manhattan Transfer* and *U. S. A.* are cinematic in method, why hasn't Hollywood brought them to the screen? Of course the ideological content of Dos Passos's early work is still strong meat for professional film-makers; but they have been known to purchase —and then adulterate—serious works of art in the past. W. M. Frohock argues: "*Moving* pictures cannot be made of the passage of time. The record of time, on film, must be kept by a series of stills. Movies call for action, and action—the picture of things happening—is not Dos Passos's line because he, like Wolfe, is interested not in happenings but rather in their effect on people."[17] True enough; but then haven't movie producers often bought fiction which (considered purely from the technical side now) was inherently nonfilmic?

Since the publication of *U. S. A.*, Dos Passos's reputation has steadily declined. It seems unbelievable that Sartre, writing in 1938, could roundly declare: "I regard Dos Passos as the greatest writer of our time."[18] If critics no longer rate Dos Passos very high among American writers, and if *Manhattan Transfer* and *U. S. A.* have not been made into movies, perhaps it is because *Manhattan Transfer* and *U. S. A.* are neither particularly good novels nor promising screen fare. Like *Intolerance*, *U. S. A.* leaves too little room for emotional rapport with its people; like some of Eisenstein's work, Dos Passos's fiction, as I suggested earlier, is vitiated by didacticism. Frequently today one hears young film critics boldly comparing Eisenstein's "intellectual montage" to the trite filmed commercials on television; while McLuhan has ably pointed out the almost ludicrous discrepancy that exists between the various devices in *U. S. A.*, and the vision of life that finally emerges from the trilogy. "In the equally bulky *Finnegans Wake* . . . which exploits all the existing techniques of vision and presentation in a consummate orchestration of the arts and sciences, there is not one slack phrase or scene," McLuhan observes. "*U. S. A.*, by comparison, is like a Stephen Foster medley played with one finger on a five keyboard instrument."[19]

By imitating the structure and style of motion pictures too closely, and by failing to subordinate his borrowings to material that remains essentially literary—as did the stream-of-consciousness novelists—Dos Passos contributed to that genre which Virginia Woolf contemptuously dismissed as the "movie novel."*

* As far as I can determine, Dos Passos worked on only one actual movie assignment. Together with Sam Winston, Dos Passos adapted a book by Pierre Louÿs entitled *The Devil Is a Woman* (1935), starring Marlene Dietrich, Cesar Romero and Lionel Atwell. Josef von Sternberg, who directed the film, remarks that the novelist was suffering from undulant fever while composing the script—which might account for the quality of the finished product. (See von Sternberg's *Fun in a Chinese Laundry* [New York, 1965], pp. 266–267.)

F. Scott Fitzgerald, Hollywood, and The Last Tycoon

I saw that the novel, which at my maturity was the strongest and supplest medium for conveying thought and emotion from one human being to another, was becoming subordinate to a mechanical and communal art that, whether in the hands of Hollywood merchants or Russian idealists was capable of reflecting only the tritest thought, the most obvious emotion. It was an art in which words were subordinate to images, where personality was worn down to the inevitable low gear of collaboration. As long past as 1930, I had a hunch that the talkies would make even the best selling novelist as archaic as silent pictures . . . [T]here was a rankling indignity, that to me had become almost an obsession, in seeing the power of the written word subordinated to another power, a more glittering, a grosser power. . . .

—F. Scott Fitzgerald

I

No major American novelist was more sensitive to the impact of the movies on society and the writer than F. Scott Fitzgerald. His novels and short stories are filled with references to the film—a medium which seems to have both fascinated and repelled him. Writing to his daughter from Hollywood in 1939, Fitzgerald spoke of the screen as "the greatest of all human mediums of communication."[1] He had gone to the West Coast for a third time deter-

mined to become a first-class scenarist; but his experiences with
the studios had gradually robbed him of his initial enthusiasm,
leaving him bitter and dejected. Yet Fitzgerald's three trips to
Hollywood furnished him with the material for his unfinished
novel *The Last Tycoon*— a work which promised to be as good as
anything he had done before—and the time spent writing sce-
narios enabled him to exercise (appropriately enough) a cine-
matic imagination in his depiction of the film colony.

In 1920 Fitzgerald published his first novel, *This Side of Para-
dise*, and became famous at the age of twenty-four. His experience
with the movies began immediately. Metro purchased his short
story "Head and Shoulders" (1920)—a *Saturday Evening Post*
potboiler—for twenty-five hundred dollars (the film was eventu-
ally released under the jazzy title *The Chorus Girl's Romance!*),
and later the same year also acquired another *Post* story, "The Off-
Shore Pirate" (1920). Fox bought still a third story, "Myra Meets
His Family" (1920), which was transformed into the deservedly
forgotten *The Husband Hunter*. Although the pictures made from
Fitzgerald's stories were even worse than their original versions,
the movie sales naturally stimulated the writer's interest in the new
medium. "In 1920 I tried to sell to D. W. Griffith the idea that
people were so interested in Hollywood that there was money in a
picture about that and romance in the studio," Fitzgerald wrote
his agent, Harold Ober, in 1936. "He was immediately contemp-
tuous of it, but of course a year later *Merton of the Movies*
mopped up the country" (*Letters*, p. 403).* After composing an
outline for a scenario according to Griffith's specifications, Fitz-
gerald soothed his guilt feelings by writing to his aunt and uncle:
". . . I am not averse to taking all the shekels I can garner from
the movies. I'll roll them joy pills (the literary habit) till dooms-

* Harry Leon Wilson's novel *Merton of the Movies* appeared in 1922; two
years later James Cruze directed the film version. *Merton of the Movies* was
not the first picture treatment of the screen colony; Cruze, for example, had
already directed *Hollywood* before turning to *Merton*.

day because you can always say, 'Oh, but they put on the movie in a different spirit from the way it was written!' " (*Letters*, p. 466).

Although K. G. W. Cross thinks that he sees a filmic imagination at work on the material of *This Side of Paradise*—"The hero's development is presented through a series of unlinked scenes or shots, some no longer than a single paragraph," asserts Cross, ". . . The technique is less impressionistic than cinematic, the narrative moving with the jerkiness of an early film"[2]—it is in *The Beautiful and Damned* (1922) that Fitzgerald actually introduces content derived from his knowledge of the movies. One of the early sections of *The Beautiful and Damned* is called "A Flash-Back in Paradise"; and evidently the author felt uneasy about it. "If you think my 'Flash-Back in Paradise' is like the elevated moments of D. W. Griffith say so," he demanded of a friend (*Letters*, p. 353). A minor character in the novel, Muriel Kane, is compared to the movie queen, Theda Bara.[3] In the course of the narrative the heroine, Gloria Patch, takes a screen test, giving the novelist an opportunity to describe the workings of a New York studio in the twenties.[4] But the most revealing indication of Fitzgerald's feelings about the movies comes from his treatment of the writer, Dick Caramel, and the producer, Joseph Bloeckman.

Apparently, Fitzgerald projected into his creation of Caramel some of his own fear about the bad effects of commercial writing on a serious artist. Hence at one point the omniscient narrator says:

> In the two years since the publication of *The Demon Lover*, Dick had made over twenty-five thousand dollars, most of it lately, when the reward of the author of fiction had begun to swell unprecedentedly as a result of the voracious hunger of the motion pictures for plots. He received seven hundred dollars for every story . . . and for every one that contained enough "action" (kissing, shooting, and sacrificing) for the movies, he obtained an additional thousand.

As a consequence of his "success," Fitzgerald makes clear, the quality of Caramel's output has deteriorated noticeably.[5]

A more important character in the novel is Bloeckman—Vice-President of Films Par Excellence—who on one occasion discourses with Caramel "about the influence of literature on the moving pictures."[6] Ambivalence seems to characterize Fitzgerald's attitude toward the producer. Bloeckman is vulgar (the name of his company, for example, is a pompous and pretentious one); and when he praises the soul of Woman, the hero of the novel, Anthony Patch, disparages him, thinking: "My God! It's a subtitle from one of his movies. The man's memorized it!"[7] Several times Gloria snobbishly refers to the producer as "Blockhead." Eventually, as he attains more power in the industry, Bloeckman changes his name to Black.

Yet Fitzgerald also appears to admire this upstart movie mogul —as he was later to admire, and to make a hero of, another Jewish producer, Monroe Stahr (a fictional counterpart of Irving Thalberg), in *The Last Tycoon*.[8] By the end of the novel the hero and heroine are in a demoralized state, but Bloeckman is full of confidence and prepared to seize whatever attracts his fancy.

The model for Bloeckman—later Black—may have been J. Stuart Blackton, who, after starting with Edison in 1896, became one of the founders of Vitagraph three years later. Blackton was a well-known, albeit mediocre, director of early films; he also financed the first popular screen publication, *Motion Picture Magazine*. Like Bloeckman, Blackton was probably fortunate that he got into the motion picture business at the beginning—though he was much less fortunate in 1929, at which time he lost millions in the crash.

Warner Brothers purchased the film rights to *The Beautiful and Damned* the same year it was published, paying the author twenty-five hundred dollars. Fitzgerald was ashamed of the sum received; nor could he have been very happy with the adaptation made from his almost equally poor book (at the time of its release someone called *The Beautiful and Damned* "the most horrendous film ever made"). The following year Famous Players bought *This Side of*

Paradise for ten thousand dollars; Fitzgerald himself undertook the screen adaptation, writing a ten thousand-word treatment—but the novel was never filmed. That same year the author also wrote *Grit*, an original scenario, for the Film Guild.

It is difficult to believe that the man who wrote *This Side of Paradise* and *The Beautiful and Damned* was capable of producing, in 1925, that modern classic novel *The Great Gatsby*—a work which T. S. Eliot called "the first step that American fiction has taken since Henry James."[9] Although it is by no means a "cinematic novel," *The Great Gatsby* does reveal traces of Fitzgerald's recent experiences with the moviemakers.* "And so with the sunshine and the great bursts of leaves growing on the trees," says Nick Carraway, "just as things grow in fast movies, I had that familiar conviction that life was beginning over again with the summer."[10] Gatsby's parties attract people like "Newton Orchid, who controlled Films Par Excellence, and Eckhaust and Clyde Cohen and Don S. Schwartze (the son) and Arthur McCarty, all connected with the movies in one way or another."[11] Needless to say, none of these characters is presented in a very attractive light. At one of the parties a famous screen star and her director appear, and their amorous relationship is made to seem artificial and silly. In *The Beautiful and Damned* Anthony escorts the promiscuous Dorothy Raycroft to the movies in his attempted flight from reality; similarly, in *The Great Gatsby* the bored Myrtle Wilson devours screen magazines, and when the leading actors in the piece are at a loss for entertainment, Tom Buchanan suggests they escape to the movies.

The Great Gatsby was made into a play shortly after publication. Paramount based its seven-reel film version on both the novel and the drama, with credits going to Becky Gardiner for the scenario and Elizabeth Meehan for the adaptation; Herbert Brenon did the directing. The film, which came out in 1926,

* One book reviewer wrote: Fitzgerald "may have had one eye cocked on the movie lots" while writing *The Great Gatsby*; but it remains "a grievous thing" to suspect him of such "catering to Hollywood" (John M. Kenny, Jr., *Commonweal*, II [June 3, 1925], 110).

starred Warner Baxter as Gatsby, Lois Wilson as Daisy, Neil Hamilton as Tom Buchanan, and William Powell as Wilson. On the screen, Fitzgerald's criticism of the rich in America virtually disappeared in favor of discovery on the part of Tom and Daisy of real values and true love.

Twenty-three years later, with Fitzgerald's name heard once again in the land, Paramount filmed *The Great Gatsby* a second time. Alan Ladd, who resembled Fitzgerald in appearance more than Gatsby in temperament, was selected for the leading part. After such inspired casting—what hope for success? The rest of the players included Betty Field as Daisy, Barry Sullivan as Tom, Macdonald Carey as Nick, and Shelley Winters as Myrtle. Once again two hacks collaborated on the screenplay: Richard Maibaum and Cyril Hume. Once more a mediocre director, Elliot Nugent, drew the assignment. The movie was, on the whole, poorly received. Too much of the quality that makes *The Great Gatsby* a major work of fiction resides in Fitzgerald's style—and, as hundreds of shoddy adaptations make clear, there is no way to photograph an author's style. If any director could bring Fitzgerald's magnificent writing to the screen with the right balance of fidelity and cinematic inventiveness, I should think it would be Antonioni. But I shall return to this matter later.*

II

In 1926 John Considine, Jr. of United Artists interested Fitzgerald in writing a silent film for Constance Talmadge about col-

* Such questions, it must be confessed, are more than a little academic. Major directors are rarely interested in adapting classics. (Stroheim's attempt in *Greed* to make a literal translation of Frank Norris's *McTeague* is unusual.) Most directors with any serious pretensions feel as do Alfred Hitchcock and François Truffaut—that is, that a literary masterpiece is already "somebody else's achievement," and that even if it is attempted "it probably wouldn't be any good" (Hitchcock). "Theoretically, a masterpiece is something that has already found its perfection of form, its definitive form" (Truffaut).[12]

lege life. The author of *This Side of Paradise* was to receive thirty-five hundred dollars in advance and eighty-five hundred more ten weeks later if the script was accepted. Fitzgerald agreed, and in January 1927 the novelist made his first trip to Hollywood. Taking rooms at the Ambassador Hotel in Los Angeles, Scott and his wife, Zelda, lost no time meeting the famous stars of the period: Lillian Gish, John Barrymore, Richard Barthelmess, Carmel Myers, and Lois Moran. The latter was twenty years old, beautiful, and very captivating to the thirty-year-old writer. Miss Moran arranged a screen test for Fitzgerald, but—fortunately for American letters—nothing seems to have come of it. Later Miss Moran became the model for the movie actress, Rosemary Hoyt, in *Tender Is the Night*. With so much pleasure available, it is not surprising that the novelist found little time or inclination to write. *Lipstick*—the abortive vehicle for Miss Talmadge—was rejected by the studio.

In November 1931 Fitzgerald embarked on a second journey to Hollywood. This time he was called out to adapt Katherine Brush's novel, *Red-Headed Woman*. This sojourn in the film community was no more successful, however, than the previous one. The director of the picture, Marcel de Sano, changed everything Fitzgerald wrote. As a result, the script was turned down by Thalberg. Fitzgerald left California in disgust, certain that he would never return.

After his first stay in Hollywood, Fitzgerald had written a pot-boiler about movie life entitled "Magnetism" (1928). The second trip gave birth to "Crazy Sunday" (1932), one of his best stories. It was also Fitzgerald's first fictional treatment of Thalberg. The writer believed that he had disguised his models so well, though, that they could not be identified. Such is not the case. Actually, most of the characters in the piece are fairly recognizable, though it is true that they are altered somewhat in order to realize the design of the story.

Joel Coles—the protagonist of "Crazy Sunday"—is a continuity writer "not yet broken by Hollywood." Joel, who bears more

than a passing resemblance to Fitzgerald himself, is working on a film with the brilliant director Miles Calman (Thalberg). Although Joel admires Calman tremendously, he also resents his highhanded manner with writers. At a party one Sunday at the Calman house, Joel burlesques the "cultural limitations" of a producer, Dave Silverstein (Fitzgerald himself performed a similar drunken stunt at the Thalberg home), but nobody laughs except Stella Calman (Norma Shearer—Thalberg's wife). Later in the story Joel sleeps with Stella while Miles goes off to his death in a plane crash (this part of the story is strictly fiction). When news of Calman's death reaches him, Joel reflects: "[Miles Calman] was the only American-born director with both an interesting temperament and an artistic conscience. Meshed in an industry, he had paid with his ruined nerves for having no resilience, no healthy cynicism, no refuge . . . Everything he touched he did something magical to . . . What a hell of a hole he leaves in this damn wilderness already!"[13] When Thalberg died in 1936, Fitzgerald's words in "Crazy Sunday" proved to be prophetic.

Between 1926 and 1934 Fitzgerald worked on *Tender Is the Night*. Much of what he felt about his experience with motion pictures went into the various versions of that complex novel. In an early draft of *Tender Is the Night*, for example, the protagonist's background includes work as an assistant director, cameraman, and cutter for King Vidor and George Collins. By the time Fitzgerald finished the novel the original protagonist, Francis Melarky, had been transformed in part into the film actress Rosemary Hoyt. Rosemary—who is under contract to Films Par Excellence (Fitzgerald obviously liked that title!)—is the star of *Daddy's Girl*, a film which underlines the incest theme in the novel. When the hero, Dick Diver, visits Rosemary's set in Rome, Fitzgerald (speaking as the omniscient narrator) remarks: "The majority of the company felt either sharply superior or sharply inferior to the world outside, but the former feeling prevailed. They were people of bravery and industry; they were risen to a

position of prominence in a nation that for a decade had wanted only to be entertained."[14] That *Daddy's Girl* is an immensely popular film represents Fitzgerald's conviction that movies offer a cheap, irrational evasion of reality.

All the characters in *Tender Is the Night* seem to be strongly influenced by the screen, and in very large measure derive their self-image and values from the motion picture. Reflecting upon the heroine, Nicole, Fitzgerald says: "she was no longer a young girl. But she was enough ridden by the current youth worship, the moving pictures with their myriad faces of girl-children blandly represented as carrying on the work and wisdom of the world, to feel a jealousy of youth."[15] And Tommy Barban, speaking to Nicole of North Africa, remarks:

> "I only know what I see in the cinema. . . ."
>
> "Is it all like the movies?" [Nicole asks]
>
> "The movies aren't so bad—now this Ronald Colman— have you seen his pictures about the Corps d'Afrique du Nord? They're not bad at all."
>
> "Very well, whenever I go to the movies I'll know you're going through just that sort of thing at that moment."[16]

Even the European psychiatrist, Franz Gregorovius, is not immune to the Hollywood film. Hence when Kaethe Gregorovius, the doctor's wife, snaps that Nicole "ought to be in cinema, like your Norma Talmadge—that's where all American women would be happy," Franz replies: "Are you jealous of Norma Talmadge, on a film?" To himself, though, the doctor says: "Norma Talmadge must be a fine, noble woman beyond her loveliness. They must compel her to play foolish rôles; Norma Talmadge must be a woman it would be a great privilege to know."[17] Drawing on his relationship with Lois Moran in Hollywood, Fitzgerald even has Rosemary arrange a screen test for Dick.[18]

After Fitzgerald's death, David O. Selznick bought the screen rights to *Tender Is the Night*. One of the most remarkable novels

ever written by an American went to Selznick in 1948 for the munificent sum of seventeen thousand five hundred dollars; later Selznick sold the rights to Twentieth Century-Fox for three hundred thousand dollars. Shooting on the film version of *Tender Is the Night* began in 1961; and, though the finished product is scarcely worth consideration, the observations of various people involved in the adaptation succeed in illuminating the typical Hollywood approach to literature. In an attempt to realize a still greater profit on his investment, Selznick cast his wife, Jennifer Jones—who was forty-two years old at the time—in the part of Nicole. Henry King, the director, defended Selznick's choice: "A lot of people think Nicole was seventeen or eighteen in the book. If so, how could she marry Diver? The main thing Nicole takes is a good, experienced actress." One wonders how closely King read the book, or indeed, whether he read it at all. When Nicole first appears at the clinic she is sixteen; a year and a half later she meets Dick, and shortly afterward marries him. *Tender Is the Night* covers four years (or five summers); consequently, during the period actually rendered in the novel Nicole's age ranges from eighteen to twenty-two.

After calling Fitzgerald a "drunkard" and an "awful rude person," King grandly conceded that "the man was a great writer." But he went on to say: "We followed him pretty close except where characters were offensive." Tom Ewell, cast as Abe North, remarked: "I've read a lot of Fitzgerald, but we are not playing Fitzgerald. I follow the lines of [script writer] Ivan Moffat. This is a collaborative medium." Jason Robards, Jr., who had the lead role, added: "You could never do the book anyway. The book is too full. You can only do the idea." Moffat himself argued that *Tender Is the Night* "is a whole book of atmosphere, in which hundreds of incidents play a part in the structure of the main character. A novel can handle this, but in a film only the result is dramatic. What interests me most about the story is where the female devours the male when he's no longer performing his func-

tion. I don't know if we've done it correctly. F. Scott found it extremely difficult adapting things to movies, himself."¹⁹ Moffat's bald description of what interested him in the novel (and he might have gotten his description of the plot from a textbook in biology) leaves out everything that makes Tender Is the Night different from everything else ever written. If, in adapting a great novel, you alter its structure, change its point of view, omit its style,* strip away its levels of meaning, distort its characters, cast the film all wrong—what becomes of the novel's "idea"?

But if anyone must attempt the difficult task of adapting Fitzgerald to the screen, it should be someone with genuine rapport with the novelist and a command of his medium comparable to the writer's mastery of fiction. Such a director, as noted earlier, might be Antonioni. It is no secret that Fitzgerald is the Italian director's favorite novelist. As Penelope Huston points out, Antonioni's "attitudes towards the society he confronts in his work are ambivalent, with the result that a strong creative tension is set up. The moralist may despise privilege without responsibility; the observer admits the lure even of a corrupting beauty."²⁰ This same ambivalence distinguishes Fitzgerald's themes.

Analysis of L'Avventura (1959) reveals that Antonioni's technique has also been influenced by Fitzgerald's writing. Consider the scene in which Claudia—the heroine of L'Avventura—attempts to escape from her growing attraction to her best friend's lover, Sandro. Inside her valise Claudia carries, among other things, two books: the Bible and Tender Is the Night. Although the girl manages to get on a departing train, Sandro follows her and tries to make love to her. In a skillful use of contrapuntal structure, Antonioni plays off the young lovers against the voices of a strange woman and "one of those typical seducers from the provinces" nearby:

* True, Moffat retains some of the dialogue; but aside from the fact that good literary dialogue is not necessarily good film dialogue, the many pages of authorial narration and analysis are inevitably lost. Which means that "F. Scott's" unique voice, his tone, is eliminated.

WOMAN's VOICE: I work there but I'm really a stranger.

MAN's VOICE: I tell you this acquaintance of mine knows you and she has often spoken to me about you.

WOMAN's VOICE: And who is she? Does she work in Catania?

MAN's VOICE: Yes, she takes care of the garden.

WOMAN's VOICE: Then it's impossible for her to know me. In the villa where I'm at, we have a male gardener.

MAN's VOICE: So? That's logical. You see, both being gardeners, they spoke about you to one another.

WOMAN's VOICE: And what did they say about me?

MAN's VOICE: They told me that you were a very nice girl, that you always mind your business . . .

. .

. . . Sandro takes hold of Claudia's hand and presses it. She doesn't resist, but allows him to do it . . . Claudia presses up close to Sandro, amused and, at the same time, obviously moved.[21]

Antonioni's counterpoint technique in the above episode is strikingly similar to a scene in *Tender Is the Night*. When Nicole contemplates abandoning Dick and taking Barban for a lover, she struggles with herself in her garden:

> [Nicole] was somewhat shocked at the thought of being interested in another man—but other women have lovers— why not me? In the fine spring morning the inhibitions of the male world disappeared and she reasoned gaily as a flower. . . Through a cluster of boughs she saw two men carrying rakes and spades and talking in a counterpoint of Niçoise and Provençal. Attracted by their words and gestures she caught the sense:
>
> "I laid her down here."
>
> "I took her behind the vines there."
>
> "She doesn't care—neither does he . . . Well, I laid her down here—"

. .

"Well, I don't care where you laid her down. Until that night I never even felt a woman's breast against my chest since I married—twelve years ago . . ."

Nicole watched them through the boughs; it seemed all right what they were saying—one thing was good for one person, another for another.[22]

In both *Tender Is the Night* and *L'Avventura* a young woman is engaged in an inner conflict between passion and loyalty; while she struggles with herself a second scene is enacted (even Fitzgerald projects the scene almost entirely through dialogue), which crudely comments upon the woman's eventual surrender to sexuality. Antonioni also borrows the small detail about the "gardeners" from Fitzgerald's novel.

III

Fitzgerald's third, and last, trip to Hollywood was made in 1937. Two years earlier, after the unfavorable critical reception of *Tender Is the Night*, the novelist wrote his agent that he would like to earn some Hollywood money, but added that screenwriting "simply fails to use what qualities I have . . . No single man with a serious literary reputation has made good there. If I could form a partnership with some technical expert it might be done . . . This man would be hard to find, because a *smart* technician doesn't want or need a partner, and an uninspired one is inclined to have a dread of ever touching tops . . . I'm afraid unless some such break occurs I'd be no good in the industry" (*Letters*, p. 400, italics in original). Nevertheless, financial need drove Fitzgerald into the studios again.

This time, though, Fitzgerald vowed not to make the old mistakes. He took a job with MGM for one thousand dollars a week (the contract running for six months), and informed his daughter that he intended to so maneuver among his associates that in the

end he would succeed in working alone. In his efforts to master the technical side of the medium, the novelist maintained a file of movie plots, studied manuals on scenario writing, analyzed films at private showings, and sought out his fellow screenwriters for information.

Dwight Taylor, who accompanied Fitzgerald to the Thalberg party which became the source for "Crazy Sunday," has written: "I remember [Fitzgerald] was always worried about camera angles, but I pointed out that it was his dialogue and characterization that they were after, and if he could manage to get his story down he could be sure that they would photograph it."[23] Similarly Laurence Stallings, another scriptwriter, has remembered Fitzgerald as being very much concerned about the difference between a lap dissolve and a simple fade-out. Stallings told Fitzgerald that optical effects were decided elsewhere, but the novelist replied: "[M]ovies are a new art, and I wish to learn the medium . . . I wish to be a first-class film writer." According to Stallings, Fitzgerald described to him "a piece of business he had invented; something about a telephone connection with a boy and his sweetheart who had quarreled. The bit he liked best was a shot of an angel fluttering down from heaven to make the plug-in at a hotel switchboard." Stallings concludes: "Time was when Scott Fitzgerald could have brought off that sort of thing in a story with matchless grace; but it was an enchantment that a camera, with its prosaic eagle eye, could never understand."[24]

After a polishing job on *A Yank at Oxford* (1937), a trite entertainment film, Fitzgerald was assigned to do the script for Erich Maria Remarque's novel *Three Comrades*. Although the book is scarcely a masterpiece, Remarque's study of the Lost Generation offered itself as a congenial subject for the writer who gave the Jazz Age its name. Unhappily, however, Fitzgerald was to share the assignment with a "technician," Ted Paramore, who was an old acquaintance of his. Indeed, Paramore was the model for Fred E. Paramore in *The Beautiful and Damned*. Since Fitzgerald had characterized Paramore as a priggish writer of nonfic-

tion, an obnoxious do-gooder whose name the hero could not even remember, the real Paramore was inclined to regard the once popular novelist with mixed emotions. Inevitably, conflict developed between the two writers over the treatment of *Three Comrades*. Fitzgerald wished to emphasize the mood of postwar disillusionment; the "professional" wanted to focus on the love story. It is painful to read Fitzgerald's long letter to Paramore in which a major American writer is forced to justify his approach to a studio hack (*Letters*, pp. 558-560). Of course, the Paramore treatment triumphed. Consequently, Fitzgerald felt constrained to write another letter—this one to the producer, Joseph Mankiewicz: ". . . I guess all these years I've been kidding myself about being a good writer . . . For nineteen years . . . I've written best-selling entertainment, and my dialogue is supposedly right up at the top. But I learn from the script that you've suddenly decided that it isn't good dialogue and you can take a few hours off and do much better . . . Oh, Joe, can't producers ever be wrong? I'm a good writer—honest" (*Letters*, pp. 563-564). It was Manckiewicz's contention that Fitzgerald's dialogue was too often redundant in a primarily visual medium. Which may have been true; perhaps the novelist had not yet mastered the technique of screenwriting.

This is not to say, however, that all the wisdom resides on the Paramore-Mankiewicz side. Henry Dan Piper argues: "Fitzgerald's treatment was original and unconventional, but it would have required an unusually talented director to turn it into a good film. The Mankiewicz-Paramore version was a much more predictable box-office success in every way."[25] If the cash register is the only consideration in film-making, then maybe Piper's reasoning makes sense. However, it does not seem to be unreasonable for a screenwriter to do the very best job he can, and to assume that a director of equal ability in his line will translate the script into motion pictures. What other industry would pay a man a thousand dollars a week for deliberately performing at a level far below his capacity? Suppose Antonioni, and not Frank Borzage, had directed

Three Comrades—would the "professional" viewpoint have seemed so cogent then? *Blow Up* (1966)—according to the "professionals"—should not have been a box office success. Yet it made more money than most films constructed for the market alone. The trouble with the "professional" mind is that it is too frequently *unprofessional*. But then Antonioni doesn't have to contend with the Paramores and the Mankiewiczs; the Italian film-maker writes and directs his own movies. According to Sheilah Graham, Fitzgerald saw this as the only solution to the problem of making films.* "Movies can be literate as well as commercial," he told her. "Why can't the writer also be the director? One man in control from the inception of the film to the finish." As Miss Graham observes: "This is quite usual today, but Scott was laughed at when he suggested it in 1937."[26]

Fitzgerald signed another MGM contract for six months at twelve hundred and fifty dollars per week, and started work on a film called *Infidelity* for Joan Crawford. The studio encountered censorship difficulties, though, and, in spite of a ludicrous change of title to *Fidelity*, the picture was finally shelved. After polishing Donald Ogden Stewart's script for *The Women* (1939), Fitzgerald was assigned to *Madame Curie* (1943). "I disagreed with everybody about how to do *Madame Curie*," the writer told his daughter, "and they're trying it another way" (*Letters*, p. 50). Fitzgerald also managed to get a hand in the scripting of *Gone With the Wind* (1939), finding the experience at least partly entertaining: "Do you know . . . I was absolutely forbidden to use any words except those of Margaret Mitchell," he informed Max Perkins; "that is, when new phrases had to be invented one had to thumb through as if it were Scripture and check out phrases of hers which would cover the situation!" (*Letters*, p. 284).

When MGM failed to renew Fitzgerald's contract in 1939, the

* In 1924 Fitzgerald wrote an unpublished outline of an essay, tentatively entitled "Why Only Ten Percent of Movies Succeed," in which he maintained that the director is the real creator of the film, and that movies will increase in artistry as better directors develop. This is, of course, the essence of the *auteur theory*.

author was compelled to free-lance. He was engaged to do the
script for Walter Wanger's *Winter Carnival* (1939)—a light-
weight project starring Ann Sheridan and Richard Carlson—with
co-writer Budd Schulberg. The story of the making of that film has
often been told; suffice it to say that Fitzgerald and Schulberg both
arrived drunk for location shooting at Dartmouth College, and
that Fitzgerald was fired by Wanger. (Schulberg later fictionalized
the tragicomedy in his novel, *The Disenchanted* [1950].) Al-
though Fitzgerald's reputation in Hollywood was hardly very high
at this point,* MGM paid him for some polishing work, and
United Artists hired him for a week to streamline *Raffles* (1939).
After completing an adaptation of his short story, "Babylon Re-
visited," Fitzgerald spent some time on *Brooklyn Bridge* and *The
Light of Heart* for Twentieth Century-Fox; both projects, how-
ever, were eventually shelved. And that was the end of Fitzger-
ald's screenwriting career. He died on December 21, 1940.

IV

While Fitzgerald was enduring the precarious existence as a free-
lance scenarist, he began writing a series of stories for *Esquire*
(seventeen in all) about a Hollywood hack named Pat Hobby.
The stories, which have been gathered together in book form, are
not representative of Fitzgerald's best work, but they do project an
interesting portrait of a type that the writer had come to know
quite well in his final years. Hobby, who is forty-nine years old,
has been a screenwriter for twenty years, during which time he has
earned thirty credits. According to Hobby, film-making is an in-
dustry, not an art ("Boil Some Water—Lots of It"); conse-
quently, Hobby regards himself as a writer, not an author
("Mightier Than the Sword"). When assigned to do an adapta-
tion, Hobby does not trouble himself to read the original; instead

* Dorothy Parker recalls a "director who put his finger in" Fitzgerald's
"face and complained, 'Pay *you*. Why you ought to pay us.' "[27]

he gets four of his friends to study the source and after they give him their reactions, he does the scenario ("A Man in the Way"). Indeed Hobby—who "used to be a good man for structure"—has "scarcely opened a book in a decade"; he remarks: "In silent days was where you got real training—with directors shooting off the cuff and needing a gag in a split second. Now it's a sis job. They got English teachers working in pictures" ("Teamed With Genius"). Hence, Hobby has had only a few credits in the past five years ("Pat Hobby and Orson Welles"); and his salary has dropped to two hundred and fifty dollars a week ("Pat Hobby's Secret"). In view of the fact that "not so much as a trio of picture writers were known to the public" ("The Homes of the Stars"), Hobby's great dream is to become a producer ("Pat Hobby's Christmas Wish"). In spite of the comic approach taken in the series, it is not difficult to detect Fitzgerald's bitterness over his Hollywood experiences.[28]

In 1939 Fitzgerald sold "Babylon Revisited"—his finest short story and one of the best short stories in American literature—to an independent producer, Lester Cowan, for one thousand dollars. Miss Graham recalls: "Cowan hired Scott to write the screenplay and paid him another three hundred a week for ten weeks. The four thousand dollars gave the producer eternal film rights to the story, whatever kind of films were made from it—no matter where they were shown, to one person or a million. It was the most ruthless contract I have ever read."[29] Fitzgerald changed the title of "Babylon Revisited" to *Cosmopolitan*, and proceeded to labor for six hours a day on the adaptation. Reports have it that the writer was happier on this project than on any other in Hollywood. Not surprisingly, though, his script was rejected. Afterward Cowan sold the story (not the scenario) for a hundred thousand dollars to MGM, who then engaged no less than three writers (apparently all "good men for structure") to "improve" on the original. The result of all this maneuvering and toil was *The Last Time I Saw Paris* (1954), directed by Richard Brooks (who was also one of the Pat Hobbys on the script), and featuring Van

Johnson and Elizabeth Taylor. Reviewers dismissed the film as just another sumptuous soap opera from the Dream Factory . . . Could *Cosmopolitan* have been any worse?

In 1947 James Thurber told Bennett Cerf that when Lester Cowan asked a certain writer to revise Fitzgerald's script, the scenarist remarked: "This is the most perfect motion picture scenario I have ever read. I don't see why you want to revise it"; to which Cowan replied: "You're absolutely right. I'll pay you two thousand dollars a week to stay out here and keep me from changing one word of it."[30] The story sounds apocryphal. *Cosmopolitan* is far from being a "perfect" scenario. This is not to say that it has no value, or that it would not prove instructive to examine the script in some detail. Fitzgerald's various plans for *Cosmopolitan* are in the Firestone Library at Princeton. The second, and last, revised draft is dated August 13, 1940—roughly four months before the writer's death. If Fitzgerald possessed any talent for screenwriting it should have been displayed in this last full script he adapted from "Babylon Revisited."

First, however, it should be noted that about a year before writing *Cosmopolitan* Fitzgerald ghosted a long lecture about Hollywood for Sheilah Graham. This piece of writing shows clearly that the novelist had an understanding of the basic principles of cinema, and that he was well aware of the essential differences between fiction and film. "A writer's instinct," Fitzgerald wrote, "is to think in words. The director has got to work with the writer and turn the writer's words into visual images for the camera. We can do without speeches, but we've got to see, for on the screen, *seeing* is believing, no matter what the characters say. . . ." Whereas the reader of fiction can skip dull passages, the movie viewer is compelled to watch everything—or exit. "So, there can be no uninteresting parts, nor even any highly complicated parts [in a film]. Everything has got to be simple, forthright, and compellingly interesting." Nor does visual appeal necessarily mean violent action; visual impact can be conveyed by something small but revealing. Fitzgerald stressed that movies "can convey an

emotion more easily than a *thought*. Pictures are an emotional rather than an intellectual medium."[31]

Although the lecture reveals Fitzgerald's grasp of cinematic fundamentals, his task of applying such knowledge to an adaptation of a short story masterpiece like "Babylon Revisited" remained far from simple. The story covers about eighteen pages and is divided into five parts. Structurally, "Babylon Revisited" resembles a tragedy, with the turning point occurring in part four when the "ghosts out of the past"—Lorraine and Duncan—materialize at the Peterses to upset Charlie's hopes of regaining custody of his daughter Honoria. Conflict is strong in the story: Charlie is the protagonist, Marion is the antagonist. Except for a single paragraph all the action is seen from Charlie's point of view. In addition to its dramatic structure, "Babylon Revisited" has an overall cyclic pattern, beginning as it does in the Ritz Bar and ending in the same place—thus underlining the idea that one cannot escape the past.

Whereas a novel needs to be cut drastically for the screen, a short story generally needs to be expanded if it is to last the required number of reels. Hence the tight dramatic structure of "Babylon Revisited" had to be collapsed in order to enact the story within proper filmic limits; similarly, the neat cyclic pattern had also to be altered with the addition of new material. Fitzgerald's *Cosmopolitan* script runs to a hundred and thirty-six pages, and is divided into five major sequences of action. Henry Dan Piper remarks: "To the story of Charlie Wales's touching effort to regain custody of his small daughter, [Fitzgerald] added a sentimental love story between Wales and a hospital nurse, as well as a gangster subplot that brought the film to a close with a slapstick cops-and-robbers chase across Paris. In the process, the tender father-daughter relationship of the original story, and the memorable mood of *temps perdu*, were both virtually obliterated."[32] Fitzgerald also provided *Cosmopolitan* with a happy ending in place of the original "catastrophe."

Although Fitzgerald was enormously interested in the art of the

film, and although he held great hopes for the future of the medium, his experience with the studio system had persuaded him that good material was not really wanted in Hollywood; in short, he could not approach film-making with the complete seriousness he reserved for novel writing. As a result, he was led into padding *Cosmopolitan* with plot devices gleaned from trashy movies. Yet one must remember that before he wrote *The Great Gatsby*, Fitzgerald had turned out inferior novels such as *This Side of Paradise* and *The Beautiful and Damned*. Given time, encouragement, and increasing self-confidence, the author might very well have created that "perfect motion picture scenario" which some fanciful individual erroneously claimed for *Cosmopolitan*. But this is to put the matter in too negative a light. Piper overstates the case against Fitzgerald's script. True, the plot of "Babylon Revisited" is cheapened in its transformation into *Cosmopolitan*; nevertheless, there are some good things in the scenario. What is most striking about *Cosmopolitan* is its clear evidence of Fitzgerald's developing cinematic imagination—an imagination which was to appear again, and in a much more brilliant fashion, in *The Last Tycoon*.

At the end of the *Cosmopolitan* script, Fitzgerald says: "This is an attempt to tell a story from a child's point of view. . . ." The reader will recall that in "Babylon Revisited," Charlie was the commanding center; by placing Honoria—Victoria in the film—in the center, Fitzgerald introduced a major alteration in the structure. Frankly, though, the author's note about point of view is not entirely accurate. Some of the action is seen from Charlie's perspective, and at times the little girl is not even present. It is a rare movie, however, that is wholly consistent in point of view. By alternating Victoria's viewpoint with her father's, Fitzgerald projects an interesting and complex counterpoint that is probably more satisfying than if he had maintained a single limited focus of observation. Nevertheless, the chief angle of vision remains Victoria's. Hence when the child pleads with the agent at the railroad station to let her on the train even though she lacks the fare, Fitzgerald notes: "Victoria's back is toward us. We only see the

agent from her level, enormous and ominous as he looms over her (This is a point where the camera might be tipped up from Victoria's angle to point at the agent.)" Similarly, when Charlie fusses about his daughter's poor posture, the camera "is low at this point to include in a two shot all of Victoria, leaving out her father's head and shoulders. Through this shot it continues to photograph at this level." At times the camera itself becomes an active observer, as when Fitzgerald calls for it to pan "a little way into [a] crowd as if searching for Victoria and her father."

Throughout the script Fitzgerald holds dialogue to a minimum. Diction and syntax are kept fairly simple, and there are very few speeches of any great length. Repeatedly the writer asks for facial expressions and gestures to convey emotional effects. Furthermore, there is a noticeable stress on objects—such as, Victoria's schoolbag or a ticker tape—in the scenario, objects which the eye of the camera can magnify into symbols on the screen. Nor is Fitzgerald neglectful of variety. *Cosmopolitan* calls for approximately three hundred camera setups, with instructions for varying camera distance and angle to render each scene as expressively as possible. In other words, Fitzgerald is not afraid to use the unique resources of his medium (and I don't think he can be accused of *over*using them either) in order to give life to his story. When the ticket agent refuses to allow Victoria on the train, for example, "music surges up, as the camera moves swiftly backward and we see this part of the station from a wide angle: the waiting orphans, the little girl turning away from the ticket window, the nun taking her place." Perhaps a more subtle instance of Fitzgerald's cinematic imagination appears shortly after the opening of the film. We watch Victoria walking down the street, absorbed in thought; and as she walks, the camera trucks back before her, so that she appears to be walking directly towards *us*, thus increasing our sympathy for her.

Fitzgerald also employs montage effects in *Cosmopolitan*— most tellingly in the climactic scene on shipboard when Helen Wales commits suicide. As tension mounts, Charlie's face is high-

lighted, "very distraught, with other faces around him—all speaking to him:

VOICES

Not here, Mr. Wales.
Not there, Mr. Wales.
Not in her room.
Not in the bar, Mr. Wales.
Not in there, Mr. Wales.

Throughout this, the ship's dance orchestra is playing tunes of 1929 in a nervous rhythm." Fitzgerald then cuts abruptly to a "dark sky filled with seagulls. The sudden sound of a wild shriek —which breaks down after a moment, into the cry of the gulls as they swoop in a great flock down toward the water. Through their cries we hear the ship's bell signalling for the engines to stop." By using the technical means at his disposal, Fitzgerald is thus able to present Helen's suicide *indirectly*—which is often a sign of superior artistry.

Finally, though Fitzgerald abandoned the cyclic structure of "Babylon Revisited," he managed to pattern *Cosmopolitan* with recurrent images. At the end of the first sequence, the camera searches out the girl seated in the train: "Through the glass of the compartment door, in the background of the shot, we see Victoria." Cut then to the inside of the car for a close shot of the child, looking very much alone. Afterward, in the final sequence, the script calls for a similar exterior shot of a funicular car. Cut suddenly to the inside of the car for a close-up of Victoria, again looking forlorn. "She should be picked up in profile," notes Fitzgerald, "or in the same sort of shot in which we left her at the end of Sequence One."

To conclude: although the plot of *Cosmopolitan* leaves much to be desired, the technique through which the story is rendered shows that Fitzgerald had begun to master the skills of screenwriting. In time, as noted, the author of *The Great Gatsby* and *Tender*

Is the Night might have been able to bring form and content together for the creation of a cinematic work of art.

V

That Fitzgerald's last years in Hollywood had an enormous influence on his imagination can be seen from a consideration of *The Last Tycoon*. According to Sheilah Graham, the writer had been thinking about a Hollywood novel ever since his first encounter with Thalberg. "No one's yet written *the* novel on Hollywood,"* Fitzgerald told her, adding that "most writers had approached Hollywood almost sneeringly, treating it as though it were a cartoon strip peopled by one-dimensional comic-book characters—every producer gross and illiterate, every writer charmingly unstable, every star an overgrown child." Fitzgerald vowed to "write a serious novel" about the movies, its focus on Thalberg, and its basic theme "the creative versus the commercial."[33]

In the lecture he wrote for Miss Graham, Fitzgerald says: "Once in a while a great figure has appeared [in Hollywood] Griffith was one, Thalberg was another. There is no such person now . . . no single person whom we, of the movie industry, believe capable of controlling this vast art in all its many manifestations."[34]

Monroe Stahr, the character Fitzgerald based on Thalberg, represents responsible power. When a Negro informs Stahr that he never goes to the movies or allows his children to go, the tycoon reflects:

* Over five hundred novels have been written with Hollywood settings. Naturally, the quality of such works varies greatly. On the one side lie *The Last Tycoon*, Nathanael West's *The Day of the Locust*, Evelyn Waugh's *The Loved One*, and Norman Mailer's *The Deer Park*. Somewhere in between perhaps are Budd Schulberg's *What Makes Sammy Run?* and Irwin Shaw's *Two Weeks in Another Town*. While on the far side—and composing the bulk of the genre—are such "fleshploitation" items as *The Movie Maker* (Herbert Kastle), *The Deal* (G. William Marshall), and *The Beautiful Couple* (William Woolfolk).

A picture, many pictures, a decade of pictures, must be made to show him he was wrong. Since he had spoken, Stahr had thrown four pictures out of his plans—one that was going into production this week. They were borderline pictures in point of interest, but at least he submitted the borderline pictures to the negro and found them trash. And he put back on his list a difficult picture that he had tossed to the wolves, to Brady and Marcus and the rest, to get his way on something else. He rescued it for the negro man.[35]

Stahr "was a marker in industry like Edison and Lumière and Griffith and Chaplin. He led pictures way up past the range and power of the theater, reaching a sort of golden age, before the censorship" (p. 28); "almost single-handed [Stahr] had moved pictures sharply forward through a decade, to a point where the content of the 'A productions' was wider and richer than that of the stage" (p. 106). By linking Stahr to various American presidents—Jackson, Lincoln, McKinley (even the producer's first name is derived from a president)—Fitzgerald seeks to establish the movie executive within an existing, though difficult to locate, tradition of authority. Stahr seems to embody the American Dream, which is threatened—as always—by crass commercial designs.

Yet the novelist's view of Stahr is not unrealistically adulatory. In a note on *The Last Tycoon*, Fitzgerald says: ". . . I want to show that Stahr left certain harm behind him just as he left good behind him" (p. 150). According to Cecilia, the narrator, Stahr "watched the multitudinous practicalities of his world like a proud young shepherd" (p. 15); Robby—Stahr's troubleshooter on the lot—is referred to as a "sheep dog" (p. 26). In other words, the tycoon is paternalistic—he is *too much* of a shepherd. (In Chaplin's *Modern Times* [1936], with which Fitzgerald was probably familiar, a picture of rushing sheep is immediately followed by a shot of fast-moving workers.) How could the author of *The Last Tycoon* give his complete sympathy to a producer who used scriptwriters in teams? Although Stahr is a great man and an organizational genius, his type is doomed. In Fitzgerald's story,

"The Last Kiss" (1940), a character says of Hollywood: "It's a jungle. Full of prowling beasts of prey."[36] A close analysis of the imagery in *The Last Tycoon* reveals Fitzgerald's view of Hollywood as a "jungle." The worst tendencies of an acquisitive society seem to be emphasized in the movie business. Eastern finance controls the studios, thus imposing its box-office standards on producers, directors, writers, everyone. Stahr, finally, is caught between two implacable forces: the first, represented by Brady, wants to debase man and art in the interests of money; the second, symbolized by Brimmer, seeks to organize labor in the interests of the class struggle.

In an unpublished note on the novel, Fitzgerald remarks of a character: "His submission of a scenario was probably a very quaking venture on his part . . . He must have had no more aesthetic education after finishing secondary school than I did . . . [H]e probably learned pictures from pictures." Fitzgerald himself, though, did not wholly rely on either his experiences in the studios or his watching of pictures in preparing himself for *The Last Tycoon*. "Get from the library the books on the movies and go through them," he writes in another manuscript note. "First get list of titles of such books." Fitzgerald's papers indicate that he had read material such as Terry Ramsaye's history of the silent film era, *A Million and One Nights* (1926), William C. de Mille's autobiography, *Hollywood Saga* (1939), and Thalberg's 1932 article for *Fortune*.

More important, Fitzgerald's notes make clear how deeply his filmic imagination was stirred by the material he did not live to finish. Speed, fluidity—that was what the novelist wanted in *The Last Tycoon*: "We are going to cut at this point to the meeting of camera men (cutters) at which Robinson will be present"; "We will go from here by the very quickest way"; "Words too long"— he remarks in the margin of one passage; and so forth. "In a very short transition or montage," he says in a note published with the novel, "I bring the whole party West on the Chief" (p. 153).

But there is not only quick cutting in *The Last Tycoon*—there

are seven short scenes (eight planned) in the twenty pages of Chapter Three, for example, and seven scenes in the seventeen pages of Chapter Four—there is also evidence of parallel editing. Fitzgerald's intentions are perfectly clear on this point: "Talk with Eisenstein," he says in a manuscript note; and, more meaningfully, he remarks elsewhere: "Cross-cutting in Eisenstein." In Chapters Three and Four the focus is steadily on Stahr; in Chapter Five, however, the writer keeps shifting his point of view from one character to another. Hence Cecilia narrates her own activities for several pages; then there is a cut to Stahr and Kathleen which occupies about twenty-seven pages; this is followed by another cut to the narrator as she again recounts her experiences during the time period just treated (which takes six pages); and then there is a final cutaway to Stahr.

"Even unfinished," King Vidor says of *The Last Tycoon*, "it is the best novel of Hollywood."[37] Most critics agree with Vidor's evaluation. In my opinion, *The Last Tycoon* represents one of the most striking applications of the cinematic imagination to a literary subject that has yet been written. Only the stream-of-consciousness genre and some works in Hemingway's canon possess anything comparable to Fitzgerald's achievement in his last novel. Although the writer had movie construction in mind during the composition of *The Last Tycoon*, he did not commit Dos Passos's mistake in *U. S. A.* of projecting a "movie novel." Fitzgerald's cinematic method remains relatively unobtrusive; the technique is assimilated to the subject, and not the other way around; the emphasis properly remains on character; and without the authority of the writer's presence—that is to say without the tone and style of the narrator—the novel would be nothing.

Nathanael West—The Pictorial Eye in Locust-Land

The world outside [of Hollywood] doesn't make it possible for me to even hope to earn a living writing, while here the pay is large (it isn't as large as people think, however) enough for me to have three or four months off every year. . . .

—Nathanael West

I

The day after Fitzgerald died from a heart attack in Hollywood, Nathanael West was killed in an automobile accident near El Centro, California. Although Fitzgerald admired West's last novel, *The Day of the Locust* (1939), he could not concur in his fellow screenwriter's savage, wholesale attack on Hollywood. But then perhaps West had much more reason than even Fitzgerald had to be bitter about the studio system and the fate of the writer in America.

Today, West's literary reputation is high and his novels are required reading in colleges across the land. During his lifetime, however, West's fiction was not widely read. When he went out to California to write movie scripts, he had to defend himself against attacks on the score of "selling out" by reminding his critics that even an artist cannot live on two hundred and sixty dollars a year. (West's total earnings from two novels in three years was seven hundred and eighty dollars.) West argued—and how familiar the

argument sounds!—that writing screenplays permitted him several months of leisure each year in which to compose his serious fiction. Unlike Fitzgerald, however, West worked for the shoddier studios and received only three hundred and fifty dollars per week. Yet West had one thing in common with the author of *The Great Gatsby*; like Fitzgerald, West saw his finest novel, *Miss Lonelyhearts* (1933), mangled until it was unrecognizable in a screen adaptation.

In fact, it was the publication of *Miss Lonelyhearts* which first brought the novelist to the attention of the motion picture people. Although West's masterpiece sold less than eight hundred copies, the better reviewers of the time greeted its appearance with high praise. Twentieth Century-United Artists not only promptly purchased the screen rights but they also hired West as a scenarist. It was Leonard Praskins, however, who performed the hack work on *Miss Lonelyhearts*—transforming it into *Advice to the Lovelorn* (1933), with Lee Tracy in the starring role. It would be a waste of time to discuss the film. The critics rightly dismissed it, as *Time* put it, as one "more farce-melodrama of the cityroom"; while William Troy added that *Advice to the Lovelorn* somehow manages to get "mixed up with a propagandist thesis directed against chain drugstores which sell poisonous prescriptions."[1] Hollywood made no attempt to be even faintly loyal to West's subject matter or vision of life.

Yet even had the film-makers endeavored to treat *Miss Lonelyhearts* in good faith there is reason to doubt that the novel would have lent itself to successful adaptation. There is probably no more misleading statement about West's novel than the following by Josephine Herbst: "[The] realism [of *Miss Lonelyhearts*] is not concerned with actuality but with the comprehension of a reality beyond reality. The furniture of the speakeasy, the upside-down quality of New York night and day life provide a background that only a fine movie camera could actually interpret. . . ."[2] Since when was the movie camera ideally suited for photographing "a reality beyond reality"? West's writing, it is true, is filled with

images; but—well, there are images and images, and not all of them are cinematic.

It is no secret that West had a "pictorial eye."[3] Throughout his life the writer remained very much interested in painting. At one time, West even considered subtitling *Miss Lonelyhearts* as *A Novel in the Form of a Comic Strip*. Though he decided against this idea, he kept (in his own words) "some of the comic strip technique: Each chapter instead of going forward in time, also goes backward, forward, up and down in space like a picture."[4] A number of contemporary film directors have admitted being influenced by the comics. One such is Antonioni. Another is Godard, whose *Alphaville* (1965) clearly uses "the comic strip technique." And Resnais has said: "What I know about film has been learned from comic-strips as much as from the cinema—the rules of cutting and editing are the same for the comics as for the cinema." Similarly, more than one film historian has called attention to certain similarities of structure and composition in movies and comics.[5]

Nevertheless, it is important to recognize a crucial difference between, on the one side, paintings and comics, and, on the other, movies. As Antonioni has said: "*seeing* is a necessity [for a director]. For a painter too, the problem is *to see*. But while the painter has to discover a static reality, or even a rhythm perhaps, but a rhythm stopped in midair, the problem for a director is to catch reality an instant before it manifests itself and to propound that movement, that appearance, that action as a new perception."[6] Compare the foregoing remarks by the Italian film-maker with James F. Light's observations on West's novel: "Juxtaposed pictorially against the growing alienation of Miss Lonelyhearts from the world of reality, the minor characters serve primarily as contrast and chiaroscuro. This static, pictorial quality is also true of the actions, which seem like candid snapshots of people caught in mid-air against a background of dull sky and decaying earth. Each action becomes a symbol of an abstract state of mind and heart, and leaves one remembering a series of almost independent

pictures rather than with a memory of the developing actions. . . ."⁷ In short, *Miss Lonelyhearts* reveals a pictorial eye—but it is the eye of a painter or a photographer, not the eye of a novelist with a cinematic imagination.

Consider West's use of language. In *Miss Lonelyhearts* the imagery is rarely, if ever, filmic—as the following excerpts make clear: "[Miss Lonelyhearts] walked into the shadow of a lamp-post that lay on the path like a spear. It pierced him like a spear"; "He searched the sky for a target. But the gray sky looked as if it had been rubbed with a soiled eraser. It held no angels, flaming crosses, olive-bearing doves, wheels within wheels. Only a news-paper struggled in the air like a kite with a broken spine"; "He felt like an empty bottle that is being slowly filled with warm, dirty water"; "He fastened his eyes on the Christ that hung on the wall opposite his bed. As he stared at it, it became a bright fly, spinning with quick grace on a background of blood velvet sprinkled with tiny nerve stars. Everything else in the room was dead . . . He thought of this black world of things as a fish. And he was right, for it suddenly rose to the bright bait on the wall. It rose with a splash of music and he saw its shining silver belly."⁸ In the same way, West's dialogue remains nonfilmic. His characters are sym-bols or types, not "real people"; consequently, the speeches they make—especially Shrike's—remain rhetorical.

That *Miss Lonelyhearts* is not cinematic receives additional support from an analysis of a second screen version of West's novel—called simply *Lonelyhearts* (1958)—written by Dore Schary and directed by Vincent J. Donehue. Unlike *Advice to the Lovelorn*, *Lonelyhearts* merits discussion, though it cannot be affirmed that the film is a success either on its own terms or as a faithful adaptation. Nonetheless, the Schary-Donehue treatment manages to reveal the basic difficulties of structure, character, dialogue, and theme facing any film-maker attempting to translate *Miss Lonelyhearts* into pictures.

The structure of West's short episodic novel is divided into fifteen chapters. Each chapter represents an attempt on the part of

the title character to solve the tormenting problem of human suffering. In the film, West's fifteen segments of action are expanded into twenty-six scene units in an endeavor to impose a greater mobility on the original material. By omitting such chapters as "Miss Lonelyhearts and the Clean Old Man" and "Miss Lonelyhearts and Mrs. Shrike," Schary and Donehue further seek to render the film more tightly unified and dramatic than the novel. (The movie treatment was also partly based on an equally unsuccessful stage version of *Miss Lonelyhearts*.) But the omission of the second chapter mentioned also underlines major alterations in character and theme.

As noted, in *Miss Lonelyhearts* West's characters are flat; they function as symbols in a highly stylized rendering of life. The film medium—though it can handle people in the mass better than the stage or the novel—also favors the individual and the concrete. Understanding this bias of the camera, Schary and Donehue try to make West's characters more "real," or psychologically complex, than they are in the novel. Hence Miss Lonelyhearts (played by Montgomery Clift) is given a name: Adam White; and his motivation is made more "plausible." Early in the movie White visits his father who has been imprisoned for the murder of the hero's mother and her lover; this unfortunate background has influenced White's view of evil and universal suffering. Likewise, the cynicism and bitterness of West's anti-Christ, Shrike, is "explained" in terms of his wife's single infidelity years before the opening of the film. In their attempt to make Shrike more "realistic," it is interesting to note, the film-makers omit much of the novel's original dialogue. This was, to be sure, necessary; for where Shrike's key speeches are retained, none of actor Robert Ryan's skills can prevent the words from sounding unbelievably hollow and literary. Finally, the elimination of the scene in which Miss Lonelyhearts tries to seduce Mrs. Shrike (played in the film by Myrna Loy) is an obvious effort to make both characters more "sympathetic." As a result, the film becomes so much less Westian and that much more Hollywooden.

Not surprisingly, then, the theme of *Miss Lonelyhearts* all but disappears in its transference to celluloid. The film-makers, in deference to the censors and to the box office, continually play down West's animosity toward religion. (Even *Peter* Doyle is changed to *Pat* Doyle!) At the conclusion, in place of Miss Lonelyhearts's insane identification with God and his destruction at the hands of Peter, the movie has Adam White soothing his would-be assassin, converting Shrike to the positive thinking "theology" of Norman Vincent Peale, and agreeing to continue his column for the paper. Montgomery Clift even gets to marry a beautiful Dolores Hart! In other words, *Lonelyhearts* fades out on a trite studio happy ending.

II

After the release of *Advice to the Lovelorn* West left California, went back East, and wrote "Business Deal," a not very good short story in which he attacked the movie industry. Two years later, however, the novelist was back on the Gold Coast working for Republic Studios. During 1936, West collaborated on three films: *Ticket to Paradise, Follow Your Heart* and *The President's Mystery*. The titles of these movies alone are an indication of their quality, though the last named received a fair critical reception at the time. In 1937 West wrote *Rhythm in the Clouds*, and in 1938 an original scenario called *Born to be Wild*. Also in 1938, the novelist teamed with Dalton Trumbo and Jerry Cady at RKO Radio to do *Five Came Back* (released in 1939), a melodrama about a plane crash in the jungle with Chester Morris and Wendy Barrie. Around this same time West also sold a play, *Good Hunting*, to Hollywood, but apparently it never went before the cameras. The year 1939 saw West further lending his talents to *I Stole a Million* and *Spirit of Culver* for Universal; while the following year he moved back to RKO Radio for *Let's Make Music* and *Men Against the Sky*—the latter a routine aviation melodrama

featuring Richard Dix, Wendy Barrie, Kent Taylor, and Edmund Lowe. The year that he died West sold his 1934 novel, *A Cool Million*, to Columbia and worked on an adaptation of it with Boris Ingster, who had previously worked with Eisenstein; once again, though, the film property never materialized on the screen.

In *Hollywood: The Movie Colony and the Movie Makers*, which was published the year after West died, Leo C. Rosten offers some illuminating material on the artistic versus the financial conflict within the studio system. According to Rosten's findings, based on the work of trained researchers, "writers, of all the groups in the movie colony, feel most frustrated by the constricting demands of producers, the public and censorship." The scriptwriter is not treated with any respect; and he is forced to work with people whom he despises. But the basic cause of the writer's discontent, Rosten contends, is his lack of control over his story material. Whereas the producer wants a picture to make money, the writer wants it to be a work of art, or if that isn't quite possible, at least something he need not be too much ashamed of. Writers who have worked only in pictures and writers who have been newspapermen are the happiest as scenarists; novelists and dramatists—in other words those who have enjoyed absolute or near absolute sovereignty over their work—are the unhappiest people in picture-making.[9]

That West could not have possibly been happy in Hollywood goes without saying. According to Wells Root: "[West] was a competent screen writer . . . He could turn out a sound script in a reasonable time . . . I think he figured in respect to producers and directors that movies were their business, not his. He was a sort of architectural assistant working on plans for a house." Is it likely, though, that West's considerable work for the screen in the years during which he was also writing *The Day of the Locust* had no influence on that novel? Says Root: "Whatever happened to [West] in pictures, good or bad, up to the time of his death, had affected in no way his real work, which was writing novels."[10] Even a brief consideration of the subject matter of *The Day of the*

Locust—to say nothing for the moment of its technique—is sufficient to refute this.

"It is hard to laugh at the need for beauty and romance, no matter how tasteless, even horrible, the results of that need are," West writes near the beginning of *The Day of the Locust*. "But it is easy to sigh. Few things are sadder than the truly monstrous" (p. 3). Movies project an unrealistic picture of life; people like the character Faye Greener, though, mistake the false images flickering on celluloid for the true and the beautiful. Indeed, Faye is so captivated by movies that she dreams of writing similar fantasies—thus becoming even further estranged from things as they are. The screenwriter, Claude Estee, knows the hoax being played on the public; yet, speaking of the "real," he can only lament: "It's good, but it won't film. You've got to remember your audience. What about the barber in Purdue? He's been cutting hair all day and he's tired. . . . What the barber wants is amour and glamor" (p. 15). Two of Estee's friends blame the fraud on the Jewish bosses who control the industry; at the same time, however, they cannot help admiring such "successful" individuals: "Maybe they're intellectual stumblebums, but they're damn good business men. Or at least they know how to go into receivorship and come up with a gold watch in their teeth" (p. 14). The famous nightmare-like chapter that concludes the novel—that insane eruption of repressed frustration and aggression on the part of the masses—is the product of a vast spiritual and aesthetic hunger in American society which the Hollywood Dream Factory has cruelly exploited.

Several critics have been perceptive enough to note that West's technique in *The Day of the Locust* is cinematic. Richard B. Gehman, for example, describes the structure of the novel as "panoramic": "The early scenes are leisurely, fading in and out as though the writer were turning his mind upon them like a camera, and then, as the characters come more and more into focus, becoming tighter, faster and more merciless" (p. xix). James F. Light contends that *The Day of the Locust* "owes more to West's

writing of screenplays than to any other source. In writing for the
screen West learned the cinematic advantages of writing in short
scenes or 'shots' . . . The use of this roving, panoramic technique
in *The Day of the Locust* effects extreme pictorialization, often
highly symbolic, as well as numerous short chapters. In most of
the chapters image upon image is flashed swiftly upon the reader's
eye."[11] Not all commentators have regarded the filmic mode of
West's novel with approval; thus an early critic remarks: "The
worst fault of the book is that it follows the choppy, episodical
technique of a movie scenario. It has that peculiar disorganization
that most movies have. Maybe this was deliberate on the part of
the author; if so, I think it was ill advised."[12]

I think Gehman and Light are largely correct in their analysis,
though I would question the latter's suggestion that movie-writing
necessarily determined West's use of "short scenes." The twenty-
seven chapters of *The Day of the Locust* average about five pages
each; the fifteen chapters of *Miss Lonelyhearts*—written before
West had any scenario-writing experience—average about six and
a half pages. Perhaps it would be more correct to argue, then, that
the novelist's stay in Hollywood intensified an already existing
tendency in him to write "in short scenes or 'shots'." *Miss Lonely-
hearts* and *The Day of the Locust* are both episodic novels; if
the earlier work is a more satisfactory piece of fiction than the
later one, the reason would seem to lie not in the cinematic nature
of *The Day of the Locust* but in its uncertainty in regard to point
of view. (Some readers find Tod Hunter at the center of the action,
others believe that Homer Simpson is the major character.) The
average movie is no more "disorganized" than the average novel.
West's adoption of a filmic method of presentation in a book
about Hollywood is a strategy that should be praised rather than
condemned. What I am saying is that *The Day of the Locust*, like
The Last Tycoon, is in no way a "movie novel."

In my discussion of *Miss Lonelyhearts*, I pointed out that char-
acter in that novel was projected in a highly symbolic manner, and
that the second film version of the book succeeded in making

West's stylized literary conventions even more apparent. It is still another sign of Hollywood's influence on West that in *The Day of the Locust*—though the symbolic element is far from absent—his characters possess a "realistic" dimension, too. The reader learns little or nothing about the backgrounds of the individuals in *Miss Lonelyhearts*; in *The Day of the Locust* Homer, Faye, and several others have a biography, or a life story behind them. Furthermore, whereas much of the dialogue in the earlier novel is very literary —that is, rhetorical and poetic—the language spoken by the characters in the later work is much more natural. Writing film scripts had forced West to rely entirely on dialogue and action for characterization; not surprisingly, *The Day of the Locust* remains more objective in approach than *Miss Lonelyhearts*. The same tendency toward the external presentation of material is also manifest in Fitzgerald's unfinished Hollywood novel.

If West's pictorial eye is like that of a painter or photographer in *Miss Lonelyhearts*, that eye has come to resemble (as Light also points out) the lens of a movie camera in *The Day of the Locust*. The description of a Hollywood lot in Chapter One, and the view of a camera crew shooting on location in Chapter Eighteen, are both cinematic. Images follow one another rapidly on the page, conveying the flow of experience with economical but telling effect. By maintaining his description on a linear plane, and by filtering his pictures through Tod's recording consciousness, West achieves a remarkable fluidity. Here is a single paragraph from the latter chapter:

> Throwing away his cigarette, [Tod] went through the swinging doors of the saloon. There was no back to the building and he found himself in a Paris street. He followed it to its end, coming out in a Romanesque courtyard. He heard voices a short distance away and went toward them. On a lawn of fiber, a group of men and women in riding costume were picnicking. They were eating cardboard food in front of a cellophane waterfall. He started toward them to ask his way, but was stopped by a man who scowled and held up a sign—

"Quiet, Please, We're Shooting." When Tod took another step forward, the man shook his fist threateningly. (p. 80)

The continuity here is notable. West presents only the essentials of a given action—and observe that the entire paragraph is a series of *actions*—yet at the same time he skillfully keeps the reader in suspense. For example, Tod hears voices before he can identify the source of the sound; here the writer not only carries the reader's eye from point to point, he also leads the reader's ear. Other chapters in *The Day of the Locust* would serve almost as well to underline the cinematic texture of West's last novel.

West was still developing as an artist when his life was abruptly ended. Whether he would have written another novel about Hollywood, or whether his future fiction would have revealed evidence of a cinematic imagination, will never be known. In time, Wells Root remarks, West might have progressed to better pictures and perhaps "his attitude toward films might have been less detached. I'm not sure, and I don't think it's very important" (p. xvii). I think it *is* important. *The Day of the Locust* makes clear that the novelist took both Hollywood and the art of the motion picture much more seriously than some commentators would allow. After West's death, a rough first draft of a film adaptation of *Miss Lonelyhearts* was discovered among his papers. Since West himself undoubtedly realized that *Miss Lonelyhearts* was his finest novel, this would scarcely seem to be the gesture of a writer who had no genuine interest in the movies.

SHORT SUBJECT

*I have listened to writers who had a book published shudder with
horror at the very mention of Hollywood—some of them have
even asked me if I would even listen to an offer from Hollywood
—if I could possibly submit my artistic conscience to the prostitu-
tion of allowing anything I'd written to be bought in Hollywood,
made into a moving picture by Hollywood. My answer to this has
always been an enthusiastic and fervent yes. If Hollywood wants to
prostitute me by buying one of my books for the movies, I am not
only willing but eager for the seducers to make their first dastardly
appeal. In fact, my position in the matter is very much that of the
Belgian virgin the night the Germans took the town: "When do
the atrocities begin?"*

—Thomas Wolfe

*[I]t seems to me that when a movie is made from a novel the
novel is merely raw material, the movie is a new creation, and the
novelist can properly attract neither praise nor blame for it.*

—Robert Penn Warren

Ernest Hemingway—Cinematic Structure in Fiction and Problems in Adaptation

If you go out [to Hollywood] they get you writing as though you were looking through a camera lens. All you think about is pictures when you ought to be thinking about people.

<div align="right">—Ernest Hemingway</div>

I

Ernest Hemingway has frequently been called a cinematic writer; but it is only in the fiction of his middle period that we find him imitating motion picture construction. Two short stories, "The Capital of the World" (1936) and "The Snows of Kilimanjaro" (1936), and two novels, *To Have and Have Not* (1937) and *For Whom the Bell Tolls* (1940), show evidence of a filmic imagination. During the same period Hemingway contemplated making a movie about Spain with director Lewis Milestone, worked with novelist Prudencio de Pereda on a documentary propaganda film called *Spain in Flames* (1937), and wrote and narrated another documentary, *The Spanish Earth* (1937), the text of which was published the year after its release.

It is not easy to say why Hemingway was drawn to cinematic form in the thirties. Certainly his initial experiences with Hollywood were not very fortunate. After paying the novelist five hun-

dred dollars for his collection of short stories entitled *Men With-out Women* (1927), Fox saved only the title for a trite melo-drama about submarine life.

Nor was the writer overjoyed about the fate of *A Farewell to Arms* (1929) at the hands of the movie people. Paramount wanted the picture's world première to be held in Piggott, Arkansas, where Hemingway was living in 1932. "The studio undoubtedly hoped for favorable publicity," the writer's brother recalls. "But in this it ran into a solid wall of frustration. Ernest took a dislike to the advance arrangements when he learned of them and calmly declined to attend the first showing."[1] When he did finally view the film, Hemingway deplored its happy ending and dismissed it as a sentimental perversion of the original. The screenwriters, Benjamin Glazer and Oliver H. P. Garrett, chose to soften the violence of the war as Hemingway described it in his book, and they also elected to sanctify the love affair. Frank Borzage, who directed the film, hardly possessed a talent commensurate to the task which faced him. In his review of the movie, Alexander Bakshy—after noting that *A Farewell to Arms* "not only falls short of being great in any sense of the word, but is actually merely another screen 'romance,' differing from its countless predecessors only in its more natural dialogue and better acting" —perceptively added that Hemingway's "novel does not lend itself to successful dramatization."[2] Had Hollywood producers listened to Bakshy in 1933 they might have saved themselves a good deal of money and much unfavorable criticism in the years ahead. As for Hemingway, all he got out of the first film treatment of his fiction was twenty-four thousand dollars and the lasting friendship of Gary Cooper, who portrayed Frederick Henry. (Others in the cast included Helen Hayes as Catherine Barkley and Adolphe Menjou as Major Rinaldi.)

Discussion of Hemingway's cinematic method of organization begins, as I have suggested, with "The Capital of the World." The main character in the story is a Spanish youth named Paco, who

works as a waiter in a Madrid hotel and whose approach to life is excessively romantic. Throughout the piece Paco is contrasted with various other employees in the hotel and with a number of customers. Life has broken the adults who surround Paco—all of them suffer from some defect or have compromised with their early ideals—but the youth still retains his illusions. To be a hero in Hemingway's world, a man must test himself against life with skill as well as courage. Although Paco possesses the latter virtue, he very much lacks the former quality. As a result, at the end of the story he is killed by a dishwasher in a mock bullfight.

"The Capital of the World" begins slowly, as Hemingway introduces Paco and then each of the other characters: three matadors, two picadors, one banderillero, two waiters, some priests, Enrique the dishwasher, and Paco's sisters. After establishing the basic contrast between the youth and the others, the author proceeds to increase the tempo of the action. In *The Sun Also Rises* and *A Farewell to Arms*, where counterpoint is used in a symbolic structure, point of view is first-person; in "The Capital of the World," where counterpoint is used in a montage structure, point of view is third-person. According to A. E. Hotchner, Hemingway once told him: "it's harder to write in the third-person but the advantage is you move around better."[3] In "The Capital of the World" the narrative mobility of third-person point of view permits Hemingway to employ a filmic crosscutting technique.

When Paco and Enrique begin their sham bullfight, for example, Hemingway uses a cutaway which discovers the boy's two sisters on their way to the cinema to see the "talkie" version of O'Neill's *Anna Christie*. This cut is followed by a second one to the priests, and in turn it gives way to a third cut to the bullfighters; and so on—until the narrative focus again returns to Paco and the dishwasher. As the youth lies on the floor of the kitchen bleeding to death, and as Enrique goes in search of a doctor, Hemingway crosscuts to the movie theater as the two sisters register their disappointment with *Anna Christie*. It seems that none of the patrons of the cinema enjoy the movie because it reveals

Greta Garbo "in miserable low surroundings when they had been accustomed to see her surrounded by great luxury and brilliance."[4] Once again Hemingway cuts back to the hotel, focusing now on the two priests, now on the picador, before returning to the kitchen to record the passing of Paco. The story ends with a final juxtaposition between the youth, who died "full of illusions," and the other characters, who live on. Paco died too soon to be wise about life: "He had not even had time to be disappointed in the Garbo picture which disappointed all Madrid for a week."[5] It is interesting to note that Hemingway's "The Capital of the World," like Fitzgerald's *The Last Tycoon* and West's *The Day of the Locust*, borrows filmic techniques for material that deals with motion pictures.

"The Snows of Kilimanjaro," which Hemingway considered his finest short story, is much better known than "The Capital of the World." Although both works rely on movie devices to move the action, their specific techniques differ due to the radical difference in the subject matter of "The Capital of the World" and "The Snows of Kilimanjaro." Hemingway's formal problem in the latter story was to find a means of getting into Harry's past through long internal monologues without destroying the structure of the present action. By plunging into the stream of consciousness, Hemingway was led to duplicate cinematic techniques used earlier by Joyce, Virginia Woolf, and Faulkner. Whereas in "The Capital of the World" time remains fixed while the spatial dimension changes, in "The Snows of Kilimanjaro" space remains fixed while the protagonist's consciousness moves fluidly in time (except for the last hundred and seventy-five words or so everything is seen from Harry's viewpoint). Four years later Hemingway was to combine the montage methods of the two 1936 stories in structuring *For Whom the Bell Tolls*.

In "The Snows of Kilimanjaro" the narrative focus swings smoothly from scenes between Harry and his wife to close-ups of Harry's consciousness as he recalls significant moments of his

past. The more or less objective scenes contain occasional interior monologues, but in the subjective passages the monologue device takes over completely. Although syntax is much less formal in the latter passages, Hemingway maintains continuity between the sections by having recourse to free association of ideas. At one point, for example, the protagonist reflects that quarrelling with the previous women in his life had always eventually destroyed his relationship with them; this general observation then prompts Harry to recall a particular case in point. Hemingway's shifts from objective to subjective are signaled by italics for the sustained internal monologues, which device was also employed by Faulkner in *The Sound and the Fury.* In the example at hand, the word "quarrel" is carried over into the italicized passage, thus tending to bind the two modes of presentation.[6] The technique here strongly resembles the relational dissolve used in films, where similar screen images provide a link between events separated by time and/or space. Today of course movie construction—which has been influenced by the stream-of-consciousness writers—frequently relies on the repetition of a word or group of words in bridging scenes.

If Hemingway appears to dissolve from the objective to the subjective, or sometimes merely to fade into the stream of consciousness, he generally returns to the objective again with an abrupt cut. Twice the woman startles Harry out of his inner preoccupations with a direct question; once Harry's inner monologue terminates on the italicized "*Why?*"—followed by a rapid cut to the objective, as the hero says: "You tell them why. . . ."[7] Nor does Hemingway fail to take into account the rhythm of his cutting. In conventional movie structure where parallel editing is used (such as in one of Griffith's "last minute rescue" sequences) the intercutting of shots grows faster and faster in an effort to achieve a maximum degree of tension. Although Hemingway is dealing with psychological material rather than physical action, his narrative strategy is identical with a movie Western climax scene. Two of the last three objective scenes between Harry and his wife are

less than a page each in length; similarly, the last two italicized sections are brief: the first is about one page in length, the second amounts to no more than a single paragraph. A page and a half is given over to the last scene between Harry and his wife; two pages are needed to cover Harry's dying glimpse of Kilimanjaro's summit; and a half page suffices for the conclusion in which Hemingway cuts to the wife's viewpoint as she discovers Harry's body. The opening and middle sequences in the story—both those in the objective mode and those in the subjective—remain more extended in treatment than the closing scenes. *For Whom the Bell Tolls*, it should be observed, is distinguished by a similar manner of construction.

"The Snows of Kilimanjaro" was made into a film in 1952 by Darryl F. Zanuck. It was reported that Casey Robinson, the screenwriter, had labored for three years in order to construct a suitable ending (obviously this was a bad sign, inasmuch as Hemingway's own ending was readily available); finally, the scriptwriter decided to let Harry survive his gangrene poisoning and escape—not, as in the original, to the House of God—but to the house of the wealthy Susan Hayward. In other words, Robinson extracted the positive note from Hemingway's story—namely, the spiritual salvation of the writer—but he allowed Harry, played by Gregory Peck, to enjoy a more material happy ending than in the story. For Hemingway, a hero can be destroyed but not defeated; for Robinson (and other Hollywood hacks), a hero can be neither destroyed nor defeated. Not surprisingly, the majority of reviewers scorned the film; while Hemingway himself contemptuously dismissed it as *The Snows of Zanuck*.

In spite of its cinematic technique, "The Snows of Kilimanjaro" would not seem to be promising material for a motion picture. (Perhaps only the Ingmar Bergman who directed *Wild Strawberries* could hope to bring Hemingway's complex story to the screen with any degree of beauty and invention.) There is little or no action in the conventional sense in "The Snows of Kilimanjaro"; all of the writer's interest is centered on the psychological proc-

esses of Harry's mind. It seems doubtful whether there has ever been a successful movie about an author, and the Zanuck production—which resembles a travelogue more than a journey through the heart and soul of a man—is no exception. Robinson's screenplay never makes the writer *qua* writer credible. Nor does the film ever make clear why Harry loves Africa so much. Extended footage is devoted to shots of wild animals, it is true, and occasional grunts of approval issue from Peck—but no real feeling about the country is ever projected on the screen. Some of these difficulties derive from the nature of Hemingway's prose, which was not written to be spoken by actors. There is probably no more embarrassing or artificial a moment in talking pictures than the one in *The Snows of Kilimanjaro* where Gregory Peck solemnly intones Harry's famous speech on how he had destroyed his talent. Such rhetoric sounds absurdly unnatural on the screen.

Hemingway once said that he had put the material for four novels into "The Snows of Kilimanjaro." Though it might be argued that the story is somewhat diffuse, it is also true that this is a work which uses the stream of consciousness and hence a certain amount of "looseness" would seem desirable for the sake of realism. Occasionally, one encounters a critical study in which Harry's interior monologues are called "flashbacks"; but it should be noted that Hemingway scrupulously avoids presenting the hero's memory sequences scenically. By centering the point of view in Harry, and by keeping the remembered moments from the past within the protagonist's mind *at present*, Hemingway maintains control over and unifies his material.

The film-makers, however, are much less skillful. Although the flashbacks are presented from Harry's viewpoint, they are rendered with the same order of concreteness as the scenes set in the present (there are no italicized passages in the movie); consequently, the story becomes more episodic on the screen than on the page. Furthermore, the scenarist has not always attended precisely to the logic of point of view. In one scene Harry's first wife, Cynthia (played by Ava Gardner), reveals her fear of pregnancy

to the professional hunter, Johnson; but Harry—who is supposed to be recalling all this—is not even present. No such problems of viewpoint distract the reader of Hemingway's story. The film, unlike the original, is monotonously paced. Whereas Hemingway uses a variety of means for moving back and forth between the objective and subjective, the creators of the color movie eschew dissolves and rely exclusively on cuts. And in place of Hemingway's structure of rising tempo, the film—thanks to the need for a standard Hollywood happy ending—slows down painfully in order to allow sufficient time for Gregory Peck's miraculous recovery. After Susan Hayward dismisses a local witch doctor and "operates" on the hero herself, director Henry King clumsily crosscuts between Harry's bandaged leg and an obtrusively symbolic hyena prowling outside the tent. Once the contrived climax has passed, the dawn comes up like thunder and the rescue plane wings into view. The final image on the screen is of a huge tree which has replaced the hyena outside Harry's tent. No doubt, Robinson and King intend this image to symbolize "the tree of life." Hemingway's story, however, concerns "the snows of Kilimanjaro," or "the House of God"—which is not at all the same thing.

Although *To Have and Have Not* is far from being one of Hemingway's best novels, its structure and treatment of viewpoint is of interest in the light of the author's progress toward the cinematic form of *For Whom the Bell Tolls*. With the exception of Hemingway's parody of Sherwood Anderson in *The Torrents of Spring* (1926), *To Have and Have Not* represents the writer's first serious attempt to construct a novel in the third person. Unlike "The Capital of the World" and "The Snows of Kilimanjaro," though, the 1937 novel never succeeds in establishing unity of narrative focus or action. The structure of *To Have and Have Not* is divided into three parts: Part One is told in the first person by the protagonist, Harry Morgan; Part Two is narrated in the third person with the focus mainly on Harry; and Part Three is various

in point of view: the first-person opening report by Harry's friend, Albert, gives way to an interior monologue by the hero, followed by a return to the third-person form but with shifts in perspective from one character to another.

To Have and Have Not is not especially filmic, yet in it Hemingway's experiments with form and viewpoint, though confusing and lacking in a rationale, prepared him to use the cinematic skill displayed in "The Capital of the World," "The Snows of Kilimanjaro," and *For Whom the Bell Tolls*.

Incidentally, Hollywood has made three film versions of *To Have and Have Not*. Faulkner and Jules Furthman worked on the first version, released in 1944, which was directed by Howard Hawks, and featured Humphrey Bogart and Lauren Bacall. Little was retained of the original; and critics agreed that the film was no more than a good action story. The second version, directed by Michael Curtiz, appeared in 1950 as *The Breaking Point*. This treatment was more faithful, but the result was again merely effective melodrama. The last version, under the original title, was shown in 1958, and was poorly received. In 1948 John Huston used the ending of the novel for the conclusion of the film version of Maxwell Anderson's play *Key Largo*. (Needless to say, Hollywood has gotten a lot of mileage out of *To Have and Have Not!*)

The year in which *To Have and Have Not* was published also saw the appearance of *The Spanish Earth*, directed by Joris Ivens. Hemingway composed the commentary for the picture and also narrated it. Like the Italian neorealist films that were to come later, *The Spanish Earth* used local people in the cast instead of professional actors; director Ivens also employed a hand-held camera in order to move closer to the action. Hoping to draw attention to the movie, Hemingway prepared for *Life* magazine captions especially written to accompany pictures from *The Spanish Earth*.[8] The novelist's work with Contemporary Historians not only testifies to his awakening social consciousness during the thirties (he even showed the film to President Roosevelt at the White House), but also to his growing interest in motion pictures.

With the publication of *For Whom the Bell Tolls* at the end of the decade, the cinematic tendencies in Hemingway's fiction of the middle period finally become unmistakable. (According to Sheilah Graham, Fitzgerald told her that *For Whom the Bell Tolls* was written "for the movies."[9]) Perhaps the first thing to observe about the novel is its point of view, which consistently remains in the third person. While most of the action is seen from Robert Jordan's viewpoint, Hemingway frequently shifts his focus of narration to some of the other principal figures in the tragedy. In Chapter Five, for example, the reader overhears Pablo talking to his horse, though Robert Jordon remains out of earshot; in Chapter Thirty-Two, Karkov assumes the commanding center. Sometimes the narrative focus shifts several times within a single chapter. For example, in Chapter Twenty-Eight the central observer's post is occupied first by Robert Jordon, then by the Fascist Lieutenant Berrendo, and finally by old Anselmo—all within the space of five and a half pages. First-person narration, as E. M. Halliday remarks, would not have suited Hemingway's theme of "human interdependence" so well as the third person, where the writer is "free to move from one character to another, showing the common elements in the respective views which each of them has of the action."[10] Although Fitzgerald combined the first-person mode of narration with crosscutting extremely well in *The Last Tycoon*, the risks involved in fusing the two techniques are very great. There is always the question of credibility; the reader wonders how the narrator possesses such complete knowledge of character motivation and of events which he did not actually witness or experience. There is also the loss of immediacy; that is, the reader remains conscious of the fact that the story is being "told" and is not, as in a play or film, happening "now." Though in the third-person form the writer ordinarily uses the past tense, the illusion of events occurring in the present nevertheless seems greater when the story is not recounted by a first-person narrator.

When W. M. Frohock argues that the story in *For Whom the*

Bell Tolls is restricted to a few days because Hemingway had his eye on a Hollywood sale and wanted to make certain that action would be sustained, he may have a point.[11] But the critic apparently overlooks the structural and thematic advantages gained *in terms of the novel itself* by Hemingway's choice of a restricted time-sequence. It is certainly valid for a writer to focus on a few days, or even a few hours, in order to develop maximum tension and significance. As several commentators have noted, the form of *For Whom the Bell Tolls* is circular, with the bridge at the center of both the action and the symbolic structure. In an attempt to enlarge the meaning of Robert Jordan's assignment to destroy the bridge, Hemingway uses two devices—namely, flashbacks and crosscuts—which switch attention to another time and/or place. Though the "movie flashbacks" (as Frohock calls them) tend to break the tension established in the present order of action, they also serve to render the novel more complex in meaning. Two versions of the flashback—Pilar's long discourse in Chapter Ten on the murder of the Fascists, and Robert Jordan's equally lengthy indirect interior monologue in Chapter Eighteen involving the Gaylord Hotel in Madrid—succeed in projecting Hemingway's ironic perspective on both sides in the conflict. Other examples to support the point would not be difficult to find.

Crosscutting in *For Whom the Bell Tolls* is similarly employed in an imaginative fashion. The first half of the book develops the action slowly, as Hemingway introduces the characters, establishes the setting, and suggests the theme. Then, commencing with Chapter Nineteen (there are forty-three chapters in the novel), the pace quickens as the plans for destroying the bridge begin to be realized. In the second half of the novel the chapters are generally brief—most of them half the length of the earlier ones—as the writer, in an endeavor to augment tempo, continually indulges in parallel editing. By switching from Robert Jordan to El Sordo to Lieutenant Berrendo, Hemingway portrays the horror of war in perhaps the most economical and telling way possible. Crosscutting, in other words, enables the novelist to reveal the humanity of certain men on both sides in the fight, at the same time that it also

allows him to underline the forces that are destroying such men. Furthermore, through the repeated cutaways from Robert Jordan waiting at the bridge to Andrés as the latter carries the hero's message through the rear lines (see the last ten chapters of the book), Hemingway is able to expose "the betrayal of the Spanish people—both by what lay within them and what had been thrust upon them—and it is presented with that special combination of sympathetic involvement and hardheaded detachment which is the mark of the genuine artist."[12]

Although I would hesitate to call *For Whom the Bell Tolls* Hemingway's greatest novel (I concur with the majority critical opinion in finding *The Sun Also Rises* and *A Farewell to Arms* superior to any of the author's subsequent efforts), I also feel that it is a far better work than it is acknowledged to be. And much of the brilliance of the writer's achievement resides, I think, in his inspired use of filmic technique—a technique, it should be noted, that is not imposed mechanically on the material for the purpose of achieving a cheap melodramatic tension but which naturally follows upon the author's complex approach to his subject. Hemingway may or may not have written *For Whom the Bell Tolls* with a future screen sale in mind; whatever the author's motives or intentions, the finished work—in spite of its cinematic borrowings —remains very much a *novel*.

Yet it was to be expected that Hemingway's best seller would be brought to the screen. In 1943 Paramount made *For Whom the Bell Tolls* into a movie, advertising it as the most spectacular production since *Gone With the Wind*. It was reported that the film took three years to cast, that thirty thousand fans mailed in their choices for the starring roles, that Hemingway himself wanted Gary Cooper to play Robert Jordan and Ingrid Bergman to play Maria, and that the studio spent three million dollars adapting the novel for the cameras. One of Hollywood's finest scriptwriters, Dudley Nichols, was assigned to do the screenplay, and Sam Wood was given the job of directing. Nevertheless, *For Whom the Bell Tolls* is a bad film.

One reason for the unsatisfactory nature of the movie was the

political timidity of the Paramount bosses. "We don't think it will make any trouble," President Barney Balaban said hopefully. Adolph Zukor, chairman of the board, agreed: "It is a great picture, without political significance. We are not for or against anybody." And director Wood added sagely: "It is a love story against a brutal background. It would be the same love story if they were on the other side."[13] Such callousness in respect to Hemingway's theme naturally resulted in technical defects in the completed film.

A second, and probably even more important, reason for the failure of the picture was more or less inevitable given the problems involved in any adaptation of a complex novel to the screen. Although a good deal of Hemingway's book presents Robert Jordon in an objective or dramatic fashion without reference to his thoughts or feelings, much of the nearly five hundred pages of text is devoted to interior monologues and reminiscences on the part of the hero. Most of the latter passages had to be eliminated from the screenplay; as a result, the protagonist seems isolated from his past and insufficiently motivated. No filmic equivalent appears, for example, for Robert Jordon's long interior monologue about the Gaylord Hotel in Chapter Eighteen—thus much of the book's thematic significance is omitted. Furthermore, as Manny Farber pointed out in his review, "the flashback to the guerrillas' early days [Pilar's recital in Chapter Ten of the novel] is . . . insufficiently shown and completely useless to the film, since it not only failed to get across any great image of the first day of a revolution, but failed to explain Pablo, ostensibly its reason for being there." (This flashback, by the way, is among the forty or so minutes that have since been cut from the film's original hundred and sixty-eight minutes of running time.)

The movie starts out promisingly enough. Whereas the novel opens on Robert Jordon studying the bridge he is committed to destroy, followed by a flashback to his conversation with General Golz on the previous night when he was given his assignment, the film begins with strong visual action. We watch the hero blow up

an enemy train and make his escape; then we follow him to his meeting with Golz; and finally we move with him to the original scene at the bridge. The rest of the film, though, has little to recommend it. Ironically, Hemingway's most obvious cinematic borrowing—his use of parallel editing—is incompetently managed by the film-makers. In the book, Hemingway cuts back and forth between El Sordo and Lieutenant Berrendo in an attempt, as previously noted, to render both sides in the war sympathetically. In the movie, the action is never seen from the perspective of the enemy, and El Sordo is viewed wholly—and much too sketchily— from the outside. Hence the latter's battle and death on the hilltop seems like just another typical Hollywood "shoot-'em-up," lacking any real thematic values. Even more awkwardly handled are the crosscutting equivalents that Wood devised for Hemingway's parallel editing in the last ten chapters of the novel. The pace of *For Whom the Bell Tolls*, as written, quickens markedly near the conclusion as Hemingway intercuts Andrés' journey to the rear with scenes in and around the cave involving Robert Jordon and the others waiting to destroy the bridge. But, though the tempo here is properly faster than in the earlier portions of the story, Hemingway gives each scene sufficient scope either through psychological analysis of Andrés or Robert Jordon, or through pointed dialogue in scenic form. Hemingway cuts to Andrés four times and to Robert Jordon six times; Wood cuts to Andrés nine times—but the intercuts are much too fast, and they in no way convey Hemingway's purpose in using the device in his novel. Worse yet, the scenes showing Robert Jordon with Maria, which continue to alternate with the shots of Andrés on his journey, seem to be paced much too slowly for a movie at this point in its structure.

Interior monologues are almost always rendered in an artificial and clumsy manner on the screen. Probably they are most successful when the camera moves very close to the monologuist and the script establishes the right setting for the inner revelation, such as a scene showing the hero at prayer or fully absorbed in writing a

letter. Having avoided projecting Hemingway's simplified exploration of the stream of consciousness (even in those quiet moments of the movie where it might have been tried in an almost desperate effort to get *some* psychological density into the story), the filmmakers suddenly—just before the hero's death—resort to an interior monologue! It is perhaps the worst possible moment for such a technique. Even in the novel Robert Jordon's lengthy talks with himself are not—especially near the end—unassailable; but at least in the novel the concluding monologues are related to previous self-disclosures through the same device. Nichols and Wood, though, fail to prepare the audience for the shift in perspective, and furthermore they use it at a moment of much noise and confusion. Moreover, the protagonist's monologue consists of only a few almost incoherent sentences and—since it does not begin to suggest Hemingway's point about suicide, death and the value of a man's fighting to his last breath—could have been omitted without loss.

Whereas Hemingway concludes his novel with Robert Jordon watching Lieutenant Berrendo approach closer and closer to the moment in which both these good and brave men will perish in a tragic act of war, the movie has Gary Cooper aim his machine gun directly into the face of the viewer—and pull the trigger. Thus, as the audience is suddenly placed in the position of the enemy, what little meaning the film version of *For Whom the Bell Tolls* hoped to convey disappears under a cloud of gunsmoke.

The rationale for this shift in point of view is difficult to fathom. Perhaps the movie is trying to say that "no man is an island," that the enemy remains a human being like any member of the audience. If so, the film-makers have failed once again to prepare the audience for this alternation in viewpoint. More than likely someone on the set figured it would make a "snappy" ending irrespective of its logic. We are back again with Porter's *The Great Train Robbery*, which had a bandit fire point-blank at the viewer. According to the 1904 Edison Catalogue: "This scene can be used to begin or end the picture." Indeed!

After writing *For Whom the Bell Tolls*, Hemingway appears to have lost interest in the possibilities of filmic structure. In *Across the River and Into the Trees*, as Peter Lisca reminds us, "only the short first chapter and the last thirty pages originate in an omniscient third-person who occasionally tells us . . . of things the Colonel cannot know. All the rest is narrated by Colonel Cantwell himself. . . ."[14] Which means that the ironic montage construction of "The Capital of the World" is largely impossible of attainment here. Although *The Old Man and the Sea* is consistently in the third person, Hemingway generally stays within a single character's field of vision. The fluid, cinematic transitions of "The Snows of Kilimanjaro" are not duplicated in the last novel published before Hemingway's death, not even when the old man remembers events from the past or daydreams about lions.

In spite of the fact that only a few Hemingway works are "cinematic," and in spite of the poor critical reception of Paramount's *For Whom the Bell Tolls*, Hollywood proceeded after 1943 to film a number of the author's works. Since Hemingway has been one of the two most influential novelists of the twentieth century (the other one is Joyce), it should prove instructive to analyze some of the screen versions of his work in an effort to underline essential differences between film and fiction.

II

According to A. E. Hotchner, Hemingway liked to watch films in his livingroom in Cuba; but the only picture based on his own work which he considered good was *The Killers* (1946).* Written by Anthony Veiller and directed by Robert Siodmak, the adaptation received generally favorable reviews. Burt Lancaster, Ava Gardner, Edmond O'Brien, Sam Levene, and Albert Dekker were excellent.

* The 1964 film version appeared after Hemingway's death and is beneath contempt.

The opening portion of the film follows the original exactly as written. Since point of view in "The Killers" (1927) is objective or dramatic—that is, all the action is externalized—the scriptwriter's task was relatively easy. After the opening, however, the rest of the film is Veiller's creation in the form of flashbacks. (Perhaps that is why Hemingway, in spite of his stated liking for the film, always fell asleep before the first reel ended![15]) In the story the reader never learns precisely why the gunmen want to kill Ole Andreson. "Double-crossed somebody," George says. "That's what they kill them for."[16] Using this single line in the original as a guide, Veiller constructs a plausible background for the protagonist.[17] After quitting the ring because of a broken hand, Swede takes to thievery, is arrested, but is actually convicted for a crime he did not commit. The real culprit, Kitty, allows Swede to go to jail for her, while she continues to sleep with the gangster boss. After the hero's release from prison, he joins with the gang in a daring payroll robbery. Informed by Kitty that the boss intends to cheat him out of his share of the loot, Swede double-crosses the gang and takes the girl to Atlantic City. Several days later Kitty abandons Swede—taking the money with her—and the ex-boxer is a dead man.

The critic for *Life* called *The Killers* "superb film melodrama. There is not a dull moment in [it], not a corny line nor a contrived character—nothing but menacing action managed with supreme competence." John McNulty agreed: "Hollywood has so frequently botched a good short story in extending it that this one instance of preserving the quality of the original is most cheering . . . The movie starts with a terrifying quietness and maintains throughout the intensity that distinguished Hemingway's story." While praising the film, Manny Farber added that "there is a cheapness about *The Killers* that reminds you of five and ten jewelry. . . ." Perhaps James Agee registered the most perceptive judgment: "The story is well presented, but Hemingway's talk, which on the page used to seem so nearly magical and is still so very good, sounds, on the screen, as cooked-up and formal as an eclogue. From there on out the dialogue, though generally skillful

and talented, isn't within miles of Hemingway's in quality, but it is made to be seen as well as heard, so, coming out of pictures, it sounds more nearly real."[18]

In 1957 Twentieth Century-Fox produced *The Sun Also Rises* (1926), which most critics regard as Hemingway's best novel. As usual the pre-release ballyhoo emanated from Zanuck's headquarters in Hollywood. Peter Viertel, who drew the writing task, observed that "all Hemingway's books are naturals for movies because each scene is so well constructed and completely written"; Henry King, who also directed *The Snows of Kilimanjaro* (and later *Tender Is the Night*), again revealed that his literary IQ is about on a par with his cinematic skill when he announced: "Hemingway's writings are like Steinbeck's—take the vulgarity out of Steinbeck's books and it's great drama."[19]

Some reviewers of the film thought that Errol Flynn, as Richard B. Lillich puts it, "stole the show as Mike Campbell, the seedy, boozy British aristocrat."[20] But Hemingway told his wife: "Any picture in which Errol Flynn is the best actor is its own worst enemy."[21] As was to be expected, Viertel and King took more than the "vulgarity" out of *The Sun Also Rises*.

Changes in the original were naturally inevitable—given the essential differences between the two mediums—but the film-makers managed to remove everything that makes *The Sun Also Rises* as a novel important. Any serious discussion of the picture necessarily becomes a catalog of missing Hemingway materials. Although the movie Jake Barnes (Tyrone Power) still encounters the prostitute, Georgette, the latter's line—"Everybody's sick. I'm sick, too"[22]—is omitted. In the novel this line is expressed in a taxi; it looks forward to the following chapter in which Jake and Lady Brett Ashley kiss hopelessly in another cab; while both scenes foreshadow the ending wherein the futility of Jake's and Brett's position—Jake's sexual impotence as a result of his war wound symbolizes the emptiness and sterility of the postwar generation—is made clear in a final taxi ride.

Of course, Viertel and King "improved" on the original ending

by suggesting that "somewhere" there must be an "answer." Even granting, in this age of medical marvels, the possibility of a genital transplant for Jake, the point of the novel is that the war has destroyed the ability of these characters to love again. No hint of Robert Cohn's romanticism is suggested in the film, or why his belief in W. H. Hudson's *The Purple Land* "as a guidebook to what life holds" is so repellent to the members of Hemingway's Lost Generation (p. 9). True, Count Mippipopolous puts in an appearance in the film—but to no real purpose; unlike his counterpart in the novel, he fails to reveal *his* wounds; nor does Ava Gardner, playing Brett, feel moved to remark to Jake: "I told you he was one of us. Didn't I?" (p. 60).

In other words, the loss of spiritual values, which is vital to Hemingway's theme, has no place in the film. Conventional religion, as presented in the novel, is no longer able to meet the needs of this generation. Jake is the only character with any semblance of piety, but his prayers bring scant consolation. The mock religious aspect of Jake's and Bill's outing in the country (Chapter XII), and their clear preference for fishing and drinking as opposed to the monastery at Roncesvalles (Chapter XIII), disappear in Viertel's version of *The Sun Also Rises*. Stripped of a meaningful ritual in which evil may be exorcised, Hemingway's characters are driven to various individual remedies for cleansing themselves of guilt. Brett, for example, is forever taking baths; and once she even uses sexual intercourse with Romero as a means of "wip[ing] out that damned Cohn" (p. 243). The matador himself "wipes" out the memory of his fist fight with Cohn by killing the bull (p. 219). None of this comes through in the picture. Indeed, whereas Hemingway's Brett is depicted as a pagan goddess reigning over a wasteland and is prevented from entering the church in Pamplona, Viertel's Brett prays devoutly at the altar for Romero . . . But is it really necessary to go on? Thematically, *The Sun Also Rises* on celluloid is as sterile as Jake Barnes and his companions.

Nor is the movie—thanks to King's direction—interesting tech-

nically. Much of the excitement of the book stems from Hemingway's prose style, which is a perfect expression of his theme. "All is understated; all is bare outline," notes Sheridan Baker. "The reader is surprised at how much he himself is importing to fill it out."[23] No such excitement, or intellectual-emotional participation on the part of the viewer, distinguishes the film. Some critics found the scenes involving the bulls the only praiseworthy feature of the movie; but in my opinion even those scenes are bad.

Director King devotes an inordinate length of time to them, hoping probably to combine here at any rate a modicum of Hemingway with strong visual action. The director fails, however, on both counts. Too many long shots projected in a boring newsreel fashion alternating with stagy close shots of an effeminate-looking actor masquerading as the virile Romero, succeed only in wearying the audience. During long moments of this sequence one entirely forgets about Jake, Brett, and the others who are supposed to be watching. And even when King remembers his characters, he is unable to convey an attitude toward them through his technique. Early in the film, for instance, we are obliged to watch six bulls enter a corral one at a time. King shoots each bull from the same two monotonous angles. Intercut with the bulls are shots of the characters wrangling in the stands. But King's crosscutting fails to "say" anything; like the bullfight sequence, the two lines of action remain unrelated thematically.

Another way of expressing the matter is to say that the film, here and elsewhere, fails to solve the problem of point of view.

The Sun Also Rises on film opens with a voice—neither Jake's nor any other character's in the story—introducing us to the Lost Generation. The voice identifies itself with the period (he says "we"), but he is far from being verbose and he is never heard from again. After this catchy opening, Viertel introduces a soldier who happens to meet Jake on the street; the point of the encounter is simply to inform the viewer that Jake was wounded in the war. The soldier, after fulfilling his crude expositional function, exits (like the voice which preceded him) never to be seen or heard

from again. No cinematic equivalent is substituted for the intimacy which results in the novel from Jake's first-person discourse to the reader. Only in three brief instances does the movie allow the audience to see life from the protagonist's perspective. A flashback occurs twice: Jake is lying in bed, watching a light moving on the ceiling—cut then to Jake lying on a hospital operating table, with Lady Brett in attendance as a nurse. Afterward Jake and Brett are seen together on the hospital grounds. Cut back to the present—Jake still watching that light moving on the ceiling —then back to the past again, as a doctor informs the hero that he is doomed to remain impotent. As Jake rushes off, Brett calls to him—and the sound of her voice is a bridge back to the present, as Brett, standing now outside Jake's door in Paris, again calls to him.

Later in the film, King at last wields his camera to some purpose in order to capture Jake's rising jealousy over Brett's interest in Romero. As the protagonist walks down a Spanish street, he seems to be assailed on all sides by posters of the matador. With increasing rapidity the director intercuts shots of the posters, which appear to grow larger and larger on the screen, with shots of Jake's angry face—until, abruptly, a blood-red liquid splatters a' poster and another quick cut finds the drunken Jake sitting at a cafe table, having just hurled his wine at Romero's picture. The flashback scenes reveal only a moderate competence, but the expressionistic technique just described is quite effective.

However, one successful scene hardly justifies an otherwise poor film of a distinguished novel. Having emasculated not only Jake Barnes but *The Sun Also Rises* as well, Viertel and King are left with an empty, pretentious picture which refuses to move. Style and content are, in the final reckoning, inseparable; if the film lacks style, it is because it lacks real content—the film-makers, quite simply, have nothing to say. If you omit the profound conflict in Hemingway's work between nihilism and the search for values, you omit what is vital to an understanding of his art and technique. On film *The Sun Also Rises* lacks a unity derived from

a serious interpretation of life; the defect, then, is one of viewpoint —in both the narrative, or technical, sense and in the thematic, or philosophical, sense.

The year after *The Sun Also Rises* reached the screen, Twentieth Century-Fox did a remake of *A Farewell to Arms*, with Rock Hudson cast as Frederick Henry and Jennifer Jones in the part of Catherine Barkley. Hemingway had sold *A Farewell to Arms* outright to Hollywood for Paramount's 1932 adaptation. (It was not until 1941, when Edna Ferber sold *Saratoga Trunk* to Warner Brothers that a contract called for all rights to revert back to the author after a stated period.) Selznick informed the press, however, that he would pay the novelist fifty thousand dollars from the profits of the picture—if there were any profits. Hemingway, who detested Selznick, fired off a telegram to the producer in which he said "that if by some miracle, [the movie], which starred forty-one-year-old Mrs. Selznick portraying twenty-four-year-old Catherine Barkley, did earn fifty thousand dollars, Selznick should have all fifty thousand dollars changed into nickels at his local bank and shove them up his ass until they came out of his ears."[24] Although Twentieth Century-Fox spent four million dollars on *A Farewell to Arms*, the technicolor, widescreen, and stereophonic sound version was no better than the earlier, more "primitive," production.

The failure of Selznick's *A Farewell to Arms* stems from a number of sources. Originally, John Huston was to have been the director, but he quit the film shortly after production began; he was replaced by the far less knowledgeable Charles Vidor. The scenarist was Ben Hecht, whose reputation as a "professional" is as overblown as the two-and-a-half-hour running time of *A Farewell to Arms*. Speaking of the difficulty facing any adaptor of Hemingway's fiction, Hecht said: "The s.o.b. writes on water." (Aldous Huxley expressed the same idea somewhat more elegantly to Selznick: "Hemingway's gift is that he writes in the white spaces between the lines."[25]) In a well-known essay, "Observa-

tions on the Style of Ernest Hemingway," Harry Levin remarks of a passage in *For Whom the Bell Tolls*: "Each clipped sentence, each prepositional phrase, is like a new frame in a strip of film; indeed the whole passage, like so many others, might have been filmed by the camera and projected on the screen."[26] Other critics have also spoken of Hemingway's "cinematic style." But we know now that the writer's style, whether considered in terms of dialogue, narration, exposition, or description—while it may *seem* cinematic—does not really transfer successfully to the screen.

Granted that Rock Hudson and Jennifer Jones were all wrong for the parts they were required to play, the fact remains that no two actors could have spoken Hemingway's lines without sounding artificial. That the dialogue in *A Farewell to Arms* has not worn quite so well as that in *The Sun Also Rises* only partially explains the problem, for those passages of the earlier novel which were retained in the 1957 film sounded as wooden as anything issuing from the mouth of Rock Hudson or Jennifer Jones. Hemingway writes excellent dialogue—but it is *literary* dialogue, not cinematic. The same also applies to the writer's descriptive passages. On October 21, 1968 ABC television presented a film called *Hemingway's Spain: A Love Affair*, written by Lester Cooper and directed by Walker Stuart. Rod Steiger, Jason Robards, Jr. and Estelle Parsons read portions of *The Sun Also Rises, Death in the Afternoon, For Whom the Bell Tolls*, and *The Dangerous Summer* while the camera revealed the places mentioned in the narration. Although this might prove to be the best filmic approach to Hemingway—because this way we really attend to the words and are not distracted by the disjunction between the actor's face and the stilted-sounding dialogue—it too fails; because it forces us to concentrate on the words, the actors' voices render the pictures on the screen superfluous. If, instead, the director dispenses with the words and attempts to find images to take the place of the words, he fails too, because the camera cannot photograph "the white spaces between the lines."

The only memorable moments of Selznick's *A Farewell to*

Arms involves panoramic shots of snowcapped mountains and long shots of the Italian army in bedraggled retreat. In such scenes the film-makers did not try to adhere too closely to the original, or attempt a line by line, word by word picturization. However, whenever the lovers begin talking (which is often) straight from the pages of the book, a terrible falseness permeates the proceedings. Little wonder that the writer was again disappointed in a movie based on his work. After viewing Hecht's and Vidor's treatment of *A Farewell to Arms* for thirty-five minutes in a Manhattan theater, Hemingway departed, informing the future author of *Papa Hemingway*: "You know, Hotch, you write a book like that you're fond of over the years, then you see that happen to it, it's like pissing in your father's beer."[27]

The last film made from Hemingway's work before the novelist's death in 1961 was the Warner Brothers production of *The Old Man and the Sea* (1958), starring Spencer Tracy as Santiago. This time the Hollywood people would not be accused of destroying the integrity and meaning of the original; this time they vowed to be utterly faithful to Hemingway's conception. The cost of the undertaking was variously reported—some said that the studio spent four million, others five million. Hemingway himself received two hundred and fifty thousand dollars, plus a guarantee of one-third of the profits. Furthermore, in order to be sure the job was done right, the author personally took a hand in the filming. He helped director John Sturges edit Peter Viertel's script, and he spent a good deal of time with a camera crew in the fall of 1955 and the spring of 1956, looking for marlin. Although some fish were caught, the "big one" had to be manufactured in Hollywood. According to Leicester Hemingway: "It took something out of Ernest when that decision was made."[28]

It also took something out of Ernest when he saw the completed film. Hotchner says: "Ernest sat through *all* of that movie, numb."[29] But what did Ernest expect? The Nobel Prize winner for literature was a good enough artist to know that *The Old Man*

and the Sea, with its slow tempo and concentration on the thoughts and feelings of a man in a boat, could not make an exciting movie. It is, in one sense, commendable on the part of the producer, Leland Hayward, that he should attempt to counter criticism of previous Hemingway adaptations by being strictly faithful to the original. In a more important sense, though, such an attempt at a literal translation from page to screen only underlines the insensitivity of the film-makers.

Not surprisingly, John Sturges said of *The Old Man and the Sea*: "technically [it is] the sloppiest picture I have ever made."[30] Most of the novel is composed of narration; consequently, Viertel's script calls for Tracy to narrate off-screen while we watch him on the screen. In his review of the film, Arthur Knight says that "the narrational device leads to certain redundancies." Three years later, however, Knight, in "Hemingway Into Film," remarks: "Far from creating a redundancy (which would have been true were Hemingway's style literally cinematic), the [narrational] device added a new dimension to the picture—the dimension of the author's own respect for the enduring courage and indomitable will of the simple fisherman. And although little of Hemingway's prose reads well aloud, being directed toward an inner ear, the restrained eloquence of *The Old Man and the Sea* brought to the film a monumentality it could have achieved in no other way."[31] Knight, I believe, was correct the first time.

What sense does it make to show Tracy smiling to himself in the boat—while the same actor's voice on the soundtrack is heard saying: "He smiled"? True, Hemingway's style is not cinematic; but it *is* literary—perhaps more literary in this novel than anywhere else—and that fact alone would deter a sagacious film artist from attempting an adaptation. To watch the violent struggle of a man and a fish on the screen, hearing all the while off-screen that same man recite from a book in measured tones, must strike most people as the height of aesthetic incongruity. (Such a juxtaposition would be valid only if the aim of the sequence was irony or parody.) Similarly unnerving is the sound of Dimitri Tiomkin's

hundred-piece orchestra blasting periodically on the soundtrack whenever the sight of Spencer Tracy sitting in the boat, surrounded by water, threatens to become more than even a sympathetic viewer can bear. *The Old Man and the Sea* is an allegory: Santiago is Everyman; the fish is Life. On the page, Hemingway's poetic style—his cadenced Biblical rhythm—seems appropriate to his subject matter. But the camera is not congenial to walking—or swimming—abstractions. Nor does it ordinarily mix well with the kind of prose that distinguishes *The Old Man and the Sea*; it invariably makes such language seem artificial, banal, and too often superfluous.

Movie critics were about evenly divided over the merits of *The Old Man and the Sea*. The mass audience, however, suffered from no such dichotomy in its ranks. Hayward's expensive, literally faithful, eighty-six-minute adaptation was a commercial catastrophe.

The message seems clear: Hemingway's fiction—like the fiction of that other "cinematic" prose master, Joyce—is not the material from which screen masterpieces are made.

Graham Greene and
the Silver Screen

*There is no need to regard the cinema as a completely
new art; in its fictional form it has the same purpose
as the novel, just as the novel has the same purpose
as the drama. Chekhov, writing of his fellow novel-
ists, remarked: "The best of them are realistic and
paint life as it is, but because every line is permeated,
as with a juice, by awareness of a purpose, you feel,
besides life as it is, also life as it ought to be, and
this captivates you." This description of an artist's
theme has never, I think, been bettered . . . Life as
it is and life as it ought to be: let us take that as the
only true subject for a film.*

—Graham Greene

I

Before Graham Greene published the novels that made his lit-
erary reputation, he was a film critic for *The Spectator* from 1935
to 1940. Greene's movie reviews are important for two reasons:
one, they reveal much about the novelist's aesthetic in general;
and two, they help us to understand specific qualities in his imagi-
native writing.

Greene, who has divided his output into serious novels and
popular entertainments—sometimes, as in the case of *Brighton
Rock* (1938), not being always clear or consistent on the distinc-
tion—regards the movies as a mass art that must perforce estab-

lish its appeal on a broad base: "[I]t is wrong to despise popularity in the cinema—popularity there is a value, as it isn't in a book; films have got to appeal to a large undiscriminating public: a film with a severely limited appeal must be—to that extent—a bad film" (*Spectator*, June 16, 1939). In an essay entitled "Subjects and Stories," Greene enlarges upon this point:

> The poetic drama ceased to be of value when it ceased to be as popular as a bear-baiting . . . The cinema has got to appeal to millions; we have got to accept its popularity as a virtue, not turn away from it as a vice . . . There are very few examples of what I mean by the proper popular use of the film, and most of these are farces: *Duck Soup*, the early Chaplins, a few "shorts" by Laurel and Hardy. These do convey the sense that the picture has been made by its spectators and not merely shown to them, that it has sprung, as much as their sports, from *their* level. Serious films of the kind are even rarer: perhaps *Fury, The Birth of a Nation, Men and Jobs,* they could be remembered on the fingers of one hand.[1]

Although the cinema is a young art form, Greene views it as having made enormous strides forward technically in a relatively short period: ". . . twenty-five years in film history is equal to five centuries of painting" (*Spectator*, June 24, 1938).

Like so many writers, however, Greene's attitude toward the movies is ambivalent. Praising Frank Capra's technique in *You Can't Take It With You*, for instance, Greene nevertheless adds: "We may groan and blush as he cuts his way remorselessly through all finer values to the fallible human heart, but infallibly he makes his appeal—to that great soft organ with its unreliable goodness and easy melancholy and baseless optimism. The cinema, a popular craft, can hardly be expected to do more" (*Spectator*, November 11, 1938). Apparently, Greene believes that most movies are deficient in characterization. "*Even a film,*" he notes in the preface to *The Third Man and The Fallen Idol*, "depends on more than plot, on a certain measure of characterization, on mood

and atmosphere. . . ."[2] In a review of *The Rains Came*, Greene remarks: "I haven't read Mr. Bromfield's book, but I think it would be safe to say that this is the sort of story which is unbearable in book form because of the dim characterization and the flat prose, but becomes likeable as a film because a vivid camera takes the place of the pen" (*Spectator*, December 29, 1939). Even some film classics—such as Pudovkin's *The End of St. Petersburg*, in which all the poor are noble souls and all the rich are vile creatures—reveal what may be severe limitations in the medium itself.[3]

While Greene is obviously aware of essential differences between film and fiction (film characters *are*—and *must be*—thin compared to characters in a good novel), he is ever mindful of effects that can be achieved in both forms. Here he is on the "vivid camera" of *Song of Ceylon*: "One of the loveliest visual metaphors I have ever seen on any screen [appears in this film]. The sounding of the bell startles a small bird from its branch, and the camera follows the bird's flight and the notes of the bell across the island, down from the mountain side, over forest and plain and sea, the vibration of the tiny wings, the fading sounds."[4] We shall find Greene duplicating, or at least approximating, this filmic technique in some of the descriptive passages of his novels.

The author is also cognizant of the fact that too much dialogue is bad for a movie. "A detective story must be one of the hardest jobs a director can be assigned," observes Greene in a review of *The Arsenail Stadium Mystery*, "because there's got to be a lot of talk. He must be on his toes all the time to snatch out of the pages of dialogue any opportunity for visual wit. A thriller is comparatively easy: a gun is photogenic: bodies fall easily in good poses: the camera can move at the speed of a G-man's car, but in a detective story it has to amble at the walking pace of the mind" (*Spectator*, February 2, 1940). These remarks are relevant to some adaptations made from Greene's novels—*The Heart of the Matter* say or *The End of the Affair*—which have failed to measure up even on their own terms to the quality of the original

works because (among other reasons) both books depend so much on "the walking pace of the mind."

Greene the film critic, like Greene the novelist, is very much concerned with "atmosphere," or a sense of place. Reviewing *Alerte en Méditerranée*, he says: "It succeeds mainly in the accuracy of its detail—which is where English films so often fail—in the dying seagulls scrabbling against the glass: the top of the masts moving into obscurity through the black clouds of gas: the unnautical fountain pen in Mr. Martin's breastpocket and his sad drooping outcast mouth. It may be the function of French cinema to teach us how to handle realism, as they taught it in the novel years ago . . ." (*Spectator*, November 18, 1938). *Prisons de Femmes* receives Greene's approval chiefly because of "the authenticity the French always put into their sets and characters. A shabby hotel on the French screen never looks studio built. Those stone stairs and stained walls have grown there for a century" (*Spectator*, March 1, 1940). Of course, the novelist realizes that too much "detail" can be harmful in a work of narrative art. "If [*The Stars Look Down*]—constructed authentically though it is of grit and slag-heap, back-to-back cottages, and little scrubby railway stations—fails to remain in the memory as long as *Kameradschaft*," he remarks elsewhere, "it will be because there is too much story drowning the theme: the particular is an uneasy ally in literature of the general" (*Spectator*, January 26, 1940).

Juxtaposition—whether of Chekhovian "life as it is and life as it ought to be," or, as Greene recognizes below, of Flaubertian "romance" versus "reality"—would seem to be the very stuff of good cinema:

> French directors at their best have always known the trick of presenting a more intimate reality: the horrible or the comic situation . . . is made convincing by its careful background of ordinary life going on, just as Madame Bovary's furious passion was caught up in the dust and cries of the cattle auction. So in *Hotel du Nord* we believe in the desperate lovers and the suicide pact on the brass bed in the shabby room, just because

of the bicyclists on the quay, the pimp quarrelling with his woman in another room, and the first-communion party on the ground floor with its irrelevant and unsuitable conversation. And the French novelist taught the French cinema too the immense importance of the careful accessory: the ugly iron bridge down which the lovers silently and sadly emerge into our own lives: the tuft of cotton wool in the young man's ear which seems to speak of a whole timid and untidy life. (*Spectator*, June 23, 1939)

How much of Greene's own technique has been learned, not from Flaubert, but from the motion picture?

Let it be observed, first of all, that it is not difficult to find the filmic techniques in the "entertainments" Greene was writing during the years he was also reviewing films for *The Spectator*. In *This Gun For Hire* (the American title of *A Gun For Sale*), Greene describes the killer's eyes in terms of "little concealed cameras" which photograph a "room instantaneously: the desk, the easy chair, the map on the wall, the door to the bedroom behind, the wide window above the bright cold Christmas street." Throughout the 1936 novel Greene's "eyes," like the killer's, function "like little concealed cameras." Nor could one discover a more cinematic mode of perception than the following extract from *The Confidential Agent* (1939):

The woods and meagre grass gave out as they pottered on from stop to stop. The hills became rocky; a quarry lay behind a halt, and a rusting single line led out to it; a small truck lay overturned in the thorny grass. Then even the hills gave out and a long plain opened up, dotted with strange erratic heaps of slag—the height of the hills beyond. Short unsatisfactory grass crept up them like gas flames; miniature railways petered out, going nowhere at all, and right beneath the artificial hills the cottages began—lines of grey stone like scars. The train no longer stopped; it rattled deeper into the shapeless plain. . . .

This passage clearly resembles the subjective camera treatment of a journey by train familiar from so many movies. And, finally, compare the "visual metaphor" (the flight of the bird) and the sound effects which Greene praised in *Song of Ceylon*, with the following paragraph from *The Ministry of Fear* (1943):

> The sun came into the room like a pale green underwater light. That was because the tree outside was just budding. The light washed over the white clean walls of the room, over the bed with its primrose yellow cover, over the big armchair and the couch and the bookcase which was full of advanced reading. There were some early daffodils in a vase which had been bought in Sweden, and the only sounds were a fountain dripping somewhere in the cool out-of-doors and the gentle voice of the earnest young man with rimless glasses.[5]

There would seem to be little question then that Greene's entertainments reveal the influence of movie technique. But for that matter so does *Brighton Rock*—which Greene initially considered an entertainment but subsequently classified as a novel. In his review of the film, *Sherlock Holmes*, the novelist speaks approvingly of its "brisk and promising beginning . . . which is not only exciting, but, more important, atmospherically correct . . . [W]e are projected straightaway . . . into that London of cobbles, mud, fast cabs and gas lamps . . . This is the *atmosphere* conveyed, I should make clear, and not the effect of the photography, which is very beautiful" (*Spectator*, March 8, 1940, italics in original). Now here is the famous opening paragraph from *Brighton Rock*:

> Hale knew they meant to murder him before he had been in Brighton three hours. With his inky fingers and his bitten nails, his manner cynical and nervous, anybody could tell he didn't belong—belong to the early summer sun, the cool Whitsun wind off the sea, the holiday crowd. They came in by train from Victoria every five minutes, rocked down Queen's Road standing on the tops of the little local trains, stepped off in bewildered multitudes into fresh and glittering air: the new silver paint sparkled on the piers, the cream

houses ran away into the west like a pale Victorian watercolor; a race in miniature motors, a band playing, flower gardens in bloom below the front, an aeroplane advertising something for the health in pale vanishing clouds across the sky.[6]

How does the novelist's opening differ in its technical strategy— that is, in terms of "the *atmosphere* conveyed"—from the film critic's description of *Sherlock Holmes*?

II

Before considering Greene's major novels in an attempt to determine to what extent such works are also cinematic, I should like to make some observations on the writer's relationship with the motion picture industry. In "The Novelist and the Cinema—A Personal Experience," Greene has some illuminating things to say on the subject of adaptations and screenwriting. *Stamboul Train* (1932) was the first of Greene's novels to be sold to the movies, and with the money he received the author was able to pursue his chosen calling for another two years. "You take the money, you can go on writing," Greene reflects. "[Y]ou have no just ground of complaint. And the smile in the long run will be on your face. For the book has the longer life."

Since 1932 Greene's fiction has become one of the most fertile sources of motion picture material in the world. Thirteen of his novels have been brought to the screen, one of them twice. No figures are available on how much money Greene has earned from movie sales, but one is not surprised when he says that his "first feeling towards the film is one of gratitude." Yet when it comes to his actual work for the movies, Greene says: "a writer should not be employed by anyone but himself. If you are using words in one craft, it is impossible not to corrupt them by employing them in another medium under direction . . . This is the side of my association with films that I most regret and would most like to avoid in the future if taxation allows me to." Today's novelists, Greene

thinks, are more fortunate than writers of the thirties, who could not earn enough money from the sale of their books to resist the lure of the films. Greene believes that none of his original scripts deserve to be considered first-rate. If *The Fallen Idol* (1949) and *The Third Man* (1950) remain good films, the author contends, the credit should go to director Carol Reed—and not to a novelist who has never really learned how to write for the screen. All the same, Greene manages to end "The Novelist and the Cinema—A Personal Experience" on a note of pride: "[Novelists] have to learn [their] craft more painfully, more meticulously, than those actors, directors and cameramen who are paid, and paid handsomely, whatever the result. They can always put the blame for a disaster elsewhere which no novelist can."[7]

Of the four major Greene novels which have received screen treatment—*The Power and the Glory* (1940), *The Heart of the Matter* (1948), *The End of the Affair* (1951), and *The Quiet American* (1956)—only the first named was an out-and-out failure. In the essay referred to above, Greene mocks *The Fugitive* (as *The Power and the Glory* was called on the screen), in which his alcoholic and cowardly priest is transformed into a "pious and heroic" figure. Indeed, Dudley Nichols's script for the 1947 movie proved so distasteful to Greene that he refused to view the finished product. John Ford's opening shot—revealing Henry Fonda as the priest framed in the doorway of his church with his shadow falling conveniently across the floor in the shape of a cross—establishes the level of merit attained throughout the dreary, pretentious proceedings. *The Fugitive* is so bad in every department—writing, directing, acting, sound effects—that it is not worth serious commentary.

Like Greene's less accomplished fiction, *The Heart of the Matter*—the story of the Catholic policeman, Scobie, whose excessive pity drives him to self-destruction and damnation—bears evidence of a cinematic imagination. Visual metaphors, for example, are employed in a striking way throughout the book. The first time

the accountant Wilson sees Scobie, Greene notes: "A vulture flapped and shifted on the iron roof and Wilson looked at Scobie."[8] After Scobie's death, the "vulture" Wilson takes up with Louise, the policeman's widow. Greene's camera-eye method of description is also discernible in *The Heart of the Matter*. When the reader is taken into Scobie's home for the first time, the hero glances about his bedroom the way a film director would have his lens pan over a multitude of objects: "The dressing table was crammed with pots and photographs—himself as a young man in the curiously dated officer's uniform of the last war: the Chief Justice's wife whom for the moment [Louise] counted as her friend: their only child, who had died at school in England three years ago—a little pious nine-year-old girl's face in the white muslin of her first communion: innumerable photographs of Louise herself . . ." (p. 16).

Perhaps the most interesting cinematic technique in the novel occurs when Scobie—who is deeply involved with another woman, Helen, and who is forced to deal with the corrupt Yusef —reads a letter from his mistress while Yusef tries to bribe him. In order to juxtapose the protagonist's pity and the consequences of his fatal flaw, Greene sets up a crosscutting situation—as this extract from the scene makes clear:

> Scobie sat down at the table and laid the note open in front of him. Nothing could be so important as those next sentences. He said, "What do you want, Yusef?" and read on. *When I heard your wife was coming back, I was angry and bitter. It was stupid of me. Nothing is your fault. You are a Catholic. I wish you weren't, but even if you weren't you hate not keeping your word.*
> "Finish your reading, Major Scobie, I can wait."
> "It isn't really important," Scobie said. . . . "Tell me what you want, Yusef," and back his eyes went to the letter. *That's why I'm writing. Because last night you made promises about not leaving me and I don't want you ever to be bound to me with promises. My dear, all your promises . . .*
> "Major Scobie, when I lent you money, I swear it was for friendship, just friendship. . . ." (p. 216)

Scriptwriter Ian Dalrymple and director George More O'Ferrall recognized the filmic nature of the foregoing and did not fail to use the scene in their 1953 movie version of the novel. However, whereas Greene juxtaposes Scobie's talk with Yusef and the reading of the letter from Helen eight times, the film-makers do so only twice. Consequently, the scene in the movie is far less forceful and memorable than it is in the novel.

Greene's cinematic mode of presentation notwithstanding, *The Heart of the Matter* remains very much a work of literary art. Without a penetration in depth of Scobie's Catholicism—which can only be adequately conveyed through internal analysis and interior monologue—the full thematic significance of the story is vitiated. It is certainly no accident that the movie lacks the psychological and theological complexity of the original. Some of the blame for this defect, it is true, is traceable to Dalrymple's and O'Ferrall's fear of making a film that would be "too Catholic" for a mass audience. By minimizing the theological thrust of the original, however, the screen story comes to resemble the triangle pattern of countless other films more than it does the unique novel upon which it is based. Scobie's affair with Helen, for instance, frequently strikes the viewer as a mere romantic sexual encounter; while the ending, in which the policeman plans to kill himself but is instead dispatched by some African natives, wholly alters the meaning of the original. But aside from the timidity of the people responsible for the film—and granting that, thanks to the strong plot and fine characterization supplied by Greene, much of the power of the original is manifest on the screen—it must be clear that a loss of density would be inevitable in any adaptation of *The Heart of The Matter*.

The reasons are, as I have suggested, technical. A camera that can compete with the prose writer in capturing the thought processes of a character has yet to be constructed. In order to externalize the psychological conflicts and spiritual agonies of Scobie, the screenwriter attempts a number of not wholly satisfactory strategies. At one point, while the hero (played remarkably well by Trevor Howard) is suffering from fever, he mutters: "Pity

. . . Louise—she must be happy. . . ." Some of the policeman's thoughts are transformed into dialogue form for the movie; and on one occasion, having decided upon suicide, Scobie even addresses a religious statue: "Don't you see—it's You I have to hurt—not Helen or Louise!" Once Dalrymple's script calls for an interior monologue. As the officer exits from his home intent upon killing himself, his voice is heard "over": "I want to stop hurting people" —followed by Helen's voice remembered from a previous scene in which self-destruction was discussed: "Suicide—what a horrible thing to talk about!" Like the interior monologue introduced at the end of *For Whom the Bell Tolls*, however, this one also arrives without warning, and in a too obtrusive and clamorous fashion. This is not to say that none of these filmic techniques, if handled well, are legitimate. However, they do remain comparatively super-ficial; some novelistic effects lie, for the most part, outside the range of the motion picture, which is unable "to amble at the walking pace of the mind" for any great distance. And because this is true Scobie—as well as other Greene characters—seems less real on the screen than on the page.

 The problems inherent in any attempt to film *The Heart of the Matter* are, if possible, even more pronounced when *The End of the Affair* is compared with the 1956 motion picture made from that novel. As A. A. De Vitis points out, *The End of the Affair*— with its "emotionally involved narrator, the stream-of-conscious-ness technique, the flashback, the diary, the inner reverie, and the spiritual debate"—is a much more "modern novel" than *The Heart of the Matter*.[9] Although I regard the movie version of the book in a more favorable light than most critics, and although I believe that a better writer and a more sensitive director might have improved upon Lenore Coffee's script and Edward Dmytryk's direction, there appears to be little doubt that *The End of the Affair* is not really suitable material for the screen. True, much about Greene's story of Sarah Miles, the slut who attains sanctity, looks "cinematic." For example, *The End of the Affair*

would seem to be the ideal length for a film (in its paperback version it covers a mere hundred and sixty-seven pages), and Greene conveniently divides the action into five books and thirty-two chapters. There is that rapid displacement of scenes in the story that we have come to associate with movie construction. Like Bergman's *Wild Strawberries*, which appeared the year before *The End of the Affair*, Greene's novel moves backwards and forwards in time in a dazzling way. But could a man of even Bergman's stature film a novel which Faulkner described as "one of the best, most true and moving novels of my time" in a way that it deserves to be filmed? *Wild Strawberries* takes as its subject matter the mind; *The End of the Affair* is concerned with the soul—an entity that is difficult enough to probe on the page but that remains just about impossible to project on the screen.

A complete chapter by sequence comparison and contrast of the novel with the film would prove tedious, but a few observations are certainly in order. Greene starts the action after Bendrix's affair with Sarah has ended, though even in the opening chapter the narrator (Bendrix himself) deftly weaves the present and past together. It is not until Chapter Three that Greene takes the reader back to the start of the romance. The next two chapters focus on the present; the sixth chapter projects both past and present; and the last chapter of the first part is set in the past.

In the opening chapter of the second part, which is also concerned with the past, Bendrix justifies what Ford Madox Ford called "the indirect, interrupted method" of narration,[10] or broken chronology, by declaring: "If this book of mine fails to take a straight course, it is because I am lost in a strange region; I have no map. I sometimes wonder whether anything that I am putting down is true."[11] Hence the remaining seven sections of this part repeat the scrambled pattern of the preceding part. Before Book Two ends, Greene introduces the event which alters the direction of the love affair. While Sarah and Bendrix are in bed together, German bombers appear over London. Believing Bendrix has been killed by a falling door, Sarah promises God

that if He will restore her lover to life she will renounce him forever.

The seven chapters of Book Three are devoted to Sarah's diary, and from this major shift in viewpoint, the reader not only gets a fresh perspective on events previously recorded by Bendrix but is also privileged to move closer to the woman's spiritual development. In Book Four, Bendrix returns to the commanding center; action is confined to the present; and when this book ends, Sarah is dead. Book Five is largely restricted to the present—concerned as it is with evidence of Sarah's sanctity—though there is one new diary entry (really a letter to Bendrix) and one flashback.

Naturally, the movie version of *The End of the Affair* is much less formally and intellectually complex than the novel. The flashback technique, which the cinema has popularized, is not—except for the diary sequences—used at all on the screen. The film begins at the beginning of the love affair (Chapter Three of Book One), and ends with the death of Sarah—thus omitting the whole of Book Five. Structurally, the movie loses the density of the original, which through its juxtaposition of past and present manages to create an impression of God working His purposes at the level of human passion. Thematically, the film minimizes the Catholic "idea," but by eliminating the last third of the book it also eliminates most of Sarah's claim on holiness and much of the novel's significance.

There is no real equivalent in the movies for the first-person narrator. "A film is not in the first-person, or in the second or third," Julio L. Moreno observes, "for the very elementary reason that it is not a verbal narrative."[12] On the screen we can tolerate only so much of Van Johnson's voice (the "actor" chosen to play Bendrix!) narrating and interpreting events. The play of Bendrix's reflective mind over such matters as God, Sarah, love, hate, jealousy, literature, and the like—all of which contributes so much to the richness of the book—is almost totally absent from the cinema treatment. Similarly, the sequences in the film which depict revelations from Sarah's diary are much less satisfactory than in the

novel. Deborah Kerr narrates portions of the screenplay, but only a fraction of the character's original words are retained (and, alas, properly so). Much of the time there is simply silent action on the screen and music on the soundtrack. Which is all very well—*ordinarily*; but such a method of presentation can scarcely begin to illuminate those words of Léon Bloy—"Man has places in his heart which do not yet exist, and into them enters suffering, in order that they may have existence"—which Greene has appended to his novel.*

The Quiet American, like The End of the Affair, is told in the first person by an engaged narrator who presents his story in flashback form. Unlike the earlier novel, however, this work tends to keep present and past in separate, solid blocks, rather than meshing them together. The narrator is an English journalist named Fowler who prefers to remain uninvolved in the war between Vietnam and France; but when he meets the American, Pyle, who *does* get involved with a third force opposed to the Communists—an involvement which results in the death of fifty innocent people—the Englishman betrays the American to the Communists. More than politics, though, persuades Fowler to conspire in Pyle's death. Although the journalist has a wife in England, he has been keeping a local girl, Phuong, as his mistress. Pyle falls in love with the girl and takes her away from Fowler. After Pyle's death, Fowler's wife finally agrees to a divorce and the newspaperman marries Phuong. "Everything had gone right with me since he had died," Fowler says, "but how I [wish] there existed someone to whom I could say that I was sorry."[13] Like

* There is an interesting scene in the novel (omitted, to be sure, from the adaptation) which deserves to be mentioned here. Bendrix, who is a novelist, takes Sarah to see a movie version of one of his books: "The film was not a good film, and at moments it was acutely painful to see situations that had been so real to me twisted into the stock clichés of the screen . . . At first I had said to her, 'That's not what I wrote, you know,' but I couldn't keep on saying that" (pp. 33–34). No doubt, Greene had little difficulty identifying with Bendrix in this scene.

Bendrix in *The End of the Affair*, Fowler is a narrator who claims to be a rationalist but who seems to believe in God more than he knows. (When the journalist is wounded, for example, he prays to a God who supposedly does not exist [p. 146].) In short, there are many references to religion woven throughout this novel which is ostensibly concerned with politics and sex. Similarly, Fowler's attitude toward Pyle—and toward America in general—is more complex than the majority of critics apparently realize.

Greene's reflections on the cinema—of marginal importance only in *The End of the Affair*—become more pertinent in *The Quiet American*. Phuong goes to the movies regularly; and Fowler, who at one point recalls having seen *The Great Train Robbery* (p. 190), immediately after betraying Pyle escapes into a theater where an American film is being shown: "—Errol Flynn, or it may have been Tyrone Power (I don't know how to distinguish them in tights), swung on ropes and leaped on balconies and rode bareback into Technicolor dawns. He rescued a girl and killed his enemy and led a charmed life. It was what they call a film for boys, but the sight of Oedipus emerging with his bleeding eyeballs from the palace at Thebes would surely give a better training for life today" (p. 240). Pyle is a product of the same America which has spawned Hollywood and its distorted view of life. According to Fowler, Pyle's flaw was his fatal innocence, or ignorance—his mistaken belief that the Vietnamese truly desired democracy (p. 32).

In "The Novelist and the Cinema—A Personal Experience," Greene complains that the 1958 film treatment of *The Quiet American* was the worst perversion yet perpetrated on one of his serious novels. The screenplay, written and directed by Joseph L. Mankiewicz, certainly reveals important thematic alterations. Pyle (played surprisingly well by Audie Murphy) remains guiltless in the movie, while Fowler (played expertly by Michael Redgrave) is duped by the Communists (the latter, of course, are the real villains of the piece). In short, Greene's criticism of America disappears from view. And except for the ending, in which Fowler

says that he wishes there was "someone" to apologize to, all references to the Deity are banished. Instead of Greene's ironic "happy ending," Mankiewicz punishes Fowler by withholding from him the now steadfast Phuong. Although *The Quiet American* on the screen is considerably diminished in scope and complexity, enough of the original conception nevertheless remains to make Mankiewicz's film a distinguished achievement.

One reason for this is that *The Quiet American* is technically less inaccessible to the movie camera than either *The Heart of the Matter* or *The End of the Affair*. Excellent as it is as a piece of fiction, *The Quiet American* does not probe either the mind or the soul as deeply as do the two previous works. Plot and character come close to striking a balance in *The Quiet American,* while in *The Heart of the Matter* and *The End of the Affair* character tends to be of uppermost importance. Furthermore, the structure of *The Quiet American,* unlike that of *The End of the Affair,* offers no real difficulty to the film-maker; indeed, Mankiewicz adheres almost completely to the original form. Both versions begin after the death of Pyle; and, after Fowler identifies the American's body, both versions flashback to the beginning of the encounter between the two men. Greene continues the flashback until Part Three, Chapter One, in which he briefly returns to the present before resuming the flashback. In Part Four, Chapter One, Greene once more returns to the present; then he moves back to the past again in Chapter Two; and finally he concludes his story in Chapter Three in the present. Mankiewicz simply remains in the past throughout the film until Pyle is killed—which event brings the action back to the opening sequence.

It must be owned, though, that the flashback structure is not handled by the film-maker with complete success. The reader of the novel can easily accept the convention of a first-person narrator writing down his reflections of events occurring in the past. It is much more difficult for the viewer to accept Michael Redgrave standing before the body of Audie Murphy as he remembers out loud all the happenings of the past—only to discover the actor

more than ninety minutes later still standing in the same position!
Like *The End of the Affair*, *The Quiet American* on film employs
the narrator for transitions between scenes; and like the earlier
movie (though not to the same extent, for reasons already dis-
cussed), there is an inevitable reduction in reflective significance
in the translation from page to screen.

Although the adaptations of *The Heart of the Matter*, *The End
of the Affair* and *The Quiet American* are better than the average
film, they still remain, both technically and thematically, slighter
accomplishments than their originals. This is so in spite of the
cinematic technique which is such a conspicuous feature of
Greene's writing. The explanation for this apparently paradoxical
situation is that in Greene's work the filmic approach remains
ancillary to a vision which is basically novelistic. In short,
Greene's cinematic imagination is "literarized" in his finest writ-
ing.

John Steinbeck, Point of View, and Film

I don't think I shall ever do another shooting script. It isn't my kind of work—this moving a camera around from place to place.

—John Steinbeck in 1945

I

Edmund Wilson was one of the first critics to note the influence of the motion picture on the work of John Steinbeck. Writing in 1941, Wilson said: "John Steinbeck, in *The Grapes of Wrath* [1939], has certainly learned from the films—and not only from the documentary pictures of Pare Lorentz, but from the sentimental symbolism of Hollywood. The result was that *The Grapes of Wrath* went on the screen as easily as if it had been written in the studios, and was probably the only serious story on record that seemed equally effective as a film and as a book."[1] The "cinematification" of Steinbeck's fiction had, however, begun earlier than with *The Grapes of Wrath*.

In his first novel, *Cup of Gold* (1929), Steinbeck's prose is "literary"; the work shows no evidence of the spare style and objective technique that would later allow so many of his stories to be smoothly transferred to the screen. Interestingly enough, the writer himself believed that *Cup of Gold*, which relates the romantic adventures of Sir Henry Morgan, would be the only novel of his to be purchased by Hollywood.[2] (According to *The New York*

Times—December 16, 1945—Steinbeck *did* finally sell *Cup of Gold* to the movies; apparently, however, the picture has never been made.) The plot of *Cup of Gold*, in short, seems ideally suited for a standard motion picture treatment. As Peter Lisca, the author of the best study on Steinbeck, puts it: *"Cup of Gold* gives the surface impression that if its author had been an experienced hack purposely writing for Hollywood, he could not have done a better job of it. . . ."³

Steinbeck's second novel, *The Pastures of Heaven,** reveals signs of the author's developing cinematic and dramatic method of writing. Hollywood ignored Steinbeck, however, until *Tortilla Flat* (1935) appeared. After selling his fourth book to the moviemakers for four thousand dollars, the novelist confessed in a letter: "I do not see what even Hollywood can make of *Tortilla Flat* with its episodic treatment."⁴ Steinbeck, who had no control over the filming of his book (John Lee Mahin and Benjamin Glazer did the adaptation), was right: Hollywood was unable to make much of *Tortilla Flat*. The movie was released in 1941, and starred Spencer Tracy, Hedy Lamarr, and John Garfield. *Newsweek* thought that *Tortilla Flat*, as directed by Victor Fleming, was "an unusual film that creates a reasonable facsimile of the Steinbeck flavor"; but Manny Farber, far more accurately, called it a bad film and unfaithful to its source.⁵ What Steinbeck thought of the picture—if indeed he even bothered to see it—is not known. Back in 1936 when he sold *Tortilla Flat* to Hollywood, the novelist said: "On an average, I go to about one movie a year . . . My stuff isn't picture material. If it is bought it is because of some attendant publicity. *Tortilla Flat* was the exception. There won't be a nibble on *In Dubious Battle* and if there were the producers would not use the story, and it is a conscientious piece of work."⁶

Although four thousand dollars seems like a modest sum compared with Steinbeck's later film sales, *Tortilla Flat* was sold to Hollywood during the Great Depression and the novelist felt

* Although *The Pastures of Heaven* was published in 1932 and *To a God Unknown* in 1933, the latter book was actually composed earlier.

richly rewarded. According to Lewis Gannett, it was only after 1936 that Steinbeck "developed that passionate interest in dramatic forms and in the mass audience of the movies which was so powerfully to affect his career for the next decade."[7] Gannett appears to overlook the fact that *In Dubious Battle* is cinematic in its impersonality and objectivity. Here is a sample paragraph from that 1936 novel:

> He walked to the corner and looked at the clock in a jeweller's window—seven–thirty. He set out walking rapidly eastward, through a district of department stores and specialty shops, and then through the wholesale produce district, quiet now in the evening, the narrow streets deserted, the depot entrances closed with wooden bars and wire netting. He came at last to an old street of three-storey brick buildings. Pawnshops and secondhand tool dealers occupied the ground floors, while failing dentists and lawyers had offices in the upper two flights. Jim looked at each doorway until he found the number he wanted. He went in a dark entrance and climbed the narrow stairs, rubber-treaded, the edges guarded with strips of brass. A little night light burned at the head of the steps, but only one door in the long hall showed a light through its frosted glass. Jim walked to it, looked at the "Sixteen" on the glass, and knocked.[8]

This passage, which reads like a scenario, seems made for a camera. Whereas Hemingway writes in the white spaces between the lines, Steinbeck simply leaves spaces—which is one reason why Steinbeck goes on film better than Hemingway. Everything in *In Dubious Battle* is presented in action and dialogue; the author scrupulously avoids internal revelation of character.

The Red Pony (1937), which Steinbeck himself later adapted for the movies, is told almost entirely in description and dialogue. The opening paragraph, part of which follows, is typical:

> At daybreak 'Billy Buck emerged from the bunkhouse and stood for a moment on the porch looking up at the sky. He was a broad, bandy-legged little man with a walrus mustache,

with square hands, puffed and muscled on the palms. His eyes were a contemplative, watery gray and the hair which protruded from under his Stetson hat was spiky and weathered. Billy was still stuffing his shirt into his blue jeans as he stood on the porch. He unbuckled his belt and tightened it again.[9]

If one compares this passage with the opening paragraph of *The Pastures of Heaven* (which, as I have said, already showed signs of an alteration in focus of narration) the differences are striking:

> When the Carmelo Mission of Alta California was being built, some time around 1776, a group of twenty converted Indians abandoned religion during a night, and in the morning they were gone from their huts. Besides being a bad precedent, this minor schism crippled the work in the clay pits where adobe bricks were being molded.[10]

This is summary narrative: the author is "telling" a story, and at the same time conveying an attitude toward his material. *The Red Pony* is mostly bald description: the narrator is "showing," not "telling."

Norman Friedman has isolated eight modes of transmitting story material in fiction: Editorial Omniscience, Neutral Omniscience, "I" as Witness, "I" as Protagonist, Multiple Selective Omniscience, Selective Omniscience, The Dramatic Mode, and The Camera.[11] By the time Friedman's last two categories are attained, the writer has achieved to an absurd degree what Stephen Dedalus described as an aesthetic ideal in A *Portrait of the Artist as a Young Man*:

> The personality of the artist, at first a cry or a cadence or a mood and then a fluid and lambent narrative, finally refines itself out of existence, impersonalizes itself, so to speak. The aesthetic image in the dramatic form is life purified in and reprojected from the human imagination. The mystery of aesthetic like that of material creation is accomplished. The artist, like the God of the creation, remains within or behind or beyond or above his handiwork, invisible, refined out of existence, indifferent, paring his fingernails.[12]

Although Joyce used cinematic techniques in his fiction, he never forgot that he was primarily a novelist. Apparently, Steinbeck was much less thoughtful—or perhaps responsible—than Joyce.

By 1937 Steinbeck was increasingly concerned with The Dramatic mode and The Camera. *Of Mice and Men* (1937) was the future Nobel Prize winner's first attempt at the play-novelette form; in that experiment, Steinbeck wanted to see how far a novel could be written like a play and still remain a novel. For reasons that were to become all too clear, Steinbeck seemed anxious to eliminate the chief advantage that the prose writer has over the playwright and film-maker—namely, the freedom to move deep inside the mind of a character and to treat complex ideas. *Of Mice and Men*, which is really a much better piece of writing than the impulses that prompted it might suggest, was followed by two similar experiments: *The Moon Is Down* (1942) and *Burning Bright* (1950). All three works became plays; the first two were also made into motion pictures. It seems worth noting that Eugene Solow, who wrote the screenplay for *Of Mice and Men* (1943), based his translation on the novel and not on the play; and that Lewis Milestone, who directed the movie, tried to inject as much physical movement as possible into a work that often seemed too talky (the film opens, for instance, with the two leading characters, George and Lennie,* escaping from a posse on a freight train before the credits appear). In his unfavorable review of the film, Franz Hoellering asked: "Can it be that *Of Mice and Men* was from the beginning a Hollywood story?"[13]

Whatever the answer to that question, in 1943 Twentieth Century-Fox also brought out *The Moon Is Down*, having paid Steinbeck three hundred thousand dollars (a record sum in those days) for the privilege. After seeing the movie, which Irving Pichel directed, the author wrote to scenarist Nunnally Johnson: "There is no question that pictures are a better medium for this story than

* Played memorably by Burgess Meredith and Lon Chaney, Jr., respectively.

the stage . . . It was impossible to bring the whole countryside and the feeling of it onto the stage, with the result that the audience saw only one side of the picture."[14] As a novel *The Moon Is Down* was a best seller; as a play it was a disaster; and as a film it received mixed notices (*Newsweek* liked it, for example, but James Agee panned it[15]). Today *The Moon Is Down* makes painful reading. Perhaps Joseph Fontenrose sums up critical opinion on the novel in the most charitable way: "The book has its merits, but it shows plainly the inadequacies of Steinbeck's interpretation of society and history."[16] The preachy, ill-made movie version has only an excellent performance by Sir Cedric Hardwicke as a German colonel and a striking prologue (while the credits are being flashed on the screen we see a map of Norway and hear Hitler's voice ranting louder and more hysterically as he repeats the word "Norway" over and over again) to recommend it. By 1942 Steinbeck was getting involved in the actual production of films, and he was writing fiction which seemed, with few exceptions, to be consciously or unconsciously designed for the motion picture camera.

II

It was *The Grapes of Wrath*, written three years before *The Moon Is Down*, which made Steinbeck's reputation. Never before —and never after—was the writer able to combine so well the novelistic and cinematic modes of presentation within a single work. The enormous success of the book and of the later film version brought Steinbeck the popularity he apparently craved and the money which all too frequently proves the death of a serious artist.

Much has been written about Steinbeck's novel and about the excellent screenplay by Nunnally Johnson made from it, and I have no mind to duplicate what can be found elsewhere. However, perhaps a few points about the novel and the movie need to be

recalled here. *The Grapes of Wrath* consists of thirty chapters, about one-third of which are inter-chapters, or short generalized commentary on the Depression scene by the omniscient author. Like the opening of *The Pastures of Heaven*, these portions of the book are largely *told* in a summary fashion. The bulk of *The Grapes of Wrath*, though, tends toward The Dramatic Mode and The Camera. This means that the members of the Joad family are known almost entirely by what they say and do, and that much stress is placed on description and pictorial narration.

When Edmund Wilson says that *The Grapes of Wrath* "went on the screen as easily as if it had been written in the studios," he probably means that the core of the action was transferred whole to celluloid (though even here, due to time limits imposed on the medium, *everything* concerning the Joads could not be photographed). What was obviously and necessarily lost—and with it much of the book's thematic density—were the inter-chapters (though the director, John Ford, attempted—not with complete success—to compress the thrust of the inter-chapters into one filmic sequence). As George Bluestone points out, Johnson and Ford altered the structure of Steinbeck's novel for the screen. The form of the story as projected by the film-makers is not only made clearer and simpler, but the ending becomes much more "positive" than the ambiguous conclusion of the original. According to Bluestone, the change in the ending "satisfies expectations which are there in the novel to begin with and which the novel's ending does not satisfactorily fulfill."[17] Not all readers will share Bluestone's evident delight in "clarity" of theme and "neatness" of structure. Of course, the form and content of a long novel must be simplified for the cameras; however, it might be argued that the Nunnally Johnson-John Ford version of *The Grapes of Wrath*— though it remains an outstanding motion picture*—manages to conclude with a standard Hollywood happy ending.

It is perhaps not without significance that after the Zanuck

* Henry Fonda as Tom Joad, Jane Darwell as Ma and John Carradine as the preacher, Jim Casy, contribute enormously to the success of the film.

production of the movie Steinbeck's fiction (to say nothing of his screenplays) became conspicuously more positive. However, as the author endeavored to project in his work a more conventional image of man and experience than had previously distinguished his output, critics tended increasingly to dismiss the results as being merely "banal" and "sentimental."[18] Is it an accident that around the same time that the novelist became seriously concerned with the movies, his literary work began to deteriorate and critics began to speak of his decline as an artist? Steinbeck would not be the first writer who composed novels with the prospects of a future movie sale in mind. It might therefore prove instructive to trace the second half of Steinback's career in an effort to illuminate a pattern which, unfortunately, will probably become ever more familiar in the years ahead.

III

After writing *The Grapes of Wrath* Steinbeck turned to a screenplay, *The Forgotten Village* (1941). In his short preface to the published text of the film, he explains that his aim was to convey the quality of life in a Mexican village by focusing on one family in that village. By identifying with a few people the audience would finally be led to see the wider social implications of the script. Here Steinbeck is duplicating "the strategy of *The Grapes of Wrath*. Whatever value the Joads have as individuals is 'incidental' to their primary function as a 'personalized' group."[19] There are other points of similarity between *The Grapes of Wrath* and *The Forgotten Village* which I shall mention in due course; but here I should like to stress that the screenplay, unlike the book, is in no way either structurally or thematically complex. Says Steinbeck:

> The story was simple: too many children die—why is that and what is done about it, both by the villagers and by the gov-

ernment? . . . What we found was dramatic—the clash of a
medicine and magic that was old when the Aztecs invaded the
plateau with a modern medicine that is as young as a living
man . . . We did not editorialize, attack or defend anything.
We put on film what we found, only arranging it to make a
coherent story . . . A curious and true and dramatic film has
been the result.

It is interesting to note that Steinbeck, who gradually eliminated
the omniscient narrator in his fiction in favor of The Dramatic
Mode and The Camera, introduces a literary device—namely, a
narrator—in *The Forgotten Village*.

The most difficult problem of all was the method of telling
the story to an American audience. Sound recorded on the
scene was impracticable: the village was inaccessible to sound
equipment. Dialogue was out of the question, even in Span-
ish, since many of the older people spoke little Spanish; they
used the Indian language of their ancestors. The usual narra-
tive method did not seem quite adequate. It was decided
finally to use the old story-teller—a voice which interpolated
dialogue without trying to imitate it, a very quiet voice to
carry the story only when the picture and the music could
not carry it; and, above all, a spoken story so natural and un-
obtrusive that an audience would not even be conscious of
it.[20]

The Forgotten Village involves Juan Diego and his family in the
pueblo of Santiago in Mexico. At the start of the story, Juan's
mother is pregnant again and journeys to see the Wise Woman,
who supposedly can predict the sex and future of the unborn
child. This charlatan is paid in foodstuffs—thus her personal stake
in the perpetuation of superstition, or the status quo, is estab-
lished. Juan's father grows corn, but the rich landowners have the
right to first choice of half the crop. When Juan's family com-
plains that now they should have more corn to feed more mouths,
the owners flatly refuse. The boy Juan goes off to school in order

to learn how to overcome superstition and greed, and how to make the future better than the past.

Paco—Juan's younger brother—gets sick, and so do many of the other children in the village. In school Juan learns about germs; the teacher blames the children's sickness on contaminated water. Meanwhile a battle begins between the old people, who pray and put their trust in charms, and the young people, who look to science for help. Finally Paco—like many other children in the village—dies of the sickness.

One night, as his mother gives birth to a baby boy, Juan reads aloud to the family about another Indian boy named Juarez, who grew up to become the president of Mexico. The life of Juarez seemed to suggest that one day all the people would enjoy freedom and happiness. When Maria—Juan's sister—also gets sick, the young hero decides to go to the city for medical help. Although the peasants reject the city doctor, the man of medicine disinfects the well water and Juan removes his sister from the village. Later Maria returns home in good health; the elder Diego, however, casts Juan out and forbids him to return. At the end, the hero is diligently studying in a city school, determined to make a better life for himself and others. Says the narrator: "From the govern-ment schools, the boys and girls from the villages will carry knowledge back to their own people. . . ."[21]

I have given this plot summary of *The Forgotten Village* because it reveals so many familiar Steinbeck characteristics. For example, there is present the novelist's hatred of ignorance; his anger at corrupt economic management; his optimistic belief in the eventual triumph of the "little people" and the young; and his Biblical simplicity of character, language, and theme. But compared to *The Grapes of Wrath*, *The Forgotten Village* is—in all its elements—*too* simple; it looks forward to *The Pearl* (especially the script form) and the scenario of *Viva Zapata!*. Steinbeck's statement that he "did not editorialize, attack or defend anything" is simply untrue, as my account of the action makes plain.

The Forgotten Village received mixed notices from film review-

ers. *Newsweek* reacted favorably, calling the documentary "outstanding"; but Otis Ferguson seemed nearer the mark when he reported that the movie, which was directed by Herbert Kline, was "out-of-the-way, but not an extraordinary film."[22]

Steinbeck's next movie assignment was *Lifeboat* (1944). The original idea for the film derived from Alfred Hitchcock, who then asked the novelist to write the story. *Lifeboat* is an unusual motion picture in that all the "action" takes place in a single setting: a lifeboat shared by the survivors of a torpedoed ship and a Nazi submarine commander. For two hours nine people, who represent a carefully selected social cross section, attempt to illuminate the global situation during the Second World War.

Newsweek called *Lifeboat* "one of the most exciting films of the year" (since the year was only seventeen days old when the review appeared perhaps the writer was not as intemperate as he sounds); James Agee, however, referred to the film as an "allegory . . . too carefully slideruled."[23] More recently John Russell Taylor, noting that the characters in the Hitchcock film "are all more quasi-allegorical abstractions than believable human beings," has blamed Steinbeck for the "heavily literary" dialogue.[24] It is not entirely clear, though, to what extent the novelist was responsible for the final product. Hitchcock told Truffaut that Steinbeck's "treatment was incomplete and so I brought in MacKinlay Kantor, who worked on it for two weeks. I didn't care for what he had written at all."[25] Jo Swerling, finally, received credit for the screenplay. Whatever Steinbeck's share in the Hitchcock film may have been, the subject matter and method of *Lifeboat* bear a striking similarity to the author's later novel *The Wayward Bus* (1947).

In 1945 Steinbeck collaborated with Jack Wagner on the story for *A Medal for Benny* (Frank Butler did the screenplay), which Irving Pichel directed. A love story involving California paisanos and the reaction of the town leaders to news that one of their sons has died a hero's death in combat provide the movie's plot. The

familiar Steinbeck sentimentality can be found in the following typical extract:

> CHARLIE: . . . Benny came from that house—(*pointing to his home*) and Benny is a hero.
>
> We get flashes of Charlie's friends—Joe—Lolita—the General—a couple of simple G.I. Joes—and Pantera citizens.
>
> CHARLIE'S VOICE (*over the flash of citizens*): I know there can be heroes from other kinds of houses, too, because a man is only what he grows out of—his family, his friends and his home. (*Over a flash of the Mayor*) Maybe it was kind of people to want to change us, but Benny came from us and we will not change. Maybe that is a good thing for the whole country. (*Over a flash of G.I. Joes*) Maybe it is good for the country that she must depend for her life on all kinds of people—[26]

The reviewers tended to be kinder to this sudsy Steinbeck outpouring than the film deserved. Dorothy Lamour (the Sarong Girl), Arturo de Cordova, and J. Carrol Naish headed the cast.

Two years after writing *A Medal for Benny*, Steinbeck published *The Wayward Bus*. Like *Lifeboat*, *The Wayward Bus* is an allegory; like the film, the novel employs a vehicle—the bus of the title—as a device to bring together a cross section of humanity. And like *Lifeboat*, *The Wayward Bus* is not a successfully realized work of art. Part of the difficulty stems from Steinbeck's inability to charge his fiction with the old anger and passion. Too much of what Agee described as the "sliderule" approach in *Lifeboat* is also discernible in *The Wayward Bus*. But part of the trouble is also traceable to the mode of narration itself. As Peter Lisca observes, *The Wayward Bus* is even more rigorous in its "objectivity," more "catalog-like" in its prose, and more "visual" in its description than *In Dubious Battle*. Omniscient narration is kept to a minimum, and all that seems to distinguish the "novel" from a motion picture is the absence of a musical score.[27]

It is one thing for a novelist to borrow cinematic devices in an

effort to multiply the number of technical options available to him. It is quite another thing for him to so confound fiction and film that, under the guise of writing a novel, he is really turning out a scenario. "Go to a movie," Mrs. Pritchard tells her husband in *The Wayward Bus*, ". . . Go to a movie."[28] By the mid-forties, Steinbeck himself was probably going to the movies more regularly than he said he did in the middle of the Great Depression. In view of the immense debt his fiction owes to the film, and in view of his continuing cinema work, Steinbeck's assertion in 1945 that scenario writing was not to his liking seems strange to say the least.

During 1947 and 1948 Steinbeck worked on film adaptations of *The Pearl* and *The Red Pony*, and began the scenario of *Viva Zapata!* A comparison of the prose version of *The Pearl*, which was written in 1945, with its film treatment offers some interesting insights into Steinbeck's art. One of its author's most popular works, *The Pearl* is based on a folktale of lower California, and like a number of other Steinbeck pieces it is an allegory. In the story Kino, a Mexican fisherman, discovers a pearl. With this newfound treasure the simple man plans to fashion a new life for his wife, Juana, and his son, Coyotito. The pearl, however, brings only trouble. A doctor tries to steal it; some pearl buyers want to cheat the owner out of it; Kino and Juana quarrel over it; and in the end, in a fight with some men, Coyotito is killed and Kino commits murder—all because of the pearl.

It is a simple but strange story. As Steinbeck transforms the folk material, Kino's desire for the pearl is suspect because it is too strong: "It is not good to want a thing too much. It sometimes drives the luck away. You must want it just enough, and you must be very tactful with God or the gods."[29] The pearl threatens the peace and harmony of the family: "For it is said that humans are never satisfied, that you give them one thing and they want something more" (p. 37). Steinbeck appears to be asking: "What is a man profited, if he shall gain the whole world, and lose his own

soul?" As Kino puts it: "This pearl has become my soul . . . If I give it up I shall lose my soul" (p. 93). Finally, at the conclusion, Kino casts the pearl back into the sea and returns to what remains of his former way of life. Although Kino apparently wanted only legitimate things from the pearl, he was presumptuous in believing that he could attain his heart's desire, in thinking that any man could change his destiny. One may quarrel with Steinbeck's simplistic approach, but at least the author's theme in the prose version of *The Pearl* is reasonably clear.

The same cannot be said of Steinbeck's screenplay. While much of the action in the novel is in The Camera Mode he uses in other works, *The Pearl* has little dialogue and a good deal of philosophizing. Although a narrator opens the film adaptation, he appears only briefly and sporadically thereafter; as a result no equivalent is found—either in dialogue or narration—for the missing author. The audience watches Kino dive into the water, come up with a pearl, and suddenly laugh hysterically at the heavens; it sees that Kino is experiencing all manner of difficulty on account of the pearl, and it hears one observer remark: "Kino's sin was in finding the pearl—though it was an accident." But the nature of Kino's "sin" is never revealed to the audience.

If *The Wayward Bus* gave the impression of being "a realistic motion picture—without background music" (Lisca), *The Pearl* is replete with a musical score even on the page, as Steinbeck orchestrates the Song of the Family, the Song of Evil, and the Song of the Pearl. While—thanks to the narrative method—the book manages to explain these motifs, the film, unfortunately, does not. Throughout the movie seemingly endless scenes of singing and dancing are intercut with the story action, but the relevance of the musical numbers to the plot is kept a carefully guarded secret. And, because of the artificial nature of the interludes (the music is nonillusionistic—indeed it sounds like a full symphony orchestra—and the women are all dressed alike, in the manner of Mexican Rockettes), the otherwise realistic style of the film suffers from a shift in approach which is neither justified nor assimilated to the total design of the work.

Not that the movie is ever really convincing, however, as a realistic picture of Mexican life. Although Maxwell Geismar has praised Steinbeck's loving concern in the novel for the village and the natural world,[30] none of this fine awareness is communicated through the camera. The audience is never made conscious of the fact that Kino is part of a social and natural order, or, furthermore, that his discovery of the pearl is a defiance of either order. Meaningless conventional religious symbolism—at times Kino, Juana, and Coyotito, for example, are shot in such a way as to suggest the Holy Family—is substituted for the more authentic treatment of the milieu that is actually required. Emilio Fernandez's direction may be at fault here too, though such trite and sentimental effects mar even *The Grapes of Wrath*.

A reading of *The Wayward Bus* made one feel that Steinbeck had very much confused novel writing with scenario writing. In his transference of *The Pearl* from book to screen, however, the author also seems to have forgotten that philosophical ideas which are expressed in a novel by means of an omniscient narrator must be converted into visual action, dialogue, or even crude narration in a film, otherwise the events depicted on the screen will appear unmotivated and meaningless. Of course, in neither version of *The Pearl* is Steinbeck's concern truly with character; his whole approach is abstract, general, and rather wooden. Faults inherent in the original novel merely become magnified in the screen version. Loud music, pretentious acting, and arty camera work cannot conceal the essential emptiness of Steinbeck's later writing.

In 1952 the novelist himself was finally persuaded to move in front of the cameras in order to narrate portions of *O. Henry's Full House* for Twentieth Century-Fox. The film is composed of five short stories by O. Henry; each is preceded by the appearance of Steinbeck, who utters a few words of praise about the "master" storyteller and introduces the subject of the tale. It took the talents of five teams of writers and directors to bring this new pearl to the screen, and it is no better for that. As Arthur Knight observes: "it was impossible to detect any evidence of stylistic differences. It

might have been the work of a single individual. And in a sense, it was—the corporate individual known as Twentieth Century-Fox."[31] According to Manny Farber, Steinbeck's voice was dubbed in by the actor Ward Bond,[32] but to one viewer at least this fact was difficult to determine. With or without dubbing, however, the novelist seemed to have adjusted himself all too well to the Hollywood system.

The same year that Steinbeck appeared in *O. Henry's Full House* he also wrote the script for *Viva Zapata!*, based on a novel by Edgcumb Pinchon. Beginning with the young manhood of Zapata and ending with his death as a mature leader, Steinbeck's screenplay is necessarily episodic. This is not in itself a defect, of course, but in this case the total effect of the film leaves something to be desired. Like so much of Steinbeck's writing the scenario is a mixture of strong action and sympathetic characterization on the one hand, and obvious sermonizing and polarized conceptualization on the other. *Viva Zapata!* was directed by Elia Kazan, but the consensus of critical opinion seemed to be that whatever faults the film possessed were basically due to Steinbeck's script.

With *Viva Zapata!* Steinbeck's screenwriting career came to an end.

IV

Critics have offered various explanations for the unsatisfactory nature of Steinbeck's later work, and no doubt the sources of his decline as a writer are complex. Success, however, has ruined more than one talent in America, and there is no greater spoiler than Hollywood. Steinbeck, who was a mediocre scriptwriter, ended by also being a mediocre novelist. Using filmic techniques in fiction, it should be clear by now, is not necessarily injurious to a novelist—perhaps not even to one who thinks about selling his book afterward to the movies—provided he knows what he is doing, knows the difference between fiction and film, and makes

the borrowed devices serve an essentially literary purpose. Steinbeck, though, appears to have sought for an escape from the complexity of the inner man and of the challenges of the contemporary intellectual condition, settling instead for an externalized or camera-eye point of view and trite Hollywood moralizing. In short, it could be maintained that John Steinbeck's filmic experiments in fiction, like his film work for the studios, eventually came to represent an evasion of his obligations as a serious artist.

SHORT SUBJECT

How shall we incorporate some of our potential readers into our actual public? Books are inert. They act upon those who open them, but they can not open by themselves. There can be no question of popularizing; we would be literary morons, and in order to keep literature from falling into the pitfalls of propaganda we would be throwing it right in ourselves. So we must have recourse to new means. They already exist; the Americans have already adorned them with the name of "mass media"; these are the real resources at our disposal for conquering the virtual public —the newspaper, the radio, and the movies. Naturally, we have to squelch our scruples. To be sure, the book is the noblest, the most ancient of forms; to be sure, we will always have to return to it. But there is a literary art of radio, film, editorial, and reporting. There is no need to popularize. The film, by its very nature, speaks to crowds; it speaks to them about crowds and about their destiny . . . We must learn to speak in images, to transpose the ideas of our books into these new languages.

—Jean-Paul Sartre

What I deplore most is that the medium of the film has never been properly exploited. It's a poetic medium with all sorts of possibilities. Just think of the element of dream and fantasy. But how often do we get it? Now and then a little touch of it, and we're agape. And think of all the technical devices at our command. But my God, we haven't even begun to use them. We could have incredible marvels, wonders, limitless joy and beauty. And what do we get? Sheer crap. The film is the freest of all media, you can do

marvels with it. In fact I would welcome the day when the film would displace literature, when there'd be no more need to read. You remember faces in films, and gestures, as you never do when you read a book.

<div style="text-align: right">

—Henry Miller

</div>

Alain Robbe-Grillet, the New Novel, and the New Cinema

This is what makes the cinema an art: it creates a reality with forms. It is in its forms that we must look for its true content.

—Alain Robbe-Grillet

I

Perhaps the best way to approach Robbe-Grillet's New Novel, as well as his contribution to the New Cinema, is by way of his theory as set forth in *For a New Novel: Essays on Fiction*,[1] parts of which originally appeared in various journals between 1955 and 1963. After considering Robbe-Grillet's conceptual orientation, we should be in a better position to comprehend his literary techniques and his film work.

Robbe-Grillet's basic assumption seems to be that the old forms of fiction are dead because the old ways of viewing man and nature are dead: "to write like Stendhal one would first of all have to be writing in 1830" (p. 10), he says. For Robbe-Grillet, the world is neither meaningful nor meaningless: "It *is*, quite simply" (p. 19); and it remains the task of the New Novelist to express this "*is*-ness" of the world. In order to make his point clearer, Robbe-Grillet asks the reader to recall what generally occurs when a novel is adapted to the screen. The responsible film-maker de-

sires to be faithful to the original work; but he also wants to use his medium in conformity with its own unique powers; in short, he seeks to translate words into images, hoping at the same time to retain the essential significance of the words. Thanks to the peculiar properties of the camera, however, a new world is made manifest on film. Whereas in the novel the objects tend to vanish in favor of their *"significations,"* in the movie—while the significations remain—the objects themselves assume a distinct *"reality."* Robbe-Grillet's conclusion here appears to be that the novelist should become more like a camera: "Instead of this universe of 'signification' [in the old novel] . . . we must try . . . to construct a world both more solid and more immediate. Let it be first of all by their *presence* that objects and gestures establish themselves . . ." (p. 21, italics in original)—though he later denies (but as we shall see, not very convincingly) that his own writing tends toward filmic objectivity.

If essentialism is dead, and if phenomenology alone remains a valid index to "reality," Robbe-Grillet's "visual bias" (as it has been described) is at least understandable. Since "we" no longer believe that the world has "depth," the writer argues, "the *surface* of things has ceased to be for us the mask of their heart . . ." (p. 24, italics in original). What Robbe-Grillet is saying is that the surface of the world *is* its "reality." Such being the case, literary language must necessarily conform to the structure of the world. Exit all "words of a visceral, analogical, or incantatory character"; enter "the visual or descriptive adjective, the word that contents itself with measuring, locating, limiting, defining . . ." (p. 24). If man, like the world which he inhabits, has neither depth nor higher nature, descriptive notation of external objects is everything. Declares Robbe-Grillet: "The sense of sight immediately appears . . . as the privileged sense," for it "most readily establishes distances" (p. 73); "The sense of sight remains . . . our best weapon, especially if it keeps exclusively to outlines" (p. 74). Some cherished elements of the old novel, it is true, must perforce disappear. Since the reign of the individual is over, "character" in

fiction must go (p. 28)—though "man" lingers on (p. 137).*
(Robbe-Grillet is guilty now and then of stacking the cards
against his detractors in his zeal to generalize from his own liter-
ary practice. For example, he claims that Faulkner makes plain
that "character" in the novel is dead because he gives the same
name—presumably "Quentin" in *The Sound and the Fury*—to
two characters [p. 28]. Hence, Robbe-Grillet not only misreads
the strategy of Faulkner's play on names in the book, but he
further ignores the fact that the American author, who was as
"modern" as any New Novelist, also created a whole gallery of
unforgettable characters.) Furthermore, since the intelligibility
of the world is no longer taken for granted, plot and story likewise
have had their vainglorious day (pp. 32-33). Yet the New Novel-
ist will take consolation in what is left behind, albeit that may not
seem enough to be worth troubling about to lovers of the old
form.

To his critics, Robbe-Grillet stoutly contends that his fiction
is not cinematic, because cinema is objective and for the New
Novelist description is always and inevitably subjective (p. 74).
However, the author's mode of reasoning here becomes a little
slippery, and one must attend it carefully. Whereas the old novel-
ist merely *reproduced* a pre-existing reality through description,
the New Novelist actually *creates* reality. And what the New
Novelist can invent, he can also destroy. Consequently, the writer
who is in Robbe-Grillet's camp is scarcely interested in "the thing
described, but in the very moment of the description" (p. 148).
Such an approach, Robbe-Grillet insists, cannot be cinematic be-
cause the cinema, like the old-fashioned novel, focuses *solely* on
the objective (p. 149). Of course, Robbe-Grillet is fully aware
that his defense has a good many exaggerated claims in it; but he

* Ben F. Stoltzfus in *Alain Robbe-Grillet and the New French Novel*
(Carbondale, 1964), p. 10, and John Ward in *Alain Resnais or the Theme
of Time* (New York, 1968), p. 122, both argue that "character" *does* remain
in Robbe-Grillet's fiction; but, unlike in the old novel, it is created indirectly
through perception. This is quite true; both critics fail to add, however, that
there are distinct limits to how much "character" can be revealed through
Robbe-Grillet's very restricted technique.

attempts to protect himself, at least in part, by speaking of the "*naturalistic* cinema." At any rate, he immediately adds that it is not the "camera's objectivity" that interests fiction writers, but "its *possibilities* in the realm of the subjective" (p. 149, italics mine). This would suggest that the subjective camera technique was in a state of "potency" (if one might employ the vocabulary of that old essentialist Aristotle) awaiting the advent of Robbe-Grillet's New Novelist to confer "act" upon it.

Determined to confound his critics still further, the writer then proceeds to argue that what really *most interests* the fiction artist in respect to the film is precisely "what has most escaped the powers of literature: which is not so much the image as the sound-track . . . above all the possibility of acting on two senses at once, the eye and the ear"—but also the means of "presenting with all the appearance of incontestable objectivity . . . what is only imagination" (p. 149). The immediacy of image and sound in a movie is cause for envy in the New Novelist, who aspires to create the same "*is*-ness," the same sense of a perpetual "present tense of the indicative. In any case, film and novel today meet in the construction of moments, of intervals, of sequences which no longer have anything to do with those of clocks or calendars" (p. 151).

II

So much for theory. If one wants to view the fiction itself perhaps *Jealousy* (1957)—Robbe-Grillet's third, and according to some critics his finest, novel—would prove most representative of his work. *Jealousy* is a short book of roughly one hundred pages, which (if you subtract the stills) is just about the length of Robbe-Grillet's scenario for *Last Year at Marienbad*. Included is a table of contents with titles and page numbers; the text itself, however, remains unmarked—only extra spaces indicate transitions of a sort—so that the "action" continues in the present indicative tense without any break, as is the case in all save a very

few motion pictures. Point of view is in the first person, though there is never any reference to "I" or "me" by the jealous narrator, whose monomania is manifest from the repetitive descriptions in the book. As one who has read *For A New Novel* might guess, the recitations by the narrator in *Jealousy* are largely confined to the surface of things, to measuring outlines and distances, and to describing various kinds of movement. Here is an example:

> The right hand picks up the bread and raises it to the mouth, the right hand sets the bread down on the white cloth and picks up the knife, the left hand picks up the fork, the fork sinks into the meat, the knife cuts off a piece of meat, the right hand sets down the knife on the cloth, the left hand puts the fork in the right hand, which sinks the fork into the piece of meat, which approaches the mouth, which begins to chew with movements of contraction and extension which are reflected all over the face, in the cheekbones, the eyes, the ears, while the right hand again picks up the fork and puts it in the left hand, then picks up the bread, then the knife, then the fork. . . . [2]

And so on and so on. There would seem to be little here—or for that matter elsewhere in *Jealousy*—which could not be duplicated on film by a cameraman . . . But would it be worth it?

Throughout *Jealousy* Robbe-Grillet's paragraphs tend to be brief—indeed, many of them contain only one or two short sentences. Thus, the reader's eye is forced to move more or less quickly from one object to another, from one person to another, as the I-am-a-camera narrator shoots the scene now from this angle, now from that angle, with cold geometric precision. The short paragraphs are probably a slight concession to the reader on Robbe-Grillet's part for the scarcity of dialogue in the novel, inasmuch as most readers look upon conversations between fictional characters as a sign of some liveliness in a book. But there is little talk in the New Novel because ordinary language is impure and hence suspect. I shall have more to say about *Jealousy* in my discussion of *Last Year at Marienbad.*

Most commentators have agreed that Robbe-Grillet's aesthetic

concerns are better suited to the screen than to the page. Yet the French novelist has not been without his defenders. In an introductory essay to *Two Novels*, Bruce Morrissette says:

> The art of Robbe-Grillet, with its objectification of mental images, its use of psychic chronology, its development of "objectal" sequences or series related formally and functionally to plot and to the implicit psychology of characters, its refusal to engage in logical discourse or analytical commentary, is as ideally suited to film as to narrative, and may well serve as the basis for a "unified field" theory of novel-film relationships in the future. "Nouveau roman, nouveau cinéma," says Robbe-Grillet: after the new novel, the new cinema. But, at the same time, let us be prepared for new novelistic surprises, for Robbe-Grillet is, and will remain, essentially a creator of *fiction*, whose structures will require the novel as well as the film to attain their fullest development.[3]

On the face of it, one would be inclined to say that a technique which "is as ideally suited to film as to narrative" should very likely prove to be something considerably less than first-rate as either film or narrative. And like most experiments in mixed-media, the product of a " 'unified field' theory of novel-film relations" would probably end up being less than the sum of its parts. Unfortunately, Morrissette's essay is somewhat vague on *how* precisely Robbe-Grillet's structures "require the novel as well as the film to attain their fullest development." Since for our purposes Morrissette ends where we should prefer him to begin, perhaps it is time to look at Robbe-Grillet's contribution to the cinema.

III

Last Year at Marienbad (1961) remains Robbe-Grillet's best known and perhaps most impressive venture into film.* Alain

* Since 1961 Robbe-Grillet has written and directed four films: *The Immortal Woman* (1962), *Trans-Europ-Express* (1968), *The Man Who Lies* (1969), and *Eden and After* (1970).

Resnais, who directed the movie, apparently was in complete accord with his collaborator. Speaking of the director of *Hiroshima, Mon Amour*, Robbe-Grillet has remarked:

> I knew Resnais's work and admired the uncompromising rigor of its composition. In it I recognized my own efforts toward a somewhat ritual deliberation, a certain slowness, a sense of the theatrical, even that occasional rigidity of attitude, that hieratic quality in gesture, word and setting which suggests both a statue and an opera. Lastly, I saw Resnais' work as an attempt to construct a purely mental space and time . . . without worrying too much about the traditional relations of cause and effect, or about an absolute time sequence in the narrative.[4]

In *Jealousy*, as noted, there is a single point of view—namely, that of the obsessed first-person narrator—and a triangular plot involving the narrator, his wife (called simply "A"), and another man. As in all the author's novels, there are sundry questions left unanswered when one has finished reading *Jealousy*: Is there any "real" cause of jealousy on the narrator's part? Will a murder actually take place? And if so, who will be the victim? Much of the ambiguity in the book derives from the author's fidelity to "a purely mental space and time." The same "world" also appears in *Last Year at Marienbad*. Once again there is an obsessed narrator, a triangular plot, and much ambiguity. The narrator encounters a beautiful young woman named "A" (in the film none of the characters have names) at a fashionable resort, and he endeavors to persuade her that they once met and loved. The girl, who is accompanied by a man who *may* be her husband, denies having known the narrator last year at Marienbad (or whenever and wherever it was).

Throughout *Last Year at Marienbad*, as the importunate narrator seeks to win over the woman, various versions of the alleged liaison appear on the screen. As in *Jealousy*, the film challenges what Robbe-Grillet conceives to be the average man's "naive" idea of "reality." Point of view in the film is actually more com-

plex than in *Jealousy*. Some scenes seem to take place in the narrator's mind, some in A's mind and some in the minds of both simultaneously, as the focus swings along four levels of time: present, past, future, and conditional. To those who feel that the film is confusing, or that Robbe-Grillet is unduly mystifying, the author asserts: "If the world is so complex, then we must re-create its complexity. For the sake of realism."⁵ But the writer has fallen into the imitative fallacy. Suggesting the world's complexity and merely re-creating it are two different things.

Last Year at Marienbad, like *Jealousy*, has very little dialogue. The stress is on the flow of images, which—thanks to Resnais and the cameraman, Sacha Vierny—are beautiful. Long after one has seen the film its pictorial loveliness lingers in the mind. Also similar to *Jealousy*, wherein the narrator's mode of description causes one object to be rapidly displaced by another, *Last Year at Marienbad* projects images which sometimes last less than a tenth of a second on the screen. Abrupt cuts between time-sequences and shifts in perspective take the place of old-fashioned flashbacks with laborious dissolves, though occasionally dissolves are employed for the sake of variety and/or to unify patterns of images.

There is little or no "action" in the film (the same is true, to be sure, of *Jealousy* and of other novels by Robbe-Grillet); consequently, Resnais keeps his camera moving almost constantly. This probably would be distracting and censurable in an ordinary movie; here, however, the fluidity of the picture suggests Robbe-Grillet's desire to focus not on the thing described, but on the creative movement itself. That is to say, as the narrator's voice drones on—softly, hypnotically, monotonously—in an effort to convince the young lady, the movement of the camera down seemingly endless corridors, through spacious rooms which open into still more spacious rooms, and over a multitude of objects, appears to invent "reality" as it proceeds. True to his theory, Robbe-Grillet's scenario (again like his fiction) dispenses with "character"; for the nameless marionettes in the film have no biography— they have, in the ordinary sense (and in the special sense in which

we manage to speak of such matters in art), neither past nor future. "As for the past the hero introduces," remarks the script-writer, ". . . we sense he is making it up as he goes along. There is no last year. . . ."[6] How misleading it is then for critics—and on occasion also for the film-makers themselves—to speak of flash-backs when there is nothing to flashback *to!*

Sound—which, the reader will recall, Robbe-Grillet cites as the most important attraction film holds for the novelist—is used ex-tensively in *Last Year at Marienbad*. The picture opens with a "romantic, passionate, violent burst of music,"[7] and ends with the theme song. Throughout the film music is employed to parallel the emotions of the heroine: now it is anxious and frightened, now tremulous and provocative. Nonmusical sounds are also used with calculated effect: pistol shots, footsteps whispering on soft carpets or crunching almost ominously across gravel, the ticking of a clock, a shrill bell—and always sound played off against periods of unbroken but meaningful (if one can legitimately call upon that word in the present context) silence.

Last Year at Marienbad, like *Jealousy*, was patently con-structed to support any number of interpretations. Like the novel, the movie mocks our rational organization of experience. The minute but finally insane descriptions in *Jealousy* find their paral-lel in the abstract interior settings and in the symmetrically de-signed gardens of *Last Year at Marienbad*, both of which are juxtaposed to the illogical "content" of the film. In every serious work of art interpretation poses a problem; however, in a play like *Hamlet* or in a novel like *Moby Dick* interpretation is circum-scribed by certain objective and verifiable elements in the work: *some* readings of Shakespeare's play and Melville's novel are ob-viously ridiculous. When the director of *Last Year at Marienbad* seems willing to entertain an analysis of the movie which views the narrator and the woman as merely a couple of "ghosts," the rules of the game have changed.[8] As Pauline Kael observes in *I Lost It at the Movies*: "If you compose a riddle and then say all solutions are right, then obviously there is no solution, and the interest must

be in the complexity or charm or entertainment of the riddle and the ideas or meanings it suggests to you—in its *artfulness*"; but the same critic goes on to suggest that a film should not be approached as if it were a Rorschach Test. A more sympathetic commentator, Susan Sontag, remarks: "the temptation to interpret *Last Year at Marienbad* should be resisted. What matters . . . is the pure, untranslatable, sensuous immediacy of some of its images, and its rigorous if narrow solutions to certain problems of cinematic form."[9]

I for one am quite content to resist interpreting *Last Year at Marienbad*—since it makes no sense anyway—while at the same time I repeat that it is frequently a very striking visual experience. But is that enough? In every serious or genuine work of art something mysterious and untranslatable is present at its core; however, even the greatest plays, novels, and films have much in them that can be translated into rational terms. In fact, it is the coexistence of rational and irrational levels of meaning in a narrative work which provides the interest for most people. And why can't a film appeal to us in more ways than one? Why must there be sensuous images, and nothing else? One can put down *Jealousy*, and then pick it up again when ready for another bout with it (though one is tempted to say that once you put down a Robbe-Grillet book you *can't* pick it up again); but one is compelled to sit through the movie, and it takes enormous self-discipline to prevent the mind from wandering. In short, the ninety-three minutes of *Last Year at Marienbad*, like the hundred odd pages of *Jealousy*, strike me as being too much of the same thing.

IV

Nevertheless, a comparison of Robbe-Grillet's fiction with his work for the screen suggests that his peculiar talents may be better suited to motion pictures than to novel writing. As the author himself has said of *Last Year at Marienbad*:

No doubt the cinema is the preordained means of expression for a story of this kind. The essential characteristic of the image is its presentness. Whereas literature has a whole gamut of grammatical tenses which makes it possible to narrate events in relation to each other, one might say that on the screen verbs are always in the present tense . . . [B]y its nature, what we see on the screen is in the act of happening, we are given the gesture itself, not an account of it.[10]

A novelist can sacrifice story, character, a distinguished style, various forms of analysis—a number of traditional fictional elements—provided he supplies some compensatory qualities in the purged work. The medium is the message; but in Robbe-Grillet's work the message—at least for most people—seems not to amount to very much and the medium is too often employed in a repetitious, boring way. Although a subjective world is indirectly presented through perception in Robbe-Grillet's fiction, there is really very little in that world that could not be captured on celluloid. When a novelist decides to limit his approach solely to description of external objects and bodies in motion, he would appear to be writing not from strength but from weakness—regardless of the theory advanced to justify the method. After all, a theory is no better than the kind of work it inspires or rationalizes. And in this case the work in question reveals a basic confusion in the author about the nature of fiction.

Compared to the novel, as we have repeatedly seen, film is a medium limited in its ability to probe complex interior states and complicated themes. Similarly, character is generally not as fully developed in the film (which resembles a short story in this respect) as in the average novel. Sight and sound being so important to Robbe-Grillet, then, I would venture to say (*pace* Morrissette) that the author is *not* "essentially a creator of *fiction*" and that his increasing preoccupation with moviemaking is not without its wisdom.

Critique of the Cinematic Novel and Present Trends

I

Clearly, the motion picture has had an enormous influence on the novel and short story. If the cinematic imagination in fiction is to be a positive force, though, it must be assimilated to an intrinsically literary form of expression, or a literary way of "getting at" life. To express the point differently: the influence of film on the novel and short story can be salutary if the fiction *is* fiction essentially, and not a scenario pretending to be fiction.

Dos Passos, Steinbeck, and Robbe-Grillet are examples of writers who use their camera-eye in the service of external dramatization; they tend to favor visual action, surface description, and a point of view which excludes deep analysis of mental states or any form of authorial commentary. Much of their work leaves an impression of incompleteness; one feels that the fiction of these writers has been impoverished rather than enriched by the influence of the film.

The stream-of-consciousness writers—Joyce, Virginia Woolf, and Faulkner—use cinematic techniques, but they explore areas of experience that, for the most part, lie beyond the reach of even the most sophisticated cameras; thus, their novels remain literary abstractions from, or transformations of, "reality." In their different ways, Hemingway, Fitzgerald, West, and Greene integrate filmic methods with narrative elements that are interior, discursive, and often abstract; like the stream-of-consciousness artists,

these writers construct word pictures, not screen pictures—as the adaptations made from their fiction make plain.

The same general principle would seem to apply to screen treatments of both plays and novels: "The better the original work, the worse the movie that will be made from it." As John Simon puts it: "a great novel has yet to make a great film. Rarely, very rarely, an estimable achievement comes along . . . But always either the book or the film is less than absolutely first-rate."[1] A film version of a major novel should reflect through the means of its own medium the technical complexity and thematic density of the original. The level of achievement, however, is necessarily restricted in advance by the nature of the motion picture; even in the hands of the most inspired artist, the camera cannot reveal character in the way that Joyce or Faulkner can on a page. Nor can the film-maker alter the form of a serious novel without altering its meaning, for the structure of a novel remains the backbone of its theme. "Fiction," says John Howard Lawson, "cannot be transformed into film by duplicating the 'dramatic' scenes and omitting the prose passages."[2] One can go even further and argue that the dramatic scenes cannot even be transferred to film in their totality. There are two reasons for this: one, the motion picture is limited as to length (witness the difficulty that exhibitors encountered with the Soviet production of *War and Peace* [1968], which even trimmed to six and a half hours placed a great strain on the mental and physical capacities of movie audiences); and two, good literary dialogue is not good movie dialogue (witness the problem that film actors have had with Hemingway's supposedly "realistic" talk).

In an inductive study of novels into film made some years ago, Lester Asheim was able to show that adaptations inevitably result in serious modifications of the original. According to Asheim, whose conclusions more or less corroborate my own, almost ninety per cent of films adopt an omniscient and impersonal point of view, regardless of the viewpoint in the novel. Due to the nature of the screen medium, the more "active" side of the book is re-

tained—and in some cases it is very much expanded upon—while a good deal of material *essential* to the novelist's purposes is *necessarily* omitted. Simplification rules in nearly every case: normal chronological sequence replaces the indirect narrative method (to some extent this structural practice is changing since Asheim conducted his researches); condensation results in more "unity of action"; and character and theme are similarly cut to fit the requirements of an art form which makes its appeal primarily through pictures, and only secondarily through words.

Asheim believes that box-office considerations weigh more heavily "as a bar to intellectual content" than technical considerations.[3] While I would not wish to minimize as a leading factor in intellectually impoverished adaptations the film producer's desire to make money, I also believe that technical differences between fiction and film are of equally decisive importance. Too many film theorists, after years of suffering from an inferiority complex, have lately developed an even worse case of hubris. "In theory, there is little that a novel can do that a movie can't," says Pauline Kael, "but, practically, American audiences won't sit for the length and detail and complexity of a novel."[4] Length is only one of the problems that needs to be considered in a comparison of film and fiction. *Tom Jones* is not, as great novels go, an intellectually formidable book; and the 1963 John Osborne-Tony Richardson film version of Fielding's classic was justly praised as being one of the more successful adaptations on record. All the same, the eighteenth-century scholar Martin C. Battesten (who is not insensitive to cinematic values) argues: "What is missing from the film is exactly that quality which [is] . . . the distinctive characteristic of Fielding's fictional world—namely, that 'moral seriousness' which underlies all of Fielding's humor and his satire and makes of *Tom Jones* not merely a frivolous, if delightful, romp through English society, but a complex symbolic expression of its author's Christian vision of life."[5] And that "vision of life" could not have been imparted to a movie audience, in all probability, even had that audience been willing to sit for ten or fifteen hours.

For the film and the novel—though they obviously touch at many points—remain basically different modes of apprehending experience. Even the serious novel influenced by the cinema, as I have been at pains to show, moves and has its being at the level of language, not at the level of the moving picture. There is something irreducible in every genuine work of art, something which perhaps even defies precise analysis. "There are many reasons why we ought to avoid filming existing literature," says Ingmar Bergman, "but the most important is that the irrational dimension, which is the heart of a literary work, is often untranslatable, and that in its turn kills the special dimension of the film."[6] Elsewhere the Swedish director adds: "If, despite this, we wish to translate something literary into film terms, we must make an infinite number of complicated adjustments which often bear little or no fruit in proportion to the effort expended."[7] While one knows full well that adaptations of novels are going to continue for a long time, and that occasionally an "estimable achievement" will result, one feels very much compelled to agree with Bergman. It would seem best if film-makers concerned themselves solely with original works for the screen.

II

Be that as it may, novels continue to be the chief source of films in America. And far from apologizing for it, the typical Hollywood producer brags about his dependence on another medium. For example, on September 24, 1968, *Variety* quoted Darryl F. Zanuck as follows: "[Twentieth Century-Fox] buy[s] more stories, novels and plays than any other major motion picture company, in my opinion. Essentially, we try to sense the temper of the times and set production with what we think people will like to see on the screen." The following month Zanuck took a full page ad in *The New York Times* (October 6, 1968), in which he proudly announced that his company was in the process of placing

eight plays and eighteen novels before the cameras. It is a well known fact that a movie version of a novel has a tremendous influence on the sale of the original book. An outstanding case in point is Charles Webb's *The Graduate*, which sold about twenty-five hundred copies in hardcover and under two hundred thousand in paperback before the appearance of the film; the success of the adaptation sent paperback sales up over the million and a half mark. When the 1962 movie *To Kill a Mockingbird* finally appeared on television in 1968, the publisher of the paperback version promptly brought out another hundred and fifty thousand copies in anticipation of further demand. Hence novelists seem to be exposed to even greater artistic and financial temptations from the motion picture than playwrights.

Of late, book reviewers and literary critics have become skillful at identifying the "movie novel." The species can be known by its skin-deep characterizations, its structure of truncated scenes, its jump-cut transitions, its dialogue intended to complement the screen image, and its theme which can be projected in one picture without a thousand words. But why, it is sometimes asked, don't these "novelists" simply make movies? The answer is that it remains almost impossible for a beginner to become a scenarist or film director—at least above the underground (and below ground there is little gold)—without first establishing a literary reputation. However, once a novelist has earned a name for himself, there is practically no limit to how much money he can make from a film sale. Today's novelists enjoy contracts that would have made Faulkner, Fitzgerald, Steinbeck, and Hemingway envious. One can scarcely name a current writer of any talent who has not sold material to the movies or worked on a script. It is, of course, the fate of the "serious writer" in this situation which calls for attention.

Faulkner once remarked: "Nothing can injure a man's writing if he's a first-rate writer. If a man is not a first-rate writer, there's not anything can help it much. The problem does not apply if he is not first-rate, because he has already sold his soul for a swimming

pool."[8] The Nobel Prize winner was a little too contemptuous of second-rate writers. After all, the vast majority of authors whose work concerns us today are not major talents; but the loss of their fiction as a result of a conflict on their part between the demands of the novel and the requirements of the screen would certainly impoverish our literary scene.

In the hands of a writer who is primarily committed to the word, cinematic techniques can assist him in exploring his theme in a more dynamic and meaningful way than he might otherwise be able to do. This is a point which has been sufficiently established throughout the second part of this study. While actual film writing need not do harm, there is clear evidence that too many writers *are* harmed by the influence of the films. This is especially true of those with too great an interest in their standard of living. However, the latter problem raises moral questions which lie outside the concerns of this survey.

Aesthetically, however, it is cause for some troubled thought when a writer like John Barth—whose excellence as a novelist resides chiefly in his manipulation of language—joins with the likes of Terry Southern to adapt *The End of the Road* to the screen. Eventually, a complete confusion of art forms may come about as novels become nearly totally cinematic and films become increasingly novelized. An even more pessimistic view might envision the gradual disappearance of literature entirely. Indeed, the authors of one recent historical and analytical study of narrative art suggest just this possibility; for they regard Antonioni, Bergman, Fellini, Resnais, and Truffaut as carrying on a tradition begun by Homer and practiced so brilliantly by Balzac, Flaubert, Tolstoy, Joyce, and Lawrence in the modern age.[9] Today most young people would probably rather create a great American film than "the great American novel" of yesterday.

One can hope, though, that the future will find need for diverse narrative approaches to experience, that both the novel and the film will be able to coexist in their legitimate spheres—now and then even fruitfully influencing one another but without either art

violating the basic integrity of the other. Even the lure of Hollywood dollars on young writers need not be as harmful as one might suppose in one's more gloomy moments. It is possible to conceive of the bright day when the majority of novelists—having purged their systems of film writing through an overindulgence in same—might actually return to their original calling purified and rededicated to the obvious truth that the novel is a verbal art . . . But admittedly, this is an optimistic view of the future.

ACKNOWLEDGMENTS

I wish to thank the State University of New York for a Faculty Research Fellowship in 1969 which helped me to complete this study. I also want to thank Mr. Alexander P. Clark, Curator of Manuscripts at Princeton University, for allowing me to read the F. Scott Fitzgerald Papers; Princeton University Library for permission to quote from unpublished manuscripts by Fitzgerald; and Harold Ober Associates, Inc., for permission to quote from unpublished Fitzgerald material.

)

Notes

INTRODUCTION

1. Quoted in Lloyd Morris, *Not So Long Ago* (New York, 1949), p. 21.
2. See *Stage to Screen: Theatrical Method From Garrick to Griffith* (Cambridge, Mass., 1949).
3. Quoted in Jay Leyda, *Kino: A History of the Russian and Soviet Film* (New York, 1960), p. 410.
4. *Film Form and The Film Sense* (New York, 1957), pp. 195–255.
5. *The English Journal*, IV (May 1915), 292–298.

CHAPTER ONE

1. *Film: The Creative Process* (New York, 1964), p. 324.
2. "Films: Concerning Dialogue," *The Nation*, CXXXV (August 17, 1932), 151–152.
3. James Agee, *Agee on Film: Reviews and Comments* (Boston, 1964), p. 211.
4. *The Movies* (New York, 1957), p. 25.
5. Quoted in William Flanagan, "The Art of the Theater IV: Edward Albee; An Interview," *Paris Review*, X (Fall 1966), 102.
6. Lawson, p. 192.

CHAPTER TWO

1. *The Plays of Eugene O'Neill* (New York, 1928), p. 187. Subsequent references to this play will be documented in the text.
2. *New Cinema in the USA* (New York, 1968), p. 90, italics mine.
3. Reprinted in *American Playwrights on Drama*, ed. Horst Frenz (New York, 1965), p. 12.

4. Anon., XXII (September 25, 1933), 31–32.
5. *A Grammar of the Film* (Berkeley, 1962), pp. 235–236.
6. In their edition of the play (New York, 1934), p. 61.
7. Quoted in Arthur and Barbara Gelb, *O'Neill* (New York, 1960), p. 717.
8. *Ibid.*, p. 719.
9. *Ibid.*, p. 720.
10. *New Republic*, LXXII (September 14, 1932), 124–126.
11. *The Nation*, CXXXV (September 28, 1932), 292.
12. Gelbs, p. 857.
13. *Ibid.*, pp. 857–858, italics in original.
14. *Ibid.*, p. 872.
15. *American Playwrights on Drama*, pp. 8 and 12. Subsequent references to this piece are documented in the text.
16. (New Haven, 1962), p. 61.
17. *Film Quarterly*, XXI (Winter 1967–1968), 12.
18. *Films in Review*, IX (June–July 1958), 340.

CHAPTER THREE

1. "Two Lectures," *Tulane Drama Review*, XI (Fall 1966), 186. (Meyerhold's essay originally appeared in *Reconstruction of the Theater* [1930].)
2. Quoted in Olga Carlisle and Rose Styron, "The Art of the Theater II: Arthur Miller: An Interview," *The Paris Review*, X (Summer 1966), 77.
3. *New Theaters for Old* (New York, 1962), p. 421.
4. Brecht's "Organum" is reprinted in *Playwrights on Playwriting*, ed. Toby Cole (New York, 1961), pp. 72–105.
5. "The German Drama: pre-Hitler"—as well as Brecht's other essays referred to in this chapter—appear in *Brecht on Theater: The Development of An Aesthetic*, ed. John Willett (New York, 1964): "The German Drama," pp. 77–81; "Theater for Pleasure or Theater for Instruction," pp. 69–77; and "The Film, the Novel and Epic Theater," pp. 47–51.
6. *The Mother* (New York, 1965), pp. 133–134.
7. *Film: The Creative Process* (New York, 1964), p. 353.
8. "Film and Theater," *Tulane Drama Review*, XI (Fall 1966), 35.
9. *Bertolt Brecht* (New York, 1967), p. 190.
10. (Princeton, 1966), p. 243.
11. *Bertolt Brecht*, p. 382.
12. Michael Kirby, "The Uses of Film in the New Theater," *Tulane Drama Review*, XI (Fall 1966), 49–61.

13. Sheldon Renan, *An Introduction to the American Underground Film* (New York, 1967).
14. Gregory Battcock, *The New American Cinema* (New York, 1967).
15. Kirby, 60.
16. "Happenings," in Battcock, p. 76.
17. Quoted by Toby Mussman, "The Images of Robert Whitman," in Battcock, p. 159.
18. "On Filmstage," *Tulane Drama Review*, XI (Fall 1966), 68, 70.

CHAPTER FOUR

1. (Cleveland, 1965), p. xii.
2. (New York, 1966), p. 39 and p. 76, italics in original.
3. Maxwell, p. xii.
4. "The Past, the Present and the Perhaps" in *The Fugitive Kind* (New York, 1960), p. vii.
5. Edwina Dakin Williams, *Remember Me to Tom* (New York, 1963), p. 105. The author is the playwright's mother.
6. *Saturday Review*, XLIX (June 25, 1966), 40.
7. Quoted in Nancy M. Tischler, *Tennessee Williams: Rebellious Puritan* (New York, 1961), p. 242.
8. *The Glass Menagerie*, p. x. Further references to this play will be documented within the text.
9. *Tennessee Williams* (Minneapolis, 1965), p. 33.
10. "Translating *The Glass Menagerie* to Film," *Hollywood Quarterly*, V (Fall 1950), pp. 14–32.
11. *Remember Me to Tom*, p. 210.
12. (New York, 1961), no page number.
13. *Camino Real* (New York, 1953), p. ix.
14. *Summer and Smoke* (New York, 1961), p. 35 and p. 41.
15. *Camino Real*, pp. 101–102.
16. (New York, 1962), p. 106.
17. *The Mirror and the Lamp: Romantic Theory and the Critical Tradition* (New York, 1958), p. 88.
18. (New York, 1960), p. 83.
19. *Tennessee Williams*, p. 42.
20. *In American Theater*, ed. John Russell Brown and Bernard Harris (New York, 1967), pp. 163–187.
21. Murray Schumach, *The Face on the Cutting Room Floor: The Story of Movie and Television Censorship* (New York, 1964), p. 76.
22. Quoted in Schumach, p. 78.

23. *Remember Me to Tom*, p. 210.
24. Schumach, p. 74.
25. (New York, 1958), p. 25, italics in original.
26. See pp. 123 and 59, italics in original.
27. (New York, 1960), pp. 83, 16 and 61.
28. *Suddenly Last Summer*, p. 34.
29. Quoted in *Time*, LXXV (January 11, 1960), 66.
30. Quoted by Tischler, p. 257.
31. (New York, 1964), p. 48 and pp. 65–66.
32. *The Night of the Iguana*, p. 116.

CHAPTER FIVE

1. *Arthur Miller, Dramatist* (New York, 1967), pp. 25–33.
2. "Introduction," *Collected Plays* (New York, 1957), p. 26.
3. "Miller's innovation is in the direction of more complete *visualization*; what Ibsen was content to leave as narrative, information conveyed by the dialogue, Miller dramatizes" (Alan S. Downer, *Fifty Years of American Drama* [Chicago, 1966], p. 74, italics mine).
4. "Designing a Play: *Death of a Salesman*," in *Death of a Salesman: Text and Criticism*, ed. Gerald Weales (New York, 1967), pp. 192–193.
5. Miller, pp. 26–27.
6. Miller, p. 25.
7. *Death of a Salesman* in *Collected Plays*, pp. 171–172.
8. *Ibid.*, p. 165.
9. "Play Into Picture," *Sight and Sound*, XXII (October–December 1952), p. 82.
10. *Ibid.*, p. 84.
11. *Ibid.*, p. 84.
12. *Ibid.*, p. 84.
13. "*The Misfits*: Epic or Requiem?" *Saturday Review*, XLIV (February 4, 1961), p. 27.
14. Quoted by Hollis Alpert, "Arthur Miller: Screenwriter," *Saturday Review*, XLIV (February 4, 1961), 27 and 47.
15. (New York, 1961), p. ix.
16. Miller, *Ibid.*, p. x. Subsequent references to this work are documented in the text.
17. "Arthur Miller: Screenwriter," 47.
18. *The Story of the Misfits* (Indianapolis, 1963), p. 106.
19. "Arthur Miller: Screenwriter," 27, italics in original.

20. *The Story of the Misfits*, p. 261.
21. *After the Fall* (New York, 1964), p. 1. Further references to this play are documented in the text.
22. André Bazin, *What Is Cinema?* (Berkeley, 1967), p. 35.
23. Quoted by John Russell Taylor, *Cinema Eye, Cinema Ear* (New York, 1964), p. 223.

CHAPTER SIX

1. (New York, 1961), pp. 236–237.
2. (New York, 1964), pp. 15–18, italics in original.
3. *Ibid.*, p. 29.
4. *Ibid.*, pp. 158–159.
5. *Ibid.*, p. 189, italics in original.
6. *A Treasury of the Theater: From Henrik Ibsen to Eugène Ionesco*, ed. John Gassner (New York, 1960), pp. 1248–1249.
7. *The Chairs*, p. 1249.
8. *Agee on Film: Reviews and Comments* (Boston, 1964), p. 8.
9. *Charlie Chaplin* (New York, 1951), pp. 75, 79 and elsewhere. (W. C. Fields "contemptuously dismissed Chaplin as [a] 'ballet dancer' . . ." [p. 254].)
10. *The Chairs*, p. 1240.
11. *Ibid.*, pp. 1247 and 1248.
12. Richard Griffith and Arthur Mayer, *The Movies* (New York, 1957), p. 216.
13. *Private Screenings* (New York, 1968), p. 262.
14. *In Search of Theater* (New York, 1954), p. 298.
15. See *Theory of Film: The Redemption of Physical Reality* (New York, 1965).
16. (New York, 1954), p. 7. Further references will be documented in the text.
17. *For a New Novel: Essays on Fiction* (New York, 1965), pp. 115–116, italics in original.
18. "Being Without Time: On Beckett's Play *Waiting for Godot*," in *Samuel Beckett: A Collection of Critical Essays*, ed. Martin Esslin (Englewood Cliffs, N. J., 1965), p. 142.
19. Quoted by Anon., "Beckett," *The New Yorker*, XL (August 8, 1964), 23.
20. "Reality Is Not Enough: An Interview with Alan Schneider," *Tulane Drama Review*, IX (Spring 1965), 139.
21. "Beckett," 22.
22. "Reality Is Not Enough," p. 139–140.

23. (New York, 1966), p. 372.
24. *A World on Film* (New York, 1967), p. 409.
25. (New York, 1968), p. 187.
26. Quoted by Raymond Federman, "Film," *Film Quarterly*, XX (Winter 1966–67), 50.

CHAPTER SEVEN

1. *The Idea of a Theater* (New York, 1949), pp. 250–255.
2. Quoted in Arthur and Barbara Gelb, *O'Neill* (New York, 1960), p. 858.

CHAPTER EIGHT

1. *Films and Feelings* (Cambridge, 1968), p. 164.
2. "The Nature of the Cinema," in *Introduction to the Art of the Movies*, ed. Lewis Jacobs (New York, 1960), p. 151.
3. Quoted in James Agee, *Agee on Film: Reviews and Comments* (Boston, 1964), p. 326, italics in original.
4. *Film Technique and Film Acting* (New York, 1960), p. 36.
5. "The Novel and the Film," in *The Creative Vision*, ed. Haskell M. Block and Herman Salinger (New York, 1960), p. 163, italics in original.
6. *Some Observations on the Art of Narrative* (New York, 1947), p. 48.
7. *Films and Feelings*, p. 39.
8. (New York, 1929), p. 4.
9. Donald Hall, *The Modern Stylists: Writers on the Art of Writing* (New York, 1968), p. 5.
10. See *Joseph Conrad on Fiction*, ed. Walter F. Wright (Lincoln, 1964), p. 162.
11. Quoted in Arthur Knight, *The Liveliest Art: A Panoramic History of the Movies* (New York, 1957), p. 37.

CHAPTER NINE

1. *Letters of Theodore Dreiser: A Selection*, Vol. III, ed. Robert H. Elias (Philadelphia, 1959), p. 789. The letter to Eisenstein is dated January 3, 1938.
2. *Esquire*, XX (July 1943), p. 50.

3. (New York, 1928), pp. 204–8.
4. (New York, 1952), p. 121.
5. *Film Form and The Film Sense* (New York, 1957), p. 96.
6. Quoted in Arthur Knight, *The Liveliest Art: A Panoramic History of the Movies* (New York, 1957), p. 83.
7. *Film Form and the Film Sense*, p. 96.
8. *Ibid.*, pp. 103–104.
9. *Ibid.*, pp. 237–238.
10. Vol. II (Cleveland, 1946), p. 78.
11. *Film Form and The Film Sense*, p. 240.
12. *Letters of Theodore Dreiser*, Vol. II, pp. 510–512.
13. W. A. Swanberg, *Dreiser* (New York, 1967), p. 451.
14. *Letters*, Vol. II, pp. 526–530.
15. *Ibid.*, p. 562.
16. CXXXIII (September 2, 1931), p. 237.
17. *Dreiser*, pp. 453–454.
18. (New York, 1965), p. 46.
19. *The Films of Josef von Sternberg* (New York, 1966), p. 33.
20. *An American Tragedy*, Vol. II, p. 405.

CHAPTER TEN

1. *James Joyce: A Definitive Biography* (London, 1941), p. 199.
2. *That Summer in Paris* (New York, 1964), pp. 139–140.
3. *Film Form and The Film Sense* (New York, 1957), p. 104.
4. Marie Seton, *Sergei M. Eisenstein: A Biography* (New York, 1952), p. 490.
5. *Ibid.*, p. 457. Obviously, Eisenstein was not always consistent in his remarks.
6. *Ibid.*, p. 149.
7. *James Joyce* (New York, 1965), p. 666.
8. *The Art of James Joyce* (New York, 1964).
9. (New York, 1934), p. 768. Further references to *Ulysses* will be documented parenthetically within the text.
10. "It seems that Joyce remarked in passing one day that he had seen a film on astronomy before writing the Penelope episode of *Ulysses*. This suggested that he should give the thoughts of Molly Bloom something of the rhythm of the moon's movement which he had seen there" (Patricia Hutchins, "James Joyce and the Cinema," *Sight and Sound*, XXI [August–September 1951], 9–12).
11. All of which has betrayed Harry Levin into saying: "Bloom's

mind is neither a *tabula rasa* nor a photographic plate, but a motion picture, which has been ingeniously cut and carefully edited to emphasize the close-ups and fade-outs of flickering emotion, the angles of observation and the flashbacks of reminiscence. In its intimacy and in its continuity, *Ulysses* has more in common with the cinema than with other fiction" (*James Joyce* [Norfolk, 1941], p. 88). Levin has allowed himself to be swept away, I'm afraid, by the force of his analogy. Bloom's "mind" is *not* "a motion picture," and if *Ulysses* really did have *more* in common with the film than with other fiction, it would be a very strange great novel.

12. *Stream of Consciousness in the Modern Novel* (Berkeley, 1955), pp. 50 and 53.
13. *A Portrait of the Artist as a Young Man* (New York, 1965), p. 215.
14. See, for example, Joseph Campbell and Henry Morton Robinson, *A Skeleton Key to Finnegans Wake* (New York, 1944), p. 39; but especially Clive Hart, *Structure and Motif in Finnegans Wake* (Evanston, 1962), p. 89.
15. (New York, 1939), p. 3.
16. *Stream of Consciousness: A Study in Literary Method* (New Haven, 1955), p. 241.
17. Seton, *Sergei M. Eisenstein*, p. 491. The Russian director's full statement is as follows: "I feel that *Work in Progress* is retrogressive; now Joyce can go no further in literature." *Finnegans Wake* is, of course, far from being "retrogressive." Eisenstein speaks of "literature," but he really means that Joyce's work has nothing in it of interest to the film-maker. Even if *Ulysses* was later to prove that Joyce's work could not be filmed, the earlier work at least used cinematic techniques, albeit in a literary way, whereas *Finnegans Wake* is largely innocent of such borrowings.
18. "Abstronics," *Films in Review*, V (June–July 1954), 263–266.
19. "An Interview With Mary Ellen Bute on the Filming of *Finnegans Wake*," *Film Culture*, XXXV (Winter 1964–1965), 25–28. The italics in the last quotation are in the original.
20. *Stream of Consciousness: A Study in Literary Method*, p. 241.

CHAPTER ELEVEN

1. *A Writer's Diary* (New York, 1953), p. 350.
2. Quoted by François Truffaut, *Hitchcock* (New York, 1967), p. 89.

3. *Contemporary Writers* (New York, 1966), p. 84.
4. Quoted by Donald P. Costello, *The Serpent's Eye: Shaw and the Cinema* (South Bend, 1965), p. 15.
5. See "The Movies and Reality," XLVII, 308–310.
6. XLVIII (September 15, 1926), 95–96.
7. (New York, 1925), p. 212.
8. *A Writer's Diary*, p. 136.
9. (New York, 1945), pp. 90–91.
10. *A Writer's Diary*, p. 250.
11. *The Moment and Other Essays* (New York, 1948), p. 174.
12. (New York, 1958), pp. 136–137.
13. *Virginia Woolf* (London, 1963), p. 101.
14. (New York, 1923), pp. 286–287.
15. *Virginia Woolf* (Norfolk, 1963), p. 65.
16. For an analysis of Mrs. Woolf's montage technique in the sky-writing scene, and for a close reading of the opening six pages of *Mrs. Dalloway* in terms of filmic devices, see Robert Humphrey's *Stream of Consciousness in the Modern Novel* (Berkeley, 1955), pp. 51–56.
17. *Mrs. Dalloway* (New York, 1925), p. 19.
18. *Stream of Consciousness: A Study in Literary Method* (New Haven, 1955), p. 199.
19. *Tower of Babel: Speculations on the Cinema* (Philadelphia, 1966), p. 154.
20. See Cooke's essay "The Critic in Film History" in *Footnotes to the Film*, ed. Charles Davy (New York, 1937), pp. 238–263.
21. *A Writer's Diary*, p. 60.

CHAPTER TWELVE

1. Blotner believes that two scenes in *The Southerner* (1945), which Faulkner worked on with director Jean Renoir, suggest parts of *Go Down, Moses* (1942), and that *Deep Valley* (1947) is similarly evocative for one familiar with the novelist's canon. It says little for Faulkner's skill as a screenwriter, though, when Blotner goes on to argue that the Hollywood years may have enabled the author to master the dramatic structure of that mishmash, *Requiem for a Nun* (1951). (See Joseph Blotner, "Faulkner in Hollywood," in *Man and the Movies*, ed. W. R. Robinson [Baton Rouge, 1967], pp. 261–303.)
2. Faulkner worked on *A Fable* for eleven years, finally deciding to make it a novel. Although one reviewer, Brendan Gill (*New*

Yorker, XXX [August 28, 1954], p. 78), spoke of the book as "mint De Mille," even a cursory examination of the writing shows it to be nonfilmic. Since *A Fable* is full of Faulkner's later tendency toward abstract statement and windy rhetoric, it is also nonnovelistic—but that's another matter.

3. *Writers at Work*, ed. Malcolm Cowley (New York, 1959), p. 139.
4. (New York, 1929), p. 147.
5. *The Sound and the Fury*, p. 90, italics in original.
6. *Literary Essays* (New York, 1957), p. 79.
7. *The Sound and the Fury*, p. 197.
8. *The Social History of Art, Volume Four: Naturalism, Impressionism, The Film Age* (New York, 1958), p. 239.
9. *Literary Essays*, p. 79.
10. *Faulkner in the University*, ed. Frederick L. Gwynn and Joseph Blotner (New York, 1965), p. 132.
11. See *Quest for Failure: A Study of William Faulkner* (Ithaca, 1960).
12. *Film Form and the Film Sense* (Cleveland, 1957), p. 37.
13. *William Faulkner: A Critical Study* (New York, 1951), pp.202–203.
14. *Light in August* (New York, 1959), pp. 103–104, italics in original.
15. *Ibid.*, pp. 27–28.
16. See "Faulkner and Hollywood," *Films in Review*, X (March 1959), 129–133.
17. *The Quarterly of Film, Radio and Television*, VIII (Fall 1953), 51–71.
18. *A Reader's Guide to William Faulkner* (New York, 1964), p. 345.
19. Steven H. Scheuer, *Movies on TV* (New York, 1968), p. 352.
20. *Faulkner in the University*, p. 102.
21. Quoted by Blotner in "Faulkner in Hollywood," p. 279.
22. Quoted by Arthur Knight, *Saturday Review*, XXXVIII (June 25, 1955), 24.
23. *Writers at Work*, p. 125.
24. Speaking of story construction, Pauline Kael says that Faulkner and his fellow writers on *The Big Sleep* "split the seams" of the well-made movie. Since they could not understand the plot, and figuring "that nobody gave a damn anyway," the writers used "sophisticated sex talk" as structural links for the story. *"The Big Sleep* made us aware how little we often *had* cared about the ridiculously complicated plots of detective thrillers, how fed up

with them we were . . ." (see *Kiss Kiss Bang Bang* [Boston, 1968], pp. 6–7).

25. Quoted by Robert Coughlan, *The Private World of William Faulkner* (New York, 1954), p. 87.

26. *The Faulkner-Cowley File: Letters and Memories, 1944–1962* (New York, 1968), pp. 158–159.

CHAPTER THIRTEEN

1. (New York, 1966), p. 180.
2. *Modern American Fiction*, ed. A. Walton Litz (New York, 1963), pp. 138–149.
3. *John Dos Passos* (New York, 1961).
4. *Kino* (New York, 1960), p. 288.
5. *The American City Novel* (Norman, 1954), p. 143.
6. *The Moving Image* (New York, 1968), p. 265.
7. *Manhattan Transfer* (New York, 1959), p. 3.
8. Alfred Kazin, *On Native Grounds* (New York, 1956), p. 268.
9. *Manhattan Transfer*, p. 92.
10. *The Film Till Now* (London, 1967), p. 152, italics in original.
11. *The Art of The Film* (London, 1963), p. 51.
12. *The Movies* (New York, 1957), p. 42.
13. Kazin, *On Native Grounds*, p. 276.
14. *The Big Money* (New York, 1961), p. 17.
15. *Ibid.*, p. 113, italics and ellipsis in original.
16. "The Lost Girls of U.S.A.: Dos Passos's 30s Movie," in *The Thirties*, ed. Warren French (Deland, Fla., 1967), pp. 11–19.
17. *The Novel of Violence in America 1920–1950* (Dallas, 1950), p. 21.
18. *Literary Essays* (New York, 1957), p. 96.
19. *Modern American Fiction*, p. 146.

CHAPTER FOURTEEN

1. *The Letters of F. Scott Fitzgerald*, ed. Andrew Turnbull (New York, 1963), p. 48. Subsequent references to the letters will be documented within the text.
2. *F. Scott Fitzgerald* (Edinburgh, 1964), pp. 24–25.
3. *The Beautiful and Damned* (New York, 1950), p. 83.
4. *Ibid.*, pp. 395–404.
5. *Ibid.*, p. 222.

6. *Ibid.*, p. 103.
7. *Ibid.*, p. 99.
8. *Ibid.*, p. 97.
9. Eliot's letter to Fitzgerald is dated December 21, 1925 and appears in the novelist's *The Crack Up* (New York, 1956), p. 310.
10. *The Great Gatsby* in *Three Novels* (New York, 1953), p. 5.
11. *Ibid.*, p. 48.
12. François Truffaut, *Hitchcock* (New York, 1967), pp. 49–50.
13. "Crazy Sunday" is in *The Stories of F. Scott Fitzgerald*, ed. Malcolm Cowley (New York, 1951), pp. 403–418. See pp. 403, 406, and 416–418 for references.
14. *Tender Is the Night* (New York, n.d.), p. 213.
15. *Ibid.*, p. 291.
16. *Ibid.*, p. 270.
17. *Ibid.*, p. 239.
18. *Ibid.*, p. 69.
19. Anon., "Fitzgerald on Film," *Newsweek*, LVIII (July 17, 1961), 83–84.
20. *The Contemporary Cinema* (Baltimore, 1963), p. 31.
21. *Screenplays of Michelangelo Antonioni* (New York, 1963), p.142 and pp. 154–156.
22. *Tender Is the Night*, pp. 276–277.
23. "Scott Fitzgerald in Hollywood," *Harper's*, CCXVIII (March 1959), 68.
24. "The Youth in the Abyss," *Esquire*, XXXVI (October 1951), 107, 110.
25. *F. Scott Fitzgerald: A Critical Portrait* (New York, 1965), p. 247.
26. *College of One* (New York, 1967), p. 156.
27. *Writers at Work: The Paris Review Interviews*, ed. Malcolm Cowley (New York, 1959), p. 82.
28. *The Pat Hobby Stories* (New York, 1962).
29. *College of One*, p. 138.
30. Bennet Cerf, "Tradewinds," *Saturday Review*, XXX (August 16, 1947), 4.
31. Fitzgerald's lecture is reproduced in *College of One*, pp. 165–190. All italics are in the original.
32. Piper, p. 258.
33. *Beloved Infidel* (New York, 1959), pp. 161–162.
34. *College of One*, p. 190.
35. *The Last Tycoon* in *Three Novels*, p. 95. Further references to this work be documented within the text.
36. *Collier's*, CXXIII (April 16, 1949), 44.
37. *A Tree Is a Tree* (New York, 1952), p. 171.

CHAPTER FIFTEEN

1. Anon., XXII (December 25, 1933), 22; *The Nation*, CXXXVII (December 27, 1933), 744–745.
2. Quoted by James F. Light, *Nathanael West: An Interpretative Study* (Evanston, n.d.), p. 100.
3. Light, for example, makes this point repeatedly in his study of West.
4. Quoted by Light, p. 95.
5. See, for instance, Kenneth Macgowan, *Behind the Screen: The History and Techniques of the Motion Picture* (New York, 1967), p. 406. Jules Feiffer's, *The Great Comic Book Heroes* (London, 1967), may also prove of interest to the reader who wishes to pursue this problem further.
6. "Introduction," *Screenplays of Michelangelo Antonioni* (New York, 1963), p. viii, italics in original.
7. *Nathanael West: An Interpretative Study*, p. 95.
8. *Miss Lonelyhearts* (New York, 1955), pp. 11, 12, 89–90 and 102.
9. (New York, 1941), pp. 306–310 and p. 326.
10. Quoted by Richard B. Gehman, "Introduction," *The Day of the Locust* (New York, 1963), p. xvii. Subsequent references to this "Introduction" and to the novel itself will be documented within the text.
11. *Nathanael West: An Interpretative Study*, p. 175.
12. George Milburn, "The Hollywood Nobody Knows," *Saturday Review*, XX (May 20, 1939), 14–15.

CHAPTER SIXTEEN

1. Leicester Hemingway, *My Brother, Ernest Hemingway* (New York, 1967), p. 110.
2. *The Nation*, CXXXVI (January 4, 1933), 28.
3. *Papa Hemingway* (New York, 1967), p. 56.
4. *The Short Stories of Ernest Hemingway* (New York, n.d.), p. 50.
5. *Ibid.*, p. 51.
6. *Ibid.*, pp. 64–66.
7. *Ibid.*, p. 72.
8. See *Life*, III (July 12, 1937), 20–23.
9. *College of One* (New York, 1967), p. 159.
10. "Hemingway's Narrative Perspective," in *Modern American Fiction*, ed. A. Walton Litz (New York, 1963), p. 225.
11. *The Novel of Violence in America 1920–1950* (Dallas, 1950), p. 190.

12. Carlos Baker, *Hemingway: The Writer as Artist* (Princeton, 1963), p. 241.

13. *Time*, XLII (August 2, 1943), 55–60.

14. "The Structure of Hemingway's *Across the River and Into the Trees*," *Modern Fiction Studies*, XII (Summer 1966), 235.

15. *Papa Hemingway*, p. 20. Hotchner's statement that *The Killers* was the only movie version of Hemingway's work that the writer liked appears on p. 151.

16. *The Short Stories*, p. 289.

17. Nick Adams is probably the central character in the story—though there is some critical opinion to the contrary—but in the film Ole is the hero.

18. For reviews, see: Anon., XXI (September 2, 1946), 62, 67–69; *New Yorker*, XXII (September 7, 1946), 52–53; *New Republic*, CXV (September 30, 1956), 415–416; *Agee on Film: Reviews and Comments* (Boston, 1964), p. 217.

19. See "It's Hemingway's Year," *Newsweek*, L (December 16, 1957), 116, 119.

20. "Hemingway on the Screen," *Films in Review*, X (April 1959), 216.

21. *Papa Hemingway*, p. 33.

22. *The Sun Also Rises* (New York, 1954), p. 16. Other quotations from the novel will be documented in the text.

23. *Ernest Hemingway: An Introduction and Interpretation* (New York, 1967), p. 54.

24. *Papa Hemingway*, p. 240.

25. Hecht and Huxley are both quoted in "It's Hemingway's Year."

26. *Hemingway and His Critics*, ed. Carlos Baker (New York, 1961), p. 109.

27. *Papa Hemingway*, p. 33.

28. *My Brother, Ernest Hemingway*, p. 250.

29. *Papa Hemingway*, p. 33, italics in original.

30. Quoted in *Time*, LXXII (October 27, 1958), 42.

31. See *Saturday Review*, October 4, 1958 and July 29 1961.

CHAPTER SEVENTEEN

1. *Footnotes to the Film*, ed. Charles Davy (New York, 1937), pp. 64–65, italics in original.

2. (London, 1950), p. 4, italics mine.

3. Fifteen of Greene's *Spectator* reviews are in *Garbo and the Night Watchman*, ed. Alistair Cooke (London, 1937), pp. 207–239.

For Greene's comments on *The End of St. Petersburg* see pp. 209–210.

4. *Ibid.,* pp. 210–211.
5. *Three by Graham Greene* (New York, 1952). For quotes see *This Gun for Hire,* p. 4; *The Confidential Agent,* p. 131; *The Ministry of Fear,* p. 82.
6. (New York, 1953), pp. 3–4.
7. "The Novelist and the Cinema—A Personal Experience," in *International Film Annual No. 2,* ed. William Whitebait (New York, 1958), pp. 54–61.
8. (New York, 1948), p. 6. Other quotations from this novel are documented in the text.
9. *Graham Greene* (New York, 1964), p. 104.
10. *Critical Writings of Ford Madox Ford,* ed. Frank MacShane (Lincoln, 1964), pp. 72–80.
11. (New York, 1959), p. 40. See the text for further documentation on this edition.
12. "Subjective Cinema," *The Quarterly of Film, Radio and Television,* VII (Summer 1954), 358.
13. (New York, 1956), p. 249. Subsequent quotes are documented in the text.

CHAPTER EIGHTEEN

1. *Classics and Commercials* (New York, 1950), p. 49.
2. Steinbeck in a letter dated April 15, 1936 to his agents. See Peter Lisca, *The Wide World of John Steinbeck* (New Brunswick, 1958), p. 26.
3. *Ibid.,* p. 26.
4. *Ibid.,* p. 78.
5. Anon., XIX (June 1, 1942), 66; *New Republic,* CVI (June 1, 1942), 766.
6. Quoted in Lewis Gannett's "John Steinbeck's Way of Writing," in *Steinbeck and His Critics,* ed. E. W. Tedlock, Jr. and C. V. Wicker (Albuquerque, 1957), p. 29.
7. *Ibid.,* p. 29.
8. (New York, 1936), pp. 5–6.
9. (New York, 1945), p. 9.
10. (New York, 1963), p. 1.
11. "Point of View in Fiction," in *Theory of the Novel,* ed. Philip Stevick (New York, 1967), pp. 108–137.
12. (New York, 1965), p. 215.

13. *The Nation*, CL (January 20, 1940), 80–81.
14. Quoted in *Newsweek*, XXI (April 5, 1943), 86, 88.
15. *Ibid.*, *Agee on Film: Reviews and Comments* (Boston, 1964), p. 36.
16. *John Steinbeck: An Introduction and Interpretation* (New York, 1963), p. 101.
17. *Novels Into Film* (Berkeley, 1961), p. 167.
18. See Peter Lisca's "Steinbeck's Image of Man and His Decline As a Writer," *Modern Fiction Studies*, XI (Spring 1965), 3–10.
19. Lisca, *The Wide World of John Steinbeck*, p. 167.
20. See Steinbeck's Preface to *The Forgotten Village* (New York, 1941), pp. 5–6.
21. *The Forgotten Village*, p. 140.
22. Anon., XVIII (December 1, 1941), 70–71; *New Republic*, CV (December 8, 1941), 763.
23. Anon., XXIII (January 17, 1944), 66–68; *Agee on Film: Reviews and Comments*, pp. 71–72.
24. *Cinema Eye, Cinema Ear: Some Key Film-Makers of the Sixties* (New York, 1964), p. 185.
25. Quoted by François Truffaut, *Hitchcock* (New York, 1967), p. 113.
26. The screenplay of *A Medal for Benny* appears in *Best Film Plays —1945*, ed. John Gassner and Dudley Nichols (New York, 1946), pp. 589–648. See pp. 644–645 for the passage quoted.
27. *The Wide World of John Steinbeck*, pp. 246–247.
28. (New York, 1950), p. 166.
29. (New York, 1947), p. 29. Further quotations from *The Pearl* shall be documented within the text.
30. *American Moderns* (New York, 1964), pp. 151–152.
31. *The Liveliest Art* (New York, 1957), p. 269.
32. *The Nation*, CLXXV (November 22, 1952), 475.

CHAPTER NINETEEN

1. (New York, 1965). References to the essays will be documented within the text and apply to this edition.
2. *Two Novels by Robbe-Grillet* (New York, 1965), pp. 88–89.
3. "Surfaces and Structures in Robbe-Grillet's Novels," in *Two Novels*, p. 10.
4. "Introduction," *Last Year at Marienbad* (New York, 1962), p. 8.
5. "Last Words on Last Year," in *Film-Makers on Film-Making*, ed. Harry M. Geduld (Bloomington, 1967), p. 167.

6. "Introduction," *Last Year at Marienbad*, p. 12.
7. *Last Year at Marienbad*, p. 17.
8. "Last Words on Last Year," p. 159.
9. *Against Interpretation* (New York, 1966), p. 9.
10. "Introduction," *Last Year at Marienbad*, p. 12, italics in original.

CHAPTER TWENTY

1. *Private Screenings* (New York, 1968), pp. 92–93.
2. *Film: The Creative Process* (New York, 1964), p. 206.
3. "From Book to Film," *The Quarterly of Film, Radio and Television*, VI (Spring 1951), 258–273.
4. *Kiss Kiss Bang Bang* (Boston, 1968), p. 70.
5. "Osborne's *Tom Jones*: Adapting a Classic," in *Man and the Movies*, ed. W. R. Robinson (Baton Rouge, 1967), p. 33.
6. "Each Film Is My Last," *Tulane Drama Review*, XI (Fall 1966), 97.
7. "Introduction: Bergman Discusses Film-Making," *Four Screenplays of Ingmar Bergman* (New York, 1960), p. xviii.
8. *Writers at Work: The Paris Review Interviews*, ed. Malcolm Cowley (New York, 1959), p. 125.
9. Robert Scholes and Robert Kellogg, *The Nature of Narrative* (New York, 1966), pp. 279–282.

Index